Antiques £10-£1000
The Sotheby Parke Bernet Guide

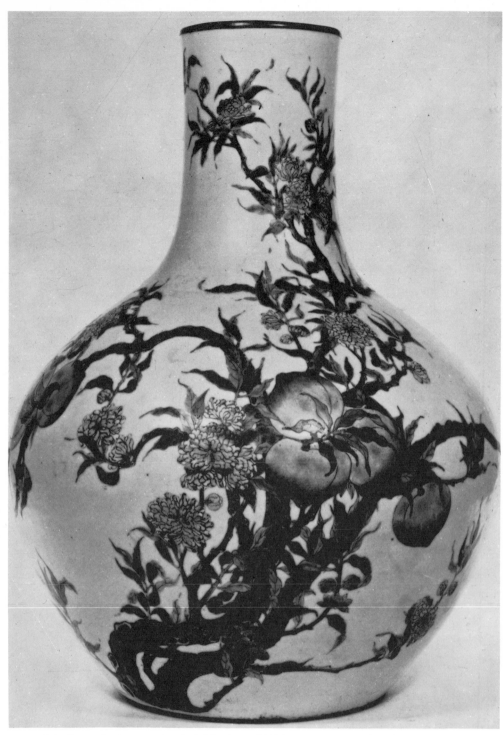

A famille-rose bottle vase, seal mark of Ch'ien Lung mid 19th century. Height 22½ in (52 cm). Belgravia 28 November £350 ($840).

Antiques £10-£1000

THE SOTHEBY PARKE BERNET GUIDE

Compiled by Ian Bennett

Country Life

Edited and designed by S. H. Verrent
Published for Country Life Books by
The Hamlyn Publishing Group Limited
London · New York · Sydney · Toronto
Astronaut House, Feltham, Middlesex, England

Introductions copyright © 1975 by The Hamlyn Publishing Group Limited
Illustrations and captions copyright © 1975 by Sotheby Parke Bernet Publications Limited

ISBN 0 600 38150 1

Printed in England by
Netherwood Dalton & Company Limited, Huddersfield

Contents

Introduction

THE salerooms of fine art auction houses are open to any-one—they are not only for the wealthy who pay the record prices which attract worldwide attention. Works of art in every field can be bought for modest sums.

In the following pages there will be found a selection of nearly eighteen hundred objects which range in price from a few pounds or dollars up to £1,000 ($2,400). In many cases they are pieces which a museum or collector of taste would be proud to own—indeed a number were purchased by national collections. Others are essentially decorative but with a charm and quality so often lacking in the mass-produced goods of today. An attempt has been made to display a representative cross-section of works of art that have changed hands during the year 1974, at sales held by Sotheby Parke Bernet in London (New Bond Street and Belgravia), New York and Los Angeles, as a guide to prospective purchasers to select pieces of good quality and to avoid the mistake made by so many collectors when first starting, that of choosing pieces either because they are very expensive or because they cost the least. Any hobby consumes time and money but these are burdens we bear willingly in pursuit of that which we love. Buying art is, at its most superficial level, a 'hobby'; it brings excitement, joy, disappointment and, in the final analysis, a great sense of achievement.

The selections have been made by the experts of Sotheby Parke Bernet; it has been a most interesting project for a number of reasons. An expert in a saleroom is in a unique position; he is able to make judgements and comparisons which only close daily contact with a very large number of antiques in his special field makes possible. He is aware that the great majority of pieces sold every year by an auction house fetch reasonably modest sums, and that anyone with an eye for quality should be able to buy outstanding works of art without necessarily being very wealthy. A book such as this is an invaluable way of propagating such knowledge.

There are few areas of the applied arts which do not appear in this book, a fact surprising in itself. What is most interesting is that within each separate category are pieces which even the staff of Sotheby's itself were surprised to find selling for such low sums. Few people would imagine that it was possible still to buy Byzantine and medieval ivories or enamels for a few hundred pounds, to purchase attractive examples of T'ang and Sung pottery or Ming porcelain for under £500 ($1,200), to acquire silver by Paul de Lamerie and Paul Storr, good examples of 18th-century French furniture by known cabinetmakers

or English 18th-century bracket clocks for similar sums. Meissen porcelain, fine examples of all the major English 18th-century porcelain factories, Japanese swords, probably the finest cutting weapons ever devised by man, 18th-century Italian violins, sculpture from the workshops of Renaissance masters and the best examples of 20th-century craftsmanship—all will be found in these pages.

It is hoped that this book will thus encourage new collectors. Most of the sections deal with specific categories of objects in sufficient detail to give an indication of the level of prices prevailing within any particular market. Furthermore, the very scope of the book should be enough to demonstrate that the salerooms are places worthy of the attention of the modestly financed collector. A knowledge of auction practices is advisable and the conventions of cataloguing, most of which are set out in the preambles to the catalogues themselves, should also be studied carefully. It would be wise to consult either the relevant expert at Sotheby Parke Bernet or, if preferred, a specialist dealer. This book, however, should recommend itself as much to those who have never purchased a work of art before as to experienced habitués of the salerooms.

Cyril Connolly, in an article entitled *Sotheby's as an Education*, wrote as follows:

It was then that I discovered Sotheby's—an emporium where nobody expects you to buy, a museum where all the objects are changed once a week like water in a swimming pool, a university which issues three or four text-books weekly... Works of art are meant to circulate, they should move on, unless they are treasured heirlooms, before they can be taken for granted ... the moment they gather dust, retire into safes and plate-chests, they cease to function. For although every year more and more works of art and antique objects soar away into the domain of the museum and the millionaire ... there remain pockets, small unprohibited areas of beauty, still within the range of the modest collector.*

Although the fourteen years since this was written have seen a considerable increase in the number of 'text-books weekly' issued by Sotheby's (there are fifteen sales a week at New Bond Street alone during the height of the season) the sentiment remains true. Every year the flow of antique works of art becomes less, so the problem of upgrading and rediscovery, the inevitable result of increasing demand, means the slow diminution of those 'pockets' which are

* Sotheby's 217th season 1960-61

still relatively inexpensive. But the single-minded pursuit of one's declared interest is part of the excitement of collecting, and successful results are nothing if not satisfying.

So far, stress has been laid upon the word 'collector'. This pre-supposes that to buy works of art necessitates a desire to assemble a *group* of objects in one particular area. Although this is an important aspect of the art market, just as significant are those people who may not wish to 'collect' in the narrowly defined sense of the word, but who simply want to own one or two good pieces which can be put to a functional as well as a decorative use, or to hang a picture on their wall which is not a reproduction. 18th- and 19th-century furniture will often cost no more than modern pieces; in the case of 19th-century furniture, pieces often fetch considerably below what one might expect to pay for new furniture from a store. Similarly, a modest but attractive piece of antique silver will often prove no more expensive than a modern piece, and a 19th-century ceramic service will usually cost less than a modern example of the same size.

The advantages in financial terms, however, are not to be reckoned solely in terms of the purchase price. A work of art of good quality, even one purchased for use, will at least hold its value if treated with care and all the evidence suggests that it will more likely increase in value steadily over the years. This cannot be said of modern commercial pieces, machine-made objects often of poor design.

Nevertheless, anyone who has never purchased at auction might well think auction houses to be daunting places. Somehow, the idea of the sudden sneeze resulting in the ownership of a Rembrandt persists, even though this never happens. For the last twenty years, Sotheby's has encouraged the idea of the saleroom as a place open to all, where there is as much opportunity to obtain modestly priced works of art as there is to acquire masterpieces.

An analysis of the company's turnover figures justifies this. Although Sotheby Parke Bernet sells many million pounds worth of works of art every season throughout the world, over seventy per cent of the total is still made up of pieces which fetch below £250 ($600). Great masterpieces may receive world-wide publicity, but objects which sell for between £50 and £250 ($120 and $600) are the lifeblood of any firm of auctioneers. Because this is so, it is essential that not only the dedicated collector, but also the public at large, should feel at ease in the salerooms.

Since the war, London auction houses and dealers have shown an increasing tendency to specialise. This has meant that buyers have been able to study individual areas of the art market in detail, to form conclusions about price levels and the availability of one field of art as opposed to another and to decide about the advantages of purchasing in one specialised area rather than spreading what might be a comparatively modest budget over many different types of art. Specialist saleroom catalogues are now considered essential works of reference, both from an economic standpoint and as art history.

It is noticeable that whenever Sotheby's decides to produce catalogues in a specialist field—clocks and watches, Art Nouveau, modern ceramics, children's books and contemporary art are some recent examples—a great number of collectors appear who have never previously attended auctions. In 1971 Sotheby Parke Bernet decided that the growing interest in 19th- and 20th-century works of art justified a separate saleroom to specialise in this field, and opened Sotheby's Belgravia. Furniture, bronze sculpture, ceramics, photographs and photographic equipment are just some of the fields of 19th-century art which were, for the first time, given individual sales. The result has been to increase awareness of Victorian design and to demonstrate clearly that the arts of the last century are as worthy of attention as those of any other age.

Of equal importance are the 20th-century works of art sold by Sotheby's Belgravia. It has been pointed out that much of modern design and craftsmanship is poor; nevertheless it should be stressed that, by this, commercial production is meant. Recent exhibitions in the United States and Europe have demonstrated clearly that individual craftsmanship of a high order still exists, only the audience for it is shrinking. Sotheby's Belgravia has sold carpets by Marion Dorn, furniture by Aalto, pottery by Decoeur, Charles Vyse, Bernard Leach and Lucie Rie, who is perhaps the finest ceramist working in the Western world today. There is no reason to suppose that a good collection of contemporary crafts, chosen with the same criteria which one would apply to antique works of art, should not be as highly regarded and as valuable in thirty to forty years time as the best examples of Art Deco are today.

After all, ceramics by Decoeur, Lenoble and Soudbinine, to name the three most important potters working in France in the 1920s and 1930s, have been sold in the last two or three years for prices ranging up to £6,000 ($14,000), good glass by Marinot is worth upward of £2,000 ($4,800), whilst the best examples of cameo-glass by English craftsmen such as George Woodall can be worth up to £10,000 ($24,000). Magnificent French furniture of the 1920s by craftsmen such as Eileen Gray, Legrain or Ruhlmann, much of it equal in quality to the best 18th-century furniture, is now worth up to £20,000 ($48,000) for a single piece, and several thousands have been paid for the jewellery of Lalique, Wolfers and Hoffmann and the Art Deco silver of Puiforcat.

In contrast, it is unusual for a good pot by Bernard Leach, certainly one of the greatest ceramists of the 20th century, to cost more than £200 ($480), examples by his Japanese co-worker Shoji Hamada rarely cost more than £400 ($960) on the Western market (the level of prices is believed to be higher in Japan) while the work of an artist of the calibre of Lucie Rie can be bought for less than £100 ($240). This, surely, is a field well worth exploring—a collection of modern glass, ceramics, textiles, metalwork, jewellery and furniture would be a viable alternative to buying antiques.

In buying, the idea of 'value for money' should be uppermost always in the mind of the prospective purchaser. One should look for things of real quality which are not necessarily by a world famous artist, whose name sometimes seems to be worth more than his work. Japanese bronzes, as can be seen from those we illustrate, are of fine quality and yet they fetch most unflattering prices. A good collection of these would be neither difficult nor particularly costly to form; illogically, the best examples are less expensive than European animalier bronzes which are so fashionable at the moment but not of higher quality.

The Japanese influence on European art and design in the 19th century was crucial to the development of modern aesthetics. The Japanese were masters of vivid naturalism alien to Chinese art, where forms tend to be more stylised; on another level, however, they developed an architectonic, functionalist mode in which the use of a superbly controlled asymmetry prevailed. While 19th-century European art abounds with decorative motifs drawn from Japanese art, a style of 'Japonisme', particularly widespread in France and England during the 1870s and 1880s, it is the latter example of flat linearism which had the most profound effect, whether in the paintings of the French Impressionists and Post-Impressionists or in the work of such designers as Christopher Dresser and William Godwin in England. The designs of these latter two, with their rigid angularity, leap out from the surrounding mass of half-digested styles as being among the major contributions of the 19th century to the development of Western design.

For this reason the Japanese section, especially that part

dealing with 19th-century works of art, will be of particular interest to the modestly financed beginner with an interest in the history of modern art. In general, Japanese art, at least that which finds its way on to the Western market, falls into a price bracket below £10,000 ($24,000)—it is only the very exceptional piece that will fetch more than this. From the 19th century, any number of splendid bronzes, ivories and ceramics can be purchased for below £200 ($480).

Other areas of 19th- and 20th-century applied art might also be singled out. Over the last three or four years, American patchwork quilts have received much scholarly attention and have been the subject of numerous published studies as well as exhibitions in the United States and Europe. Prices have moved from around $100 to over $1,000 for the finest examples, and while a good collection a few years ago would not have cost much to form, today it would be a fairly expensive business. In contrast, English quilts of the 19th century are still hardly noticed. Stylistically they are similar to their American counterparts but there is a more frequent use of materials such as silk, velvet and satin which are rare in examples from the United States. To judge from the number of pieces which appear every year on the market in England, the activity of quilt-making was as widespread in that country as in America but prices are still, in general, below £50 ($120) for good examples.

Still on the subject of 19th-century applied art, we illustrate some examples of papier mâché furniture. Brought from France to England in the late 18th century, the process was perfected in the latter country by the firm of Jennens and Bettridge of Birmingham. The thick layers of glued pressed paper, finished with shellac, oil-polished, painted and inlaid with mother-of-pearl, were moulded into many types of household furniture, from bed-fittings to trays and writing-boxes.

There is a story of how Jennens and Bettridge were commissioned by the Corporation of Birmingham to make a splendid tray for presentation to Queen Victoria, who was due to pass through the city on her way to Scotland by rail. At the appointed hour, the civic dignitaries assembled on the station with the tray, upon which rested a loyal address. During the short stop, Her Majesty appeared at the window of the royal carriage; she did not alight from the train which began to move before the mayor could finish his speech. Hurrying forward, the civic worthy handed up the tray and Her Majesty, misinterpreting the gesture, took the scroll that was upon it, leaving the prize example of Jennens and Bettridge's workmanship in the hands of the bemused Lord Mayor. In the intervening hundred years or so, appreciation of this interesting craft has not moved much beyond that of Queen Victoria and prices are still low.

Today, there is still a surprising measure of prejudice against 19th-century art. Admittedly, the Victorians were capable of monstrous errors of taste but so were the artists and craftsmen of any age, a fact which many people seem incapable of accepting. 'Paradise Lost is a very fine poem but we would not wish it longer', wrote Doctor Johnson of Milton's epic; that neo-Augustan asperity of judgement, which accepted nothing on trust and questioned everything, would appear to be lacking from much modern criticism. This may be due in part to the avidity of present-day collecting, which demands so great a quantity of art that things which might otherwise have been forgotten have been resurrected and elevated to stations beyond their proper place; thus many areas of art previous to the 19th century have become acceptable in art historical as well as social terms, while some truly great Victorian art still suffers from the indiscriminate opprobrium which has passed for so long as serious criticism.

Sotheby's Belgravia has succeeded in redressing the balance of critical opinion which has hitherto looked upon 19th-century applied art in general as slightly amusing, if not plain bad—certainly not something to be taken seriously. That Sotheby's was justified in its belief in the quality of 19th-century art is borne out by the success the saleroom has achieved in the past four years.

Nevertheless, the generally low level of prices paid for 19th- and 20th-century applied art is not surprising. Perhaps more significant is the possibility, demonstrated in this book, of purchasing good works of art from earlier periods. In the introduction to each of the sections the relevant markets are discussed in some detail. It is worth while here to point to some which appear very undervalued.

Although tribal art now has a wide audience prepared to pay extremely high prices for the finest pieces which come on to the market, there are still many good examples of African sculpture, as well as of other tribal cultures, to be had for comparatively little money, while certain specific types remain virtually ignored. Who, for instance, collects African ceramics or the jewellery of the nomadic Berber tribes of North Africa? Certain European museums have worked on these two areas, the British Museum in London for ceramics and the Musée de l'Homme in Paris for the jewellery, but these are fields largely ignored by the private sector, and as such worthy of the attention of any adventurous new collector. Similarly Ashanti bronze weights, as charming and accomplished examples in their own way of miniature sculpture as Japanese netsuke, have not attracted much attention from serious collectors and are still very inexpensive. Perhaps most surprisingly, good pre-Columbian ceramics are still very reasonably priced, although the main market is in the United States.

There are also fine pieces to be had in the field of Classical antiquities. Roman glass, for instance, has increased in price considerably over the last four or five years but still attracts only few specialist collectors. Examples of ancient Egyptian jewellery can be purchased at prices ranging upwards from a few pounds for a single string of blue-glazed faience beads, whilst in a price bracket of between £150 ($360) and £600 ($1,440), small but nevertheless extremely beautiful Egyptian bronzes are available. Egyptian alabaster vases, even the finest examples, do not usually fetch above £500 ($1,200), while good examples of painted Greek pottery can be purchased for between £200 ($480) and £500 ($1,200).

English 18th-century silver is a market with a very widespread appeal. Silver itself is a precious metal and, although the connection between the price of antique silver and silver bullion is more psychological than real, the intrinsic worth of an 18th-century coffee pot can only be an encouragement to the purchaser. Many people own a few examples of 18th- or 19th-century silver, which has the advantage of being sturdy and practical to use. Apart from a period in 1969 when, due to over-speculation the previous year, its value fell, antique silver has shown a steady appreciation over the last fifteen years and in the long term must be considered an extremely positive asset. The cost of good pieces is not necessarily very high, as can be seen from those examples illustrated in the silver section of this book; it is a market which should recommend itself as much to those people who wish to acquire one or two good things for domestic use as to the dedicated collector.

In contrast to English silver, which has a strong international appeal, English 18th-century ceramics and glass remain largely parochial markets, although there have been collectors in the United States for many years. The effect of this parochialism upon the English 18th-century ceramics market has been to depress it below what many people consider a realistic level. Admittedly, in the last two years, the finest examples of Chelsea and Worcester porcelains have begun to fetch prices more on a level with many of

the European factories with which, in artistic terms, they should be compared, but there still remains a considerable gap between the sums given for fine works from such factories as Bow, Liverpool and Leeds, the products of which often have a charm lacking from the more sophisticated pieces from the large factories, and the prices paid for minor Italian and German porcelain. In this area, as well as in the field of 18th- and 19th-century English pottery, several examples of which are illustrated, the level of prices is well within the means of the buyer with limited resources.

The same may be said of English glass. In the 18th century, England was the largest producer of fine glass in the world; there is a wide variety of types and styles, some of which—the engraved Jacobite and Williamite glasses for instance—are of considerable historic as well as artistic interest. In general, English 18th-century glass falls into a price bracket between about £50 ($120) and £2,500 ($6,000), with only a few exceptionally fine pieces making above the higher sum. Glass has the obvious disadvantage of great fragility and, despite the number of new collectors who have begun buying since the famous Smith sales at Sotheby's in New Bond Street in 1967-68, it remains a minority taste with plenty of opportunities. It might be added that good late 18th- and early 19th-century cut glass remains out of fashion and that this might be an interesting area for specialisation.

The applied arts of the United States form another parochial market. It was said earlier that patchwork quilts have reached a wider international audience in recent years but they remain an exception. Some of those examples of folk art particularly associated with the eastern states of America, Frakturs, theorem paintings, ceramics and painted tinware, appear occasionally on the European market but for the most part are sold only in their country of origin. As can be seen from the examples illustrated in this book, they have a style of their own which is instantly recognisable and they are of great charm. Certainly they deserve to be better known in Europe and it may be that an international market will appear for them in the next few years.

The definition of the terms 'Works of art' and 'Objects of vertu' are given in the introductions to each section. 'Works of art', which embraces a very wide range of objects from the Romanesque and Byzantine periods up to late 19th-century sculpture, is a fascinating area for both the collector and the casual buyer. Most people wish to have a few decorative objects in their homes; Renaissance and later sculpture can often be purchased for comparatively modest sums; English marble and ivory sculpture of the late 18th and early 19th centuries has been virtually ignored by present-day collectors. Some of those pieces which might be considered among the best examples of 'value for money' will be found in this section.

'Vertu', like silver, has the advantage of being made from precious metals. The gold boxes illustrated in this book do not cost insignificant sums—they could hardly be expected to—but they are works of art of great quality and their richness is illustrative of a way of life which typifies the 18th century. Similarly, the Renaissance and later jewels illustrated are not only pieces which can be worn but are also miniature sculptures, as representative of their age as a painting or sculpture in bronze. Their intrinsic value is often less than a modern piece where value is determined primarily by the type and quantity of gemstones used. Thus a fine Renaissance piece will generally be less expensive than a modern one which is made up of diamonds or other precious stones, but which may have little in the way of design to recommend it.

To collect art seriously seems to demand some degree of eccentricity. The history of the market is littered with characters who, were it not for their interest in art, might well have ended in asylums (many did anyway) and with artists whose activities were even more bizarre. The 19th-century biblio-maniac (his word) Sir Thomas Phillipps, whose avowed aim in life was to own one copy of every book ever written and who devoted his life and more money than he possessed to the realisation of it, assembled what is still regarded as the greatest library formed in recent times by a single individual; his wife and family passed impecunious lives due to Phillipps' uncontrollable passion for books and manuscripts, and followed him many times as he fled bailiffs and creditors, who became as natural adjuncts to his collecting as wormholes, inevitable nuisances which he tolerated. Collecting can become as habit forming as any drug, consuming time and money. But the mental stimulus to be gained from a saleroom battle won or a chance discovery is indescribable to anyone who has not experienced it. And this is apart from the pleasure to be gained from owning works of art, from living with them every day.

In many instances, the objects illustrated in this book do not, for economic reasons, represent a particular area of the applied arts at its very finest. Chinese ceramics, for instance, are now the most valuable of all the applied arts, prices of between £200,000 ($480,000) and £450,000 ($1,080,000) having been paid for the few great masterpieces which have appeared on the market in the last three or four years. It will be appreciated, therefore, that a piece of Chinese pottery or porcelain at under £1,000 ($2,400) is a comparatively modest thing. But this book is not about masterpieces: it is about objects of beauty, which, fortunately, happen to be reasonably inexpensive.

It is arguable that, to collect seriously in one particular area, a person should be able to afford to buy the very best object in that field should it become available. If he cannot do so, his collection, unless he is lucky enough to make the chance discovery, will never contain those pieces which can turn an ordinary collection into a great one. But this is only one reason for buying art. Many people, as was said earlier, are not interested in serious specialist collecting but only wish to own a few fine objects to enrich their surroundings and give them pleasure. It is believed that, to them the wide range of objects illustrated in this book will come as a pleasant surprise.

'Beauty', said Keats, 'is in the eye of the beholder'; this should be the principle behind any collection and the apologia for any collector.

ACKNOWLEDGEMENTS

Without the expert help of the staff of Sotheby Parke Bernet, this book could not have been compiled. All gave their time and help without stinting and made observations about their fields of interest which have had great influence on the contents of this book. I must thank in particular David Battie of Sotheby's Belgravia, and Robert Woolley and Bolle McIntyre of Sotheby Parke Bernet, New York, who assembled material from that saleroom. Jane Boulenger and Joan Sarll of Sotheby Parke Bernet Publications gave me much help. Finally, Sam Verrent put this book together and to him I owe the greatest debt.

GENERAL NOTE

Dollars have been calculated throughout at $2.40 to the pound but for the convenience of readers in the United States, the top limit for objects sold in New York and Los Angeles has been extended to $2,500. Unless otherwise stated, all measurements are given height before width.

Ian Bennett
Sotheby's

Antiquities

Classical European, Egyptian and Middle Eastern antiquities
Ethnographic art
Art of the Indian sub-continent

The collecting of classical Greek and Roman sculpture and artifacts is as old as the works of art themselves. We know that the rich citizens of Rome were keen collectors of Greek art and that, to satisfy the demand, Roman sculptors made copies of Greek marbles which were often sold as original Hellenistic work. In the late 18th century, first with the neo-Augustinian movement and then with Neo-classicism, the art of the ancient world was rated above all other. In the hundred year period between 1750 and 1850, quantities of Greek and Roman sculpture were brought to Europe and Great Britain, which at this time rose to the peak of its economic greatness, benefited from the plundering of classical sites; the Elgin marbles, removed from the Parthenon and purchased by the British Museum in 1816 for the then enormous sum of £35,000 are a legacy of this policy.

In recent years the market in classical antiquities has been difficult to analyse. The source countries have, quite correctly, imposed strict export bans. In past centuries there was a never-ending stream of newly discovered pieces from Greece, Italy and the Middle East, as well as great masterpieces from Egypt, but there has been no such supply of late and few important examples now reach the salerooms. This has caused the market to stagnate and whilst recent evidence has shown that collectors are prepared to pay high prices for great pieces, the majority of classical antiquities sold at auction are very reasonable in price. For a comparatively modest outlay, the new collector could acquire works of art of great age and beauty.

In contrast, the interest in Indian art and ethnographic and tribal pieces is a fairly recent development. With regard to the latter, explorers and travellers returned to England with examples of sculpture from Africa, Australasia and the Pacific Coast, while in the United States and Canada, North American Indian artifacts were accumulated. These were treated more as 'objects of curiosity' than as serious works of art until painters and sculptors working around 1910 began to appreciate the strength and beauty of so-called 'primitive' art, attributes which today we take for granted.

Although the very finest pieces now cost many thousands of pounds, collecting Ethnographic art is still within the means of the collector with only modest finances, but there are problems of which he should be aware. While age is difficult to determine, the dividing line of 'right' and 'wrong', especially for African sculpture, is whether a given piece was made for genuine tribal purposes or merely as a tourist souvenir. There is an obvious difference to the trained eye, but the new collector should be extremely wary.

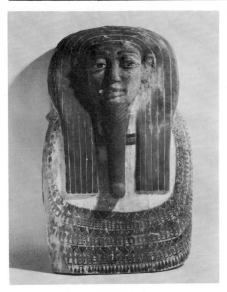

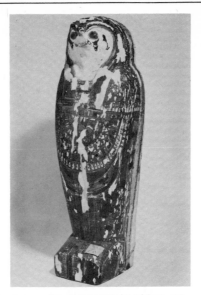

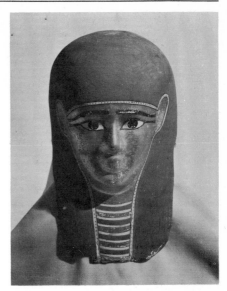

Egyptian wooden mummy mask, the eyes and brows inlaid in bronze and glass. Painted in polychrome, but primarily blue and green, on gesso over linen, 26th/30th dynasty 664-341 BC. Height 26 in (66 cm). New York 4 May $2,200 (£918)

Egyptian wooden mummy case for a falcon, containing the mummy of the bird and fragments from a group of the Four Sons of Horus. Painted red, brown and blue on gesso ground, late period 712-30 BC. Length 19½ in (49·5 cm). New York 4 May $1,000 (£417)

Egyptian cartonnage mummy mask, gilded and painted in blue, red and yellow and with dotted cosmetic lines in black. Late Ptolemaic or early Roman period, circa 1st century BC. Height 14½ in (36·8 cm). New York 4 May $1,500 (£626)

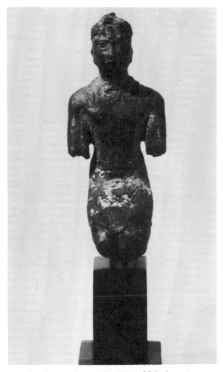

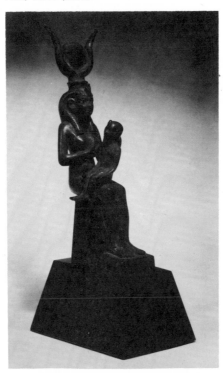

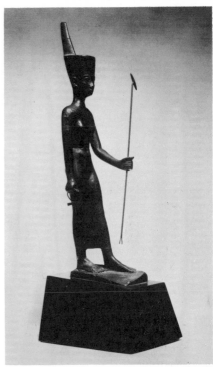

Egyptian bronze figure of a king, 25th dynasty. Height 2⅝ in (6·7 cm). New Bond Street 29 April, £140 ($336)

Egyptian bronze group of Isis and Horus, late period 715-30 BC (wooden base-stand modern). Height of bronze 9¾ in (24·8 cm). New York 4 May $1,400 (£583)

Egyptian bronze figure of Neith, wearing the red crown of Lower Egypt, 26th dynasty 664-525 BC (wooden stand modern). Height of bronze 9 in (22·9 cm). New York 4 May $2,400 (£1,000)

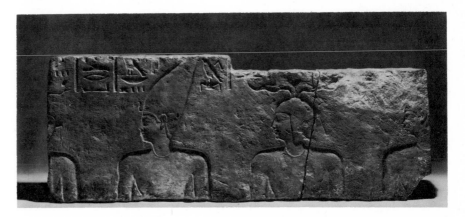

Egyptian limestone relief fragment carved with four figures, one a king wearing the white crown, facing the god Horus. 30th dynasty/early Ptolemaic period 380-200 BC. 27¾ by 10 in (69·5 by 25·4 cm). New York 4 May $1,500 (£626)

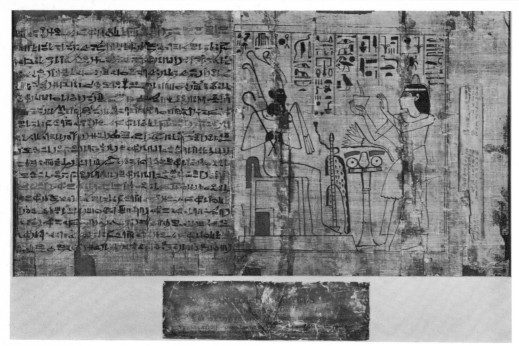

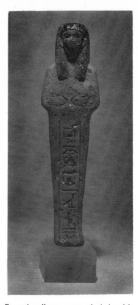

Egyptian limestone ushabti, with traces of red and black pigments, probably early 18th dynasty 1554-1500 BC. Height 8⅝ in (21·9 cm). New York 4 May $900 (£375)

Egyptian funerary papyrus, drawn with a scene of the deceased Djed-it-Khonsu-Kheper making offerings to Osiris, 3rd intermediate period 1080-712 BC. 18½ by 9 7/16 in (47 by 24 cm). New York 4 May $2,100 (£875)

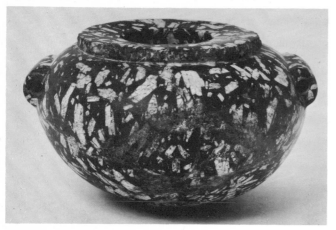

Egyptian breccia marble jar, predynastic period, Nagada II, *circa* 3500-3000 BC. Width 10¼ in (26·1 cm). New York 22 November $750 (£312)

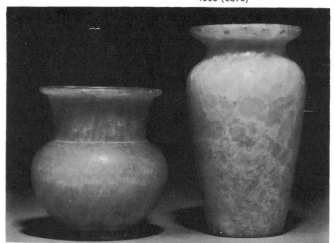

Right: Egyptian white aragonite vessel, Middle Kingdom 2134-1785 BC or earlier. Height 5½ in (13·8 cm). New York 22 November $250 (£104) *Left:* Egyptian alabaster jar, probably early 18th dynasty *circa* 1554-1450 BC. Height 3⅞ in (9·8 cm). New York 22 November $275 (£115)

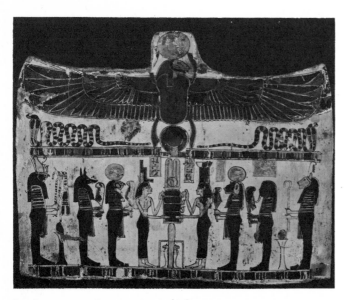

Egyptian cartonnage fragment painted with Isis, Nephthys, Horus and other divinities, 25th dynasty 745-655 BC or later. Length 13½ in (34·3 cm). New York 22 November $1,100 (£458)

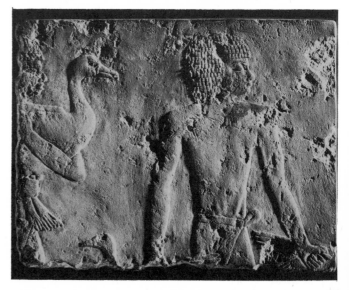

Egyptian limestone relief fragment, early 18th dynasty *circa* 1554-1500 BC. 12 by 9 in (30·5 by 22·9 cm). New York 22 November $1,200 (£500)

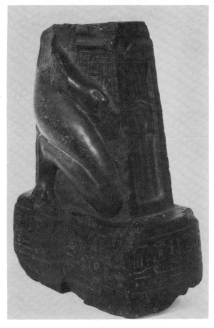

The lower half of an Egyptian black stone kneeling male figure (the high official Psamtik-em-Akhat), 26th dynasty. Height 11⅜ in (28·9 cm) New Bond Street 29 April £1,000 ($2,400)

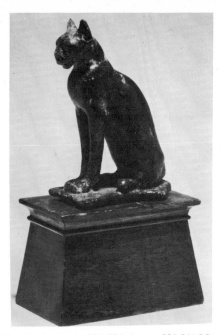

Egyptian bronze cat, 26th/30th dynasty 664-341 BC. Height 3¼ in (8·1 cm). New York 22 November $1,700 (£709)

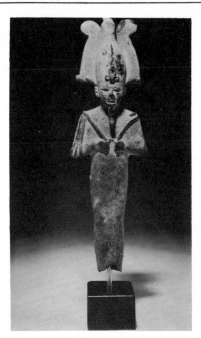

Egyptian bronze figure of Osiris, 26th dynasty 664-525 BC or earlier. Height 7¾ in (18·8 cm). New York 22 November $950 (£396)

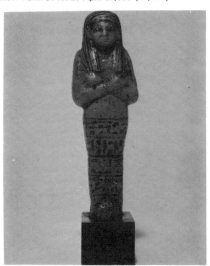

Egyptian faience ushabti, 21st dynasty 1080-946 BC. Height 6⅜ in (16·2 cm). New York 22 November $1,000 (£417)

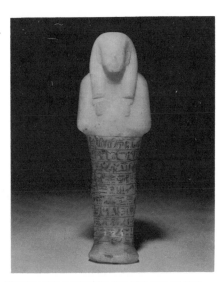

Egyptian alabaster ushabti, late 18th dynasty circa 1347-1305 BC. Height 8¼ in (20·8 cm). New York 22 November $1,500 (£625)

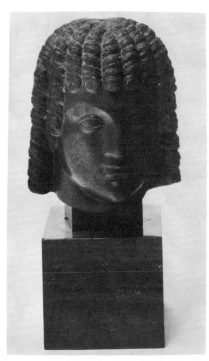

Egyptian stone head of the goddess Isis, Ptolemaic period circa 100-30 BC. Height 6 in (15·3 cm). New York 22 November $1,300 (£542)

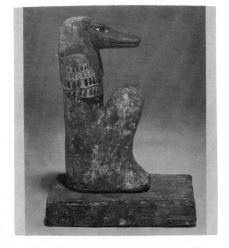

Egyptian wooden figure of a divinity, the jackal-headed figure representing either Anubis or the Genius of Nekhen, painted in red, black and green over gesso, late period 712-30 BC. Height 6½ in (16·5 cm). New York 4 May $1,900 (£790)

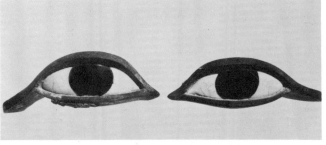

Pair of Egyptian bone, obsidian and bronze eyes from a statue, late period. Length 4 in (10·2 cm). New Bond Street 29 April £190 ($456)

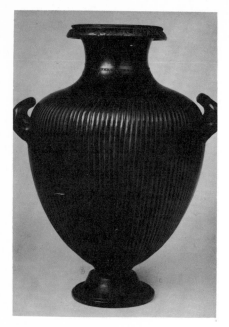

Greek pottery hydria, probably Apulian *circa* 350-300 BC. Height 15¾ in (40 cm). New York 22 November $2,200 (£918)

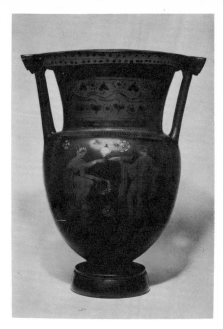

Apulian pottery column-krater, Greek *circa* 350-325 BC. Height 17⅞ in (45·4 cm). New York 22 November $1,900 (£792)

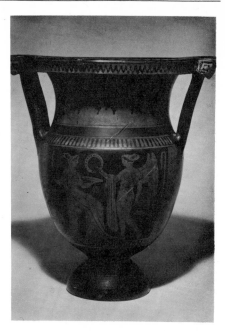

Apulian pottery column-krater, Greek *circa* 350-325 BC. Height 13¾ in (34·8 cm). New York 22 November $1,000 (£417)

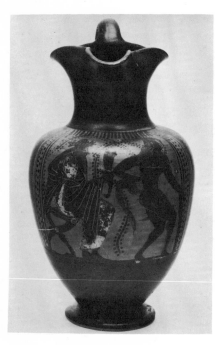

Attic pottery oinochoe, late 6th century BC. Height 9¼ in (23·5 cm). New York 22 November $900 (£375)

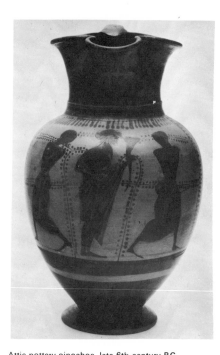

Attic pottery oinochoe, late 6th century BC. Height 9⅛ in (23·2 cm). New York 22 November $800 (£334)

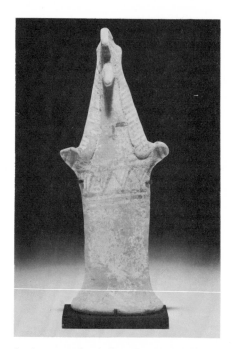

Greek terracotta female figure, Boeotia, early 6th century BC. Height 7⅝ in (19·5 cm). New York 22 November $450 (£188)

Greek bronze bull, Geometric, 8th century BC. Length 2¾ in (7 cm). New York 22 November $1,300 (£542)

Greek terracotta pig, Rhodes *circa* early 5th century BC. Length 4⅛ in (10·5 cm). New York 22 November $300 (£125)

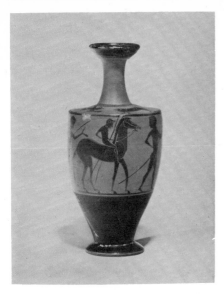

Attic black-figure lekythos, the body painted and incised with spearmen and horsemen, late 6th century BC. Height 4 7/16 in (10·6 cm). New York 22 May $750 (£313)

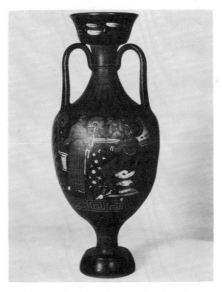

Apulian Pan-Athenaic pottery amphora from the group of Bologna 372, Workshop of the Patera painter, 4th century BC. Height 20 7/8 in (53 cm). New Bond Street 29 April £700 ($1,680)

Greek terracotta figure of a woman, Boeotia *circa* 3rd century BC. Height 6 in (15·3 cm). New York 22 November $675 (£281)

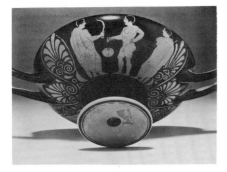

Attic pottery red-figure kylix painted with draped and nude youths, late 5th century BC. Diameter without handles 9 5/8 in (24·5 cm). New York 4 May $1,200 (£500)

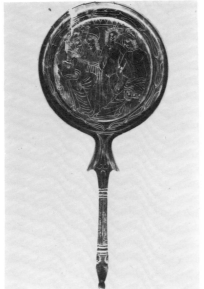

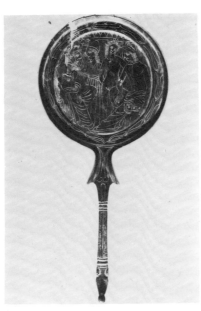

Right: Etruscan bronze mirror, *circa* 4th/3rd century BC. Height 10 1/2 in (26·7 cm). New Bond Street 29 April £600 ($1,440)

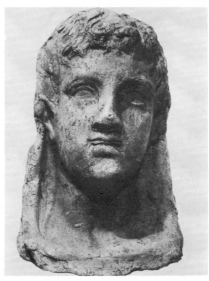

Etruscan black figure amphora by the Micali painter, 6th century BC. Height 12 1/2 in (31·8 cm). New Bond Street 29 April £800 ($1,920)

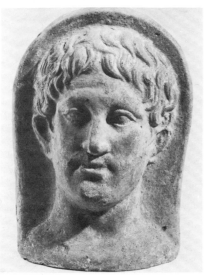

Etruscan terracotta votive head of a youth, 2nd/1st century BC. Height 10 1/2 in (26·8 cm). New Bond Street 29 April £150 ($360)

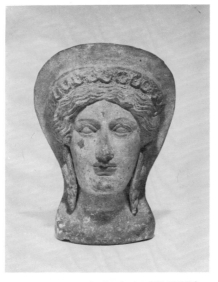

Etruscan terracotta votive head, *circa* 350-250 BC. Height 11 5/8 in (29·5 cm). New York 22 November $850 (£354)

Etruscan coarse terracotta votive head of a youth, *circa* 3rd century BC. Height 9 3/4 in (24·8 cm). New Bond Street 29 April £300 ($720)

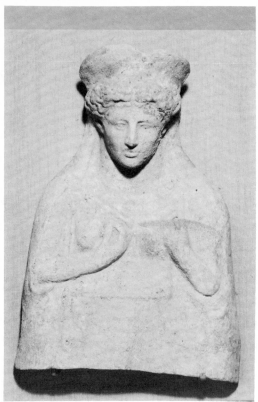

Greek terracotta protome, Attic or Boeotian
late 5th century BC. Height 12½ in (31·8 cm).
New York 22 November $550 (£229)

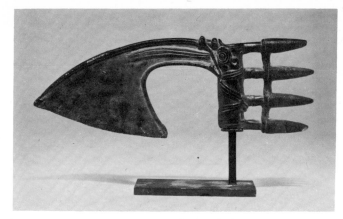

Luristan bronze axe-head, *circa* 1000-800 BC. Length 9½ in (24·1 cm)
New York 22 November $2,000 (£835)

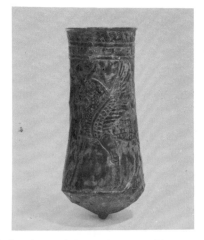

Luristan bronze situla, *circa* 8th century BC.
Height 6¼ in (15·9 cm). New York 22 November
$1,200 (£500)

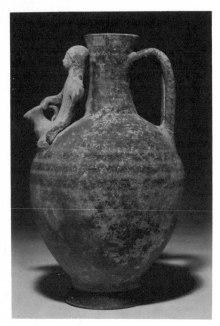

Cypriot pottery jug, *circa* 5th century BC.
Height 10¼ in (26 cm). New York 22 November
$700 (£292)

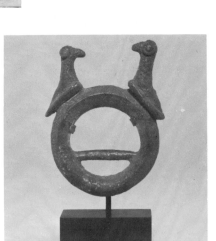

Luristan bronze rein ring, *circa* 1200-900 BC.
Height 3⅜ in (8·6 cm). New York 22 November
$400 (£167)

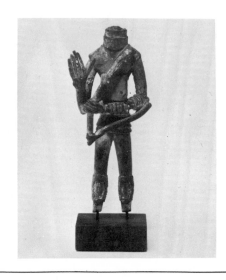

Sardinian bronze figure of an archer, *circa* 7th
century BC. Height 4⅛ in (10·5 cm).
New York 22 November $1,600 (£668)

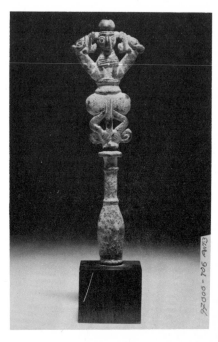

Luristan bronze standard, *circa* 1000-800 BC.
Height 7 in (17·8 cm). New York 22 November
$650 (£271)

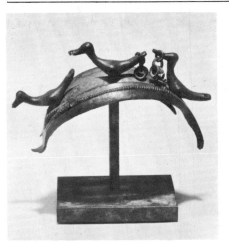

Villanovan bronze fibula, *circa* late 8th/early 7th century BC. Length 3⅜ in (8·6 cm). New York 22 November $700 (£292)

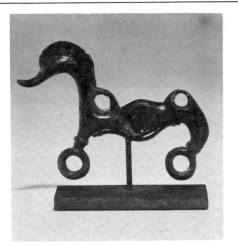

One of a pair of Villanovan cheek-pieces from a horse-bit, *circa* 8th century BC. Length 4¼ in (10·8 cm). New York 22 November $1,200 (£500)

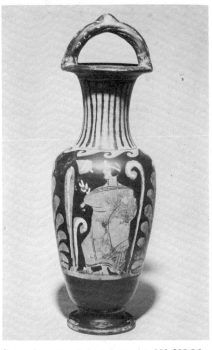

Campanian pottery bail amphora, *circa* 350-325 BC. Height 13 in (33 cm). New York 22 November $600 (£250)

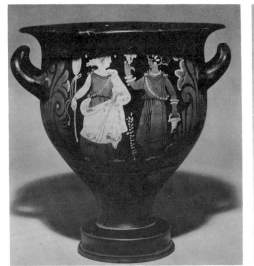

Campanian pottery bell-krater, *circa* 340-320 BC. Height 10¼ in (26 cm). New York 22 November $1,500 (£625)

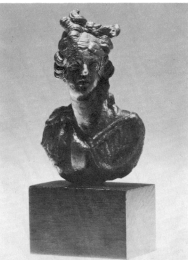

Bronze applique, late Hellenistic or early Roman period *circa* 100 BC/100 AD. Height 2⅞ in (7·3 cm). New York 22 November $600 (£250)

Hellenistic glass bowl, *circa* 2nd/early 1st century BC. Diameter 5⅛ in (13 cm). New York 22 November $400 (£167)

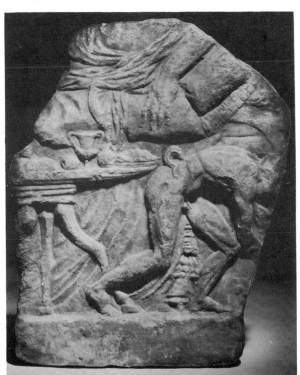

Left: Hellenistic marble fragment from an 'Icarus Relief', *circa* 1st century BC. Height 12¾ in (32·4 cm). New York 22 November $750 (£312)

Right: Marble bust of a youth, probably Hellenistic *circa* 2nd/1st century BC. Height 13½ in (34·3 cm). New York 22 November $700 (£292)

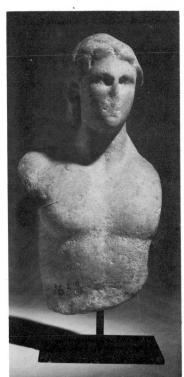

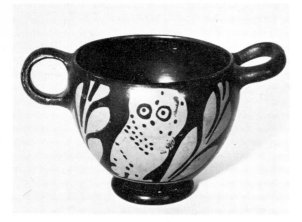

Attic red-figure pottery 'Owl' skyphos, 5th century BC. Diameter 5½ in (14 cm). New Bond Street 29 April £150 ($360)

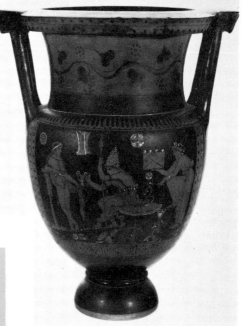

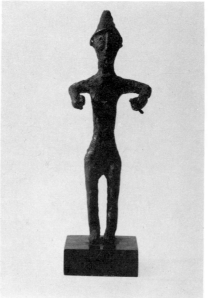

South Italian Greek pottery column-krater, 4th century BC. Height 18 in (45·8 cm). New Bond Street 29 April £900 ($2,160)

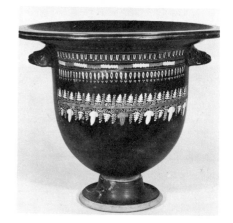

Syro-Hittite bronze male figure, 2nd millennium BC. Height 6½ in (16·5 cm). New Bond Street 29 April $360 (£864)

Attic pottery lekythos by the Carlsberg Painter, Bird Group, circa 435-425 BC. Height 13 in (33 cm). New York 22 November $2,400 (£1,000)

'Gnathia ware' pottery bell-krater decorated in white, yellow and purple paint, 3rd century BC. Height 14¾ in (37·5 cm). New Bond Street 29 April £390 ($936)

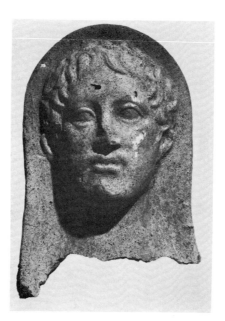

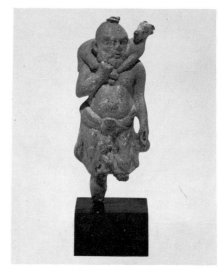

Blue sandcore glass aryballos, 5th century BC. Height 2¾ in (7 cm). New Bond Street 29 April £320 ($768)

Etruscan coarse orange terracotta votive head of a youth, circa 2nd/1st century BC. Height 11 in (27·9 cm). New Bond Street 29 April £300 ($720)

Bronze figure of a man, possibly Alexandrian circa 1st century BC. or earlier. Height 3¼ in (8·3 cm). New York 22 November $500 (£208)

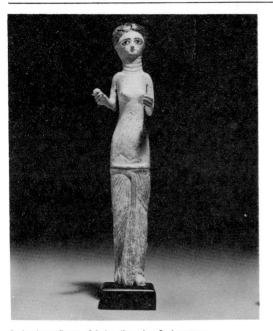

Syrian bone figure of Aphrodite, *circa* 2nd century
AD. Height 7¾ in (19·7 cm). New York
22 November $900 (£375)

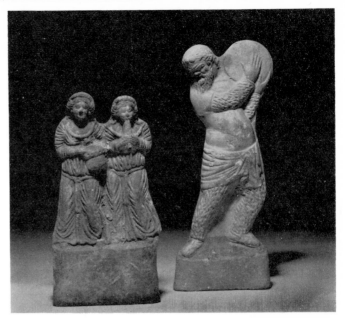

Left: Syrian terracotta group of two priestesses, Palmyra *circa* 1st/2nd
century AD. Height 6½ in (16·5 cm). New York 22 November $700 (£292)
Right: Syrian terracotta figure of a satyr, Palmyra *circa* 2nd century AD.
Height 8⅛ in (20·7 cm), New York 22 November $700 (£292)

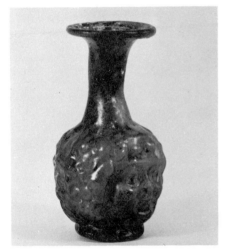

Aubergine glass janus-head flask, *circa* 1st/3rd century
AD. Height 4½ in (11·4 cm). New Bond Street
29 April £780 ($1,872)

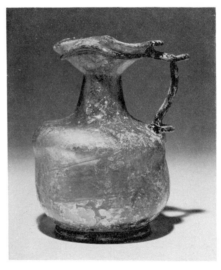

Roman glass pitcher, *circa* 3rd century AD.
Height 5⅞ in (14·9 cm). New York 22 November
$700 (£292)

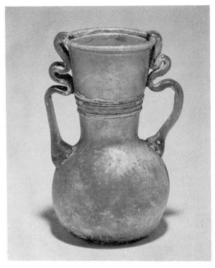

Roman glass bottle, *circa* 3rd century AD. Height 4¾
in (12·1 cm). New York 22 November $400 (£167)

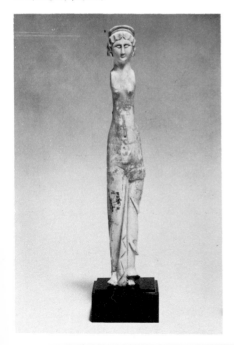

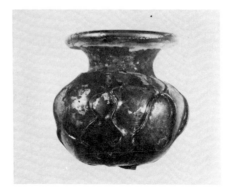

Aubergine glass jar, *circa* 3rd century AD. Height
3¾ in (9·6 cm). New Bond Street 29 April
£200 ($480)

Left: Syrian bone figure of Aphrodite, *circa* 2nd
century AD. Height 8⅛ in (20·6 cm).
New York 22 November $900 (£375)

Right: Roman glass bottle, *circa* 2nd/3rd century AD.
Height 13 in (33 cm). New York 22 November
$1,100 (£459)

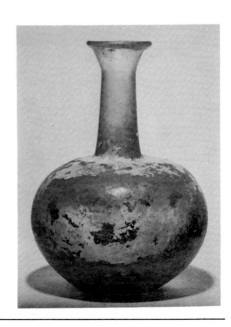

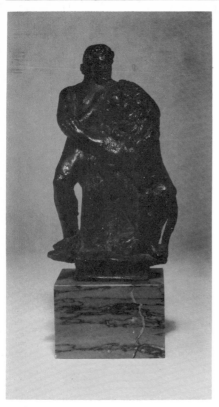

Bronze group of Hercules wrestling the Nemean lion, Roman or Byzantine, 3rd/4th century AD. Height 5¼ in (13·3 cm). New York 22 November $2,000 (£834)

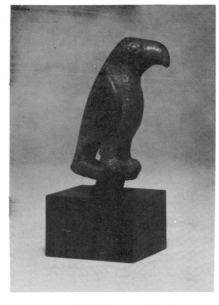

Byzantine bronze finial, 5th century AD or later. Height 3½ in (8·9 cm). New York 22 November $650 (£271)

Byzantine bronze figure of a girl, circa 4th/5th century AD. Height 3½ in (8·9 cm). New York 22 November $450 (£188)

Two Scandinavian bronze 'tortoise' brooches, Norse-Viking circa 9th century AD. Length 4½ in (12 cm). New Bond Street 29 April £400 ($960) each

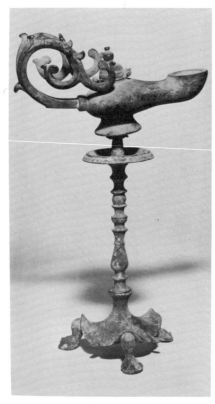

Coptic bronze lamp and stand, circa 5th/6th century AD. Height 15¼ in (38·8 cm). New York 22 November $1,200 (£500)

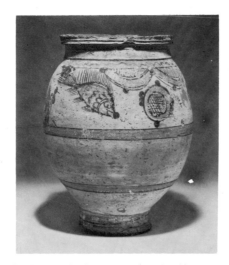

Coptic pottery jar, the worn exterior painted in orange and brown over cream slip with a camel and a fish within broad bands, probably 6th/7th century AD. 10⅞ in (27·6 cm). New York 4 May $1,100 (£459)

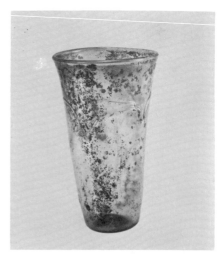

Olive-green glass beaker, Western Europe circa 4th century AD. Height 4⅝ in (11·8 cm). New Bond Street 29 April £190 ($456)

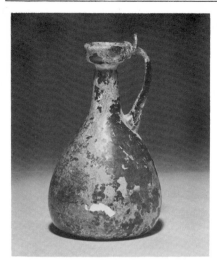

Sasanian or Islamic glass ewer of amber glass, excavated in Iran, *circa* 6th/10th century AD. Height 5⅞ in (14·9 cm). New York 4 May $800 (£333)

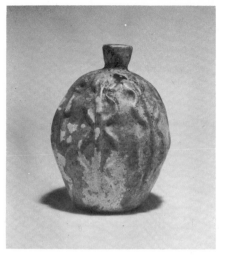

Near Eastern glass bottle, *circa* 10th/12th century or earlier. Height 3⅞ in (9·8 cm). New York 22 November $600 (£250)

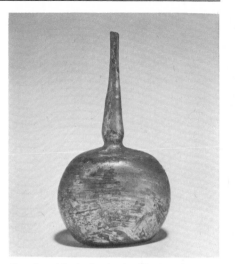

One of two Islamic glass bottles, Mamluk *circa* 13th century. Heights 5⅞ and 5½ in (14·9 and 14 cm). New York 22 November $900 (£375)

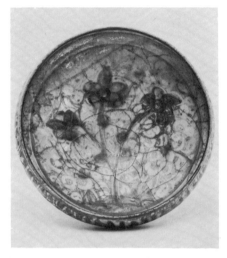

Islamic pottery bowl, Sultanabad (?) *circa* early 13th century. Diameter 8¼ in (21 cm). New York 22 November $700 (£292)

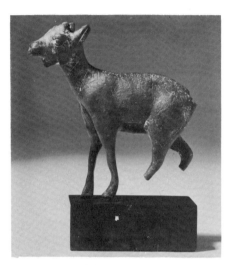

Bronze figure of a gazelle, possibly Mamluk 15th century or earlier. Length 3¼ in (8·3 cm). New York 22 November $600 (£250)

Syrian pottery jar, the body carved in relief beneath a transparent greenish glaze, school of Rakka *circa* 1175-1250. Height 12 in (30·5 cm). New York 4 May $1,900 (£790)

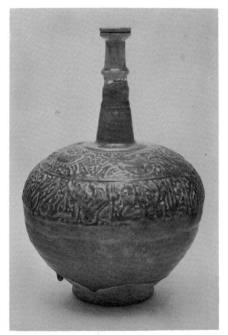

Persian pottery bottle, *circa* late 12th/early 13th century. Height as restored 10⅞ in (27·6 cm). New York 22 November $750 (£312)

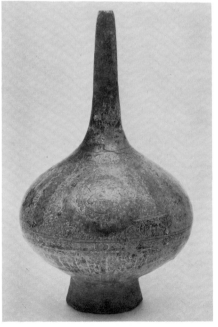

Persian pottery bottle, *circa* late 13th/early 14th century. Height as restored 11⅞ in (30·2 cm). New York 22 November $1,100 (£459)

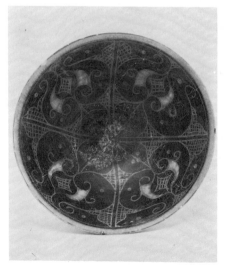

Persian pottery bowl, probably from Rayy, 2nd half of the 12th century. Diameter 8⅛ in (20·65 cm). New York 22 November $2,300 (£959)

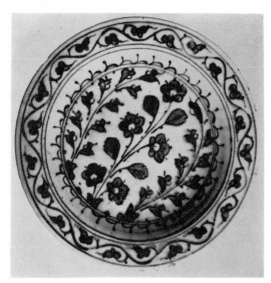

Isnik blue and white pottery dish, Turkey, late 16th/early 17th century. Diameter 10½ in (26·7 cm). New Bond Street 29 April £290 ($696)

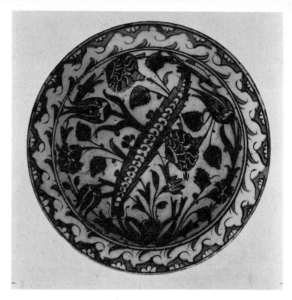

Isnik pottery dish painted in green, iron-red, black and blue, Turkey, late 16th century. Diameter 11½ in (29·2 cm). New Bond Street 29 April £600 ($1,440)

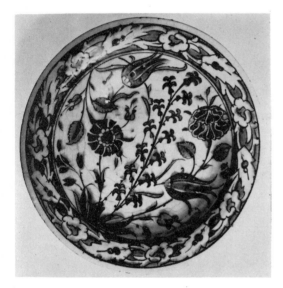

Isnik pottery dish painted in blue, iron-red and green, Turkey, late 16th century. Diameter 11¾ in (29·8 cm). New Bond Street 29 April £800 ($1,920)

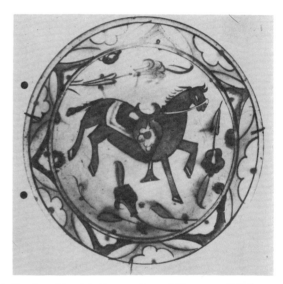

Isnik pottery dish painted in green, iron-red, blue grey and black, Turkey, 17th century. Diameter 9⅜ in (23·8 cm). New Bond Street 29 April £400 ($960)

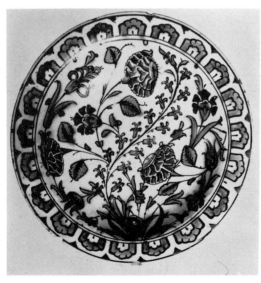

Isnik pottery dish painted in blue, iron-red and green, Turkey, late 16th century. Diameter 11½ in (29·2 cm). New Bond Street 29 April £550 ($1,320)

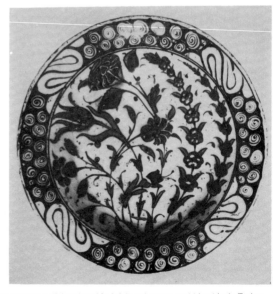

Isnik pottery dish painted in brick-red, green and blue black, Turkey, late 16th century. Diameter 10⅛ in (25·7 cm). New Bond Steret April 29 £320 ($768)

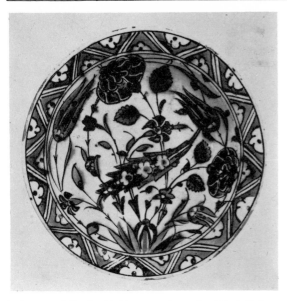

Isnik pottery dish painted in blue, green, iron-red and black, Turkey, late 16th century. Diameter 11 in (27·9 cm). New Bond Street 29 April £450 ($1,080)

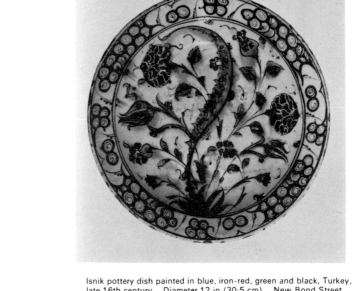

Isnik pottery dish painted in blue, iron-red, green and black, Turkey, late 16th century. Diameter 12 in (30·5 cm). New Bond Street 29 April £400 ($960)

Left: Persian pottery tile, Isfahan, 17th century. 9¼ in square (23·5 cm). New York 22 November $425 (£177)

Right: Turkish pottery dish painted in a palette of black, green and blue on a white ground. Isnik, about the first half of the 17th century Diameter 9⅞ in (25·1 cm). New York 4 May $750 (£313)

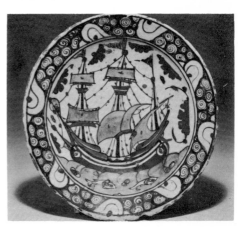

Persian pottery kalian, probably from Kirman, 17th century. New York 22 November $1,200 (£500)

Left: Persian wood mirror-case, Qajar, 19th century. Height 41 in (104·2 cm). New York 22 November $1,300 (£542)

African Senufo tribe wooden 'Firespitter' mask of of the Korubla Society. Length 25½ in (64·8 cm). New York 23 April $750 (£313)

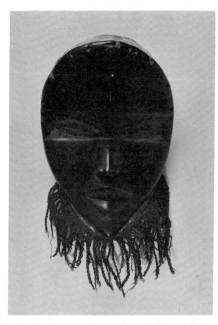

African Dan tribe wooden mask of the Poro Society, with a fibre beard. Height 9½ in (24·1 cm). New York 23 April $2,000 (£833)

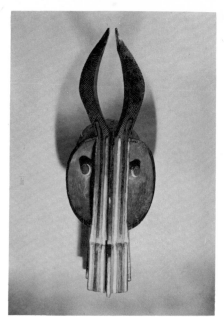

African Baule tribe wooden mask of the type called Goli, with traces of painted decoration. Length 33¼ in (84·5 cm). New York 23 April $700 (£295)

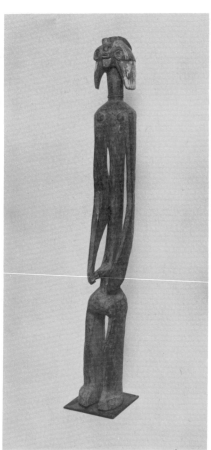

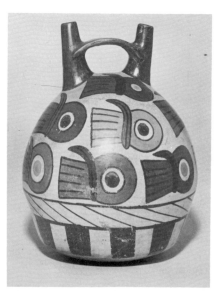

African Baule tribe wooden heddle pulley. Height 9¾ in (24·8 cm). New York 23 April $900 (£375)

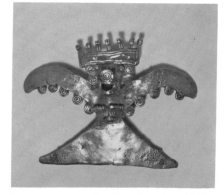

African Baule tribe wooden figure. Height 14 in (35·5 cm). New York 23 April $700 (£295)

African Chamba tribe wooden figure, the head inset with metal. traces of painted decoration. Height 51¼ in (130·2 cm). New York 23 April $2,200 (£918)

A Peruvian pottery vessel painted in shades of brown, grey, orange-red, dark red, beige and cream, Nazca, early period circa 100-300 AD. Height 8⅞ in (22·5 cm). New York 23 April $550 (£230)

Costa Rican gold pendant in the form of a stylized eagle, late Classic period 800-1500 AD. Width 3 in (7·6 cm). New York 23 April $1,600 (£667)

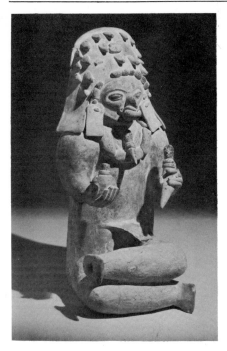

Ecuadorian pottery figure from San Isidro, Manabi, Jama Coaque, *circa* 500 BC/500 AD. Height 16½ in (41·9 cm). New York 23 April $1,500 (£626)

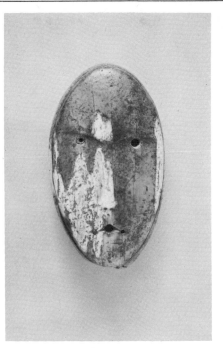

Eskimo carved ivory head made from a fragment of fossilized mammoth tusk. Height at front 4⁷⁄₁₆ in (11·6 cm). New York 23 April $1,700 (£709)

A group of 34 hollow gold Colombian ornaments hammered in the form of stylised crocodiles, Colima, *circa* 400-700 AD. Length of a single ornament 1½ in (3·8 cm). New York 23 April $1 700 (£709)

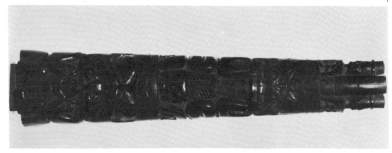

North American Indian Haida tribe argillite miniature totem, British Colombia. Height 18½ in (47 cm). New Bond Street 29 April £150 ($360)

North American Indian Haida tribe shale ceremonial pipe, British Columbia. 2⅝ by 8½ in (6·7 by 21·6 cm). New Bond Street 29 April £420 ($1,008)

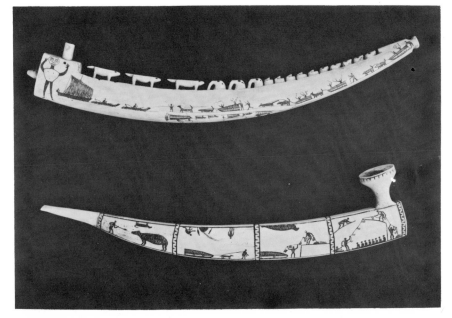

Upper: Eskimo carved walrus ivory pipe ornamented with incised scenes filled in with black pigment and inscribed 'June 14 1860—10 year (old ?)'. Length 15 in (38·1 cm). New York 23 April $1,800 (£750)
Lower: Eskimo carved walrus ivory pipe incised with four scenes filled in with black pigment. Length 14 in (35·6 cm). New York 23 April $1,300 (£542)

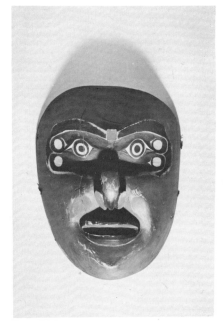

North American Kwakiutl Indian wooden mask with bright green face, red lips and nostrils and black and white mask over the eyes. Height 16⅜ in (41·6 cm). New York 23 April $2,300 (£959)

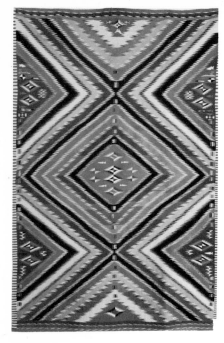

North American Navajo Indian woollen blanket in 'eye-dazzler' pattern, woven in Germantown yarn in bright red, purple, green, shades of yellow, pale browns, black and white. 84 by 55 in (213·4 by 139·7 cm). New York 23 April $1,600 (£667)

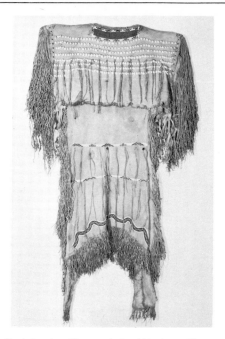

North American Cheyenne Indian hide dress with traces of painted decoration and with stitched panels of multicoloured beadwork. 29 by 45½ in (73·7 by 115·6 cm). New York 23 April $850 (£355)

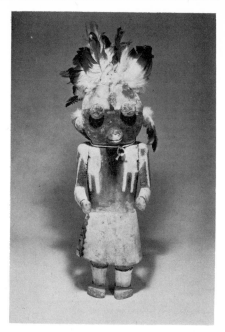

North American Hopi Indian wooden doll of the type called Kachina, depicting the god Wupamau, ornamented with feathers and with traces of painted decoration. Height 17 in (43·2 cm). New York 23 April $1,050 (£438)

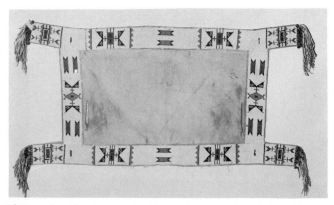

North American Sioux Indian saddle blanket, the upper surface stitched with hide panels decorated with multicoloured glass beadwork on a white ground, and with tassled lappets stitched with rows of metal bells and glass beads on the fringe. 26¾ by 55⅜ in (67·9 by 140·5 cm). New York 23 April $700 (£295)

Peruvian feather poncho, Tiahuanaco, *circa* 700-1000 AD. 22½ by 40 in (57·2 by 101·6 cm). New Bond Street 29 April £850 ($2,040)

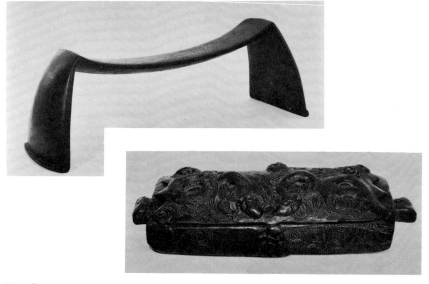

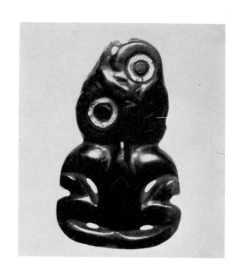

Upper: Tongan wood headrest. Length 20 in (50·8 cm). New Bond Street 29 April £220 ($528)
Lower: Maori carved wood feather box and cover. 18 in by 7¼ in (45·7 by 18·4 cm). New Bond Street 29 April £1,000 ($2,400)

Maori green jade tiki. Length 3¾ in (9·5 cm). New Bond Street 29 April £600 ($1,440)

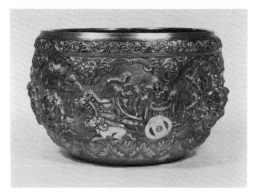

Burmese silver bowl, late 19th century. 57 oz 10 dwt. Width 11 in (28·6 cm). Belgravia 18 July £180 ($432)

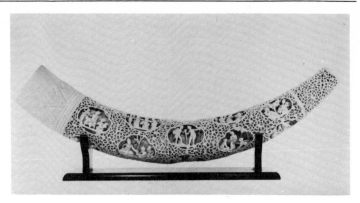

One of a pair of Burmese carved ivory tusks, early 20th century. Length 37½ in (95·2 cm). Belgravia 30 January £460 ($1,104)

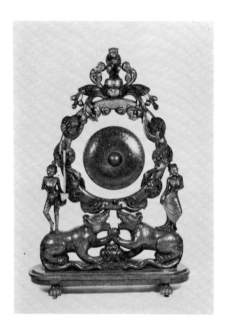

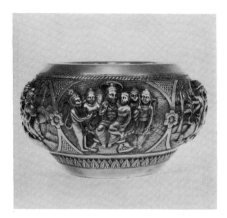

Burmese silver bowl, last quarter of the 19th century. 36 oz 12 dwt. Width 10 in (26 cm). Belgravia 18 July £125 ($300)

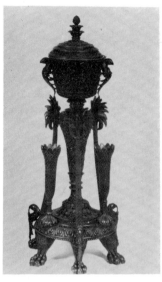

Carved hardwood jardinière, Burmese, second half of the 19th century. Height 39 in (99 cm). Belgravia 4 July £98 ($235)

Carved wood gong stand with beaten brass gong, Burmese, late 19th century. Height 54 in (137 cm). Belgravia 4 July £250 ($600)

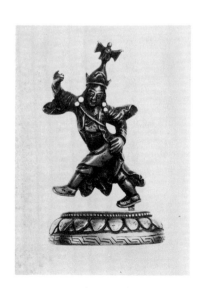

Chinese brass figure of a lesser Dharmapala or regional deity, 19th century. Height 4¼ in (10·8 cm). New Bond Street, 29 April £110 ($264)

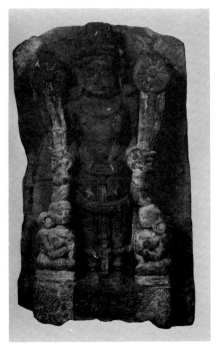

Central Indian pinkish sandstone stele, circa 12th century AD. 25 by 14½ in (63·5 by 36·8 cm). New Bond Street 29 April £270 ($648)

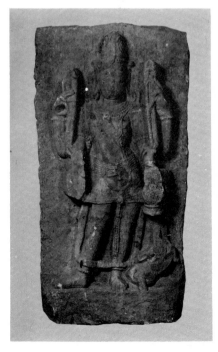

Indian grey sandstone stele, medieval period. 35 by 18 in (88·9 by 45·8 cm). New Bond Street 29 April £1,000 ($2,400)

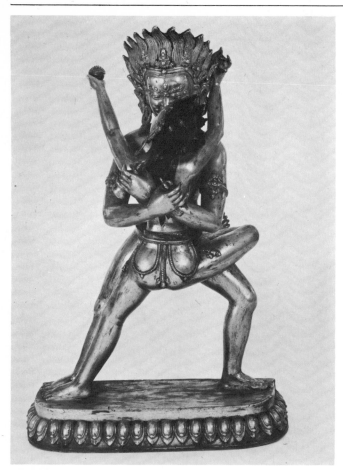

Tibetan gilt-bronze figure of the Yidam Kalacakra. Height 15½ in (39·3 cm).
New Bond Street 29 April £440 ($1,056)

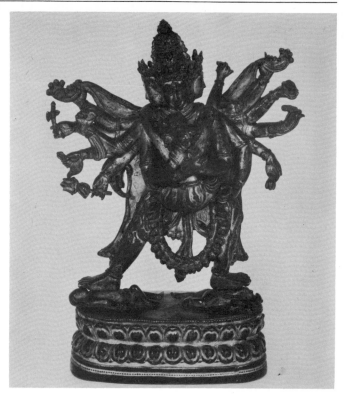

Tibetan gilt-bronze figure of the Yidam Samvara, 17th century. Height 9⅞ in
(25·1 cm). New Bond Street 29 April £520 ($1,248)

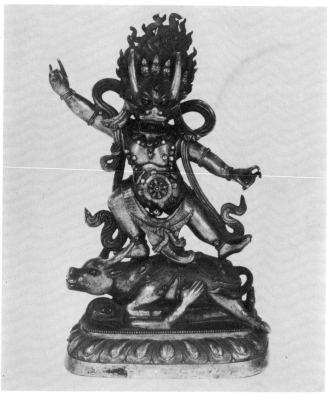

Tibetan gilt-bronze figure of the Dharmapala Yama, 19th century.
Height 11 in (28 cm). New Bond Street 29 April £480 ($1,152)

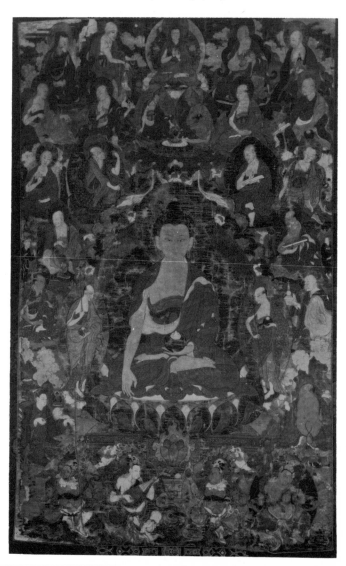

Right: Tibetan Tanka depicting Gautama Buddha, 18th century. 30 by
55½ in (76·2 by 141 cm). New Bond Street 29 April £120 ($288)

Tibetan Tanka depicting Padmasambhava, 17th/18th century. 12 by 16¼ in (30·5 by 41·3 cm). New Bond Street 29 April £100 ($240)

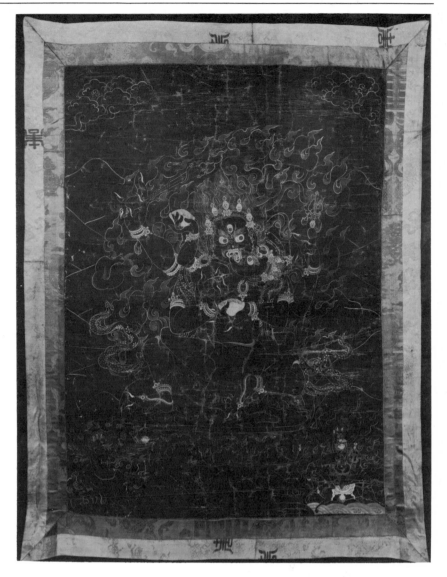

Tibetan Tanka depicting the Dharmapala Mahakala, 18th century. 35 by 56 in (88·9 by 142·2 cm). New Bond Street 29 April £470 ($1,128)

Tibetan Tanka depicting Padmasambhava, 18th century. 14½ in by 19⅛ in (36·2 by 48·6 cm). New Bond Street 29 April £100 ($240)

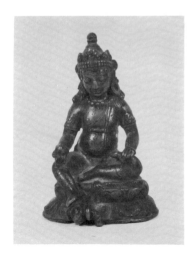

Western Tibetan bronze figure of the Yidam Jambhala, 15th century. Height 4 in (10·2 cm). New Bond Street 29 April £180 ($432)

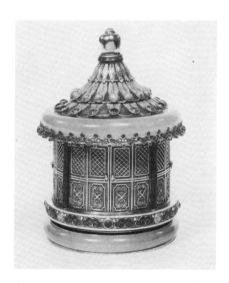

Tibetan enamelled silver and jade box inset with hardstones, late 19th century. Height 4¾ in (12 cm) Belgravia 18 July £90 ($210)

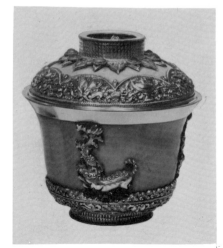

One of two Tibetan silver-mounted ivory bowls, late 19th century. Heights 4⅛ in and 4½ in (10·5 and 11·5 cm). Belgravia 18 July £120 ($288)

Works of art

There is no strict definition of the category to which Sotheby Parke Bernet gives the appellation 'Work of art'. It covers a wide range of objects, from early medieval to 19th-century enamels, ivories and sculpture in stone, bronze, wood and terracotta. Certain things, notably objects usually of small size containing jewels and precious metals, are normally referred to under the generic heading 'Objects of vertu' and we have made a separate category for them. Other examples of the applied arts—textiles, glass, ceramics, furniture, silver, pewter, *animalier* bronzes and so on— have also been given separate sections. Russian works of art have been treated individually.

The range of pieces within the category of 'Works of art' made available below £1,000 ($2,400) is truly surprising. Again an attempt has been made to choose only things of fine quality and not to consider poor or damaged examples which would otherwise fetch sums far in excess of the upper limit.

Among the earliest pieces represented here are some European enamels and metalwork of the medieval period. In the sale at New Bond Street on 12 December, particularly noteworthy were a set of four Limoges enamel and gilt-copper roundels representing the Evangelical symbols from the second half of the 13th century which fetched £560 ($1,344), and a fine pair of Limoges champlevé enamel and gilt-copper plaques also from the 13th century which sold for £340 ($876). In addition to these most attractive examples of Romanesque and Gothic metalwork, there were also some good medieval ivories to be purchased. A Byzantine plaque of *The Virgin and Child* dating from the late 11th or early 12th century realised £240 ($528), and a French panel carved with *The Crucifixion*, either from a diptych or book cover and dating from the early 14th century, realised the modest sum of £170 ($408).

Moving to a later period, we illustrate some Italian bronzes of the 16th and 17th centuries. Of exceptional interest is the boldly modelled figure of a turkey made in the workshops of Giovanni da Bologna in the second half of the 16th century; this was one of several animals and birds cast for a grotto in the Villa Reale at Castello outside Florence for Cosimo de' Medici beginning in the late 1560s. This piece, with such rich historical associations and from the studio of one of the greatest Mannerist sculptors, realised $1,500 (£625) in New York on 2 March and was of a quality which could recommend itself to the most exalted of collections.

Works of art from the 18th and 19th centuries perhaps provide the widest field for the collector in search of fine works of art for modest prices. Italian bronzes of the Neo-classical period are still most reasonably priced and a beautiful bronze bust of Hebe after Canova was sold in New Bond Street on 1 July, for £380 ($912). Similarly, some fine pieces are available in the field of English late 18th- and early 19th-century marbles, an area which appears to be out of fashion at the moment and therefore worthy of the attention of collectors whose appreciation of art is founded upon a strong individual opinion as to quality and not ruled by the dictates of others. An example is the fine relief by George Paul Eckstein which was exhibited at the Royal Academy in the 1770s and which realised £150 ($360) in New Bond Street on 12 December, a piece of quite remarkable beauty, well documented and of some rarity, yet sold for a very reasonable sum. In areas such as this, still among the backwaters of the applied arts, specialist collections could be made for a comparatively small outlay.

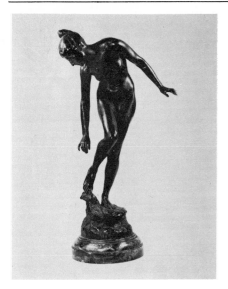

Bronze figure of a girl entitled *The Thorn* after A G Walker, English late 19th century. Height 20 in (50·8 cm). Belgravia 26 June £210 ($504)

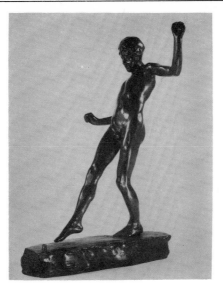

Bronze figure of a boy at play by W Goscombe John, English late 19th century. Height 18 in (45·7 cm). Belgravia 9 January £140 ($336)

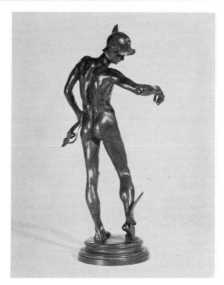

Perseus Arming, bronze figure by Sir Alfred Gilbert, English *circa* 1885. Height 14¼ in (36·1 cm). Belgravia 27 November £620 ($1,488)

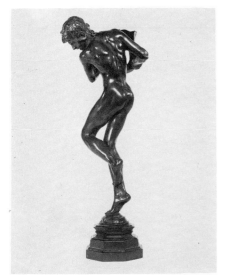

Comedy and Tragedy, a bronze figure by Sir Alfred Gilbert English, *circa* 1890. Height 13½ in (34·3 cm). Belgravia 27 November £800 ($1,920)

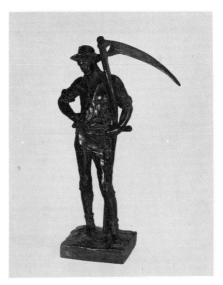

Bronze figure of *The Mower* after H Thorneycroft, English late 19th century. Height 8 in (20·3 cm). Belgravia 3 April £320 ($768)

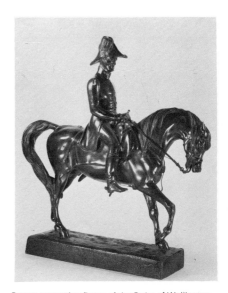

Bronze equestrian figure of the Duke of Wellington after Count d'Orsay, inscribed *D'Orsay sculp*, *J. Watesby Publishers, 15 Waterloo Place, London,* mid 19th century. Height 19 in (48·3 cm). Belgravia 17 April £320 ($768)

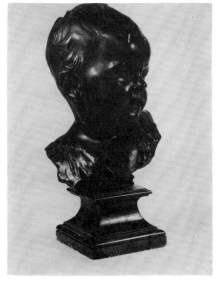

Bronze bust of a child by Francis Derwent Wood, English *circa* 1900. Height 14½ in (36·8 cm). Belgravia 26 June £190 ($456)

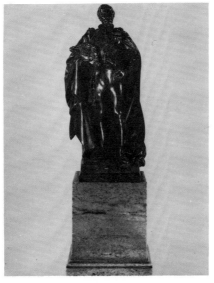

Bronze statue of Admiral Blake after F W Pomeroy, English early 20th century. Height 13½ in (34·4 cm). Belgravia 15 May £60 ($144)

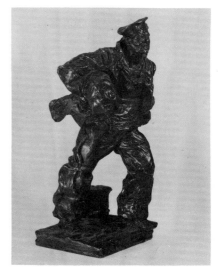

Bronze figure of a seaman by Vernon March, English *circa* 1920. Height 12½ in (31·5 cm). Belgravia 3 April £160 ($384)

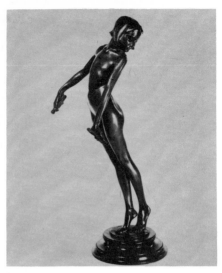

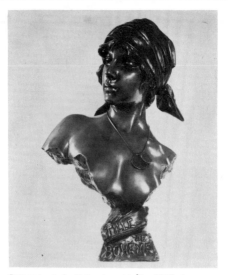

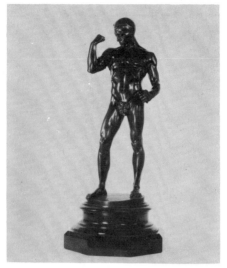

Scottish bronze figure of a girl skipping, after Alexander Carrick, reputed to have been inspired by a Russian poem by Vladim Featha. Early 20th century. Height 19½ in (49·5 cm). Belgravia 16 October £170 ($408)

Bronze bust of a Bohemian girl after E Villanis, Belgian *circa* 1900. Height 21 in (53·5 cm). (Belgravia 26 June £240 ($576)

Bronze figure of an athlete after Kowalezewski, Czechoslovakian early 20th century. Height 25 in (63·5 cm). Belgravia 3 April £180 ($432)

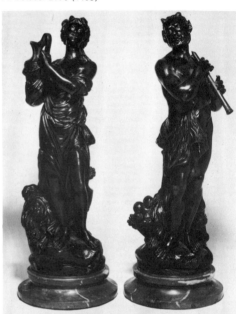

Right: Bronze figure of the Scythian slave on an ebony base with brass and ormolu mounts. French 18th century. Height of figure 10¾ in (27·3 cm). New York 2 March $1,600 (£667)

Left: Pair of bronze figures of a bacchante and a faun, apparently inspired by a biscuit centrepiece made at Sèvres in 1775, itself derived from painted decorations by Hugues Taraval for the Grande Galerie of the Louvre, never completed. French late 18th century. Heights 10⅜ in (26·3 cm) and 10½ in (26·7 cm). New York 2 March $900 (£375)

Below: Bronze figure of the crouching Venus, on an ebony base with brass and ormolu mounts. French 18th century. Height of figure 14¼ in (36·5 cm). New York 2 March $1,300 (£542)

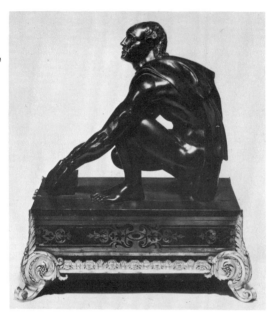

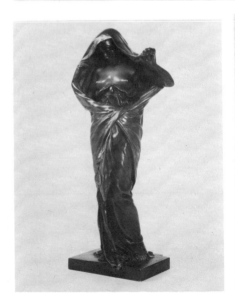

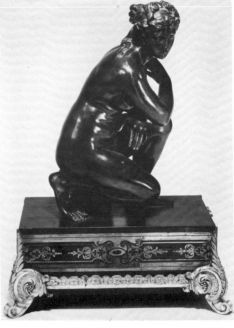

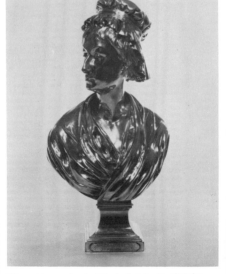

Gilt-bronze allegorical figure of *Art revealing herself to Science* after E Barrias, French late 19th century. Height 9½ in (24·1 cm). Belgravia 20 March £220 ($528)

Silvered bronze bust of Marie Antoinette after the drawing by Jacques-Louis David. French mid 19th century. Height 17½ in (44·5 cm). Belgravia 27 November £85 ($204)

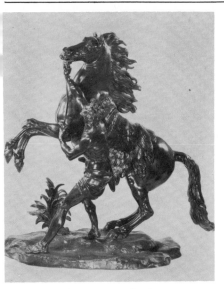

Bronze figure of a Marly horse after Coustou, French mid 19th century. Height 22½ in (57 cm). Belgravia 15 May £200 ($480)

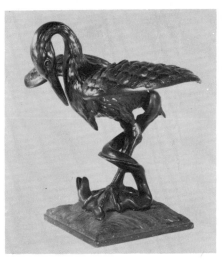

One of a pair of bronze storks, French late 19th century. Height 11 in (28 cm). Belgravia 6 February £88 ($211)

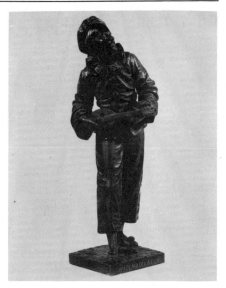

Bronze figure of a pierrot entitled *Au Clair de la Lune* after Bouret, French second half of the 19th century. Height 18 in (46 cm). Belgravia 9 January £105 ($252)

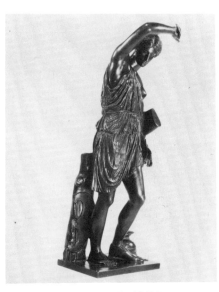

Bronze classical figure, French mid 19th century. Height 15¼ in (39·4 cm). Belgravia 9 January £62 ($149)

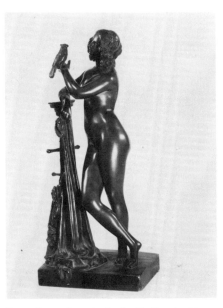

Bronze figure of a nude after Lesbie, French mid 19th century. Height 14 in (36 cm). Belgravia 9 January £110 ($264)

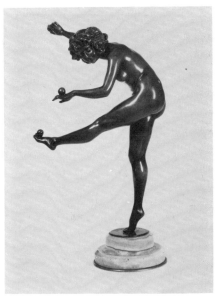

Bronze figure of a dancer after Colinet, French *circa* 1900. Height 15 in (38 cm). Belgravia 26 June £210 ($504)

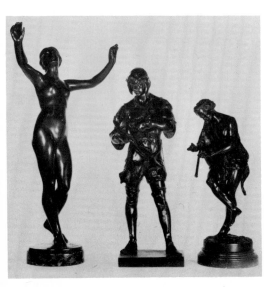

Left: Copper bronze figure of a woman after E Schlipffer, German *circa* 1900. Height 21½ in (55 cm). Belgravia 12 June £150 ($360)

Bronze figure of a musketeer after E Picaut, French late 19th century. Height 19 in (48·3 cm). Belgravia 12 June £130 ($312)

Bronze figure of Pan after Gregorie, German. Height 15 in (38 cm). Belgravia 12 June £85 ($204)

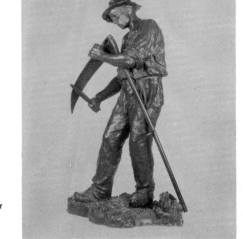

Right: Bronze figure of a harvester after Ruffony, French early 20th century. Height 33 in (84 cm). Belgravia 17 April £220 ($528)

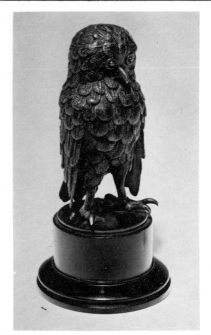

Bronze figure of an owl, South German 16th century. Height of figure 4⅞ in (12·5 cm). New York 2 March $2,200 (£918).

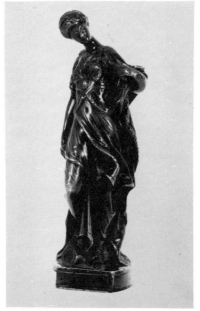

South German bronze lion sejant, Augsburg early 17th century. Height 5½ in (14 cm). New Bond Street 12 December £340 ($816)

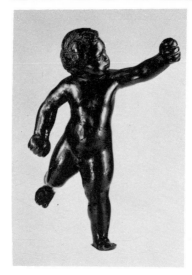

Paduan bronze figure of a nude putto, second half of the 16th century. Height 3¾ in (9·5 cm). New Bond Street 12 December £250 ($600)

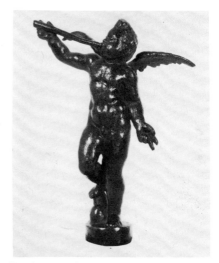

Venetian bronze figure of a cherub blowing a trumpet, 16th century. Height 5 in (12·7 cm). New Bond Street 12 December £160 ($384)

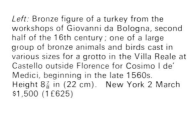

Venetian bronze figure of Fortitude, in the manner of Aspetti, early 17th century. Height 6½ in (16·5 cm). New Bond Street 12 December £180 ($432)

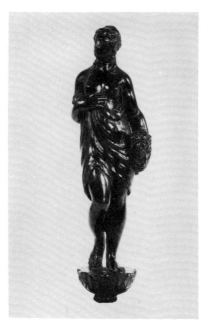

North Italian bronze figure of Pomona, 16th century. Height 7¼ in (18·4 cm). New Bond Street 12 December £450 ($1,080)

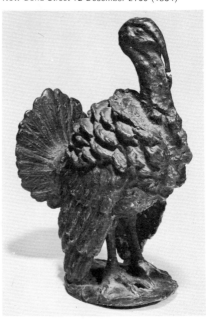

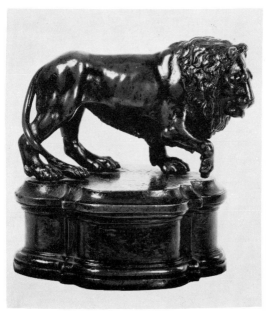

Left: Bronze figure of a turkey from the workshops of Giovanni da Bologna, second half of the 16th century; one of a large group of bronze animals and birds cast in various sizes for a grotto in the Villa Reale at Castello outside Florence for Cosimo I de' Medici, beginning in the late 1560s. Height 8⅞ in (22 cm). New York 2 March $1,500 (1 £625)

Right: Italian bronze figure of a lion, Florence *circa* 1600. Height 4½ in (11·4 cm). New Bond Street 12 December £600 ($1,440)

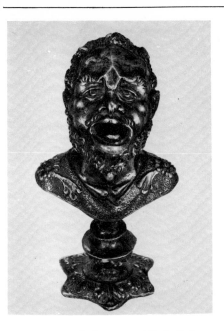

Italian bronze lamp in the manner of Riccio, Padua 16th century. Height 6½ in (16·5 cm). New Bond Street 12 December £750 ($1,800)

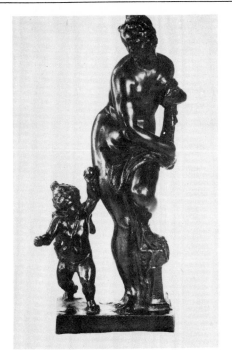

Italo-Flemish bronze group of *Venus and Cupid,* after Bologna, 17th century . Height 5¾ in (14·6 cm). New Bond Street 1 July £620 ($1,488)

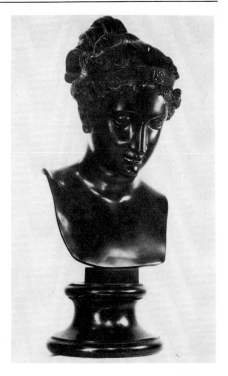

Italian bronze bust of Hebe after Canova, possibly a Boschi cast, *circa* 1810-15. Height 17½ in (34·5 cm). New Bond Street 1 July £380 ($912)

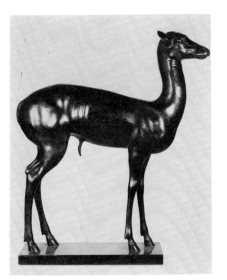

One of a pair of bronze fawns after the antique, Italian. Height 33½ in (85 cm). Belgravia 26 June £1,000 ($2,400)

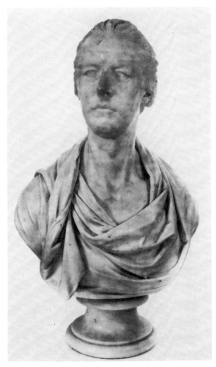

English white marble bust of William Pitt, signed *Nollekens Ft. 1807.* Height 29 in (73·7 cm). New Bond Street 15 March £260 ($624)

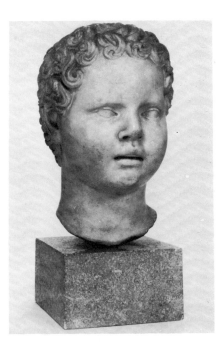

Italian white marble head of a boy after the antique, 16th century. Height 9½ in (24·1 cm). New Bond Street 1 July £720 ($1,728)

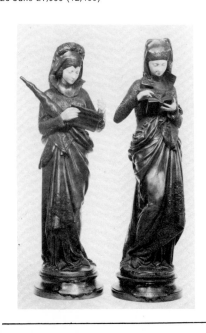

Left: Bronze and ivory figure entitled *Chant de la Fileuse* after M C Faure, French *circa* 1880. Height 24 in (61 cm). Belgravia 6 February £290 ($696)

Bronze and ivory figure entitled *La Liseuse* after Albert Ernest Carrier Belleuse, French *circa* 1880. Height 24 in (61 cm). Belgravia 6 February £460 ($1,104)

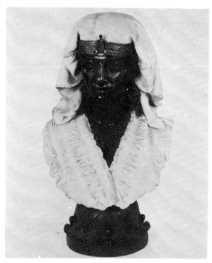

Bronze and marble bust of an Egyptian after Calvi, Italian late 19th century. Height 24 in (61 cm). (restored). Belgravia 17 April £180 ($432)

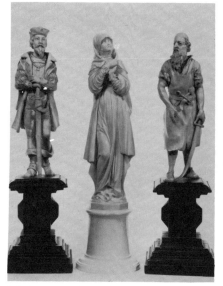

Left: Dieppe ivory figure of a Teutonic nobleman, French mid 19th century. Height 7¼ in (18·4 cm). Belgravia 24 January £180 ($432)

Centre: Ivory figure of a nun, possibly Heloise, probably French 19th century. Height 11½ in (29·2 cm). Belgravia 24 January £165 ($396)

Right: Dieppe ivory figure of a blacksmith, French mid 19th century. Height 7¼ in (18·4 cm). Belgravia 24 January £230 ($552)

South German carved ivory figure of Judith, late 16th century. Height 6¾ in (17·1 cm). New Bond Street 12 December £420 ($1,008)

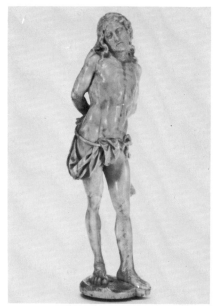

South German carved ivory figure of *Christ at the Column*, late 17th/early 18th century. Height 7 in (17·8 cm). New Bond Street 12 December £180 ($432)

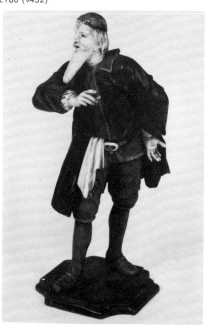

Carved ivory and wood figure of Columbine, Italian (?) mid 18th century. Height 8¼ in (20·9 cm). New Bond Street 12 December £300 ($720)

Dutch carved and painted wood figure probably depicting Maurice of Nassau (1567-1625), *circa* 1625-30. Height overall 27¾ in (70·5 cm). New Bond Street 12 December £420 ($1,008)

Carved ivory and wood figure of Pantaloon, Italian (?) mid 18th century. Height 7½ in (18·4 cm). New Bond Street 12 December £400 ($960)

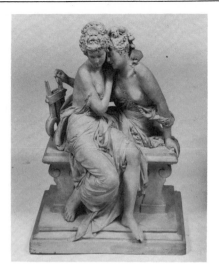

Terracotta group after A Carrier Belleuse, French third quarter of the 19th century. Height 25 in (63·5 cm). Belgravia 20 March £300 ($720)

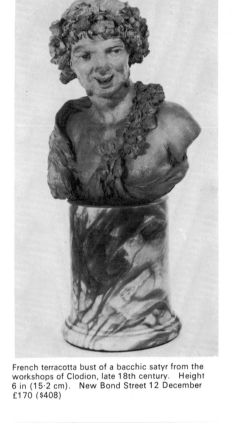

One of a pair of South German Baroque carved wood putti in the manner of Johann Christian Jorhan the Elder, third quarter of the 18th century. Height 17½ in (34·5 cm). New Bond Street 1 July £580 ($1,392)

French terracotta bust of a bacchic satyr from the workshops of Clodion, late 18th century. Height 6 in (15·2 cm). New Bond Street 12 December £170 ($408)

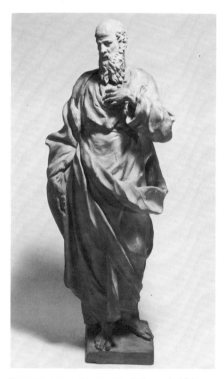

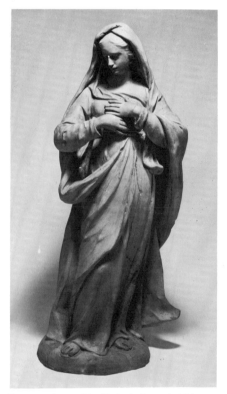

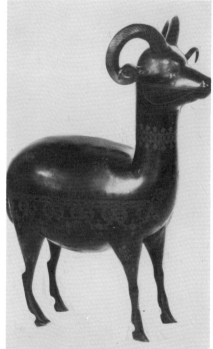

Terracotta figure of an apostle, Italian early 18th century. Height 17¾ in (45 cm). New York 2 March $750 (£313)

Terracotta figure of the Virgin, Italian early 18th century. Height 18½ in (47 cm). New York 2 March $700 (£295)

Persian iron figure of a mountain goat, 19th century. Height 17¼ in (41·3 cm). New Bond Street 12 December £480 ($1,152)

Marble group of a boy with a dog, entitled *Friendship* after C A Cubitt, English mid 19th century. Length 40½ in (103 cm). Belgravia 26 June £400 ($960)

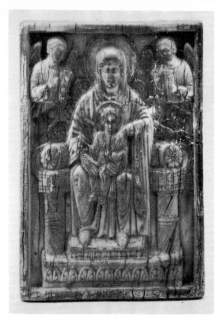

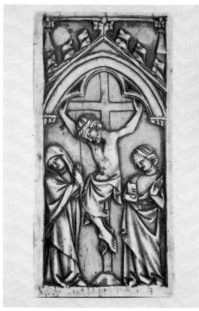

Byzantine ivory plaque of *The Virgin and Child*, 11th/12th century. Height 3⅜ in (8·6 cm). New Bond Street 12 December £240 ($528)

French carved ivory panel from a diptych (or possibly a book cover) depicting *The Crucifixion*, first half of the 14th century. Height 3½ in (8·9 cm). New Bond Street 1 July £170 ($408)

Ivory relief of Thaddeus Kosciuszko, in a contemporary ebony frame inlaid with incised ivory decoration, probably French *circa* 1820. Dimensions of relief 8¾ in by 5⅜ in (22·2 by 13·7 cm). New York 2 March $425 (£178)

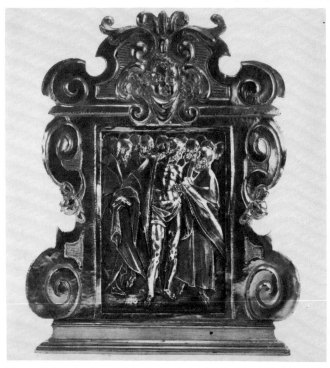

Italian cast silver plaque of *Christ appearing to the Apostles*, second half of the 16th century. Height 2¾ in (7 cm). Mounted as a pax in gilt-copper, Height overall 5¾ in (14·6 cm). New Bond Street 1 July £600 ($1,440)

Flemish alabaster relief of the Crucifixion, Malines, early 17th century. Height 15 in (38·1 cm). New Bond Street 15 March £340 (£816)

Painting on ivory depicting Napoleon riding in triumph, French *circa* 1870. Width 10⅞ in (27·6 cm). Belgravia 30 May £185 ($444)

Stained glass panel with the arms of Louis XII of France and his queen, Mary Tudor, daughter of Henry VII of England. Before 1515. Height 19 in (38·2 cm). New Bond Street 1 July £260 ($624)

Stained glass panel containing the arms of Charles Brandon, first Duke of Suffolk, *circa* 1515 (modern white glass surround). Height overall 19 in (38·3 cm). New Bond Street 1 July £320 ($768)

Stained glass panel with a Tudor badge, first half of the 16th century. Height overall 19 in (38·3 cm). New Bond Street 1 July £220 ($528)

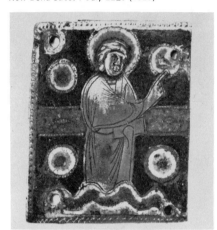

One of a pair of Limoges champlevé enamel and gilt-copper plaques. 13th century (one plaque restored). 2 in by 1⅝ in (5·1 by 4·1 cm). New Bond Street 12 December £340 ($816)

German stained glass window of *Christ before Pilate*, 16th century (with restoration). 26 in by 23 in (66·1 by 58·4 cm). New Bond Street 1 July £190 ($456)

One of a set of six stained glass panels, one signed G Meo, English *circa* 1880. Width 30 in (76 cm). Belgravia 31 July £280 ($672)

Limoges enamel polychrome painted plaque by Jacques II Laudin (*au Fauxbourgs de Manigne*) (1663-1729) depicting *A Saint* (*St Gregory* ?) at Mass, early 18th century. Height 8 in (20·3 cm). New Bond Street 12 December £170 ($408)

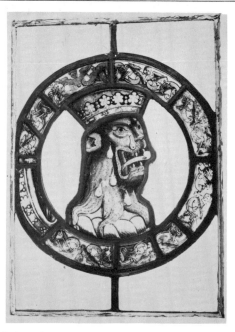

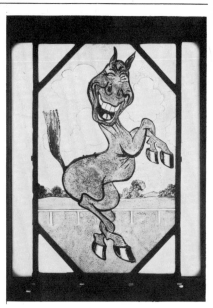

One of set of seven stained glass panels by Tom Webster caricaturing sportsmen, English *circa* 1930. 17 by 11 in (43·2 by 28 cm). Belgravia 26 June £85 ($204)

Stained glass panel with an achievement of the arms of Jane Seymour, Queen of England, 1536-7. Height overall 19 in (38·3 cm). New Bond Street 1 July £580 ($1,392)

Stained glass panel with the badge of Charles Brandon, first Duke of Suffolk, first half of the 16th century (set in a panel of modern white glass). Height overall 19 in (38·3 cm). New Bond Street 1 July £400 ($960)

Left: Flemish marble roundel with a portrait of Count Cuypers, 18th century. Diameter 27 in (68·6 cm). New Bond Street 12 December £550 ($1,320)

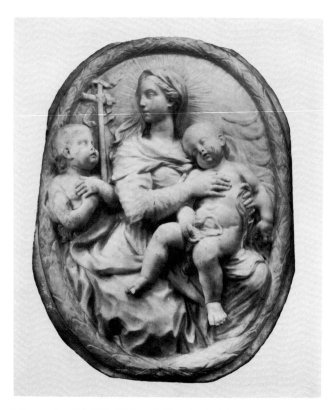

German ivory relief of *A Bear Hunt*, 17th century. Width 7¼ in (18·4 cm). New Bond Street 12 December £480 ($1,152)

Italian marble relief of *The Virgin and Child with the Infant St John*, first half of the 17th century. Height 33 in (83·8 cm). New Bond Street 1 July £600 ($1,440)

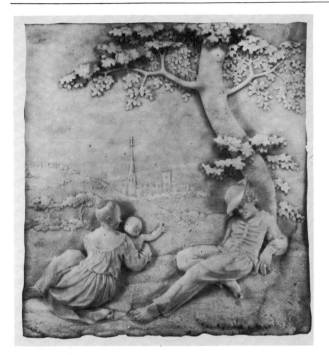

English marble relief by George Paul Eckstein. exhibited at the Royal Academy in 1777. 9 by 10¼ in (22·9 by 26 cm). New Bond Street 12 December £150 ($360)

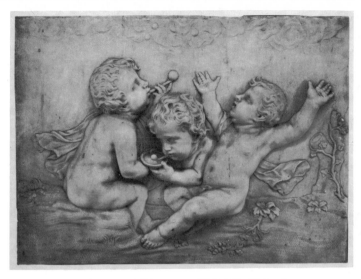

White marble relief of three putti, 18th century. Width 19 in (48·3 cm). New Bond Street 12 December £460 ($1,104)

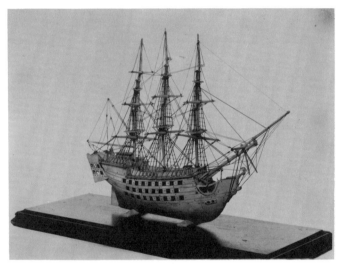

Bone ship model, *circa* 1900. Length 14 in (35·6 cm). Belgravia 1 May £220 ($528)

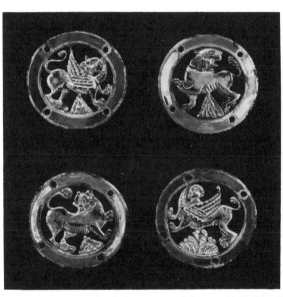

Set of four Limoges enamel and gilt-copper roundels, second half of the 13th century. Diameter 2½ in (6·4 cm). New Bond Street 12 December £560 ($1,344)

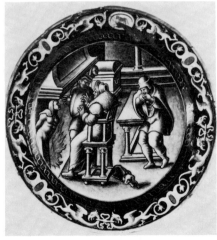

Limoges enamel plate *en grisaille* in the manner of Pierre Reymond, late 16th century. Diameter 7¾ in (19·7 cm). New Bond Street 12 December £300 ($720)

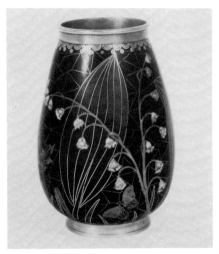

Cloisonné enamel vase by Elkington & Co, of Birmingham, *circa* 1875. Height 5¼ in (13·2 cm). Belgravia 25 July £160 ($384)

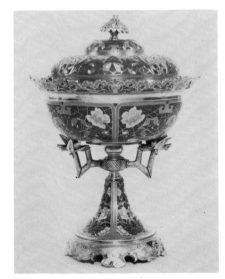

Electro-gilt electro-type pot-pourri vase and cover with champlevé enamel decoration by Elkington & Co of Birmingham, date letter for 1875. Height 8¾ in (22·2 cm). Belgravia 24 January £160 ($384)

German brass alms dish depicting harpies, Nuremberg 16th century. Diameter 9¾ in (24·8 cm). New Bond Street 15 March £520 ($1,248)

German brass alms dish depicting Adam and Eve, Nuremberg *circa* 1500. Diameter 11 in (27·9 cm). New Bond Street 15 March £650 ($1,560)

One of a pair of gilt-bronze mounted rose-marble urns, French late 19th century. Height 14 in (35·6 cm). Belgravia 24 July £170 ($408)

Ivory and silver-gilt vase and cover, probably German late 19th century. Height 18½ in (47 cm). Belgravia 30 May £700 ($1,680)

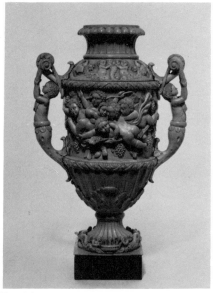

French ivory vase, signed by Hüe (probably Edouard Hüe of Dieppe) and dated 1848. Height 9¼ in (23·5 cm). Belgravia 30 May £240 ($576)

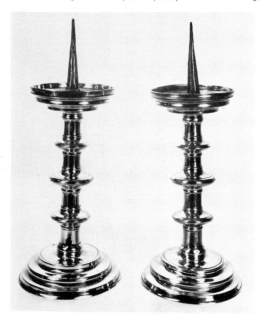

Left: Pair of Flemish brass pricket candlesticks, 16th century. Height 15½ in (39·4 cm). New Bond Street 23 May £900 ($2,160)

Right: One of a pair of brass neo-Gothic candelabra, English second half of the 19th century. Height 78 in (198 cm). Belgravia 6 February £520 ($1,248)

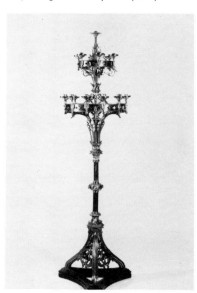

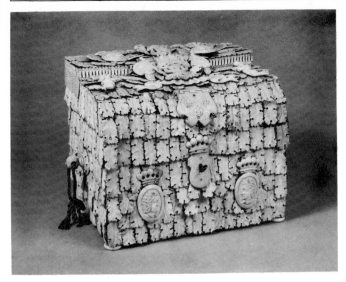

Dieppe carved ivory jewel box inscribed 'MONT. IOYES. ST. DENYS' French, 19th century. 10 in by 15 in (25·4 by 38·1 cm). New York 9 February $350 (£147)

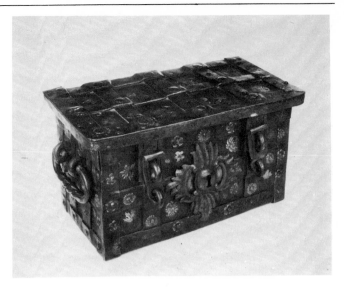

German iron strongbox, early 17th century. Length 7¾ in (19·7 cm). New Bond Street 23 May £750 ($1,800)

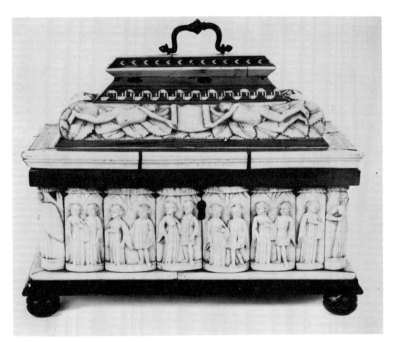

North Italian wood, horn and bone marriage casket, 15th century. Height 7 in by 9½ in by 5½ in (17·8 by 24·1 by 14 cm). New Bond Street 12 December £600 ($1,440)

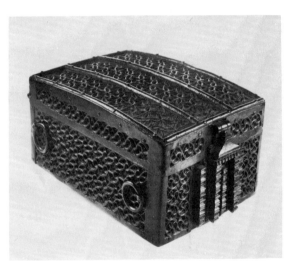

French or Spanish iron *boite-à-missal*, 15th century. Length 9 in (22·9 cm). New Bond Street 23 May £900 ($2,160)

French tooled and gilt-leather marriage casket, mid 16th century. New Bond Street 23 May £780 ($1,872)

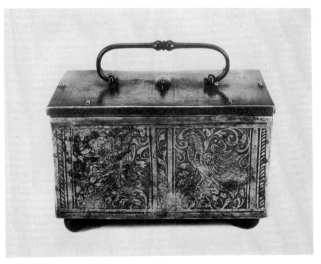

Nuremberg etched metal casket, late 16th century. Length 7½ in (19 cm). New Bond Street 23 May £650 ($1,560)

Spanish ivory, rosewood and silver-mounted Crucifix, 18th century. Height 49½ in (125·7 cm). New Bond Street 1 July £650 ($1,560)

Gilt bronze and champlevé enamel jardinière by F Barbedienne, French mid 19th century. Height 6¼ in (15·9 cm). Belgravia 9 January £110 ($264)

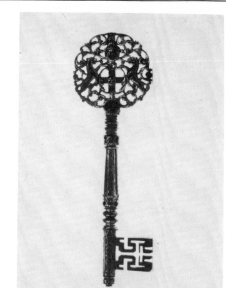

English steel door key, early 18th century. Length 5⅛ in (13 cm). New Bond Street 1 July £320 ($768)

Turkish silver spherical box, probably for a bezoar, once in the collection of Horace Walpole at Strawberry Hill, 19th century. Diameter 2¼ in (5·7 cm). New Bond Street 12 December £400 ($960)

Flemish or French bronze door-knocker in Venetian style, first half of the 17th century. Height 13 in (33 cm). New Bond Street 15 March £240 ($576)

Limoges enamel plaque en grisaille in the manner of the Penicaud workshops depicting Juno driving a peacock-drawn chariot, mid 16th century. Length 5¾ in (14·6 cm). New Bond Street 12 December £380 ($912)

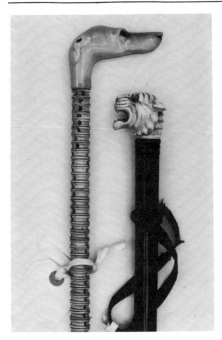

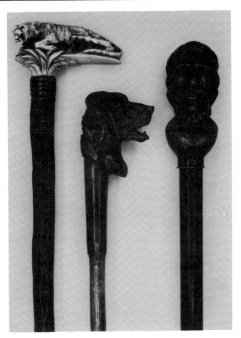

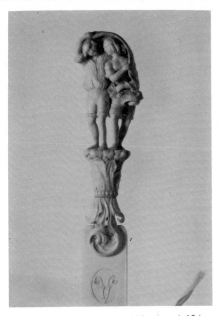

Ivory paper knife, French *circa* 1850. Length 13 in (33 cm). Belgravia 30 May £50 ($120)

Left: Vertebrae stick, the shaft of linked shark's vertebrae, the head of composition in the form of a greyhound. Sold with six other sticks. Length of illustrated piece 34½ in (87·5 cm). Belgravia 30 May £165 ($396)

Right: Walking stick with ivory handle carved as a snarling tiger. Sold with another ivory stick with carved handle. Length of illustrated piece 35½ in (90 cm). Both late 19th century. Belgravia 30 May £115 ($276)

Left: Ivory handled walking stick, late 19th century. Length 35¼ in (89·5 cm). Belgravia 30 May £95 ($228)

Centre: Walking cane with horn handle, *circa* 1900. Length 35 in (89 cm). Belgravia 30 May £75 ($180)

Right: Heavy-stick with horn handle carved as a Roman emperor. Length 35¼ in (89·5 cm). Belgravia 30 May £80 ($192)

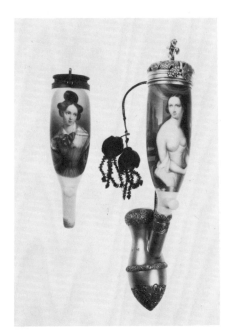

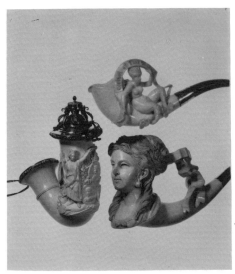

Meissen porcelain tau-shaped cane handle painted after the manner of Watteau, early 19th century. Length 5 in (12·5 cm). Belgravia 30 May £80 ($192)

Left: Painted porcelain pipe-bowl by Fisher and Reichenbach, 1835-40. Length 5 in (12·7 cm). Belgravia 30 May £20 ($48)

Right: Silver-gilt and continental porcelain pipe-bowl, the mounts by John Teare, London 1841. Length 9 in (22·8 cm). Belgravia 30 May £145 ($348)

Left: Piedmontese silver-mounted meerschaum pipe celebrating the Italian fight for freedom, silver mount Vienna 1848. Length 16 in (40·6 cm). Belgravia 30 May £58 ($139)

Right upper: Meerschaum and amber pipe, early 20th century. Length 7½ in (19 cm). Belgravia 30 May £48 ($115)

Right lower: Meerschaum pipe, *circa* 1885. Length 9½ in (24 cm). Belgravia 30 May £90 ($216)

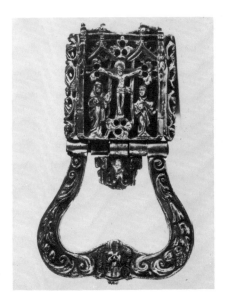

Late Gothic silver belt-buckle, Venetian *circa* 1520. Length 4¼ in (10·8 cm). New Bond Street 1 July £270 ($648)

Objects of vertu, gold boxes, Renaissance jewellery

Loosely defined, an object of vertu is a small object of fine workmanship, or of luxury, which may be be-jewelled. Although not strictly within this definition, we have also included, for the sake of convenience, English enamel boxes of the 18th and early 19th centuries.

Among the earliest pieces included in this section are some good examples of Italian Renaissance, Spanish and Northern European jewellery. Exceptional pieces are now very expensive, the current auction record for an Italian jewel being £40,000 ($96,000). However, some of the less important but attractive pieces are surprisingly inexpensive. At New Bond Street in April, an early 18th-century Spanish pendant jewel, the centre depicting the Virgin and Child, fetched £260 ($624). In the December sale at New Bond Street a 16th-century Spanish pendant enclosing a double-sided medal of *The Deposition* and *Pietà* fetched £400 ($960), an Italian rock-crystal and enamelled gold pectoral Crucifix pendant of about 1600 fetched £580 ($1,392), while an attractive secular Italian pendant in gold, agate and pearls, in the form of a flask, realised £800 ($1,920).

One of the most attractive pieces sold during the year was a matching gold and cameo necklace and ring from the first half of the 17th century, the cameos carved with portraits of the Saxon ruling house of Wettin, which fetched £680 ($1,632) in the same December sale.

Like Renaissance jewellery, the best 18th-century gold snuff boxes, especially those made in France, can make very high prices, the finest pieces now being worth close to £100,000 ($240,000). Nevertheless, extremely good examples of great beauty are still available within the price range of this book. At New Bond Street on 20 April a splendid Louis XV gold and carnelian box of about 1730 fetched £800 ($1,920) and in the same sale, a French Empire gold powder box, the lid inset with an enamel miniature of a lady, fetched £460 ($1,104). Another French Empire piece with important historical associations and bearing the Hapsburg coat-of-arms, was inset with a miniature portrait of the Empress Josephine and was engraved with inscription, *Je Vous donne mon coeur, Josephine*. This fetched £420 ($1,008) at New Bond Street on 29 April.

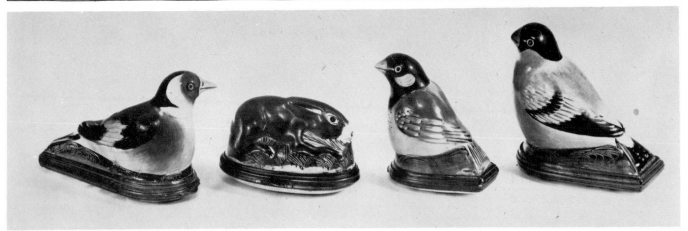

Bilston enamel goldfinch *bonbonnière*. Length 3¾ in (9·5 cm). New Bond Street 25 March £260 ($624)

Staffordshire enamel hare *bonbonnière* with metal mounts. Length 2¼ in (5·7 cm). New Bond Street 25 March £210 ($504)

Bilston enamel bird *bonbonnière*. Height 2¼ in (5·7 cm). New Bond Street 25 March £210 ($504)

Bilston enamel bullfinch *bonbonnière*. Height 2½ in (6·4 cm). New Bond Street 25 March £250 ($600)

South Staffordshire spaniel *bonbonnière*. Length 1¾ in (4·4 cm). New Bond Street 25 March £360 ($864)

English enamel *bonbonnière* in the form of a boar. Length 2¼ in (5·7 cm). New Bond Street 25 March £270 ($648)

English enamel pug's head *bonbonnière*. Height 2¼ in (5·7 cm). New Bond Street 25 March £480 ($1,152)

Birmingham enamel stag *bonbonnière*. Length 2¼ in (5·7 cm). New Bond Street 25 March £280 ($672)

Bilston enamel fruit *bonbonnière* in the form of a cluster of red plums and green foliage, with gilt-metal mounts. Height 2¾ in (7 cm). New Bond Street 8 April £200 ($480)

Bilston enamel frog *bonbonnière* with silvered mounts. Length 2½ in (6·4 cm). New Bond Street 8 April £400 ($960)

Bilston enamel *bonbonnière* in the form of a grey hawk killing a chaffinch. Length 2¼ in (5·7 cm). New Bond Street 25 March £160 ($384).

Bilston enamel *bonbonnière* in the form of the man in the moon. Diameter 2 in (5·1 cm). New Bond Street 8 April £200 ($480)

Mennecy pug dog *bonbonnière* with silver mounts. Length 2¼ in (5·7 cm). New Bond Street 8 April £300 ($720)

German enamel pug dog's head *bonbonnière* with gilt-metal mounts, 18th century. Length 2⅜ in (6 cm). New Bond Street 8 April £380 ($912)

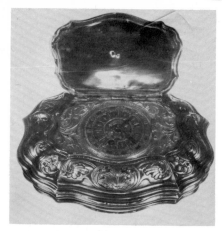

English George II silver-gilt combined watch and snuff box by Cabrier, London *circa* 1750. Length 3¼ in (8·3 cm). New Bond Street 8 April £700 ($1,680)

English George III gold snuff box by A J Strachan, London 1807. Length 3¼ in (8·3 cm). New Bond Street 29 April £460 ($1,104)

English agate snuff box, early 19th century. Length 2¾ in (7 cm). New Bond Street 29 April £320 ($768)

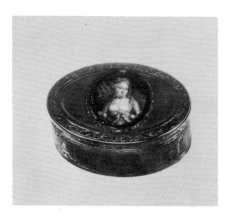

Louis XV gold snuff box, the lid inset with an enamel plaque depicting a lady, Paris 1773, mark of Farmer General Julien Alaterre. Length 2¼ in (5·7 cm). New Bond Street 29 April £680 ($1,632)

English George II gold mounted grey-agate snuff box, mid 18th century. Length 2⅛ in (5·4 cm). New Bond Street 29 April £600 ($1,440)

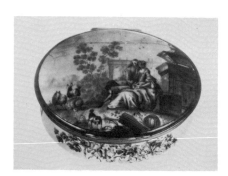

English George III gold snuff box by A J Strachan, London 1803. Length 2¾ in (7 cm). New Bond Street 8 April £520 ($1,248)

Birmingham enamel snuff box with gilt-metal mounts, the lid transfer-printed and painted. Diameter 3 in (7·6 cm). New Bond Street 8 April £140 ($336)

French Louis XVI three-colour gold snuff box by André-Antoine Poupart, Paris 1789, mark of Farmer General Henri Clavel. Length 2⅝ in (6·7 cm). New Bond Street 29 April £950 ($2,280)

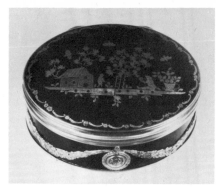

English George III silver-mounted tortoiseshell snuff box. Length 3½ in (8·9 cm). New Bond Street 8 April £70 ($168)

Bilston enamel snuff box with metal mounts. Length 3¼ in (8·3 cm). New Bond Street 8 April £95 ($228)

Louis XV French gold snuff box, the lid inset with a carnelian, *circa* 1730. Length 2¾ in (7 cm). New Bond Street 29 April £800 ($1,920)

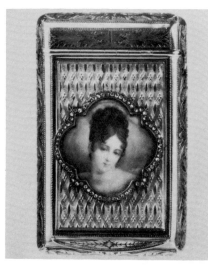

French Empire presentation gold snuff box, the lid inset with a gouache miniature of the Empress Josephine after Isabey, the interior of the lid with a Hapsburg coat of arms and inscribed *Je Vous donne mon coeur—Josephine*, maker probably Louis Tassin. Length 2¾ in (7 cm). New Bond Street 29 April £420 ($1,008)

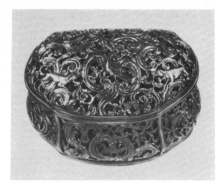

German gold and bloodstone snuff box. Length 3¼ in (8·3 cm). New Bond Street 29 April £520 ($1,248)

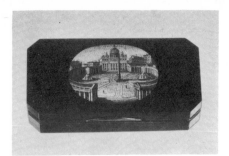

Italian silver mounted black onyx snuff box, the lid inset with a mosaic plaque depicting St Peter's, Rome, *circa* 1800. This box is said to have been presented to Napoleon by Pope Pius VII. Length 3⅛ in (7·9 cm). New Bond Street 29 April £180 ($432)

Swiss two-colour gold snuff box, early 19th century. Length 3 in (7·6 cm). New Bond Street 8 April £410 ($984)

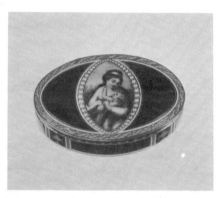

Swiss enamel and gold snuff box, the lid inset with enamel miniature with a split-pearl border, early 19th century. Length 2¾ in (7 cm). New Bond Street 29 April £780 ($1,872)

Swiss gold and enamel snuff box, the lid inset with an enamel plaque depicting Charity surrounded by her children, signed Lissignol, early 19th century. Length 3¾ in (9·5 cm). New Bond Street 29 April £650 ($1,560)

Swiss two-colour gold snuff box, the lid inset with an oval enamel plaque depicting two goddesses, early 19th century. Length 3⅛ in (7·9 cm). New Bond Street 29 April £580 ($1,392)

Swiss gold snuff box, early 19th century. Length 3¾ in (9·5 cm). New Bond Street 29 April £380 ($912)

Swiss gold and jewelled snuff box, the lid applied with blue enamel set with diamonds. Length 2¾ in (7 cm). New Bond Street 29 April £880 ($2,112)

Swiss enamel snuff box, the lid painted with a Swiss scene. Length 3¼ in (8·3 cm). New Bond Street 29 April £750 ($1,800)

Swiss enamel and gold snuff box. Length 3⅞ in (9·8 cm). New Bond Street 29 April £780 ($1,872)

Swiss gold and enamel snuff box, the lid enamelled with Venus and Cupid. Length 3¼ in (8·3 cm). New Bond Street 29 April £900 ($2,160)

Gold snuff box. Length 2½ in (6·4 cm). New Bond Street 29 April £410 ($984)

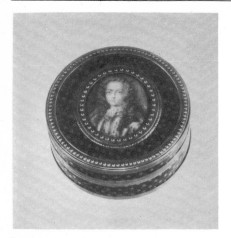

French Louis XVI gold-mounted tortoiseshell powder box, the lid inset with an enamel miniature after Huaud. Length 2½ in (6·4 cm). New Bond Street 29 April £310 ($744)

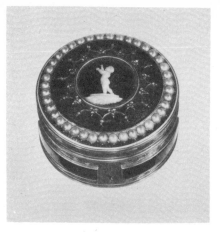

Gold and enamel powder box, the lid inset with an ivory and glass cameo of a putto. Diameter 2 in (5·1 cm). New Bond Street 29 April £300 ($720)

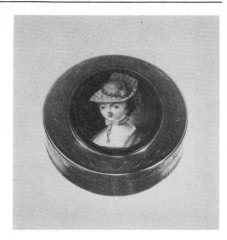

French Empire gold powder box, the lid inset with an enamel medallion painted with the portrait of a lady. Diameter 2¾ in (6 cm). New Bond Street 29 April £460 ($1,104)

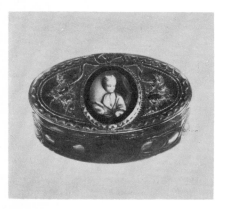

Swiss three-colour gold pill box, the lid inset with an enamelled medallion painted with the portrait of a girl, early 19th century. Length 2⅛ in (5·4 cm). New Bond Street 29 April £420 ($1,008)

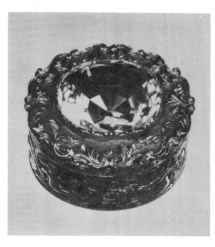

Oval gold pill box, the lid inset wtih a large facet-cut citrine. Length 1¾ in (4·4 cm). New Bond Street 29 April £140 ($336)

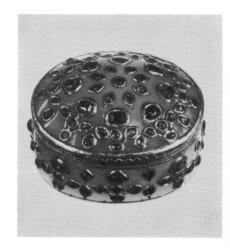

Jeypore jewelled jade spice box, late 18th century. Diameter 2⅝ in (6·7 cm). New Bond Street 29 April £750 ($1,800)

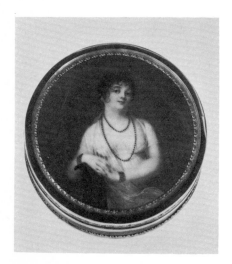

French Louis XVI tortoiseshell *boite à portrait* by Pierre-Denis Chaumont, the lid inset with an enamel miniature attributed to F Soiron, Paris 1798, the mark of Farmer General Jean-Francois Kalendrin. Diameter 3 in (7·6 cm). New Bond Street 29 April £480 ($1,152)

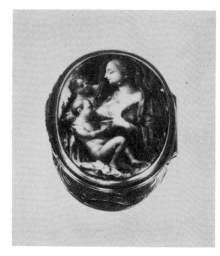

English George II gold patch box, the lid inset with an enamel depicting the Virgin and Child. Diameter 1⅝ in (4·1 cm). New Bond Street 29 April £600 ($1,440)

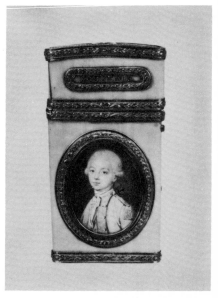

French Louis XVI gold-mounted ivory *carnet de bal*, one side inset with a miniature portrait of an officer, Paris *circa* 1786. Height 3½ in (8·9 cm). New Bond Street 29 April £280 ($672)

George IV gold vinaigrette. Length 1¼ in (3·2 cm). New Bond Street 29 April £400 ($960)

Swiss gold and enamel vinaigrette, early 19th century. Length 1½ in (3·8 cm). New Bond Street 29 April £120 ($288)

Swiss gold and enamel toothpick case, the centre enamelled *en plein* with a Swiss landscape. Length 3 in (7·6 cm). New Bond Street 29 April £520 ($1,248)

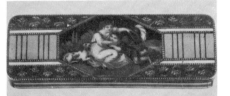

Swiss gold and enamel toothpick case, the lid inset with an hexagonal enamel medallion. Length 2⅞ in (7·3 cm). New Bond Street 29 April £520 ($1,248)

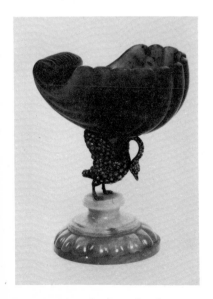

Viennese nephrite and onyx nautilus sweetmeat dish, *circa* 1880. Height 3¼ in (8·3 cm). Belgravia 24 January £240 ($576)

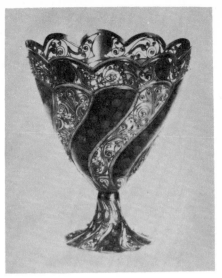

Swiss gold and enamel zarf made for the Turkish market, 19th century. Height 2¼ in (5·7 cm). New Bond Street 8 April £50 ($120)

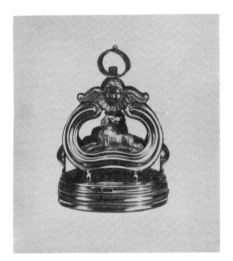

Swiss two-colour gold musical fob seal, early 19th century. Height 1⅝ in (4·1 cm). New Bond Street 29 April £350 ($840)

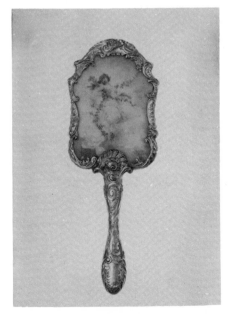

Gold-mounted lady's hand mirror set with diamonds, sapphires and a ruby, the reverse of the mirror inset with a miniature by Albertin, stamped *Tiffany & Cie*, late 19th century. Length 7½ in (19 cm). Belgravia 24 January £360 ($864).

Gold and enamel lady's cigarette case by Cartier, 20th century. Length 3⅝ in (9·2 cm). Belgravia 24 January £340 ($816)

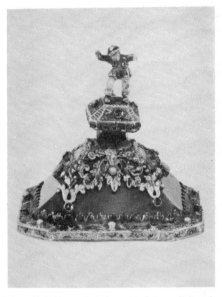

Enamelled gilt-metal, agate and heliotrope desk seal, Vienna mid 19th century. Height 2¾ in (7 cm). Belgravia 30 May £100 ($240)

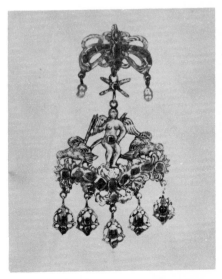

Dutch enamelled and jewelled pendant, mid 17th century. Height 3 in (7·6 cm). New Bond Street 8 April £150 ($360)

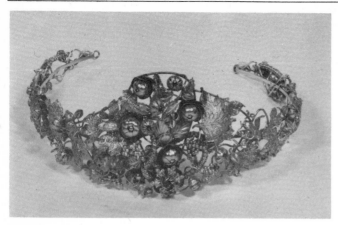

Victorian silver-gilt tiara, English *circa* 1870. Width 6¼ in (15·4 cm).
Belgravia 30 May £105 ($252)

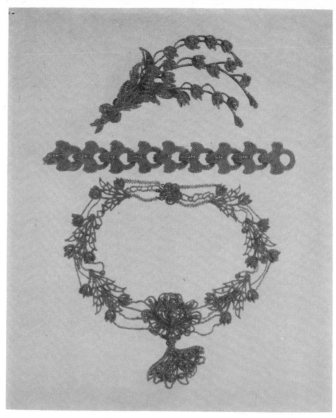

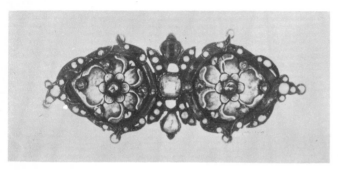

Persian silver and jewelled clasp, late 18th century. Length 3¼ in (8·3 cm).
New Bond Street 8 April £190 ($456)

Victorian seed-pearl demi-parure, English *circa* 1880. Belgravia 30 May
£80 ($192)

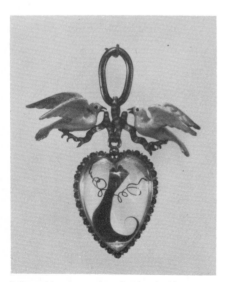

Italian gold and enamel pendant jewel with a
crystal heart enclosing a lock of hair. Height 2¼ in
(5·7 cm). New Bond Street 8 April £160 ($384)

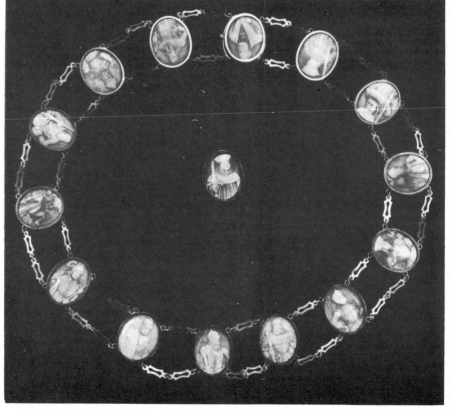

Gold and shell cameo necklace and ring carved with portraits of the Saxon ruling house of Wettin
from the Middle Ages to the Elector Christian II who died in 1611. First half of the 17th
century (one gold link missing). New Bond Street 12 December £680 ($1,632)

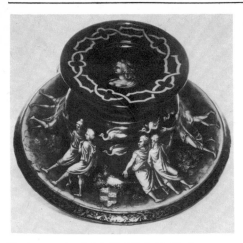

Circular enamel pedestal salt attributed to Pierre Reymond painted *en grisaille* with the bust of Dido and *The Triumph of Venus*, second half of the 16th century. Diameter 7 in (17·8 cm). New Bond Street 12 December £750 ($1,800)

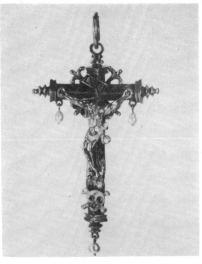

Spanish enamelled gold pendant Crucifix, 16th century. Length 3 in (7·6 cm). New Bond Street 1 July £900 ($2,160)

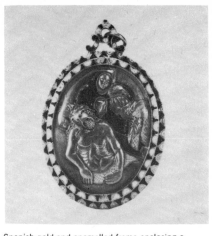

Spanish gold and enamelled frame enclosing a double-sided polychrome enamelled gold medal depicting *The Deposition* and *Pietà*, 16th century. Length 2⅜ in (6 cm). New Bond Street 12 December £400 ($960)

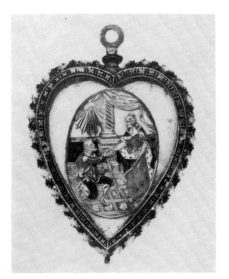

North German jewel of amber within an enamelled gold frame inset with a gold miniature of *A Queen distributing alms* and an ivory carving of *The Baptism of Christ*, mid 17th century. Height 2¾ in (7 cm). New Bond Street 12 December £700 ($1,660)

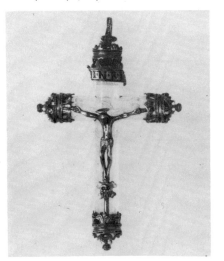

Italian rock-crystal and enamelled gold pectoral Crucifix pendant, *circa* 1600. Height 2⅜ in (6 cm). New Bond Street 12 December £580 ($1,392)

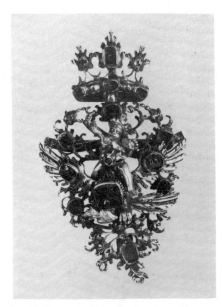

Spanish silver and gold pendant jewel set with emeralds and diamond chips, 18th century. Length 2⅞ in (7·3 cm). New Bond Street 12 December £320 ($768)

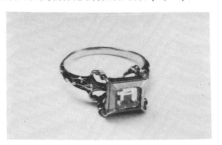

Enamelled gold ring set with a table-cut diamond, late 16th century. New Bond Street 12 December £850 ($2,040)

Italian gold, agate and pearl pendant in the form of a flask, first half of the 17th century. Length 1⅛ in (2·8 cm). New Bond Street 12 December £800 ($1,920)

Pair of polychromed terracotta baskets of fruit, flowers and vegetables from the workshops of the Della Robbias. Italian, early 16th century. Diameter 10¼ in (26 cm). New York 2 March $2,500 (£1,042)

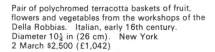

Russian works of art and Russian icons

Russian works of art have been given a special category as, in style and date, they form an homogeneous group. Most of the pieces illustrated here date from the 19th century and include a small number of examples from the workshops of Carl Fabergé, perhaps the greatest jeweller of modern times.

Russian applied art is characterised by its use of rich materials and it concentrates upon an ornate, rich surface. The silver-gilt and cloisonné enamel vessels illustrated here are good examples of the Russian approach to design and fine pieces can still be bought at a reasonable price. We include the pair of beakers by Maria Semenova, sold at New Bond Street on 18 February for £380 ($912), the spoon by the same maker at £230 ($552) and the attractive salt-cellar by Ovtchinnikov, one of the leading makers of objects of this type, which fetched £620 ($1,488). All made comparatively modest sums and might well have recommended themselves to any collector of Russian art. An interesting and most appealing use of enamel is illustrated by the *plique-à-jour* cup and saucer by Anton Kuzmickev which realised £580 ($1,392) and the similarly decorated kovsh attributed to O. Kurliukov and dated Moscow 1892, which realised £620 ($1,488), both sold at New Bond Street on 13 May.

Pieces from the workshop of the Russian court jeweller Carl Fabergé are amongst the most keenly collected examples of late 19th-century and early 20th-century works of art and are thus very expensive. It is still possible, however, to obtain good representative examples below our top limit and we illustrate a gold and enamel brooch which fetched £950 ($2,280), a gold and enamel miniature pill box in Louis XV taste which fetched £820 ($1,968) and some other small pieces as examples. Two particularly fine works are a silver and green onyx writing tablet by the Fabergé workmaster Julius Alexandrovitch Rappoport, which realised £880 ($2,112), the Fabergé workshops being famous for a combination of precious metals and hardstones, and a rare silver and strawberry enamel glue pot by Anders Johan Nevalainen which was sold for £800 ($1,920).

Russian and Greek icons are still fields which have not been over-exposed and the number of experts in Western Europe are few. While a considerable degree of knowledge is required, and the beginner should be particularly diligent in seeking proper advice, good icons still represent exceptional value for money and are, at their best, worthy to be compared with the far more expensive panel paintings produced in Italy and Northern Europe in the 15th and 16th centuries. Among particularly noteworthy and rare pieces illustrated are a 16th-century Russian icon of St Nicholas at £980 ($2,352) and a 17th-century Russian icon of St Ulita with her son St Kyrik which was sold for £900 ($2,160) at New Bond Street on 13 May.

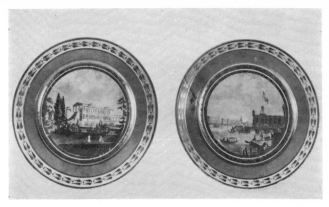

Pair of Nicholas I Imperial porcelain plates from the Field Marshal Service, one signed on the reverse by P Shchetinin and the other by S. Daladugin, both dated 1843. Diameter 9½ in (24·1 cm). New Bond Street 18 February £700 ($1,680)

Pair of St Petersburg porcelain plates, one decorated with a view of the Grand Palace, Tsarskoe Selo and the other with a view of Peter-Paul Fortress, St Petersburg and the approach to the Nevsky Gate from the river. Diameter 9½ in (24·1 cm). New Bond Street 18 February £170 ($408)

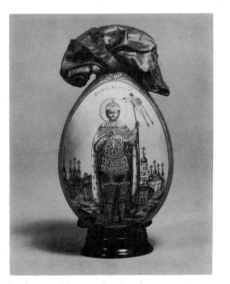

Russian porcelain egg. Los Angeles 19 November $1,000 (£417)

Russian porcelain part dinner service of 43 pieces from the Nicholas I, Alexander II and Kornilov factories. New Bond Street 13 May £450 ($1,080)

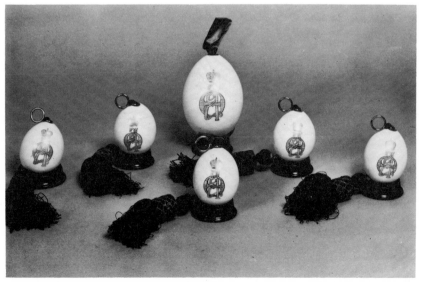

Set of six Russian porcelain Easter eggs, late 19th century. Los Angeles 19 November $1,600 (£667)

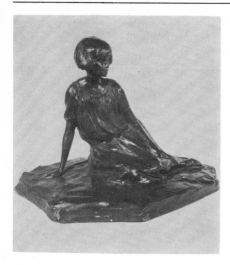

Bronze figure of a young girl by Prince Paul
Petrovitch Troubetzkoy, founders' stamp
C Valsuani Cire Perdue, dated 1924. Height 9 in
(22·9 cm). Belgravia 27 November £520 ($1,248)

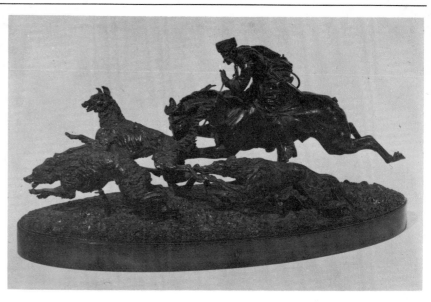

Bronze hunting group by Lieberich, founders' inscription *Fabr. C.R. Woerffel St. Petersburg*, third quarter
of the 19th century (horse's tail missing). Height 10 in (25·4 cm). Belgravia 27 November £900
($2,160)

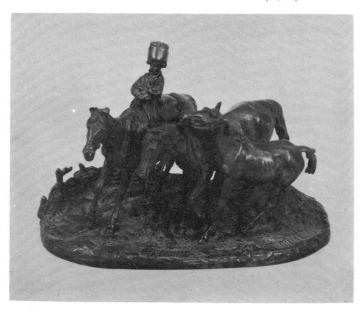

Bronze group of a young moujik with three horses by Eugene Lanceray,
foundry mark of Felix Chopin, late 19th century. Length 10½ in (26·7 cm).
Los Angeles 20 November $1,700 (£708)

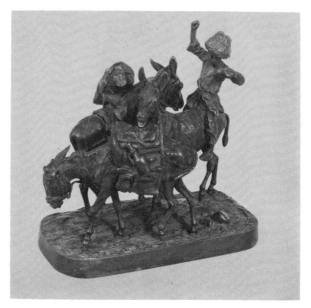

Bronze group of a Cossack boy with mules by
Eugene Lanceray, late 19th century. Length 8½ in
(21·6 cm). Los Angeles 20 November $1,500 (£625)

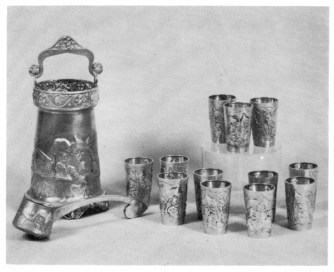

Parcel-gilt champagne bucket, ladle and twelve beakers, workmaster's initials
SB, *circa* 1900. Los Angeles 20 November $1,100 (£458)

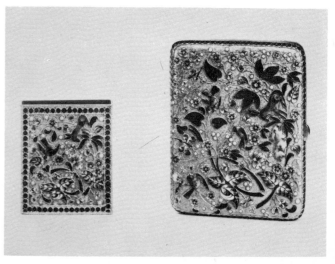

Match-box holder and cigarette case *en suite* in enamel and gold by MP
Shaposhnikov, match-box holder 2⅜ in (6 cm), cigarette case 3¾ in (9·5 cm).
New Bond Street 13 May £900 ($2,160)

Russian silver cigar box, maker's initials AR, Moscow 1873. Length 5 in (12·7 cm). New Bond Street 13 May £520 ($1,248)

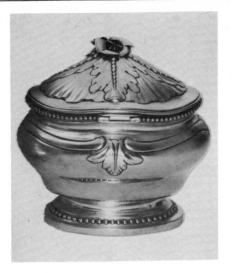

18th-century Russian sugar box, maker's mark P.S. in script, St Petersburg 1787. 19 oz 14 dwt. Height 5¾ in (14·7 cm). New Bond Street 9 May £920 ($2,208)

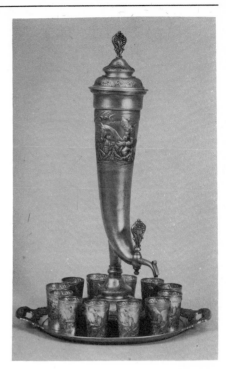

Silver wine cistern with twelve beakers and a tray, workmaster's initials SB, *circa* 1890. Los Angeles 20 November $1,600 (£667)

Russian two colour gold cigarette case by A Tillinder. Length 4 in (10·2 cm). New Bond Street 18 February £500 ($1,200)

Russian silver and enamel lady's cigarette case by I Britzin. Length 3½ in (8·9 cm). New Bond Street 13 May £440 ($1,056)

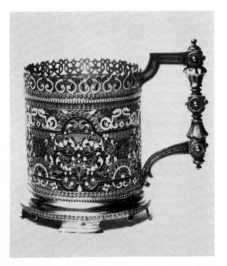

Russian silver and cloisonné enamel tea-glass holder, maker's initials GK, Moscow 1892. Height 3½ in (8·9 cm). New Bond Street 13 May £580 ($1,392)

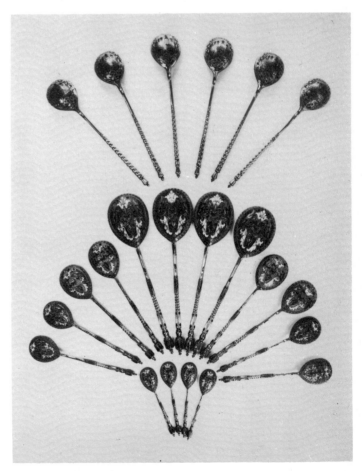

Upper: Set of six Russian silver-gilt and niello teaspoons, the backs of the bowls decorated with views of the Kremlin, maker's initials IA, Moscow 1871. Length 5½ in (14 cm). New Bond Street 13 May £135 ($324)

Lower: Set of sixteen silver and cloisonné enamel spoons by Ivan Saltykov. Length 2¾ in to 6 in (7 cm to 15·2 cm). New Bond Street 13 May £650 ($1,560)

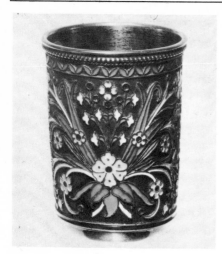

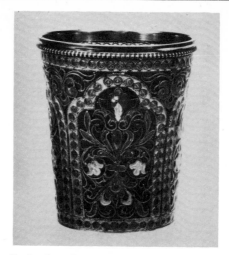

One of a pair of Russian silver-gilt and cloisonné enamel beakers by Maria Semenova. Height 2⅛ in (5·4 cm). New Bond Street 18 February £380 ($912)

Russian silver-gilt and enamel beaker by Ivan Khlebnikov, Moscow 1883. Height 2⅝ in (6·7 cm). New Bond Street 18 February £750 ($1,800)

Russian enamel cigar case by Ovtchinnikov. Length 4½ in (11·4 cm). New Bond Street 13 May £720 ($1,728)

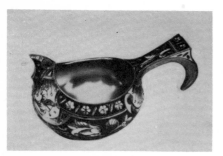

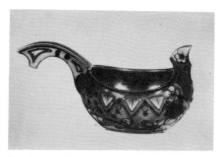

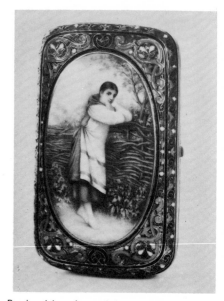

Russian silver and cloisonné enamel kovsh, maker 6th Moscow Artel. Length 3½ in (8·9 cm). New Bond Street 13 May £380 ($912)

One of a pair of Russian silver and enamel kovsh, Moscow, 11th Artel. Length 2¾ in (7 cm). New Bond Street 18 February £440 ($1,056)

Russian cloisonné enamel cigar case, makers mark JFK. Length 4½ in (11·4 cm). New Bond Street 13 May £550 ($1,320)

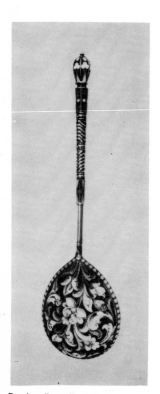

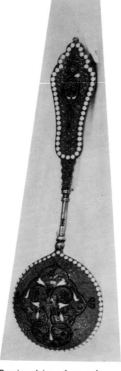

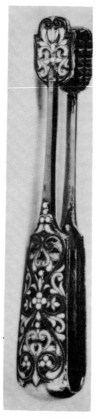

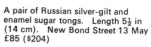

Russian silver-gilt and enamel pill box, maker's initials MK. Diameter 1½ in (3·8 cm). New Bond Street 13 May £260 ($624)

Russian silver-gilt and enamel spoon by Maria Semenova. Length 7¾ in (19·7 cm). New Bond Street 18 February £230 ($552)

Russian cloisonné enamel sugar spoon. Length 7¼ in (18·4 cm). New Bond Street 13 May £125 ($300)

A pair of Russian silver-gilt and enamel sugar tongs. Length 5½ in (14 cm). New Bond Street 13 May £85 ($204)

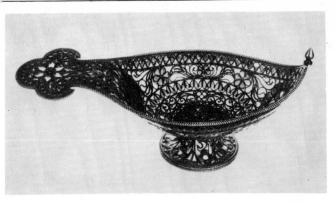

Russian *plique-à-jour* enamel kovsh attributed to O Kurliukov, Moscow 1892. Length 7 in (17·8 cm). New Bond Street 13 May £620 ($1,488)

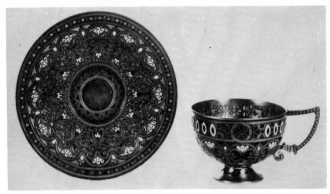

Russian silver and *plique-à-jour* enamel cup and saucer by Anton Kuzmickev. New Bond Street 13 May £580 ($1,392)

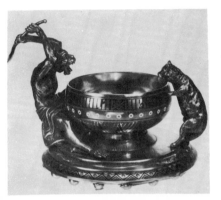

Russian silver and enamel salt cellar by Ovtchinnikov. Length 5 in (12·7 cm). New Bond Street 13 May £620 ($1,488)

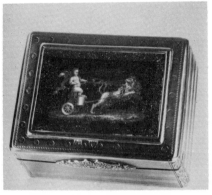

Russian silver and mosaic snuff box, makers' initials SK, Moscow 1860. Length 2¾ in (7 cm). New Bond Street 13 May £220 ($528)

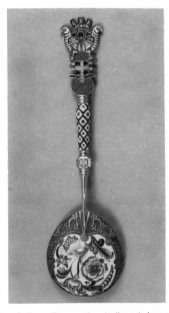

Fabergé silver-gilt enamel and *plique-à-jour* spoon, workmaster Feodor Ruckert, St Petersburg *circa* 1895. Los Angeles 19 June $1,900 (£792)

Fabergé silver-gilt and strawberry-red enamel glue pot, workmaster Anders Johan Nevalainen. Height 2⅞ in (7·3 cm). New Bond Street 13 May £800 ($1,920)

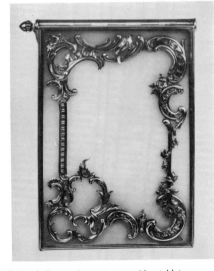

Fabergé silver and green onyx writing tablet. workmaster Julius Alexandrovitch Rappoport. Length 5¾ in (14·6 cm). New Bond Street 13 May £880 ($2,112)

Fabergé gold and enamel miniature pill box in Louis XV taste. Length ¾ in (1·9 cm). New Bond Street 18 February £820 ($1,968)

Fabergé gold and jewelled brooch. Diameter 1 in (2·54 cm). New Bond Street 13 May £350 ($840)

Fabergé gold and jewelled brooch. Length 1⅛ in (2·9 cm). New Bond Street 13 May £950 ($2,280)

Fabergé gold and nephrite pill box, workmaster Henrik Wigström. Diameter 1⅝ in (4·1 cm). New Bond Street 18 February £920 ($2,208)

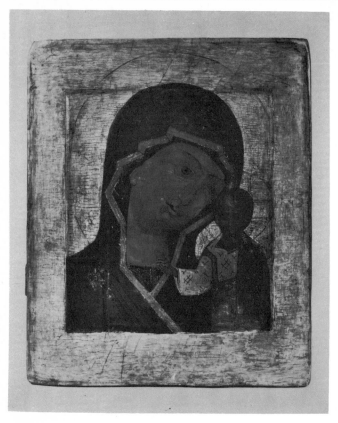

Russian icon of the Mother of God of Kazan, Moscow School early 17th century. 14 by 11¾ in (35·6 by 29·8 cm). New Bond Street 13 May £420 ($1,008)

Early Russian icon of St Nicholas, Central Russian 16th century. 22 by 15 in (55·9 by 38·1 cm). New Bond Street 1 April £980 ($2,352)

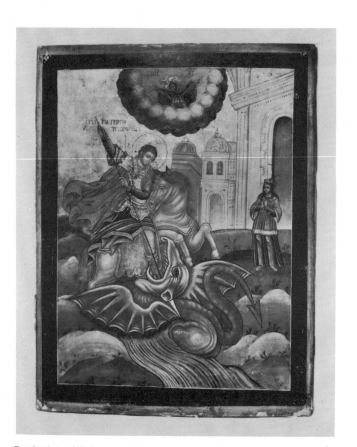

Russian icon of *St George slaying the Dragon*, Central Russian Provincial *circa* 1800. 35 by 27½ in (88·9 by 69·9 cm). New Bond Street 1 April £550 ($1,320)

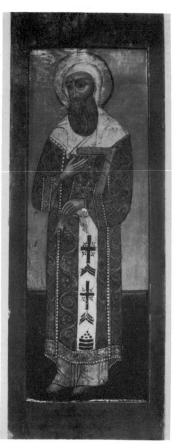

Russian iconostasis icon of St Serge of Radonej, North Russian early 17th century. 43 by 15¾ in (109·2 by 40 cm). New Bond Street 1 April £950 ($2,280)

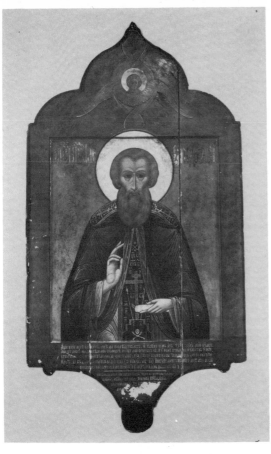

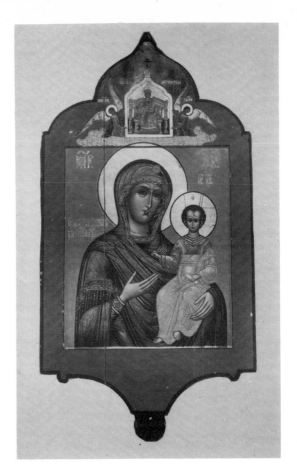

A large Russian double-sided processional icon depicting the Mother of God of Smolensk, and St Alexander on the reverse, Palekh School 19th century. 44 by 24 in (111·8 by 61 cm).
New Bond Street 1 April £900 ($2,160)

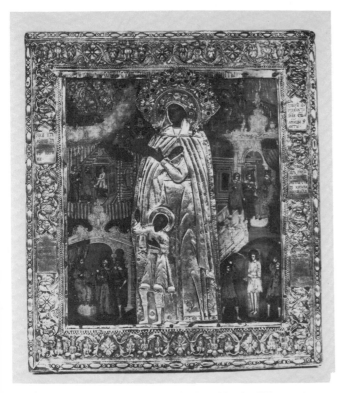

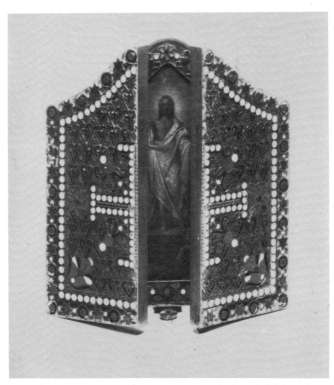

Russian icon of St Ulita with her son St Kyrik, Central Russian 17th century. 12½ by 11 in (31·7 by 27·9 cm). New Bond Street 13 May £900 ($2,160)

Russian triptych of the *Transfiguration*, flanked by the Archangels Gabriel and Michael, in a silver and cloisonné enamel case dated 1892. Height 6½ in (16·5 cm). New Bond Street 13 May £420 ($1,080)

Portrait miniatures

Before the advent of photography, the portrait miniature was the quickest and most convenient way of capturing the likeness of a relative or loved one. The art of 'limning' grew out of the miniature painting tradition of the Middle Ages and throughout the 16th, 17th and 18th centuries was developed into an art form of great individuality. In England during the 16th and early 17th centuries, artists such as Hilliard and Oliver made miniature painting an art unrivalled by domestic easel painting.

Early examples of miniature painting, especially if by artists of the calibre of Holbein, Hilliard, Oliver or other early protagonists, have always been keenly collected. In recent years outstanding examples by later limners such as John Hoskins and John Smart have also become expensive, generally fetching more than the top limit of £1,000 ($2,400). However, the majority of good miniatures sold on the open market every year fetch less and it is worth noting that in 1973 in New Bond Street, a beautiful but restored miniature of Elizabeth I by Nicholas Hilliard fetched £1,400 ($3,360), not much above the limit and a piece which would make a worthy culmination to a collection of less expensive examples of European miniature painting.

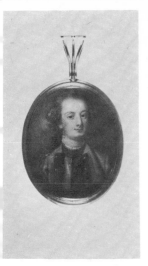

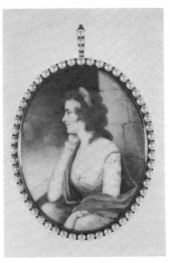

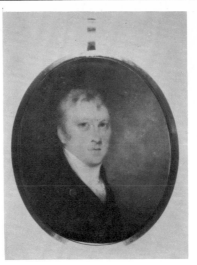

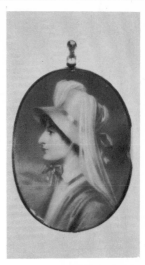

A nobleman in the manner of Arlaud. Length 1¾ in (4·4 cm). New Bond Street 25 March £120 ($288)

A lady, possibly by John Barry. Length 2½ in (6·3 cm). New Bond Street 25 March £220 ($528)

A young gentleman signed by John Thomas Barber Beaumont. Length 2¾ in (7 cm). New Bond Street 25 March £80 ($192)

Enamel miniature of Elizabeth Shutz, née Lindsay, by Henry Bone, signed and dated June 1831. Length 2¼ in (5·7 cm). New Bond Street 25 March £320 ($768)

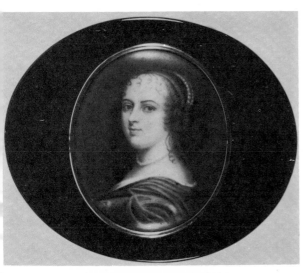

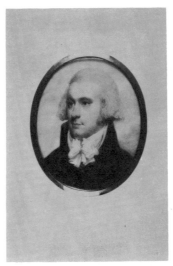

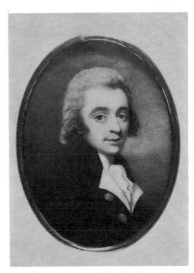

Tortoiseshell snuff box, the lid inset with an enamel miniature of a court lady after Petitot, perhaps by Henry Bone. Length of miniature 3 in (7·6 cm). New Bond Street 25 March (£320 $768).

A gentleman by Frederick Buck. Length 2⅛ in (5·4 cm). New Bond Street 25 March £180 ($422)

A gentleman by Richard Bull, signed and dated 1787. Length 3 in (7·6 cm). New Bond Street 25 March £300 ($720)

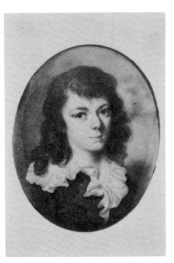

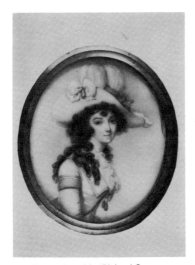

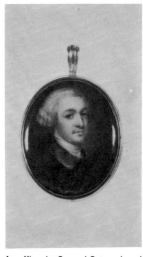

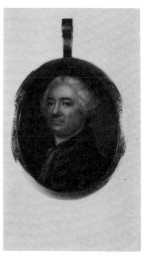

A young boy, in the manner of Richard Collins. Length 2 in (5·1 cm). New Bond Street 29 April, £260 ($624)

Miss Turner signed by Richard Crosse. Length 2½ in (6·3 cm). New Bond Street 25 March £720 ($1,728)

An officer by Samuel Cotes, signed and dated 1787. Length 1¼ in (3·2 cm). New Bond Street 25 March £140 ($336)

Portrait of Admiral Sir John Orde, Bart, by Samuel Cotes, signed and dated 1758. Length 1¼ in (3·2 cm). New Bond Street 29 April £220 ($528)

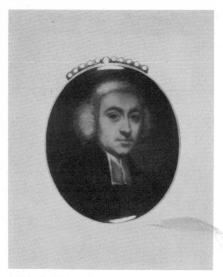

A divine by Richard Cosway. Length 1⅝ in (4·1 cm).
New Bond Street 25 March £140 ($336)

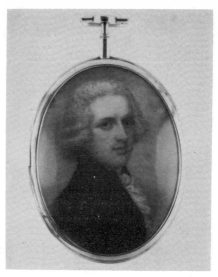

A gentleman by Richard Cosway, signed and dated
1791 in full on the reverse. Length 2 in (5·1 cm).
New Bond Street 29 April £580 ($1,392)

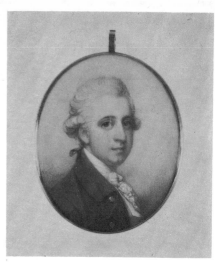

A gentleman by Richard Cosway. Length 1⅞ in
(4·8 cm). New Bond Street 29 April £420
($1,008)

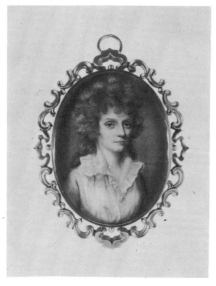

A lady, school of Engleheart. Length 2⅜ in (6 cm).
New Bond Street 25 March £180 ($456)

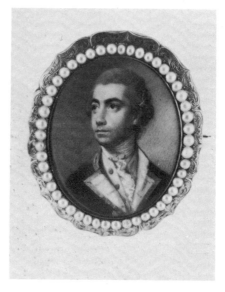

Portrait of Admiral William Clement Finch by
George Engleheart. Length 2⅝ in (6·7 cm).
New Bond Street 29 April £650 ($1,560).

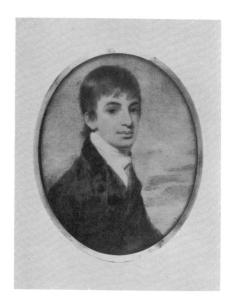

Edward Blunt, younger son of Walter Blunt, by
Henry Edridge. Length 3¼ in (8·3 cm). New Bond
Street 25 March £420 ($1,008)

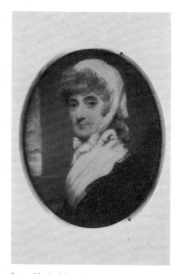

Anna Maria Blunt by Henry
Edridge. Length 3⅛ in (7·9 cm).
New Bond Street 25 March
£380 ($912)

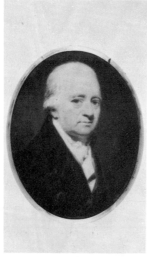

Walter Blunt by Henry Edridge.
Length 2⅞ in (7·3 cm). New
Bond Street 25 March £300
($720)

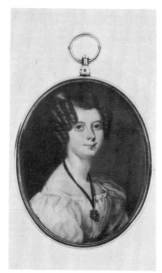

A lady by William Egley. Length
2⅞ in (7·3 cm). New Bond Street
25 March £110 ($264)

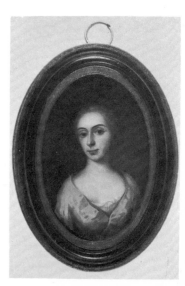

Oil on copper miniature of a lady, English
school. Length 2½ in (6·3 cm). New
Bond Street 25 March £95 ($228)

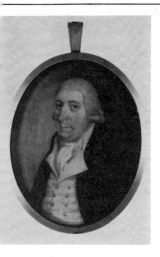

A gentleman, in the manner of Alexander Galloway. Length 2¾ in (7 cm). New Bond Street 25 March £65 ($156)

Enamel miniature of a young gentleman by A. Groth. Length 1⅝ in (4·1 cm). New Bond Street, 25 March £200 ($480)

A gentleman by William Grimaldi. Length 1½ in (3·8 cm). New Bond Street 29 April £120 ($288).

Enamel miniature of Charles Saunderson by John Haslem, signed and dated 1864. Length 1⅞ in (4·8 cm). New Bond Street 25 March £150 ($360)

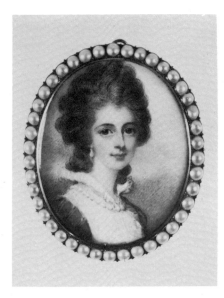

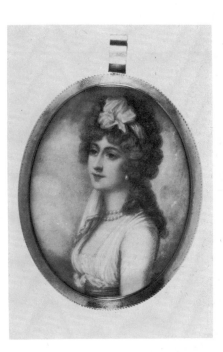

Enamel miniature of a nobleman by Johann Heinrich Hurter. Length 1¼ in (3·2 cm). New Bond Street 25 March £210 ($504)

Portrait of Lady Charlotte Finch, Countess of Suffolk, by Horace Hone, signed and dated Dublin 1787 in full on the reverse. Mounted in a split pearl bordered frame. Length 1⅞ in (4·8 cm). New Bond Street 29 April £620 ($1,488)

A lady by Mrs Charlotte Hadfield, signed and dated London July 1793. This is the only known example of the artist's work; she was sister-in-law to Richard Cosway. Length 2¾ in (7 cm). New Bond Street 29 April £520 ($1,248)

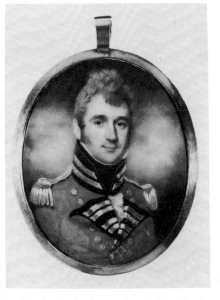

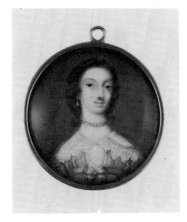

An officer by Charles Jagger. Length 2¾ in (7 cm). New Bond Street 29 April £480 ($1,152)

A lady by Peter Paul Lens. Diameter 1¼ in (3·2 cm). New Bond Street 29 April £120 ($288)

Swiss enamel oblong plaque depicting the *Departure of Ulysses*, signed and dated LJ, 1818 on the reverse. Length 2¾ in (7 cm). New Bond Street 29 April £480 ($1,152)

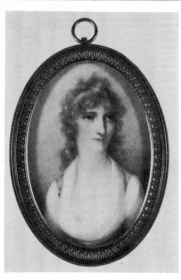

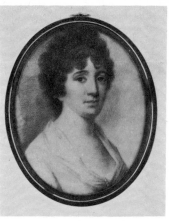

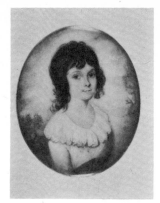

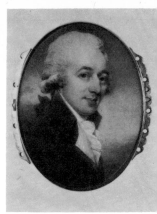

A lady by Edward Greene Malbone. Length 2⅝ in (6·7 cm). New Bond Street 25 March £560 ($1,344)

A young girl, perhaps by Patrick McMorland. Length 1½ in (3·8 cm). New Bond Street 25 March £90 ($216)

A gentleman by Edward Miles. Length 1¾ in (4·4 cm). New Bond Street 29 April £420 ($1,008)

A lady by Mrs Mee. Length 3 in (7·6 cm). New Bond Street 25 March £130 ($312)

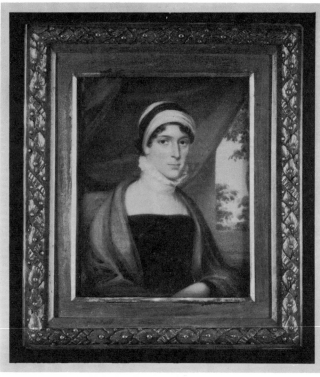

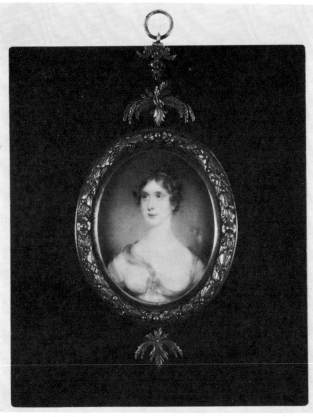

Mrs Elizabeth Nash, mother of the artist, by Edward Nash. Length 3¾ in (9·5 cm). New Bond Street 25 March £140 ($336)

A young lady by Edward Nash, in a finely chiselled ormolu surround and surmount. Length 2¾ in (7 cm). New Bond Street 25 March £110 ($264)

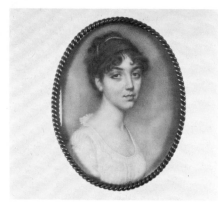

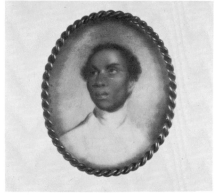

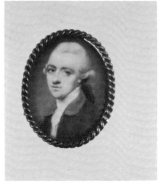

A young lady by Edward Nash after John Smart, signed and dated 1802. Length 2¾ in (7 cm). New Bond Street 25 March £460 ($1,104)

Dr Samuel Johnson's West Indian servant by Edward Nash. Length 2⅛ in (5·4 cm). New Bond Street 25 March £360 ($864)

One of a pair of miniatures of a lady and gentleman by Edward Nash after Richard Cosway. Length 1¾ in (4·4 cm). New Bond Street 25 March £120 ($288) the pair

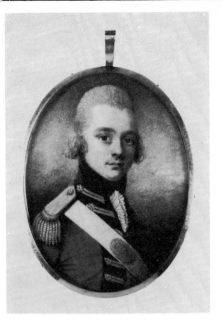

An officer signed by John Naish. Length 3 in (7·6 cm). New Bond Street 29 April £290 ($676)

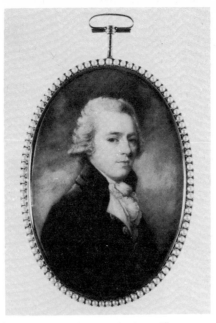

Portrait of Edward Faringdon by James Nixon. Length 3⅛ in (7·9 cm). New Bond Street 29 April £600 ($1,440)

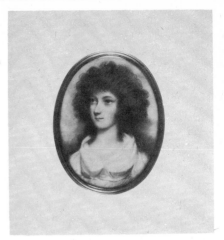

A lady by Andrew Plimer. Length 2⅛ in (5·4 cm). New Bond Street 25 March £280 ($672)

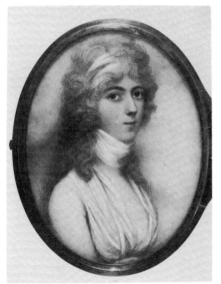

A young lady by Andrew Plimer. Length 3 in (7·6 cm). New Bond Street 29 April £400 ($960)

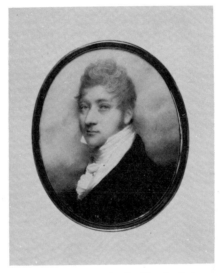

George Blunt, elder son of Walter Blunt by Andrew Plimer. Length 3 in (7·6 cm). New Bond Street 25 March £600 ($1,440)

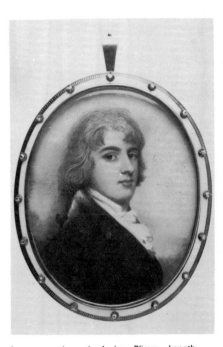

A young gentleman by Andrew Plimer. Length 2¾ in (7 cm). New Bond Street 29 April £620 ($1,488)

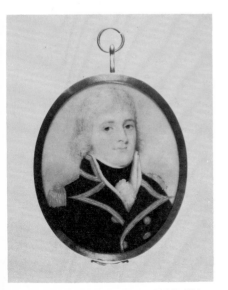

A naval officer, school of N. Plimer. Height 2⅝ in (6·7 cm). New Bond Street 25 March £80 ($192)

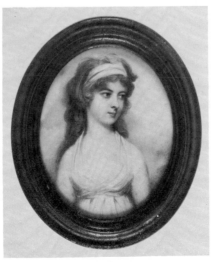

A young lady called C. B. Wynne by Andrew Plimer, inscribed and dated May 1794. Length 3 in (7·6 cm). New Bond Street 25 March £720 ($1,728)

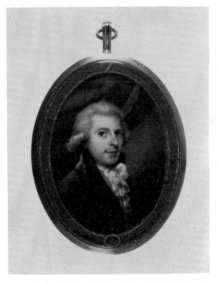

A gentleman by Peter Paillou. Length 2¾ in (7 cm). New Bond Street 25 March £240 ($576)

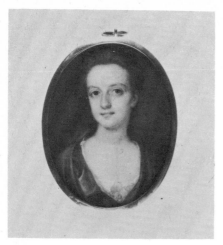

A young lady by Christian Richter. Length 1⅝ in
(4·1 cm). New Bond Street 25 March £140 ($336)

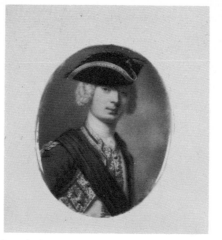

Enamel miniature of a nobleman perhaps by André
Rouquet. Length 1⅞ in (4·8 cm). New Bond
Street 29 April £400 ($960)

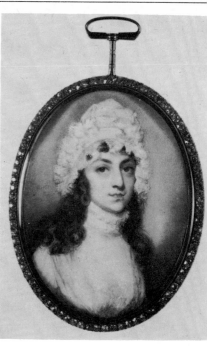

A young lady by George Place, signed and dated on
the reverse 1796. Length 2⅞ in (7·3 cm). New Bond
Street 29 April £600 ($1,440)

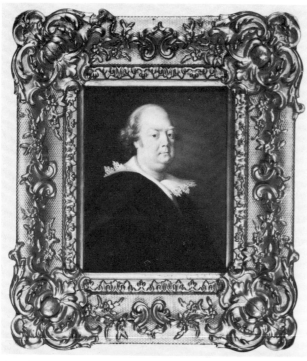

Large Italian 18th-century miniature of Samuel Bernard Vaquer by
Giuseppe Sacconi. Height 6 in (15·2 cm). New Bond Street
25 March £110 ($264)

Venus and Jupiter by Samuel Shelley, Length 5½ in (14 cm).
New Bond Street 25 March £55 ($132)

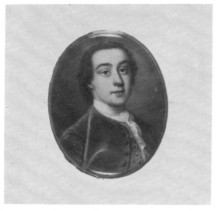

A gentleman by Noah Seaman. Length 1¾ in
(4·4 cm). New Bond Street 25 March £190 ($456)

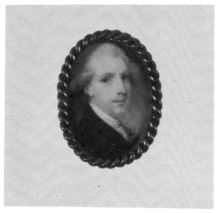

A gentleman by Samuel Shelley. Length 1 in
(2·5 cm). New Bond Street 25 March £75 ($180)

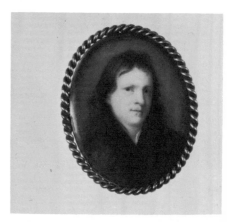

A gentleman by Samuel Shelley, after Humphry.
Length 2 in (5·1 cm). New Bond Street 25 March
£70 ($168)

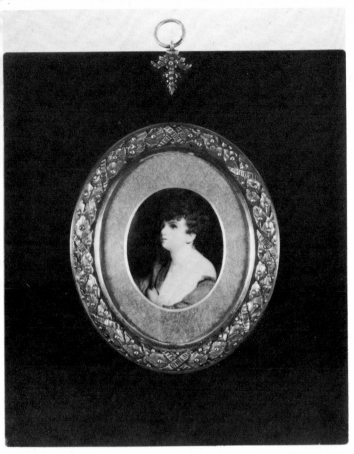

Watercolour sketch of a gentleman by John Smart. Length 2 in (5·1 cm). New Bond Street 25 March £420 ($1,008)

A child by Samuel Shelley after Sir Joshua Reynolds. Length 2 in (5·1 cm). New Bond Street 25 March £50 ($120)

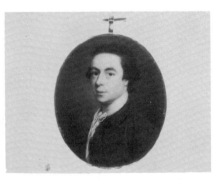

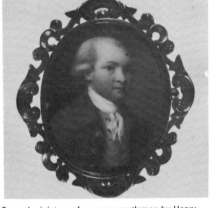

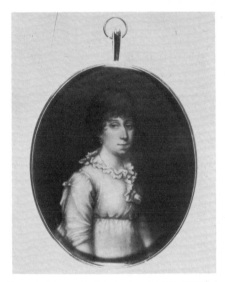

Enamel miniature of a lady by Henry Spicer. signed and dated 1800. Length 3½ in (8·9 cm). New Bond Street 25 March £340 ($816)

A gentleman by James Scouler. Length 1½ in (3·8 cm). New Bond Street 25 March £380 ($912)

Enamel miniature of a young gentleman by Henry Spicer. Length 1¾ in (4·4 cm). New Bond Street 25 March £190 ($456)

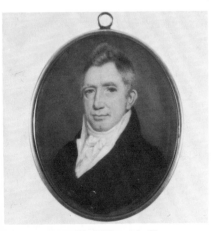

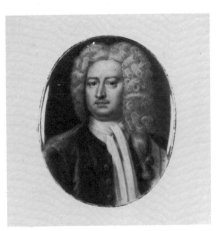

A gentleman signed by William John Thomson. Length 3 in (7·6 cm). New Bond Street 25 March £150 ($360)

Enamel miniature of a nobleman by Christian F. Zincke. Length 1⅞ in (4·8 cm). New Bond Street 29 April £320 ($768)

A gentleman by Robert Theer. Length 4⅛ in (10·5 cm). New Bond Street 25 March £130 ($312)

Silver, plate and pewter

Many people who would not describe themselves as collectors own examples of 18th- and 19th-century silver; as an art form, it is probably more widely distributed than any other. In times of economic stress, silver is attractive as a precious metal unlikely to lose its intrinsic worth with the additional recommendation of being functional.

Silver made before the 18th century is now largely beyond the means of the collector wishing to spend only £1,000 ($2,400) but a few good examples appear every year, some of which are illustrated. These include the attractive coconut cup with silver mounts datable to about 1680 and probably made in America, which fetched £440 ($1,056) at New Bond Street on 14 March, and the most attractive and rare Commonwealth sweetmeat dish made in London in 1654 which fetched £950 ($2,280) in the same saleroom on 28 February. We also illustrate a fine group of early spoons some dating back to the mid 16th century. a very popular field of specialist collecting, ranging in price between about £200 ($480) and £600 ($1,440).

Provincial British silver made during the 17th and 18th centuries is also a keenly collected field and some very interesting examples are shown. At New Bond Street on 28 February a George III Scottish provincial quaich by Charles Jamieson of Inverness, made in about 1810, fetched £600 ($1,440) and a George II Irish provincial dish by William Reynolds of Cork, circa 1755, was sold for £250 ($600). A most impressive George III circular punch-bowl by W. Nolan of Dublin, 1817, realised £700 ($1,680) on 11 April at New Bond Street.

Probably the most noteworthy examples of provincial silver sold by Sotheby Parke Bernet in 1974, however, were a group of Channel Islands pieces auctioned on 13 June in New Bond Street, each fetching less than £500 ($1,200). The finest example was a rare silver-gilt kitchen pepper by Guillaume Henry of Guernsey, circa 1730, which fetched £480 ($1,152), while for £120 ($280), one could have bought a fine mid 18th-century Guernsey christening cup by the unidentified maker 'I. H.'.

Some good pieces of foreign silver were also available at reasonable prices. French silver of the 18th century is generally more expensive than its English equivalent, but a fine Louis XVI silver cruet of large size, made in Paris in 1785 or 1786, realised $850 (£355) in New York on 6 March, and a pair of Louis XV table candlesticks, Péronne circa 1770, realised £850 ($2,040) at New Bond Street on 9 May. Among the more esoteric examples of foreign silver illustrated here, one could have purchased a Latvian standing cup and cover made in Goldingen in about 1784 for £720 ($1,728) or an Italian oil lamp in the Neo-classical taste by Stefano Fedeli of Rome, circa 1820, which realised £620 ($1,488), both at New Bond Street on 9 May.

Ten years ago 19th-century silver was considered hardly worthy of serious attention. Today, owing largely to the researches of Mrs Shirley Bury at the Victoria and Albert Museum in London and the specialist sales organised by Sotheby's Belgravia, there are many collectors for good pieces of the Victorian period. Examples by leading 18th-century and early 19th-century makers such as Paul de Lamerie, Paul Storr and others will be found illustrated here, as will fine pieces by all the leading 19th-century manufacturers. Examples of silver designed by some of the most important Art Nouveau and 20th-century makers are illustrated in the section dealing with Art Nouveau, Art Deco and modern design.

To the uninformed, pewter is the poor man's silver. Nothing, however, could be further from the truth, although pewterers often copied current silver styles, as did the manufacturers of Sheffield plate and electro-plate. But during the 18th century, pewter developed a distinctive character and style of its own which is well worth serious attention. The small section devoted to pewter concentrates upon really fine examples not only to demonstrate that such things can still be bought for prices below our top limit but also to show the quality of the best pieces.

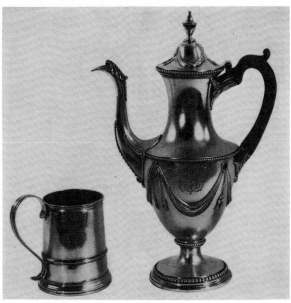

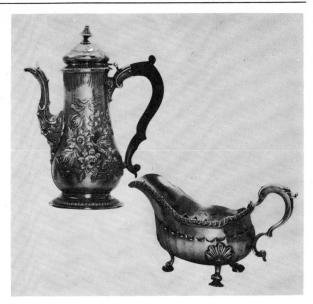

Left: George I mug by J. Elston, Exeter 1716. 4 oz 19 dwt. Height 4 in (10·2 cm). New Bond Street 9 May £190 ($456)

Right: George III vase-shaped coffee pot by Smith and Sharp, London 1776. 23 oz 10 dwt (all-in). Height 13 in (33 cm). New Bond Street, 9 May £1,000 ($2,400)

Left: Channel Islands coffee pot, maker's mark IA below a flower, Guernsey *circa* 1770. 35 oz 7 dwt. Height 10¼ in (26 cm). New Bond Street 13 June £800 ($1,920)

Right: One of a pair of George IV sauce boats by Charles Fox, London 1823. 27 oz 4 dwt. Length 9½ in (24·1 cm). New Bond Street 13 June £850 ($2,040)

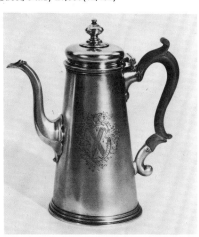

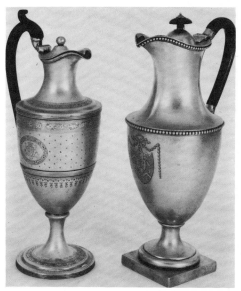

Left: George II chocolate pot by John Eckfourd, London 1732. 23 oz 16 dwt. Height 8¾ in (22·2 cm). New Bond Street 9 May £800 ($1,920)

Right: George III vase-shaped coffee jug by Henry Chawner, London 1787. 21 oz 15 dwt (all in). Height 12¾ in (32·4 cm). New Bond Street 28 February £470 ($1,128)

Far right: George III case-shaped coffee jug by John Carter, London 1773. 33 oz 17 dwt (all in). Height 13½ in (34·3 cm). New Bond Street 28 February £620 ($1,488)

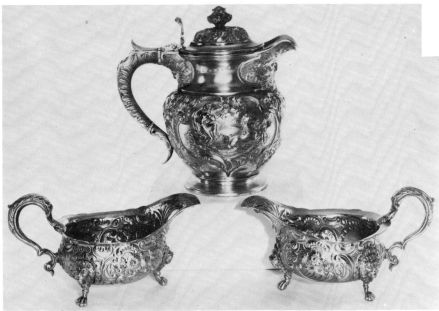

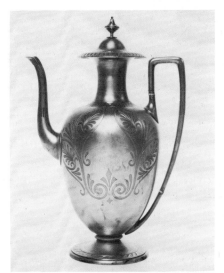

Upper: George IV Scottish inverted pear-shaped coffee jug, by J. & W. Marshall, Edinburgh 1829. 32 oz 15 dwt (all in). Height 9 in (22·9 cm). New Bond Street 14 March £380 ($912)

Lower: Two of a set of four George III oval sauce boats, probably by Samuel Whitford, London 1815. 74 oz 16 dwt. Length 8¾ in (22·2 cm). New Bond Street 14 March £750 ($1,800)

Victorian coffee pot in the antique manner by George Angell, London 1852. 25 oz 1 dwt. Height 11¼ in (28·6 cm). Belgravia 21 March £210 ($504)

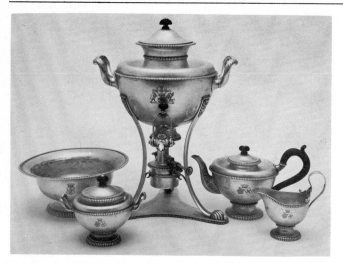

Silver five-piece tea set by Johann George Humbert, Berlin *circa* 1825. 174 oz gross. New York 6 March $1,500 (£626)

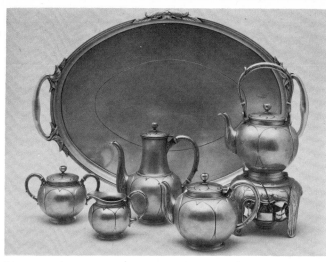

Oriental silver five-piece tea and coffee set, *circa* 1900. 236 oz gross. New York 6 March $1,750 (£730)

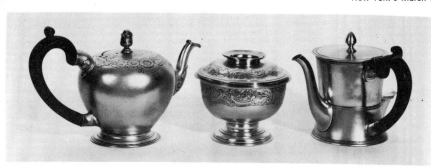

Left: George II teapot by Thomas Whipham, London 1745. 15 oz 19 dwt (all in). Height 4½ in (11·4 cm). New Bond Street 13 June £420 ($1,008)

Centre: George III covered sugar bowl by John Newton, London 1742. 9 oz 17 dwt. Diameter 4 in (10·2 cm). New Bond Street 13 June £420 ($1,008)

Right: George III spool-shaped Argyle by Frederick Kandler, London 1767. 12 oz 10 dwt. Height 4¾ in (12·1 cm). New Bond Street 13 June £480 ($1,152)

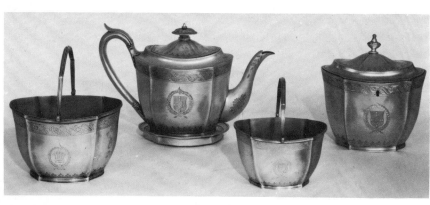

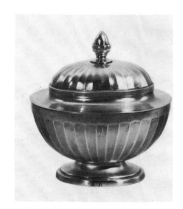

George III five-piece tea set, probably by Robert Salmon, 1795/6 (teapot handle by a different maker). 47 oz 3 dwt all in (excluding teapot stand with wooden base). New Bond Street 28 February £850 ($2,040)

18th-century Italian sugar box and cover, Genoa 1794. 15 oz 18 dwt. Height 7 in (17·8 cm). New Bond Street 9 May £720 ($1,728)

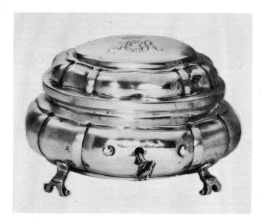

18th-century German sugar box, maker's mark AP in monogram, possibly Augustin Peisker, Breslau, *circa* 1750. 18 oz 17 dwt (all in with key). Width 7 in (17·8 cm). New Bond Street 9 May £650 ($1,560)

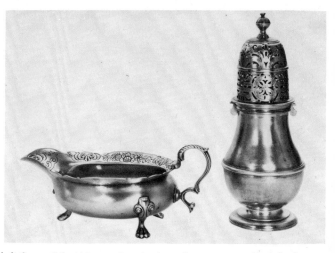

Left: George II Scottish cream boat, by James Ker, assay master Hugh Gordon, Edinburgh 1744. 7 oz 4 dwt. Length 6¾ in (17·1 cm). New Bond Street, 14 March £440 ($1,056)
Right: Queen Anne baluster caster, maker's mark apparently MA, London 1712. 7 oz 15 dwt. Height 7½ in (19·1 cm). New Bond Street 14 March £360 ($864)

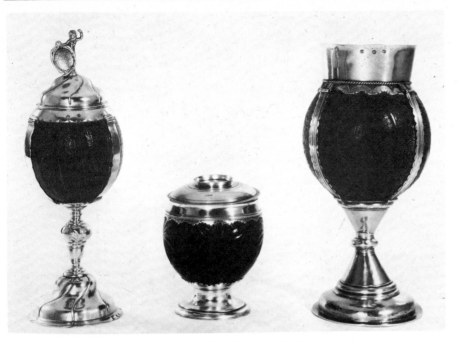

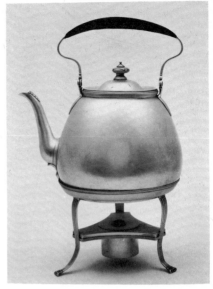

George III hot-water kettle on lampstand by Paul Storr, London 1795. 54 oz 15 dwt gross. Height 14¾ in (37·5 cm). New York 6 March $1,400 (£583)

Left: Coconut cup with German mid 18th-century silver-gilt mounts. Breslau *circa* 1755. Height 11¼ in (28·6 cm). New Bond Street 14 March £400 ($960)

Centre: Coconut sugar bowl with American 18th-century silver mounts and cover. Maker's mark WY, possibly for William Young of Philadelphia *circa* 1765. Height 5¼ in (13·3 cm). New Bond Street 14 March £380 ($912)

Right: Coconut cup with late 17th-century silver mounts. maker's mark BA, probably American *circa* 1680. Height 10½ in (26·7 cm). New Bond Street 14 March £440 ($1,056)

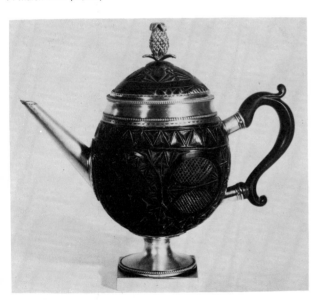

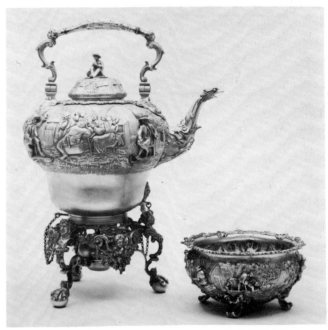

Left: Victorian silver hot-water kettle on lampstand, by Hunt and Roskell, London 1865; stamped underneath Hunt & Roskell, late Storr & Mortimer. 117 oz gross. Height 17 in (43·2 cm). New York 6 March $2,400 (£1,000)
Right: Victorian silver bowl, by John S. Hunt, London 1855, stamped underneath Hunt & Roskell, late Storr & Mortimer. 25 oz 10 dwt. Diameter 7¾ in (18·7 cm). New York 6 March $950 (£396)

Coconut teapot with George III silver mounts, by Phipps and Robinson, *circa* 1810. Height 8 in (20·3 cm). New Bond Street 14 March £360 ($864)

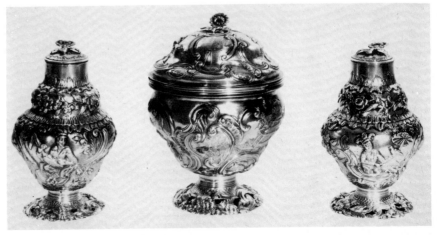

Pair of early George III tea caddies and a mixing bowl by Samuel Taylor, London 1764. 29 oz 4 dwt. Heights 5¼ and 6¼ in (13·3 cm) and 15·9 cm). New Bond Street 14 March £700 ($1,680)

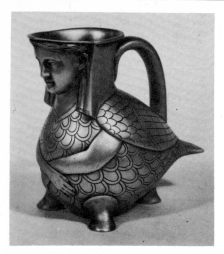

Victorian milk jug in the form of a fabulous monster by James Barclay Hennell, London 1877. 8 oz 5 dwt. Height 3½ in (8·9 cm). Belgravia 25 July £120 ($288)

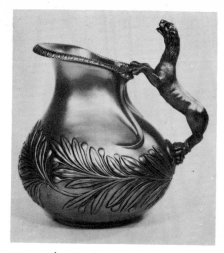

Italian jug after a Pompeian original by A G Sommer & Figlio, Naples 19th century. 77 oz 1 dwt. Height 9¼ in (23·5 cm). Belgravia 30 May £250 ($600)

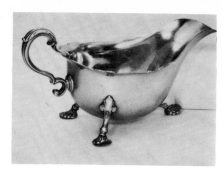

One of a pair of George II Irish sauce boats by Thomas Boulton of Dublin, *circa* 1735. 33 oz 9 dwt. Length 9½ in (24·1 cm). New Bond Street 9 May £550 ($1,320)

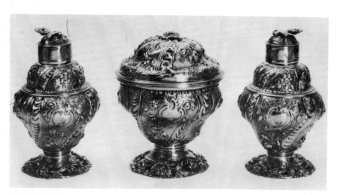

Pair of George III tea caddies and a sugar bowl *en suite*, in a contemporary shagreen case, by Samuel Taylor, London 1762. 26 oz 10 dwt. Height of caddies 5½ in (13·97 cm), and of sugar bowl 5¼ in (13·3 cm). New Bond Street 9 May £850 ($2,040)

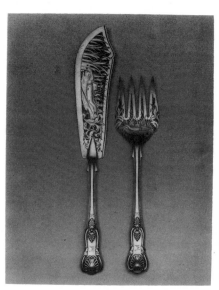

Pair of Victorian fish servers by Chawner & Co, London 1853. 10 oz 2 dwt. Length of knife 13 in (33 cm). Belgravia 30 May £90 ($216)

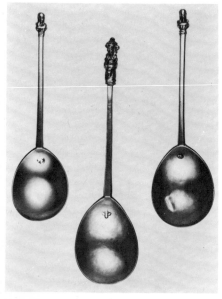

Left: Elizabeth I maidenhead spoon by I. Parnel, Barnstaple *circa* 1600. New Bond Street 9 May £250 ($600)

Centre: Mid 17th-century terminal figure spoon, possibly by Raleigh Clapham, Barnstaple *circa* 1650. New Bond Street 9 May £360 ($864)

Right: Elizabeth I maidenhead spoon by I. Parnel, Barnstaple *circa* 1600. New Bond Street 9 May £240 ($576)

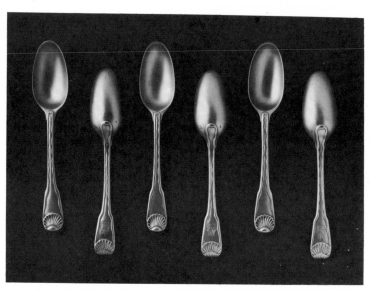

Six George II silver dessert spoons, by Paul de Lamerie, London, *circa* 1745. 9 oz 10 dwt. New York 6 March $1,500 (£626)

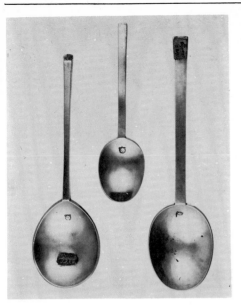

Left: Charles I slip-top spoon, maker's mark IF, London 1638. New Bond Street 9 May £480 ($1,152)

Centre: Commonwealth small Puritan spoon, maker's mark II, London 1653. New Bond Street 9 May £280 ($672)

Right: Charles II Puritan spoon, maker's mark IK, London 1670. New Bond Street 9 May £380 ($912)

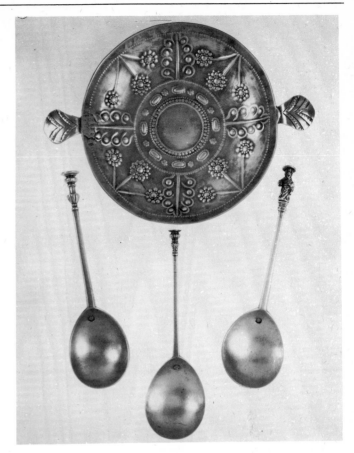

Top: Commonwealth sweetmeat dish, maker's mark WH, mullet above, crescent below, London 1654. 3 oz 19 dwt. Diameter 6 in (15·2 cm). New Bond Street 28 February £950 ($2,280)

Left: Elizabeth baluster seal-top spoon, maker's mark apparently FT with a bird's claw between, London 1571. New Bond Street 28 February £400 ($960)

Centre: English seal-top spoon struck in the bowl with a fleur-de-lys mark, East Anglian, probably Bury St Edmunds, *circa* 1600. New Bond Street 28 February £230 ($552)

Right: Elizabeth I Apostle spoon, maker's mark a crescent enclosing a mullet, London 1601. New Bond Street 28 February £360 ($864)

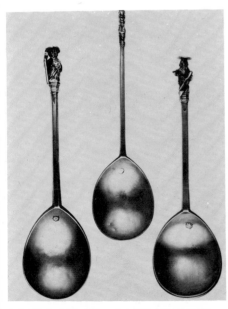

Left: Elizabeth I Apostle spoon of St Jude, maker's mark a mullet over an annulet. New Bond Street 9 May £700 ($1,680)

Centre: James I Apostle spoon of St Bartholomew, maker's mark D enclosing C, London 1622. New Bond Street 9 May £550 ($1,320)

Right: Henry VIII Lion Sejant spoon, maker's mark a fringed S, London 1543. New Bond Street 9 May £780 ($1,872)

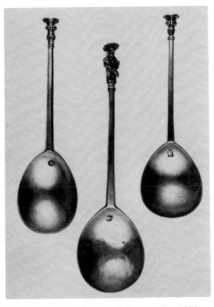

Left: James I seal-top spoon, Leicester *circa* 1620. New Bond Street 9 May £500 ($1,200)

Centre: Elizabeth Apostle spoon of St Simon, by I. Parnel, Barnstaple *circa* 1590. New Bond Street 9 May £260 ($624)

Right: James I seal-top spoon, berry mark of the Quycke family, Barnstaple *circa* 1610. New Bond Street 9 May £500 ($1,200)

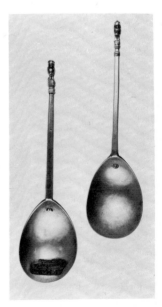

Left: James I Lion Sejant spoon, by R. Matthew, Barnstaple *circa* 1620. New Bond Street 9 May £440 ($1,056)

Right: Elizabeth I Lion Sejant spoon by Thomas Matthew, Barnstaple *circa* 1570. New Bond Street 9 May £300 ($720)

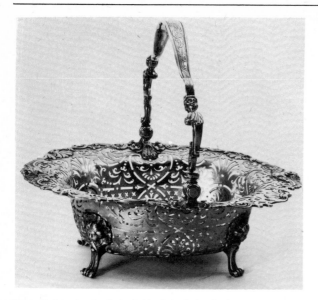

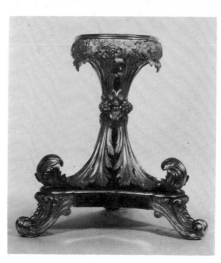

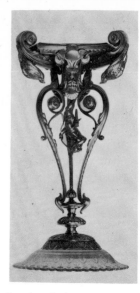

George II shaped oval cake basket by Peter Archambo, London 1744. 48 oz 19 dwt. Width 13 in (33 cm). New Bond Street 23 May £780 ($1,872)

One of a pair of German dessert stands by Wilhelm Conrad Josef Lameyer, Hanover *circa* 1830. 122 oz 12 dwt. Height 11 in (27·9 cm). Belgravia 30 May £230 ($552)

One of a pair of electro-gilt fruit stands by Elkington & Co, of Birmingham, dated 1873. Height 17 in (44·5 cm). Belgravia 24 January £180 ($432)

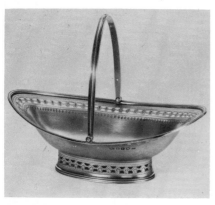

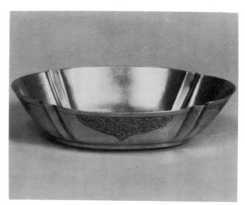

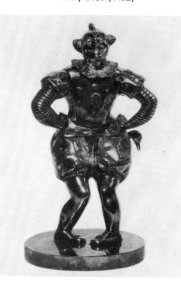

George III oval sweetmeat basket by William Abdy, London 1794. 4 oz 4 dwt. Width 6¾ in (17·1 cm). New Bond Street 1·2 December £140 ($336)

German silver-gilt sweetmeat dish by Paul Solanier, Augsburg *circa* 1730. 3 oz. Length 5 in (12·7 cm). Los Angeles $1,300 (£542)

Electro-gilt comedy condiment set in the form of a clown with detachable body and head, unmarked. late 19th century. Height 9½ in (24·1 cm). Belgravia 21 March £100 ($240)

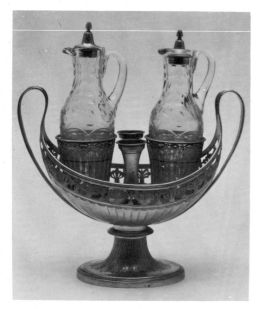

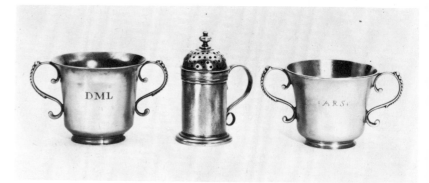

Louis XVI large silver cruet frame. Paris 1785 or 1786. 34 oz (excluding glass). New York 6 March $850 (£355)

Left: Channel Islands christening cup, maker's mark IH below four rays, Guernsey *circa* 1760. 2 oz 17 dwt. Height 2½ in (6·4 cm). New Bond Street 13 June £120 ($288)

Centre: Channel Islands silver-gilt kitchen pepper by Guillaume Henry, Guernsey *circa* 1730. 2 oz 11 dwt Height 3½ in (8·9 cm). New Bond Street 13 June £480 ($1,152)

Right: A Channel Islands christening cup by Pierre Maingy, Guernsey *circa* 1750. 3 oz 5 dwt. Height 2½ in (6·4 cm). New Bond Street 13 June £270 ($648)

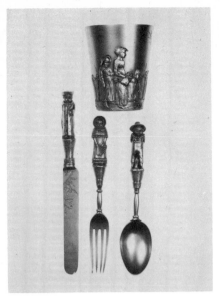

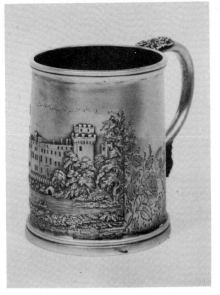

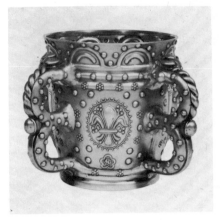

Victorian parcel-gilt christening set of four pieces by Sampson Morden & Co, London 1882. 9 oz 6 dwt (excluding knife). Height of beaker 3½ in (8·9 cm). Belgravia 25 July £280 ($672)

Victorian christening mug with a view of Warwick Castle by Taylor & Perry, Birmingham 1839. 4 oz 10 dwt. Height 3 in (7·6 cm). Belgravia 30 May £125 ($300)

Victorian replica of a Wrotham slipware tyg by R. & S. Garrard & Co, London 1895. 24 oz 7 dwt. Height 5¼ in (13·3 cm). Belgravia 25 July £145 ($348)

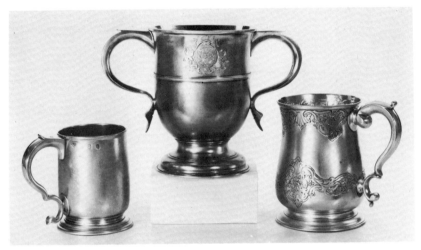

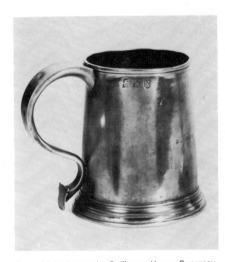

Left: One of a pair of George I half-pint mugs by Anthony Nelme, London 1721. 19 oz 8 dwt. Height 3¾ in (9·5 cm). New Bond Street 13 June £620 ($1,488)

Centre: George II two-handled cup, apparently by Thomas Tearle, London 1735. 17 oz 17 dwt. Height 5¾ in (14·6 cm). New Bond Street 13 June £200 ($480)

Right: One of a pair of George II Scottish pint mugs by William Davie, assay master Hugh Gordon, Edinburgh 1745. 26 oz. Height 5 in (12·7 cm). New Bond Street 13 June £600 ($1,440)

Channel Islands mug by Guillaume Henry, Guernsey *circa* 1740. 5 oz 3 dwt. Height 3¾ in (9·5 cm). New Bond Street 13 June £240 ($528)

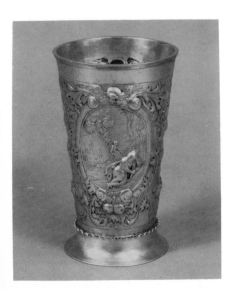

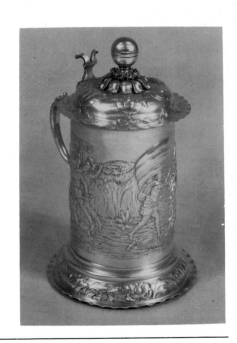

Left: German parcel-gilt beaker by Nathaniel Schlaubitz, Danzig *circa* 1685. Los Angeles 19 June $2,000 (£833)

Right: German silver-gilt tankard, maker's mark HL, Nuremberg mid 19th century. 32 oz. Height 9 in (22·9 cm). Los Angeles 29 April $1,000 (£417)

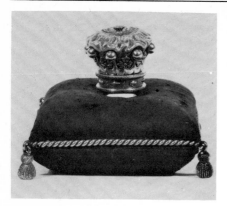

Victorian silver-gilt vinaigrette in the form of an earl's coronet, with miniature velvet cushion, unmarked, *circa* 1870. Height of coronet 1¼ in (3·2 cm). Belgravia 25 July £160 ($384)

Victorian silver-gilt vinaigrette by Nathaniel Mills & Son, Birmingham 1844. Width 1¾ in (4·4 cm). Belgravia 24 January £260 ($624)

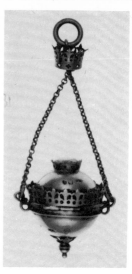

Victorian parcel-gilt vinaigrette in the form of a sanctuary lamp, maker's mark HWD, London 1872; Patent Office Design Registry mark for 11 September 1872. Height 1½ in (3·8 cm). New Bond Street 23 May £200 ($480)

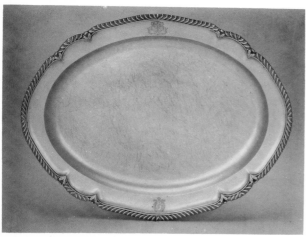

George III silver meat dish by John Angell, London 1819. The arms are those of Milne of Milne Graden, co Berwick for Admiral Sir David Milne, G.C.B. (b 1763). 119 oz. Length 23¼ in (59 cm). New York 6 March $1,300 (£542)

George III Scottish provincial quaich by Charles Jamieson, Inverness *circa* 1800. 4 oz 19 dwt. Width overall 6 in (15·2 cm). New Bond Street 28 February £600 ($1,440)

Edwardian commemorative card tray, with facsimile signatures including that of Sir Lawrence Alma-Tadema by R & S Garrard & Co, London 1902. 12 oz 16 dwt. Length 8 in (20·3 cm). Belgravia 25 July £70 ($168)

Left: Early 18th-century cylindrical nutmeg grater, maker's mark IA. English, *circa* 1700. Height 3 in (7·6 cm). New Bond Street 18 April £105 ($232)

Right: George III vase-shaped nutmeg grater by Phipps and Robinson, London 1789. Height 2¾ in (7 cm). New Bond Street 18 April £220 ($528)

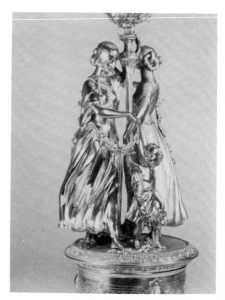

Detail of an early Victorian centrepiece by Robert Garrard, London 1845. 194 oz. 7 dwt. Height 25 in (63·5 cm). Belgravia 24 January £750 ($1,800)

George II Irish provincial dish by William Reynolds, Cork *circa* 1755. 1 oz 10 dwt. Diameter 4 in (10·2 cm). New Bond Street 28 February £250 ($600)

William III circular salver on foot by Benjamin Pyne, London 1700. 15 oz 11 dwt. Diameter 9 in (22·9 cm). New Bond Street 9 May £600 ($1,440)

One of a pair of George II Irish waiters by Christopher Locker, Dublin *circa* 1745. 15 oz 19 dwt. Diameter 6 in (15·2 cm). New Bond Street 9 May £600 ($1,440)

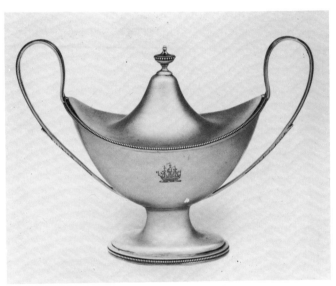

George III boat-shaped tureen and cover by Hester Bateman, London 1786. 13 oz 12 dwt. Width over handles 9½ in (24·1 cm). New Bond Street 28 February £950 ($2,280)

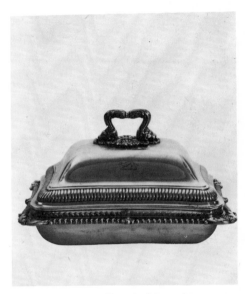

One of a pair of George III entrée dishes and covers, the handles by W. Bateman, the bases and covers by Benjamin and James Smith, London 1810. Width 11 in (27·9 cm). New Bond Street 11 April £880 ($2,112)

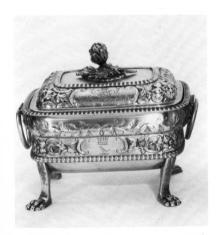

One of a pair of George III Irish sauce tureens and covers, maker's mark EG (also stamped *Law*), Dublin 1812. 50 oz 12 dwt. Width 6¼ in (15·9 cm). New Bond Street 11 April £580 ($1,392)

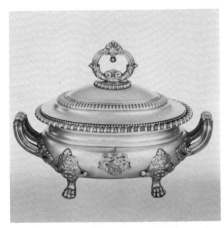

One of a pair of George IV oval sauce tureens and covers, maker's mark SH, Birmingham 1824. 49 oz 1 dwt. Width over handles 9 in (22·9 cm). New Bond Street 28 February £850 ($2,040)

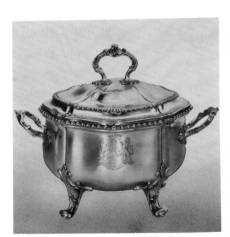

George III shaped circular tureen and cover by Frederick Kandler, London 1770. 64 oz 3 dwt. Width over handles 11¾ in (29·8 cm). New Bond Street 17 January £780 ($1,872)

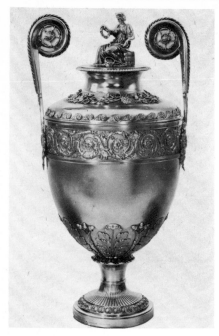

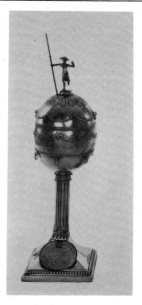

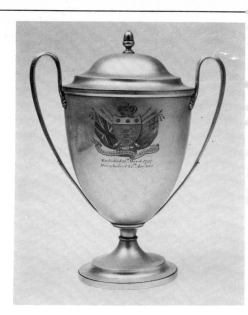

George III covered vase, base and cover marked
Scott and Smith, London 1806, the smaller cover by
Benjamin Smith London 1807, the figure finial by
John Emes. 113 oz 12 dwt. Height 16½ in
(41·9 cm). New Bond Street 13 June £620
($1,488)

18th-century Latvian standing cup and cover, with
the arms of the Bootmaker's Guild dated 1894,
maker's mark IH, Goldingen *circa* 1784. 27 oz.
Height 17½ in (44·5 cm). New Bond Street 9 May
£720 ($1,728)

George III silver two-handled regimental cup and
cover, by Paul Storr, London, 1802. According to
the inscription, this piece was presented to
Lieutenant Colonel Isaac Burgess, Commandant of
the Regiment of Pendennis Artillery Volunteers, *"at
the disembodying of that corps at the conclusion of
the general Peace in the Year of our Lord 1802"*.
51 oz. Height 12¾ in (32·4 cm). New York
6 March $1,700 (£709)

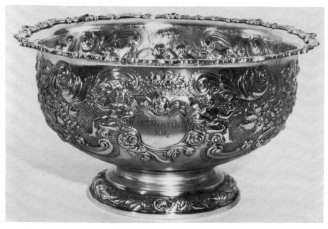

George III Irish circular punch bowl by W Nowlan, Dublin 1817. 59 oz
16 dwt. Diameter 13 in (33 cm). New Bond Street 11 April £700 ($1,680)

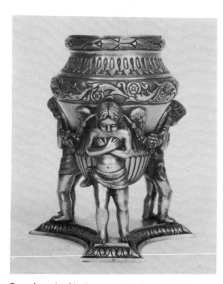

One of a pair of Italian vases, Naples mid 19th
century. 110 oz 10 dwt. Height 8¾ in (22·2 cm).
Belgravia 30 May £360 ($864)

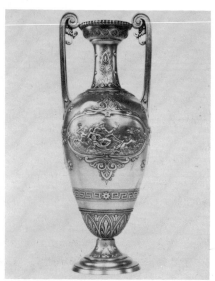

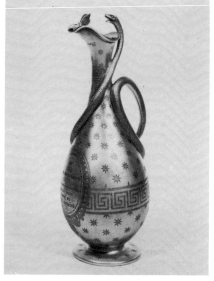

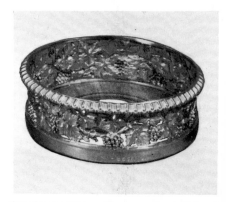

Victorian amphora-shaped presentation vase by
Edward Barnard & Sons, London 1871. 47 oz
1 dwt. Height 16¾ in (42·5 cm). Belgravia
24 January £125 ($300)

Victorian wine ewer by Edward Barnard & Sons,
London 1869. 27 oz 17 dwt. Height 13 in (33
cm). Belgravia 25 July £185 ($444)

One of a pair of George III wine coasters by Rebecca
Emes and Edward Barnard, London 1809.
Diameter 5⅝ in (14·3 cm). Los Angeles 30
September $1,200 (£500)

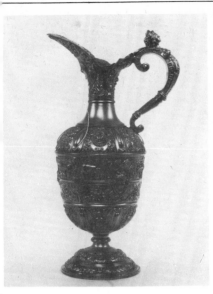

One of a pair of electro-gilt wine ewers and eight matching goblets, the goblets struck with the Patent Office Design Registry mark for 19 November 1866. Height of ewer 11½ in (29·2 cm). Belgravia 24 January £480 ($1,152)

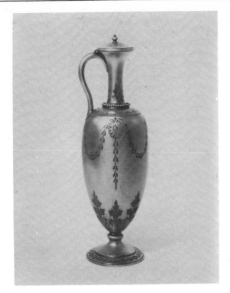

Victorian frosted silver-gilt wine ewer by Stephen Smith & Son, London 1865. 20 oz 9 dwt. Height 13 in (33 cm). Belgravia 21 March £270 ($648)

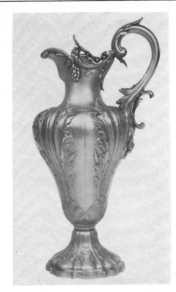

Victorian wine ewer by Edward Barnard & Sons, London 1838. 29 oz 3 dwt. Height 12¼ in (31 cm). Belgravia 10 October £410 ($984)

One of three wine labels, one being by P and A Bateman, London 1794. New Bond Street 23 May £50 ($120)

George III wine label by Hester Bateman, London circa 1775. New Bond Street 23 May £48 ($115).

One of a set of six wine labels by Sandilands Drinkwater, London circa 1745. New Bond Street 23 May £460 ($1,104)

One of a pair of George III wine labels by William Bateman, London 1815. New Bond Street 23 May £55 ($132)

George II wine label by John Harvey, London circa 1745. New Bond Street 23 May £38 ($91)

One of three matching wine labels by C Reily and G Storer, London 1830. New Bond Street 23 May £50 ($120)

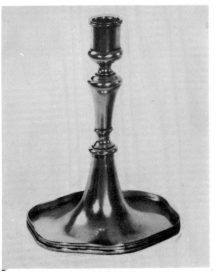

One of a pair of 18th-century Hungarian table candlesticks by Josephus Pasperger I, Budapest 1781/3. 17 oz 3 dwt. Height 6½ in (16·5 cm). New Bond Street 9 May £850 ($2,040)

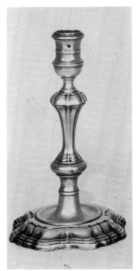

One of a pair of George II table candlesticks by John Cafe, London 1745. 34 oz 11 dwt. Height 7½ in (19 cm). New Bond Street 28 February £1,000 ($2,400)

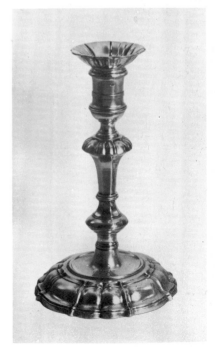

One of a pair of early George II table candlesticks by James Gould, London 1731. 30 oz 7 dwt. Height 7 in (17·8 cm). New Bond Street 23 May £1,000 ($2,400)

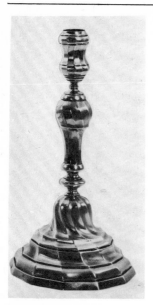

One of a pair of Louis XV table candlesticks, Péronne *circa* 1770. 23 oz 2 dwt. Height 11 in (27·9 cm). New Bond Street 9 May £850 ($2,040)

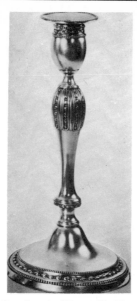

One of a pair of George III table candlesticks by John Smith (?), Sheffield 1778. Height 10¾ in (27·3 cm). New Bond Street 18 April £410 ($984)

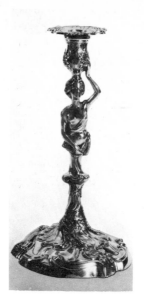

One of a pair of George III table candlesticks by Thomas Robins, London 1808. 65 oz 14 dwt. Height 11 in (27·9 cm). New Bond Street 11 April £900 ($2,160)

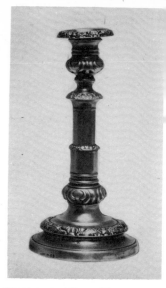

One of a pair of George IV telescopic table candlesticks by Thomas Watson & Co, Sheffield 1824. (Loaded.) Height extended 10 in (25·4 cm). Belgravia 24 January £270 ($648)

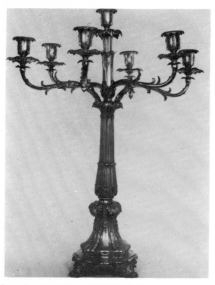

One of a pair of seven-light Sheffield plate candelabra by **Waterhouse, Hatfield & Co**, *circa* 1840. Height 32½ in (82·5 cm). Belgravia 24 January £420 ($1,008).

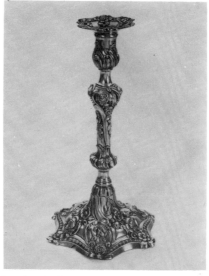

One of a pair of George III candlesticks by William Cafe, London 1766. 55 oz 5 dwt (all in). Height 11½ in (31·2 cm). New Bond Street 12 December £370 ($888)

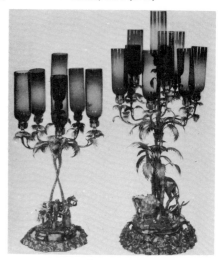

Left: One of a pair of Victorian electro-gilt candelabra and mirror plateaux by Elkington & Co of Birmingham, date mark for 1874. Height 31½ in (80 cm). Belgravia 30 May £650 ($1,560)
Right: Victorian electro-gilt ten-light candelabrum by Elkington & Co of Birmingham, date mark for 1874. Height 40 in (101·6 cm). Belgravia 30 May £650 ($1,560)

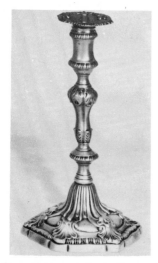

One of two matching early George III tapersticks by Ebenezer Coker, London 1768/9. 15 oz 9 dwt. Height 6½ in (16·5 cm). New Bond Street 28 February £520 ($1,248)

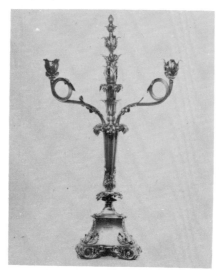

Sheffield plate four-light candelabra, unmarked, *circa* 1830. Height 35½ in (90·2 cm). Belgravia 21 March £500 ($1,200)

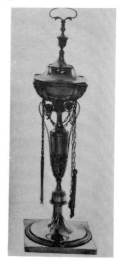

Italian oil lamp by Stefano Fedeli, Rome *circa* 1820. 24 oz 14 dwt. Height 17¾ in (45·1 cm). New Bond Street 9 May £620 ($1,488)

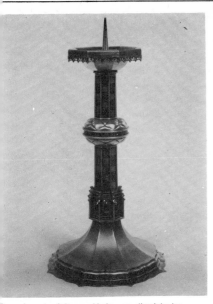

One of a pair of George V altar candlesticks by Edward Barnard & Sons, Ltd, London 1933. 30 oz 2 dwt. Height 14½ in (36·8 cm). Belgravia 0 October £330 ($792)

Sheffield plate epergne, unmarked, *circa* 1830. Height 16 in overall (40·7 cm). Belgravia 30 May £260 ($624)

Victorian racing cup and cover in mid 16th-century taste, by Stephen Smith, London 1869. 53 oz 4 dwt. Height 18 in (45·7 cm). Belgravia 24 January £190 ($456)

Victorian portrait figure of C E Howard Vincent, maker's mark MG, London 1885. Height 6¾ in (17·2 cm). Belgravia 21 March £90 ($216)

One of a pair of George IV silver-gilt dishes in 17th-century style by George Knight, Britannia Standard, London 1825. 12 oz 12 dwt. Diameter 7½ in (19 cm). Belgravia 30 May £320 ($768)

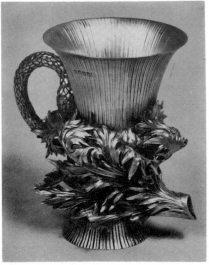

George III silver-gilt thistle cup by Benjamin Smith, London 1817. 34 oz. Height 6⅜ in (16·2 cm). Los Angeles 9 December $1,100 (£458)

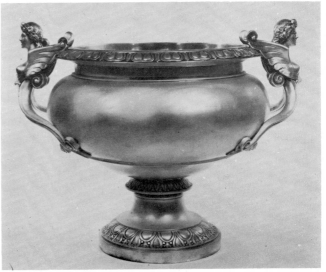

Victorian rose bowl by Hancocks & Co, London 1879. 229 oz. Width 21 in (53·3 cm). Belgravia 10 October £1,000 ($2,400)

Left: Victorian parcel-gilt scent flask by Sampson Mordan & Co, London 1882. Length 2 in (5·1 cm). Belgravia 21 March £75 ($180)

Right: Victorian card case by George Unite, Birmingham 1881. Length 3 in (7·6 cm). Belgravia 21 March £38 ($91)

Left: Victorian frosted and parcel-gilt memorandum case, maker's mark *H Bros*, Birmingham 1886. Length 4 in (10·2 cm). Belgravia 21 March £250 ($600)

Right: Victorian parcel-gilt memorandum case by George Unite, Birmingham 1882. Length 4 in (10·2 cm). Belgravia 21 March £270 ($648)

Victorian chatelaine-head in the form of a female right hand by Thomas Johnson, London 1876. 3 oz 4 dwt. Length 3¼ in (8·3 cm). Belgravia 25 July £65 ($156)

Victorian card case by Deakin & Francis, Birmingham 1882. Length 3¾ in (9·5 cm). Belgravia 30 May £125 ($300)

Left: Electro-gilt standing salt and stand of 16th-century Italian inspiration, unmarked but possibly an electrotype from Christofle of Paris, *circa* 1860. Height 12¼ in (31·1 cm). Belgravia 21 March £90 ($216)

George II tea caddy, sweetmeat basket, twelve teaspoons, mote skimmer and pair of sugar nips in contemporary fitted case with silver mounts; the caddy and basket by Samuel Courtauld, London 1759, the spoons unmarked, the skimmer maker's mark indecipherable, the nips maker's mark RM, all *circa* 1760. 23 oz 2 dwt (of silver). The caddy 5½ in (14 cm) high. New Bond Street 28 February £1,000 ($2,400)

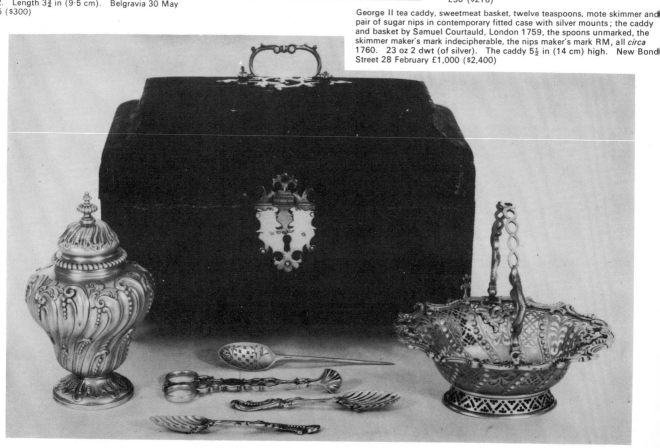

Victorian snuff box by Nathaniel Mills, Birmingham 1838. Width 2½ in (6·3 cm). Belgravia 24 January £115 ($276)

Victorian table snuff box, the lid engraved with a view of the Crystal Palace, by Nathaniel Mills, Birmingham 1851. Width 3½ in (8·9 cm). New Bond Street 23 May £180 ($432)

Louis XV silver gilt snuff box, Paris 1723. Width 2½ in (6·4 cm). New Bond Street 9 May £160 ($384)

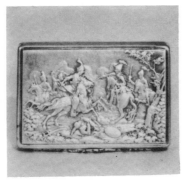

George I snuff box, maker's mark apparently LE in script, an escallop shell below, London 1716. Width 2¾ in (7 cm). New Bond Street 9 May £420 ($1,008)

George IV rectangular snuff box, the lid embossed with a battle scene probably representing John of Poland defeating the Turks in 1683, probably by J Lacey or Law, London 1826. 3 oz 10 dwt. Width 2¾ in (7 cm). New Bond Street 28 February £380 ($912)

Victorian table snuff box by Yapp and Woodward, Birmingham 1851. Width 3¾ in (9·5 cm). New Bond Street 23 May £200 ($480)

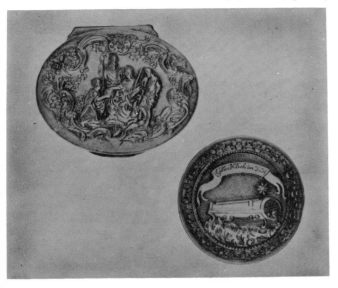

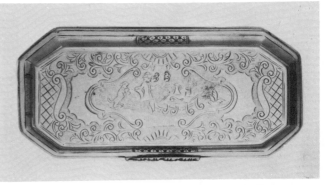

18th century Dutch tobacco box, maker's mark AM, *circa* 1750. Width 5¼ in (13·3 cm). New Bond Street 9 May £350 ($840)

Left: 18th-century silver-gilt snuff box, probably Italian *circa* 1770. Width 3 in (7·6 cm). New Bond Street 9 May £200 ($480)

Right: 18th-century German parcel-gilt memorial box, the screw on base inscribed and dated 1744-70, apparently unmarked, *circa* 1770. Width 2¼ in (5·7 cm). New Bond Street 9 May £190 ($456)

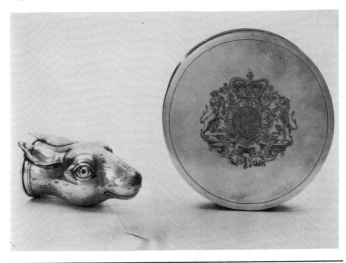

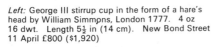

Left: George III stirrup cup in the form of a hare's head by William Simmons, London 1777. 4 oz 16 dwt. Length 5½ in (14 cm). New Bond Street 11 April £800 ($1,920)

Right: George III seal-box engraved with the Royal coat-of-arms, by William Pitts, London 1785. 20 ozs. Diameter 6¾ in (17·1 cm). New Bond Street 11 April £900 ($2,160)

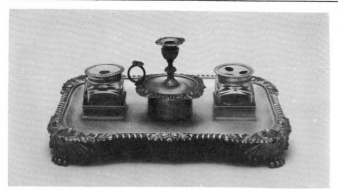

George IV silver inkstand by Emes and Barnard, London 1825 (the taperstick 1822). 43 oz (excluding bottles). Length 12¼ in (31 cm). New York 6 March $950 (£378)

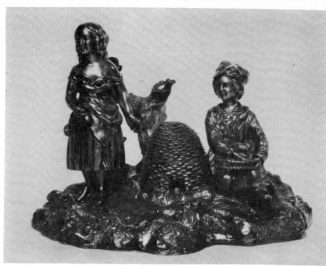

Victorian electro-gilt *Please remember the grotto* inkstand by Elkington's of Birmingham, date letter for 1851. Width 9½ in (24·1 cm). Belgravia 21 March £170 ($408)

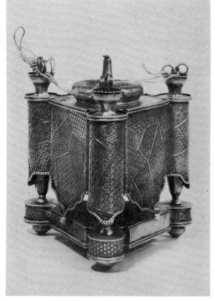

Victorian table-lighter decorated in Japanese style, by Elkington & Co, Birmingham 1880. 18 oz 5 dwt. Height 5 in (12·7 cm). Belgravia 25 July £105 ($252)

Victorian single-well inkstand in the form of an apple on a dish, by Edward Barnard & Sons, London 1862. 10 oz 7 dwt. Diameter 6 in (15·3 cm). Belgravia 25 July £185 ($444)

Victorian travelling writing box by Thomas Johnson, London 1878, with a presentation inscription from Edward VII. Width 3½ in (8·9 cm). Belgravia 25 July £150 ($360)

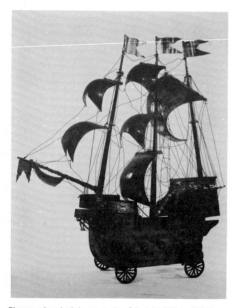

Electro-plated triple-masted nef, height 25½ in (64·7 cm). Sold with a smaller nef-deck complete with masts and rigging, height 13 in (33 cm). Both unmarked, *circa* 1900-14. Belgravia 30 May £210 ($504)

William III dressing table mirror, apparently unmarked, perhaps by Pierre Harache Senior, *circa* 1700. 37 oz 15 dwt of silver. Height 16¼ in (41·3 cm). New Bond Street 28 February £580 ($1,392)

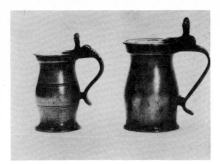

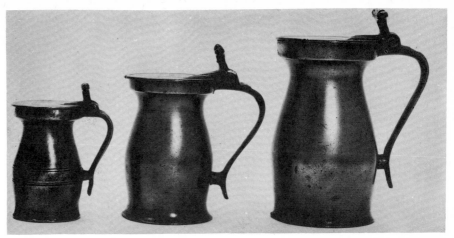

Left: 'Bud' baluster measure of half-gill capacity. Height 3½ in (8·9 cm). New Bond Street 11 February £200 ($480)

Right: 'Bud' baluster measure of gill capacity by A Hincham, second quarter of the 18th century. Height 4 in (10·2 cm). New Bond Street 11 February £210 ($504)

Left: 'Bud' baluster measure of half-pint capacity probably by John Langford, first half of the 18th century. Height 5⅛ in (13 cm). New Bond Street 11 February £125 ($300)

Centre: 'Bud' baluster measure of pint capacity probably by William Seare, first quarter of the 18th century. Height 6½ in (16·5 cm). New Bond Street 11 February £160 ($384)

Right: Baluster measure of quart capacity by John Carr, first quarter of the 18th century. Height 8 in (20·3 cm). New Bond Street 11 February £400 ($960)

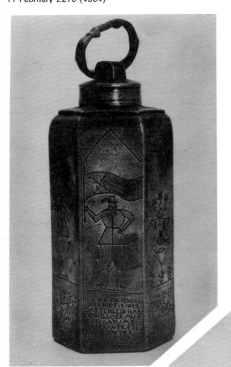

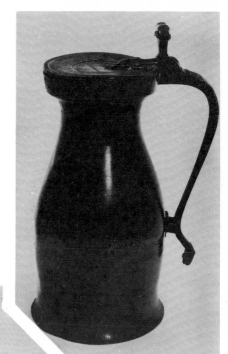

Left: Austro-Hungarian hexagonal flask with screw-on cover, engraved with a coat-of-arms dated 1648, mid 17th century. Height 10⅞ in (27·5 cm). New Bond Street 11 February £780 ($1,872)

Right: Wine measure of gallon capacity by Thomas Stevens, London *circa* 1730-40. Height 13¼ in (33·7 cm). New Bond Street 11 February £920 ($2,208)

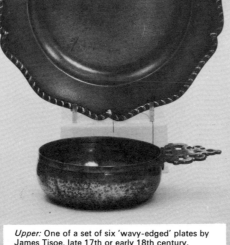

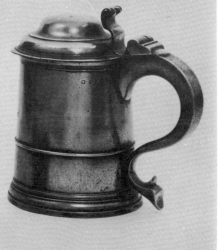

Upper: One of a set of six 'wavy-edged' plates by James Tisoe, late 17th or early 18th century. Diameter 9¾ in (24·8 cm). New Bond Street 11 February £1,000 ($2,400)

Lower: Porringer, makers' mark TS with a fleur-de-lys, late 17th or early 18th century. Width across ear 7¼ in (18·4 cm). New Bond Street 11 February £340 ($816)

Queen Anne tankard, *circa* 1700-10. Height 7¼ in (18·4 cm). New Bond Street 11 February £620 ($1,488)

Dome-lidded tankard by William Eddon, *circa* 1720-30. Height 8⅛ in (20·6 cm). New Bond Street 11 February £920 ($2,208)

Glass and paperweights

Of the categories in this book which cover works of art made prior to the 19th century, glass is one of the few in which a piece fetching over £1,000 ($2,400) is an exception. Fine English 18th-century drinking glasses range upward from about £50 ($120) and even if a new collector took his top limit on single piece as £150 ($360), he would be able still to form a collection of reasonable quality.

Among the less expensive pieces illustrated in this section, an English two-spouted lamp of the 18th century fetched £72 ($173) at New Bond Street on 4 February. This was from a most unusual collection of such pieces, some of which fetched upward of £400 ($960). Another less expensive example from this group, an 18th-century English chamber lamp, realised £75 ($180), whilst a fine pair of 18th-century oil lamps realised £115 ($276).

18th-century English drinking glasses are among the most keenly collected examples of antique glass. The finest pieces with coloured threads within the stem, known as 'colour twist' can fetch very high prices especially if the colour is a rare one such as canary yellow. In this section many types of drinking glasses are illustrated, from a plain wine glass of typical form which fetched £80 ($190) at New Bond Street on 4 February to a fine English 18th-century cylinder-knop wine glass which was sold there for £430 ($1,032) on 3 June. Examples are included of wine glasses engraved with Jacobite symbols, used by supporters of the exiled Stuart house during the reigns of the Houses of Orange and Hanover. A good early wine glass of this type fetched £430 ($1,032) at New Bond Street on 3 June. By the way of historical contrast, we illustrate a fine Newcastle wine glass engraved with the arms of William IV of Orange, which fetched £260 ($624) in the same sale.

Foreign glass is also well represented, including a goblet from that most famous of all glass producing cities, Venice; an 18th-century piece of great quality, this fetched £480 ($1,152) at New Bond Street on 4 February. German glass is also represented by an early 19th-century *Tranparent-malerei* landscape beaker of about 1810 from the Mohn workshops which fetched £620 ($1,488) in the same sale.

19th-century glass is also well represented, with fine examples from Bohemia, Germany and England. We illustrate also some paperweights, a specialist field of collecting in itself, including examples from the three great 19th-century French factories of Baccarat, Clichy and St Louis. It should be noted that examples of glass by Tiffany, Lalique, Gallé and Daum and other leading Art Nouveau and Art Deco makers will be found in the appropriate section.

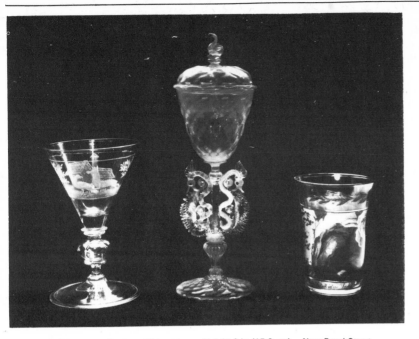

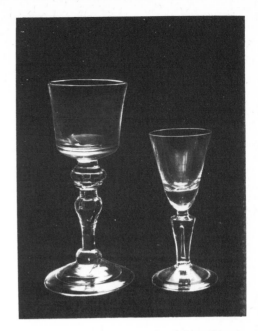

Left: Netherlands engraved goblet, 17th century. Height 6 in (15·3 cm). New Bond Street 4 February £290 ($696)

Centre: Venetian opalescent covered goblet, early 18th century. Height 10½ in (26·7 cm). New Bond Street 4 February £480 ($1,152)

Right: German *Transparentmalerei* landscape beaker from the Mohn workshops, *circa* 1810. Height 4½ in (11·5 cm). New Bond Street 4 February £620 ($1,488)

Left: English baluster-stem goblet. Height 8¼ in (21 cm). New Bond Street 3 June £260 ($624)

Right: English Silesian-stem wine glass. Height 6⅛ in (15·6 cm). New Bond Street 3 June £170 ($408)

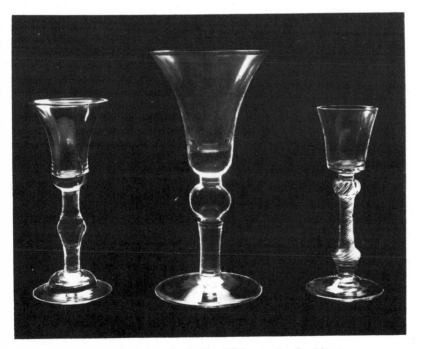

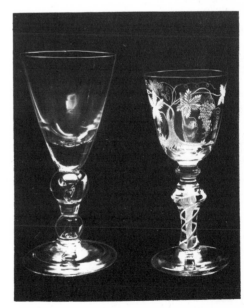

Left: English wine glass, 18th century. Height 6⅝ in (16·8 cm). New Bond Street 4 February £80 ($192)

Centre: English baluster-stem goblet, 18th century. Height 8⅜ in (21·3 cm). New Bond Street 4 February £110 ($264)

Right: English composite-stem wine glass, 18th century. Height 6⅜ in (16·2 cm). New Bond Street 4 February £110 ($264)

Left: English baluster-stem goblet. Height 8¼ in (21 cm). New Bond Street 3 June £280 ($672)

Right: English engraved composite-stem goblet. Height 7½ in (19·1 cm). New Bond Street 3 June £200 ($480)

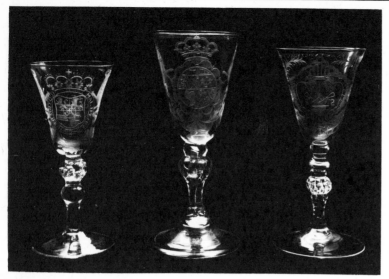

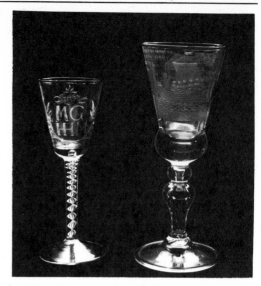

Left: English Newcastle armorial wine glass engraved with the arms of William IV of Orange. Height 6¾ in (17·1 cm). New Bond Street 3 June £260 ($624)

Centre: Saxon or Thuringian armorial goblet engraved with the arms of Anne, daughter of George II. Height 7⅞ in (20 cm). New Bond Street 3 June £250 ($560)

Right: English betrothal goblet, Dutch engraved. Height 7¼ in (18·4 cm). New Bond Street 3 June £370 ($888)

Left: Norwegian colour-twist goblet from Nøstetangen. Height 7⅛ in (18·1 cm). New Bond Street 3 June £140 ($336)

Right: Dutch engraved Lauenstein goblet. Height 8¹¹⁄₁₆ in (22·1 cm). New Bond Street 3 June £550 ($1,320)

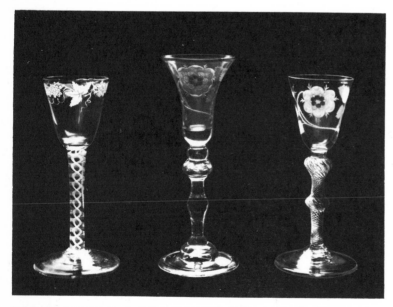

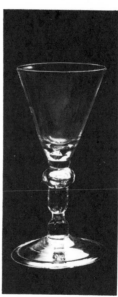

Left: English enamelled glass by Beilby. Height 6¹⁄₁₆ in (15·5 cm). New Bond Street 3 June £260 ($624)

Centre: English early Jacobite wine glass. Height 6¾ in (17·1 cm). New Bond Street 3 June £430 ($1,032)

Right: English Jacobite wine glass. Height 6¹⁄₁₆ in (15·7 cm). New Bond Street 3 June £210 ($504)

Left: English baluster-stem wine glass. Height 5⅞ in (14·9 cm). New Bond Street 3 June £150 ($360)

Right: English cylinder-knop wine glass. Height 6⅛ in (15·6 cm). New Bond Street 3 June £430 ($1,032)

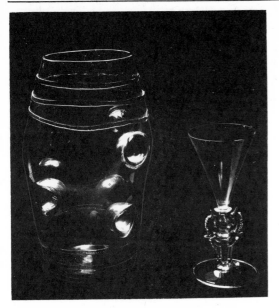

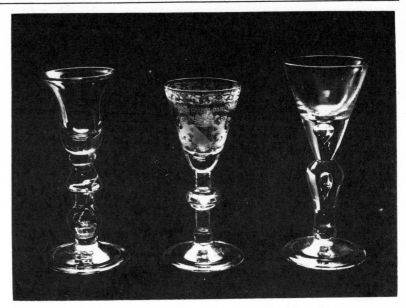

Left: German 17th-century *Daumenglas* and cover. Height 10$\frac{1}{16}$ in (26·9 cm). New Bond Street 3 June £200 ($480)

Right: 17th-century '*Façon de Venise* ' wine glass. Height 6$\frac{5}{8}$ in (16·8 cm). New Bond Street 3 June £190 ($456)

Left: English baluster wine glass. Height 6$\frac{3}{8}$ in (16·2 cm). New Bond Street 3 June £230 ($552)

Centre: English wine glass Dutch engraved in the manner of Meyden Visser. Height 6 in (15·2 cm). New Bond Street 3 June £420 ($1,008)

Right: English baluster-stem wine glass. Height 6$\frac{5}{8}$ in (16·8 cm). New Bond Street 3 June £230 ($552)

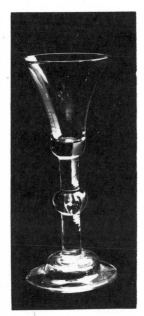

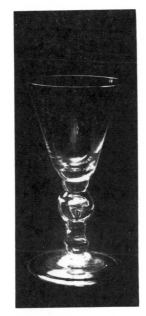

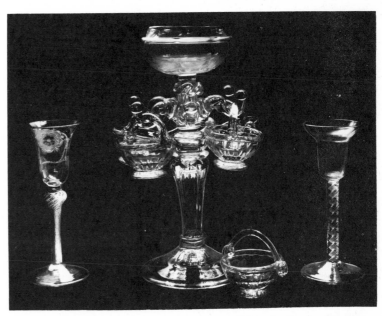

Left: English baluster-stem wine glass. Height 7$\frac{5}{8}$ in (19·4 cm). New Bond Street 3 June £100 ($240)

Right: English baluster-stem goblet. Height 7$\frac{5}{8}$ in (19·4 cm). New Bond Street 3 June £270 ($648)

Left: English engraved Jacobite wine glass. Height 6$\frac{3}{8}$ in (16·2 cm). New Bond Street 3 June £210 ($504)

Centre: English sweetmeat stand with six glasses. Height 10$\frac{1}{4}$ in (26 cm). New Bond Street 3 June £360 ($864)

Right: English mixed-twist wine glass. Height 6$\frac{1}{16}$ in (15·7 cm). New Bond Street 3 June £115 ($276)

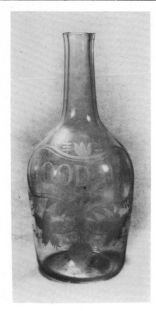

English engraved decanter. Height 10½ in (26·7 cm). New Bond Street 4 February £680 ($1,632)

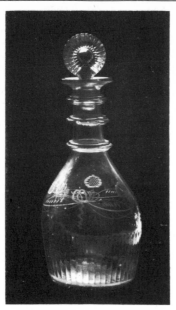

Irish decanter and stopper, the base moulded *Waterloo Co. Cork*. Height 9½ in (24·1 cm). New Bond Street 3 June £115 ($276)

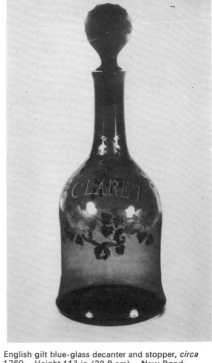

English gilt blue-glass decanter and stopper, *circa* 1760. Height 11¾ in (29·8 cm). New Bond Street 3 June £660 ($1,584)

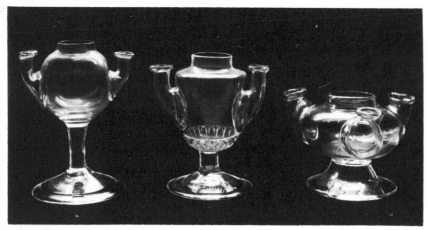

Left: English two-spouted lamp, 18th century. Height 6 in (15·2 cm). New Bond Street 4 February £72 ($173)

Centre: English lead-glass lamp, 18th century. Height 5⅜ in (13·7 cm). New Bond Street 4 February £410 ($984)

Right: English chamber lamp, 18th century. Height 4 in (10·2 cm). New Bond Street 4 February £170 ($408)

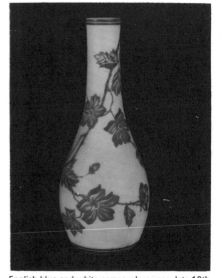

English blue and white cameo-glass vase, late 19th century. Height 10 in (25·4 cm). Belgravia 14 March £40 ($96)

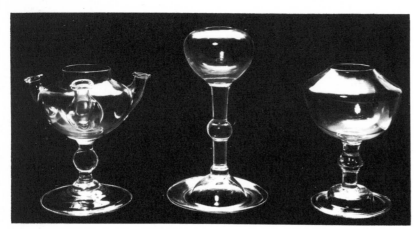

Left: English baluster-stemmed oil lamp, 18th century. Height 5½ in (14 cm). New Bond Street 4 February £130 ($312)

Centre: English chamber lamp, 18th century. Height 7⅛ in (18·1 cm). New Bond Street 4 February £75 ($180)

Right: One of a pair of oil lamps, 18th century. Height 5¾ in (14·6 cm). New Bond Street 4 February £115 ($276)

English double-overlay cameo-glass vase, *circa* 1880. Height 3¾ in (9·5 cm). Belgravia 14 March £130 ($312)

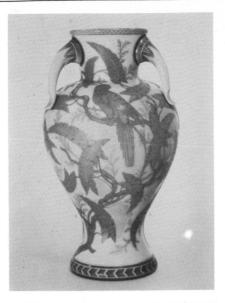

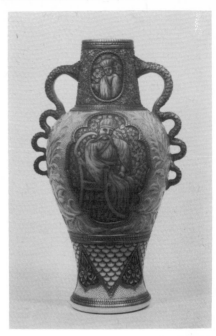

English cameo-glass scent bottle, the silver top maker's mark F.B.M, London 1884. Length 9½ in (24·1 cm). Belgravia 14 November £370 ($888)

English ivory cameo-glass vase, probably by Stevens and Williams *circa* 1885. Height 9⅝ in (24·5 cm). Belgravia 14 March £300 ($720)

'Ivory-Cameo' glass vase in Eastern taste by Thomas Webb and Sons *circa* 1880. Height 8¼ in (21 cm). Belgravia 20 June £270 ($648)

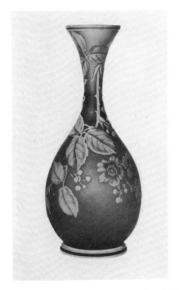

English three-colour cameo-glass vase *circa* 1885. Height 9¾ in (24·8 cm). Belgravia 14 November £500 ($1,200)

English silver-mounted cameo-glass scent bottle, silver mounts maker's mark F.B.M., London 1884. Belgravia 14 March £320 ($768)

English cameo-glass bowl, *circa* 1880. Diameter 4⅞ in (12·4 cm). Belgravia 14 March £130 ($312)

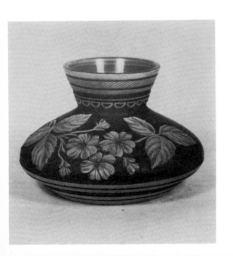

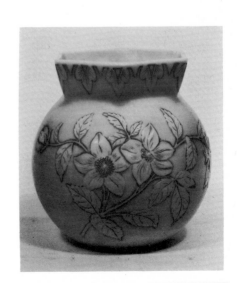

Left: English cameo-glass vase, *circa* 1885. Height 3 in (7·6 cm). Belgravia 20 June £240 ($576)

Right: 'Ivory-Cameo' glass vase by Thomas Webb and Sons *circa* 1890. Height 4 in (10·2 cm). Belgravia 20 June £280 ($672)

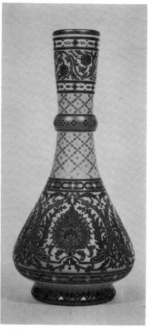

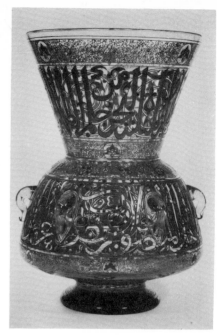

English 'Mary Gregory' enamelled glass dish with gilt-metal tripod stand, *circa* 1880. Diameter 13¼ in (33·6 cm). Belgravia 14 November £85 ($204)

Enamelled glass vase probably Russian, *circa* 1880. Height 13½ in (34·3 cm). Belgravia 14 November £100 ($240)

French enamelled 'Islamic' glass probably by Brochard, early 20th century. Height 14½ in (36·2 cm). Belgravia 14 November £180 ($432)

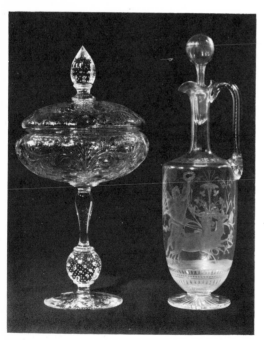

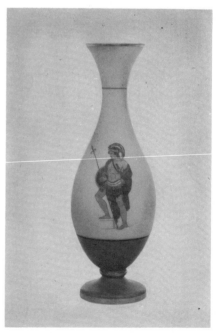

Left: 'Rock Crystal' engraved bowl and cover, *circa* 1885. Height 12¼ in (31·1 cm). Belgravia 14 November £55 ($132)

Right: Engraved glass jug and stopper, *circa* 1870. Height 12¾ in (32·4 cm). Belgravia 14 November £70 ($168)

One of a pair of enamelled glass vases, third quarter of the 19th century. Height 15⅜ in (39 cm). Belgravia 14 November £80 ($192)

One of a garniture of three opaque-white glass vases with printed Neo-classical designs by Richardson, Stourbridge, *circa* 1850. Height of vase illustrated 13¾ in (35 cm). Belgravia 20 June £80 ($192)

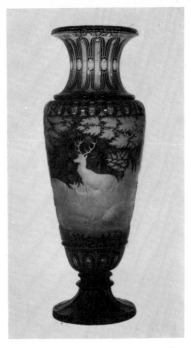

Webb Burmese-glass vase, impressed *Queen's Burmese Ware Patented Thos. Webb & Sons, circa* 1888. Height 8¼ in (20·6 cm). Belgravia 14 November £70 ($168)

One of a pair of Bohemian ruby-flash vases, *circa* 1850. Height 20¾ in (51·8 cm). Belgravia 20 June £300 ($720)

One of a pair of Bohemian overlay glass vases, *circa* 1850. Height 14¼ in (36·2 cm). Belgravia 20 June £160 ($384)

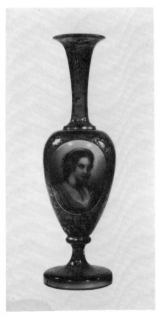

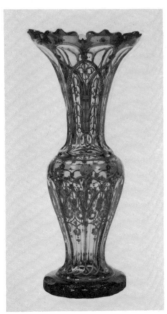

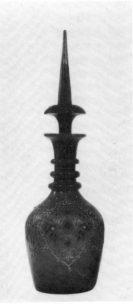

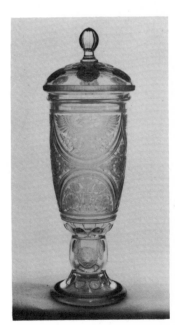

One of a pair of Bohemian overlay ruby-glass vases, *circa* 1860. Height 12 in (30·5 cm). Belgravia 14 March £160 ($384)

One of a pair of Bohemian flashed glass vases, *circa* 1840. Height 13¼ in (33·6 cm). Belgravia 14 November £190 ($456)

One of a garniture of opaque-blue vases and stoppers, mid 19th century. Height 20 in (50·8 cm). Belgravia 14 November £200 ($480)

Engraved Russian covered vase dated St Petersburg 1916. Height 28 in (71·2 cm). Belgravia 20 June £170 ($408)

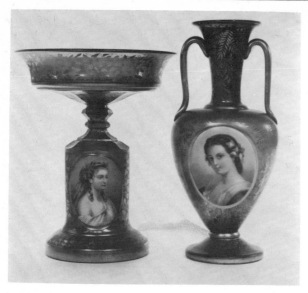

Left: Bohemian overlay glass centrepiece, *circa* 1860. Height 9⅝ in (24·5 cm). Belgravia 20 June £160 ($384)

Right: Bohemian double-handled overlay glass vase, *circa* 1860. Height 11 in (28 cm). Belgravia 20 June £120 ($288)

Silver-lined clear vase by E Varnish and Company *circa* 1850. Height 7 in (17·8 cm). Belgravia 14 March £62 ($149)

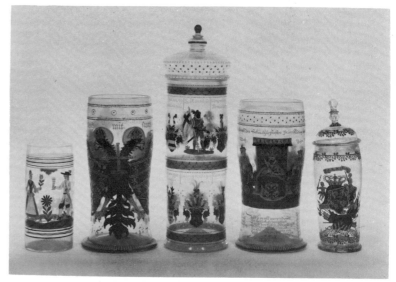

Left: Overlay glass scent bottle. Belgravia 14 March £42 ($101)

Centre: French glass overlay scent bottle. Belgravia 14 March £35 ($84)

Right: Venetian glass scent bottle. Belgravia 14 March £25 ($60)

From left to right:

German enamelled *Humpen*, late 19th century. Height 7¼ in (18·4 cm). Belgravia 20 June £30 ($72)

German enamelled *Humpen* based upon a late 16th-century example, late 19th century. Height 10¾ in (27·3 cm). Belgravia 20 June £105 ($252)

German enamelled *Humpen* and cover bearing the armorial shields of members of the Chapter of the Cathedral of Magdeburg, late 19th century. Height 16 in (40·6 cm). Belgravia 20 June £78 ($187)

German enamelled *Kurfürstenhumpen* based upon a 16th-century example, late 19th century. Height 10½ in (26·7 cm). Belgravia 20 June £62 ($149)

German *Hofkellereihumpen* and cover based on an 18th-century original, late 19th century. Height 10⅞ in (27·6 cm). Belgravia 20 June £58 ($139)

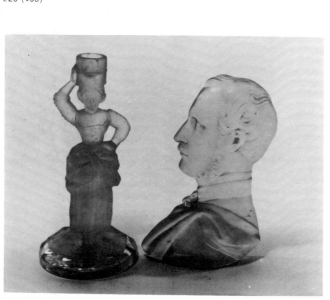

Left: One of a pair of frosted glass candlesticks, possibly Baccarat, France, *circa* 1840. Height 9⅝ in (24·5 cm). Belgravia 20 June £120 ($288)

Right: One of a pair of relief bust portraits in frosted glass of Queen Victoria and Prince Albert, *circa* 1850. Height 8⅝ in (21·9 cm). Belgravia 20 June £45 ($108)

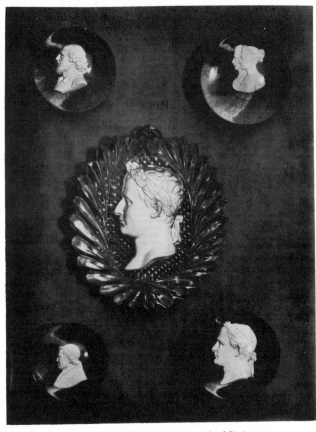

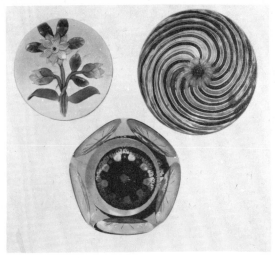

Left: Baccarat yellow clematis weight, French 19th century. Diameter 2½ in (6·4 cm). New Bond Street 2 May £600 ($1,440)

Right: Clichy three-colour swirl weight, French 19th century. Diameter 3 in (7·6 cm). New Bond Street 2 May £750 ($1,800)

Centre: Clichy faceted mushroom weight, French 19th century. Diameter 3 in (7·6 cm). New Bond Street 2 May £300 ($720)

Upper left: Sulphide portrait weight set with a portrait of Shakespeare. Diameter 2⅝ in (6·7 cm). New Bond Street 2 May £65 ($156)

Upper right: Sulphide conjugal portrait weight set with a *crystallo-ceramie* profile of Victoria and Albert. Diameter 2¾ in (7 cm). New Bond Street 2 May £55 ($132)

Centre: Baccarat portrait plaque enclosing a *crystallo-ceramie* bust of Napoleon Bonaparte, French mid 19th century. 5¼ by 5½ in (13·3 by 14 cm). New Bond Street 2 May £700 ($1,680)

Lower left: Sulphide portrait weight set with a bust of Pope Pius IX (1846-1878). Diameter 2½ in (6·4 cm). New Bond Street 2 May £50 ($120)

Lower right: Sulphide portrait weight set with a bust of Napoleon Bonaparte. Diameter 2⅞ in (7·3 cm). New Bond Street 2 May £100 ($240)

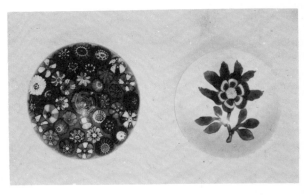

Left: Clichy colour-ground weight, French 19th century. Diameter 3⅛ in (8 cm). New Bond Street 2 May £420 ($1,008)

Right: Baccarat primrose weight, French 19th century. Diameter 3⅛ in (8 cm). New Bond Street 2 May £300 ($720)

Left: Sulphide tumbler containing a bust of Pope Pius IX. Height 4¾ in (12·1 cm). New Bond Street 2 May £65 ($156)

Centre: Stourbridge magnum close-millefiori weight. Diameter 5 in (12·7 cm). New Bond Street 2 May £150 ($360)

Right: Sulphide scent bottle and stopper set with a *crystallo-ceramie* bust of the Duke of Wellington, probably by Apsley Pellatt. Height 7¼ in (18·4 cm) New Bond Street 2 May £95 ($228)

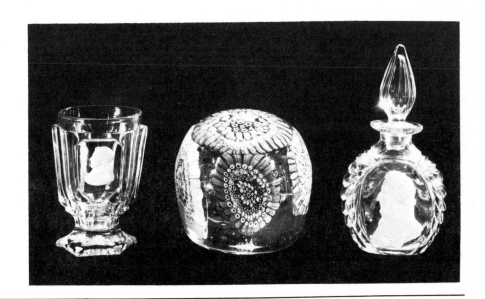

Arms and armour

Arms and armour can be divided into three distinct categories—armour, firearms and edged weapons. Each field attracts its own collectors and each can be further subdivided to give interesting areas for greater specialisation. It must be admitted that in a price range under £1,000 ($2,400) fine early firearms and the best armour are largely excluded but were the modestly financed collector to interest himself in, for instance, English military weapons of the 18th and 19th centuries, oriental edged weapons or European swords and daggers, he would find great opportunities to form a fine and representative group.

Among the edged weapons illustrated here, mention should be made of the 17th-century German rapier with its original sheath which fetched £580 ($1,392) in Bond Street, and the German smallsword of about 1780, with its white sharkskin scabbard, which fetched £190 ($456). Both were from the collection of the Counts von Giech and had remained in the possession of the same family since the time they were made; they were sold at New Bond Street on 21 May.

The same sale contained a number of unusual and interesting items which fetched very reasonable prices. Another German smallsword was sold for £85 ($204), a mid 18th-century German hunting hanger for £65 ($156), and two fine and decorative 18th-century horn powder flasks, one engraved with game animals, fetched £85 ($204) each. Perhaps the most amusing pieces in the sale were some 18th-century dog collars which fetched prices ranging between £20 ($48) and £95 ($228), the latter being applied with the silver-plated letters C.F.C.G.V.G. for the hound's original owner Christian Friedrich Carl Graf von Giech. It is this kind of sale, from an old titled family and containing a number of pieces of a type not normally seen on the art market, which offers the best opportunities to the collector seeking a specialist interest. A collection of dog collars sounds improbable but these showed that the better examples can be considered works of art and would be well worth acquiring without being too costly.

A group of Indian edged weapons were sold in a second sale at New Bond Street on 21 May. Bejewelled and jade-hilted khanjars and daggers dating from the 19th century fetched prices between £90 ($216) and £190 ($456). This field could be extended to cover Malayan and Nepalese weapons but it should be pointed out that Japanese arms form a distinct class of their own and will be considered in the section dealing with Japanese art.

The collector of firearms will find a wide range of pieces illustrated here, many of exceptionally good quality. Normally, the better pieces fall into a price bracket close to the top limit but it is worth noting that it is still possible to buy a single-barrelled flintlock fowling piece by Joseph Manton, one of the greatest English late 18th-century gunsmiths, for a mere £420 ($1,008). For enthusiasts of the Wild West, a .44 Colt New Lightning Repeating rifle could have been purchased at New Bond Street on 21 May for £90 ($216)

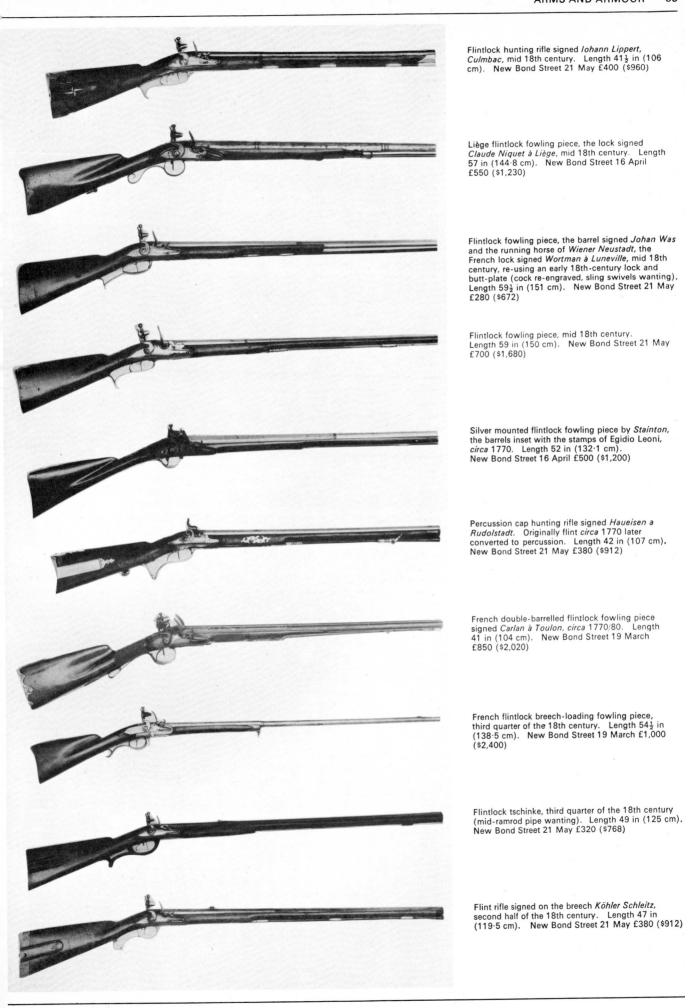

Flintlock hunting rifle signed *Iohann Lippert,
Culmbac*, mid 18th century. Length 41½ in (106
cm). New Bond Street 21 May £400 ($960)

Liège flintlock fowling piece, the lock signed
Claude Niquet à Liège, mid 18th century. Length
57 in (144·8 cm). New Bond Street 16 April
£550 ($1,230)

Flintlock fowling piece, the barrel signed *Johan Was*
and the running horse of *Wiener Neustadt*, the
French lock signed *Wortman à Luneville*, mid 18th
century, re-using an early 18th-century lock and
butt-plate (cock re-engraved, sling swivels wanting).
Length 59½ in (151 cm). New Bond Street 21 May
£280 ($672)

Flintlock fowling piece, mid 18th century.
Length 59 in (150 cm). New Bond Street 21 May
£700 ($1,680)

Silver mounted flintlock fowling piece by *Stainton*,
the barrels inset with the stamps of Egidio Leoni,
circa 1770. Length 52 in (132·1 cm).
New Bond Street 16 April £500 ($1,200)

Percussion cap hunting rifle signed *Haueisen a
Rudolstadt*. Originally flint *circa* 1770 later
converted to percussion. Length 42 in (107 cm).
New Bond Street 21 May £380 ($912)

French double-barrelled flintlock fowling piece
signed *Carlan à Toulon, circa* 1770/80. Length
41 in (104 cm). New Bond Street 19 March
£850 ($2,020)

French flintlock breech-loading fowling piece,
third quarter of the 18th century. Length 54½ in
(138·5 cm). New Bond Street 19 March £1,000
($2,400)

Flintlock tschinke, third quarter of the 18th century
(mid-ramrod pipe wanting). Length 49 in (125 cm).
New Bond Street 21 May £320 ($768)

Flint rifle signed on the breech *Köhler Schleitz*,
second half of the 18th century. Length 47 in
(119·5 cm). New Bond Street 21 May £380 ($912)

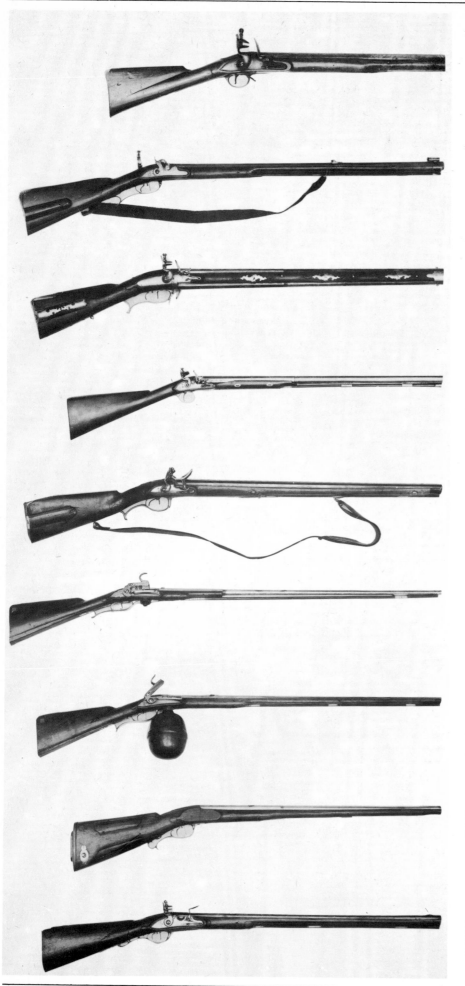

Indian pattern Brown Bess flintlock musket, the lock with the crowned GR cypher and inscribed *Tower* (the forestock with minor pieces missing), late 18th century. Length 54¾ in (138·2 cm). New Bond Street 12 February £180 ($432)

Percussion cap target rifle converted from flintlock, late 18th century, with subsequent conversion. Length 46¾ in (119 cm). New Bond Street 21 May £300 ($720)

Flintlock double-barrel Wender sporting gun, one barrel signed *A. J. Beutner 1786* and the other *In Weismayn 1786*. Length 44¾ in (114 cm). New Bond Street 21 May £950 ($2,280)

English single-barrelled flintlock fowling piece by Joseph Manton, serial number 1907, 1793-4. Length of gun 45½ in (116 cm). New Bond Street 19 March £420 ($1,008)

Double-barrelled flintlock fowling piece, signed *Goellner, Suhl, circa* 1800. Length 43½ in (110 cm) New Bond Street 21 May £800 ($1,920)

Bar-lock airgun, signed *Johann Valentin Zigling a Frankfurt* and dated 1753 (valve opener in breech missing). Length 52 in (132 cm). New Bond Street 21 May (£300 ($720)

Bar-lock airgun signed *Kohler a Schleiz*, with its original copper air cylinder and steel air-pump (valve opener in breech missing). Second half of the 18th century. Length 49 in (124·5 cm). New Bond Street 21 May £320 ($768)

Bellows gun, second half of the 18th century (ramrod missing). Length 44 in (112 cm). New Bond Street 21 May £200 ($480)

Rifled airgun signed *Lippert Culmbach*, third quarter of the 18th century (one side nail wanting). Length 47¾ in (122 cm). New Bond Street 21 May £480 ($1,152)

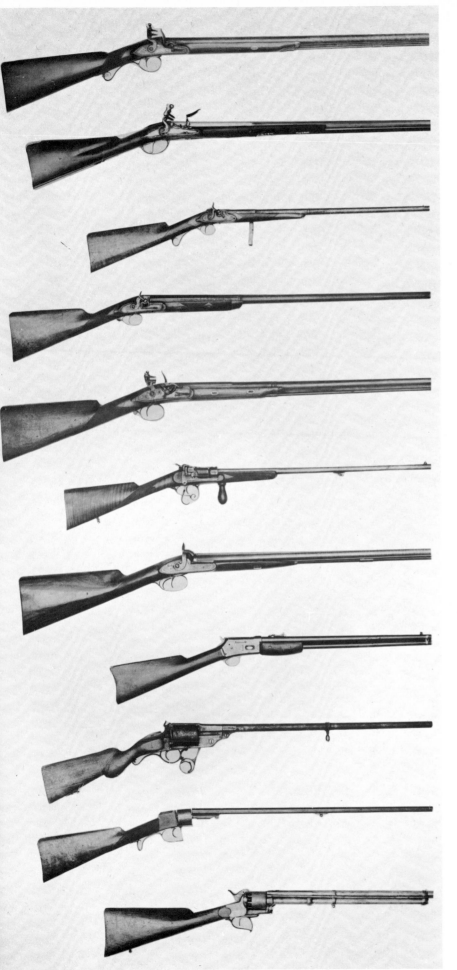

English single-barrelled flintlock shotgun signed *Ryan and Watson*, early 19th century. Length 48 in (122 cm). New Bond Street 19 March £350 ($840)

Flintlock fowling piece, the barrel signed *Chatteau a Paris*, first quarter of the 19th century, the barrel and side-plate French, the remainder German. Length 63 in (160 cm). New Bond Street 21 May £350 ($840)

Belgian tube lock breech-loading fowling piece, *circa* 1820/30. Length 40½ in (103 cm). New Bond Street 19 March £280 ($674)

12-bore tube lock fowling piece by *Geo. Fuller. 104 Wardour St., Oxford St, London, circa* 1820. Length 50 in (127 cm). New Bond Street 19 March £250 ($600)

English double-barrelled fowling piece, signed *Lacy and Co. 67 Threadneedle Street. London, circa* 1820/30. Length 47 in (120 cm). New Bond Street 19 March £600 ($1,440)

French pinfire harmonica shotgun, signed *A. Jarré Bte à Paris, circa* 1870. Length 43 in (109 cm). New Bond Street 19 March £500 ($1,200)

English 16-bore double-barrelled percussion cap sporting gun, signed *I. Blanch. 29 Gracechurch Street, London*, mid 19th century. Length 45 in (114·3 cm). New Bond Street 16 April £150 ($360)

·44 Colt New Lightning repeating rifle serial no. 80051, with 20¼ in (51·4 cm) barrel, with patent dates to Feb 22.87. Length 37 in (93·94 cm). New Bond Street 21 May £90 ($216)

Belgian L. Ghaye's patent 16-bore revolving sporting gun, serial no. 170 with 27 in (68·6 cm) round barrel (inoperative and with replaced butt). Length 45 in (114·3 cm). New Bond Street 21 May £25 ($60)

·44 Sporting rifle signed *F. Barnes & Co., London* (action defective, barrel retaining mounting lacking and spindle damaged). Length 45⅜ in (115·2 cm). New Bond Street 21 May £30 ($72)

Lemat percussion cap carbine, the barrel stamped *Syst Lemat JR S.C.D.G. Paris, circa* 1860 (action defective). Length 36⅝ in (93 cm). New Bond Street 12 February £350 ($840)

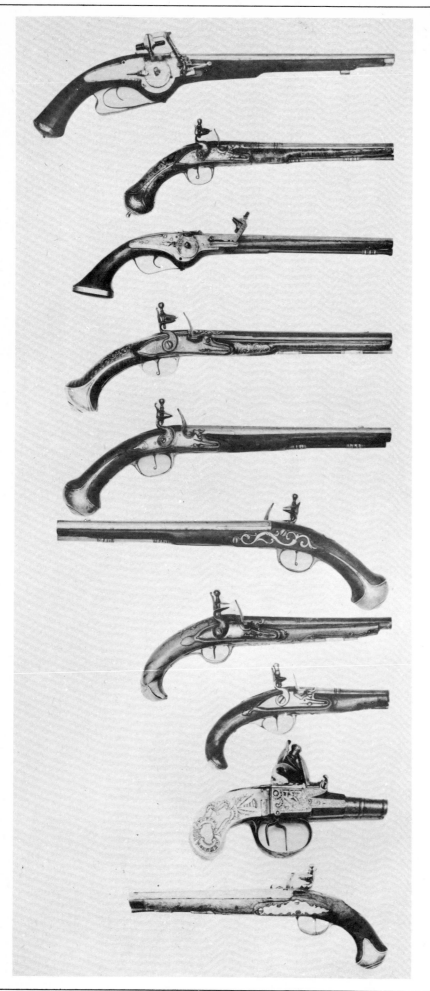

German wheel-lock holster pistol of military type, mid 17th century. Length 28 in (58·5 cm). New Bond Street 21 May £550 ($1,320)

English flintlock holster pistol signed on the lock *R. Loder, circa* 1680, (the stock with repaired fracture, the top of the cock spur lacking, worn overall). Length 19½ in (49·5 cm). New Bond Street 12 February £380 ($912)

Austrian wheel-lock holster pistol, the lock-plate signed *Jean Paul Clett.* Salzburg, *circa* 1630. Length 23 in (58·4 cm). New Bond Street 12 February £620 ($1,488)

French flintlock holster pistol, the barrel signed in gold *Le Lorain à Valence, circa* 1725 (the top of the cock and the silver trigger guard replaced). Length 18¾ in (47·6 cm). New Bond Street 12 February £1,000 ($2,400)

Pair of flintlock holster pistols, early 18th century. Length 20 in (51 cm). New Bond Street 21 May £950 ($2,280)

One of a pair of flintlock holster pistols the breeches inscribed *Anton Fock in Maynz, circa* 1740 (part of one tang lacking, one butt cap chipped). Length 14¾ in (37·4 cm). New Bond Street 12 February £460 ($1,104)

One of a pair of French flintlock pocket pistols, mid 18th century. Length 6½ in (16·5 cm). New Bond Street 16 April £460 ($1,104)

Liège all-steel double-barrelled turn-off flintlock pistol, third quarter of the 18th century. Length 5½ in (14 cm). New Bond Street 19 March £680 ($1,632)

One of a pair of German flintlock officer's pistols, signed *Jakob Kuchenreuter,* last quarter of the 18th century. Length 16 in (40·5 cm). New Bond Street 19 March £780 ($1,870)

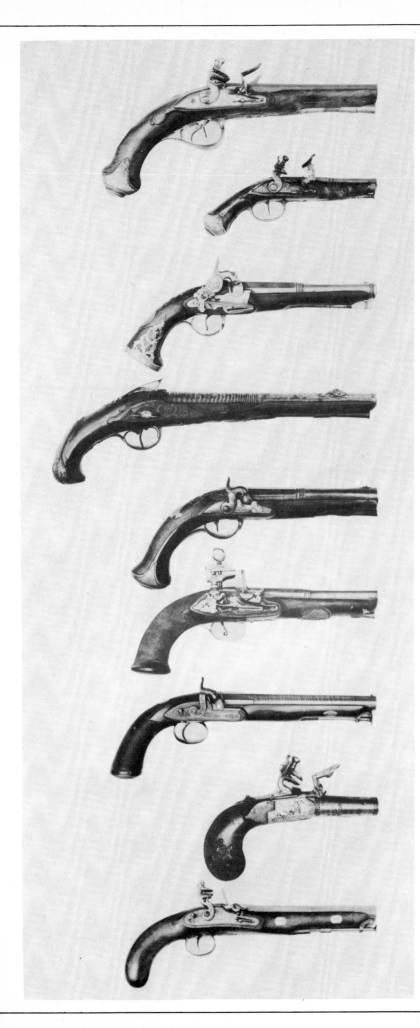

German double-barrelled side-by-side flintlock officer's pistol, signed *I. And. Kuchenreuter A Regensburg*, late 18th century. Length 13½ in (34·5 cm). New Bond Street 19 March £620 ($1,488)

Italian snaphaunce (*alla Fiorentina*) pocket pistol, mid 18th century. Length 9 in (23 cm). New Bond Street 19 March £380 ($912)

Spanish miquelet belt pistol, inscribed *Pigrau Ripoll*, late 18th century with later conversions. Length 12½ in (32 cm). New Bond Street 19 March £400 ($960)

German or Bohemian flintlock holster pistol, third quarter of the 18th century. Length 17 in (43 cm). New Bond Street 19 March £750 ($1,800)

Austrian blunderbuss pistol, signed *Joseph Schuller à Neustat*, mid 18th century. Length 13 in (33 cm). New Bond Street 19 March £240 ($576)

One of a pair of Neapolitan miquelet-lock pistols, early 19th century. Length 12¼ in (31 cm). New Bond Street 19 March £800 ($1,920)

One of a pair of percussion cap officer's pistols, signed on the barrels *Westley Richards 170 New Bond St. London*, in baize-lined mahogany case, *circa* 1845. Length 15 in (38·1 cm). New Bond Street 12 February £900 ($2,160)

Flintlock pocket pistol, signed *Manufacture de Versailles*, early 19th century. Length 5½ in (14 cm). New Bond Street 19 March £580 ($1,392)

One of a pair of Scottish flintlock cavalry officer's pistols, signed *Hunter & Co. Edinburgh*, early 19th century, Length 14½ in (37 cm). New Bond Street 19 March £450 ($1,080)

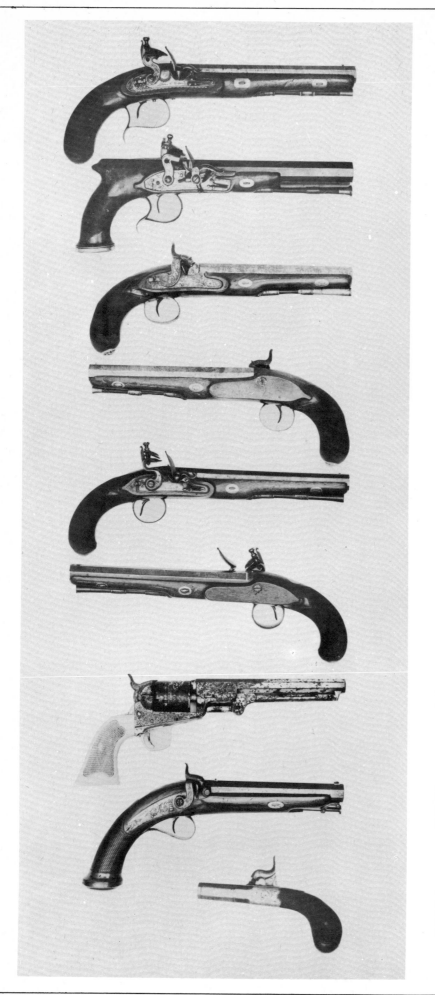

English flintlock pistol, signed *E, Bond. 45 Cornhill London.* early 19th century. Length 14½ in (36·8 cm). New Bond Street 16 April £340 ($816)

English officer's pistol, signed *Lacy and Co., Patent,* early 19th century. Length 13½ in (33·3 cm). New Bond Street 16 April £340 ($816)

Pair of English percussion cap officer's pistols signed *I. & W. Calverts, Leeds,* in a baize-lined mahogany case complete with detachable skeleton butt, early 19th century, Length 14 in (35·6 cm). New Bond Street 21 May £580 ($1,392)

Pair of flintlock duelling pistols, the barrels inscribed *no. 55 Charing Cross, London* and the lock signed *S. Brunn,* early 19th century. New Bond Street 21 May £600 ($1,440)

Colt ·36 model 1851 percussion cap navy revolver, the barrel stamped *Address Col. Saml. Colt New-York U.S. America* (action defective). Length 13¼ in (33·7 cm). New Bond Street 12 February £450 ($1,080)

One of a pair of percussion cap officer's pistols, the barrels signed *Collins. London,* in fitted mahogany case with some accessories (spur on one hammer lacking), *circa* 1840. Length 12¼ in (31·1 cm). New Bond Street 12 February £360 ($864)

One of a pair of percussion cap boxlock pocket pistols, the breeches signed *Jn. Manton & Son, London,* in mahogany case. Length 5¾ in (14·6 cm). New Bond Street 12 February £480 ($1,152)

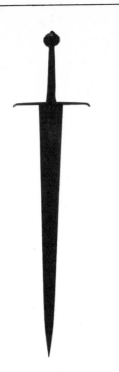

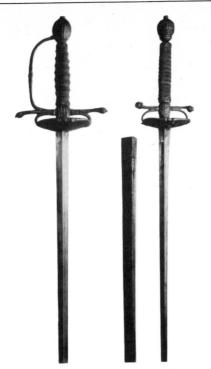

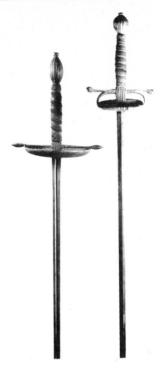

Italian medieval sword, 14th century (the blade slightly reshaped at the point). Length 40 in (101·6 cm). New Bond Street 12 February £850 ($2,040)

Left: German rapier with Panzerstecher blade of triangular section with black leather sheath, mid 17th century. Length 44 in (112 cm). New Bond Street 21 May £580 ($1,392)

Right: Italian smallsword, the triangular blade hollow-ground and etched, 17th/18th century. Length 42 in (107 cm). New Bond Street 21 May £130 ($312)

Left: German duelling rapier, second half of the 17th century. Length 52 in (132 cm). New Bond Street 21 May £480 ($1,152)

Right: German duelling rapier, third quarter of the 17th century. Length 46¾ in (119 cm). New Bond Street 21 May £250 ($360)

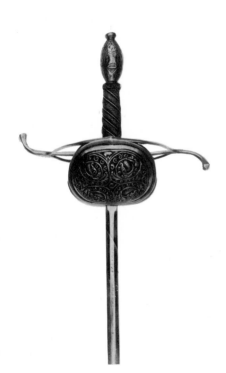

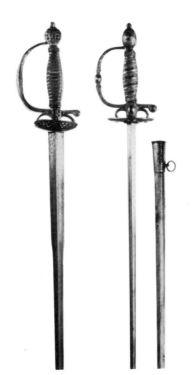

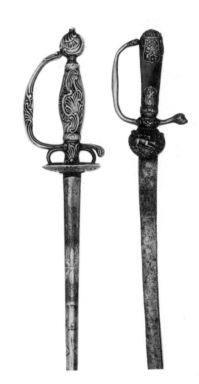

Rapier, the blade inscribed *Civitas Serval,* early 17th century. Length 49 in (124 cm). New Bond Street 12 February £460 ($1,104)

Left: German smallsword, the Colichemarde blade engraved with a coat-of-arms, *circa* 1780. Length 39 in (99 cm). New Bond Street 21 May £85 ($204)

Right: German smallsword, the blade of triangular hollow-ground section, with white sharkskin scabbard, *circa* 1780. Length 38 in (97 cm). New Bond Street 21 May £190 ($456)

Left: Silver-hilted boy's smallsword, probably German, mid 18th century. Length 25¾ in (65 cm). New Bond Street 21 May £260 ($624)

Right: German hunting hanger, mid 18th century. Length 27½ in (70 cm). New Bond Street 21 May £65 ($156)

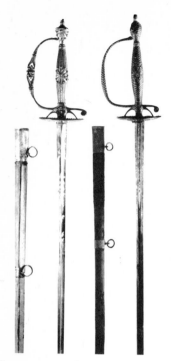

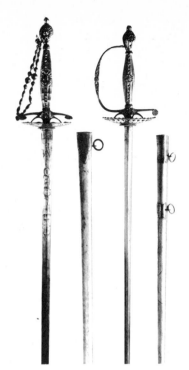

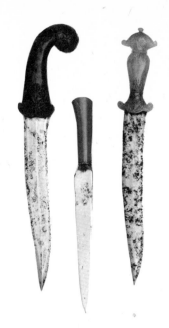

Left: German court sword with scabbard, *circa* 1800. Length 39 in (99 cm). New Bond Street 21 May £110 ($264)

Right: German court sword with scabbard, signed in gilt at the forte *Thomas Ayalla, circa* 1800. Length 38¼ in (97 cm). New Bond Street 21 May £30 ($72)

Left: German court sword with white vellum scabbard, early 19th century. Length 38 in (96·5 cm). New Bond Street 21 May £95 ($228)

Right: German court sword with white shagreen scabbard, early 19th century. Length 36 in (91·5 cm). New Bond Street 21 May £85 ($204)

Left: Indian khanjar with jade hilt. Length 15¾ in (40 cm). New Bond Street 21 May £110 ($264)

Centre: Indian dagger with gold flowers at the forte and a jade hilt. Length 12⅝ in (32·1 cm). New Bond Street 21 May £90 ($216)

Right: Indian khanjar with carved jade hilt. Length 15⅛ in (38·4 cm). New Bond Street 21 May £140 ($336)

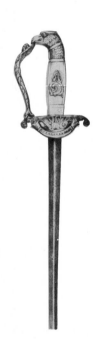

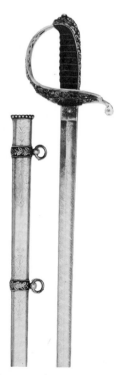

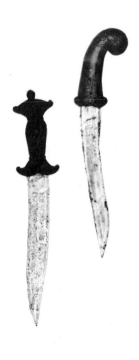

Austrian silver-hilted court sword, the blade inscribed *P. D. Moll a Solingen*, the silver mounts bearing Italian hallmarks, 19th century (applied panel of the grip lacking). Length 37½ in (95·2 cm). New Bond Street 12 February £100 ($240)

English silver presentation sword with silver scabbard, London hallmarks for 1876. Length 38¾ in (98·4 cm). New Bond Street 21 May £350 ($840)

Right: Indian khanjar with carved spinach green jade hilt. Length 14½ in (36·2 cm). New Bond Street 21 May £190 ($456)

Left: Indian dagger with carved jade hilt. Length 17⅝ in (44·4 cm). New Bond Street 21 May £160 ($384)

Dark brown deep leather dog collar, with red leather borders, a fringe of hair and an iron ring, 18th century. Maximum circumference 22½ in (57 cm). New Bond Street 21 May £20 ($48)

Horn powder flask, 18th century. Height 7½ in (19 cm). New Bond Street 21 May £15 ($36)

Upper: Horn powder flask with gilt mounts, late 18th century. Length 11 in (28 cm). New Bond Street 21 May £85 ($204)

Lower: Horn powder flask engraved with game animals, late 18th century. Length 10½ in (26·5 cm). New Bond Street 21 May £85 ($204)

Brass dog collar with applied silver-plated letters *CFCGVG* for Christian Friedrich Carl Graf von Giech. Circumference 18 in (46 cm). New Bond Street 21 May £95 ($228)

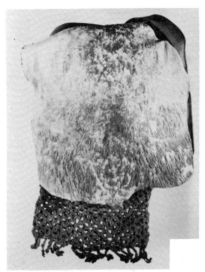

Deerskin wildfowler's bag late 18th century. Width 9½ in (23·5 cm). New Bond Street 21 May £65 ($156)

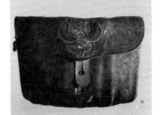

Leather cartridge box containing brass cartridges for a fowling piece, late 19th century. Width 9 in (22·5 cm). New Bond Street 21 May £35 ($84)

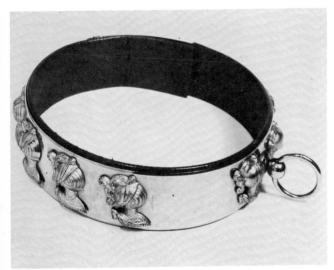

Decorative dog collar of plated metal on red leather, *circa* 1830. Maximum circumference 22 in (56 cm). New Bond Street 21 May £75 ($180)

Deep leather collar applied with silver-plated mounts and silver-plate letters *Graf Giech*, mid 18th century. Maximum circumference 23 in (58·5 cm). New Bond Street 21 May £85 ($204)

Clocks, watches and scientific instruments

Sotheby's first held specialised horological sales about eight years ago. During this time the value of English 17th- and 18th-century clocks, both long-case and bracket, has risen substantially. Though the market reached a peak in 1974, prices since then have fallen back, but those within our price limit have remained steady. English clockmakers of this period are renowned for their scientific achievements, quite apart from the magnificent quality and aesthetic appeal of their work. It would be a shame if it were no longer possible to purchase a good 18th-century clock for a price within our range but, as is shown, for a price between £500 ($1,200) and £1,000 ($2,400) examples still appear in the salerooms.

Illustrated here is a beautiful George I quarter-repeating bracket clock with a black-japanned case. This was made in the early 18th century by William Webster of 21 Exchange Alley, London and fetched £1,000 ($2,400) at New Bond Street on 20 May. Early in the year a fine quarter-repeating bracket clock of the same period by Gregg, with an ebonised case, fetched £950 ($2,280) and in the same sale an early George IV chiming bracket clock with a mahogany case by J. Green of London also made £950 ($2,280).

Although clocks by the great early makers such as Thomas Tompion, Daniel Quare or George Graham are now beyond our limit, watches by these makers will occasionally fetch below £1,000 ($2,400) although, in these cases, the purchaser must expect some degree of restoration. A good example was the repoussé gold pair cased verge watch by Tompion and his partner Edward Banger of London, the inner case hallmarked 1703 and the outer 1730, which fetched £650 ($1,560). Opportunities such as this, to buy a piece by one of the greatest horological craftsmen, are rare. Another example illustrated is a splendid gold repoussé-cased cylinder watch by George Graham of London, *circa* 1730, which fetched £1,000 ($2,400) at New Bond Street on 18 March.

Collecting scientific instruments is a highly specialised activity and the value of any piece, not unnaturally, stems as much from its importance within the history of science as from its aesthetic appeal. There is included a small group of such pieces to show something of the range of scientific instruments available at auction.

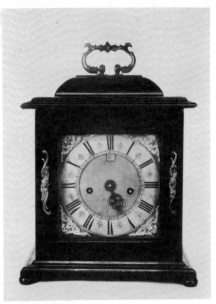

Late 17th-century ebonised bracket clock. Height 11½ in (29·2 cm). New Bond Street 18 March £780 ($1,872)

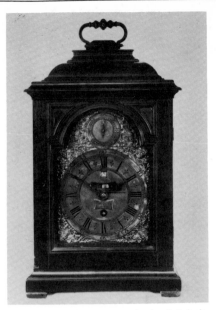

George I ebonised quarter-repeating bracket clock signed *Fra: Gregg London*, early 18th century. Height 15½ in (39·4 cm) New Bond Street 4 February £950 ($2,280)

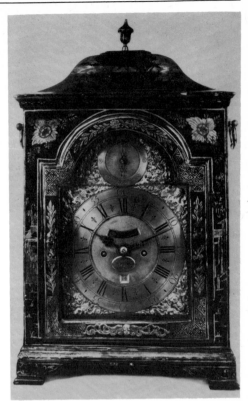

George I black-japanned quarter-repeating bracket clock signed *Wm Webster, Exchange Alley London*, early 18th century. Height 22 in (55·8 cm). New Bond Street 20 May £1,000 ($2,400)

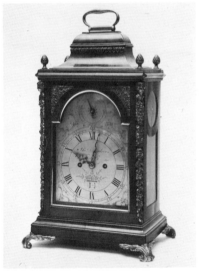

George III mahogany bracket clock by *Tho. Andrews, Dover, circa* 1785. Height 19 in (48·3 cm). New York 23 March $1,800 (£750)

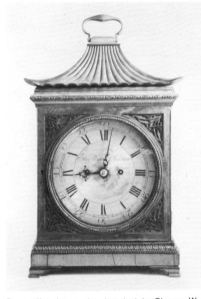

George II mahogany bracket clock by *Thomas Wynn, London, circa* 1760. Height 19 in (48·3 cm). New York 23 March $1,900 (£791)

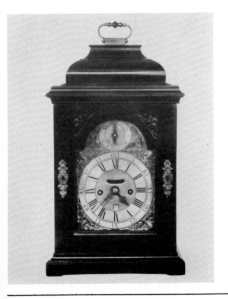

George II ebonised bracket clock. Height 17½ in (44·4 cm). New Bond Street 18 March £1,000 ($2,400)

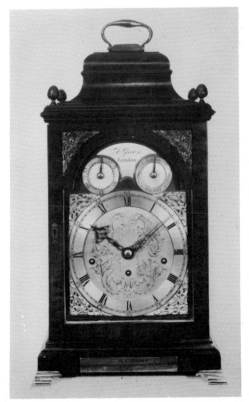

Early George III mahogany chiming bracket clock signed *J. Green London*. Height 21 in (53·3 cm). New Bond Street 4 February £950 ($2,280)

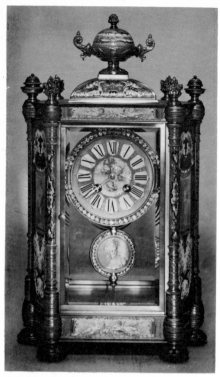

French ormolu and cloisonné enamel clock signed *Tiffany & Co*, probably 19th century. 17 by 9½ in (43·4 by 24·1 cm). New York 9 February $2,000 (£833)

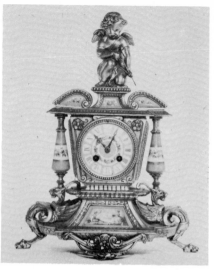

Porcelain-mounted gilt-metal mantel clock, the two-train movement stamped *Japy Freres & Cie., Gde Med. D'Honn.* and the case stamped *P H Mourey*, French late 19th century. Height 15½ in (39·4 cm). Belgravia 9 January £120 ($288)

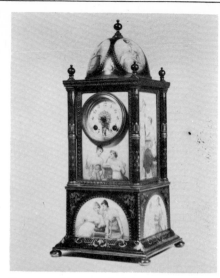

Vienna porcelain-mounted gilt-bronze mantel clock, one porcelain panel signed *Johner*, French *circa* 1880. Height 17 in (43·2 cm). Belgravia 9 January £540 ($1,296)

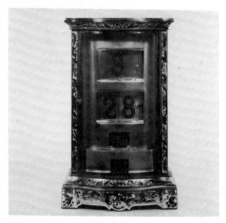

Gilt-bronze and champlevé enamel digital mantel clock, French *circa* 1900. Height 10 in (25·4 cm). Belgravia 17 April £400 ($960)

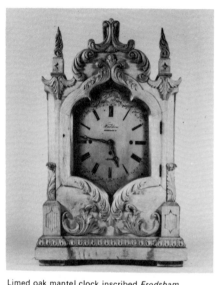

Limed oak mantel clock inscribed *Frodsham, Gracechurch Street, London.* Height 27 in (68·6 cm). Belgravia 6 February £280 ($672)

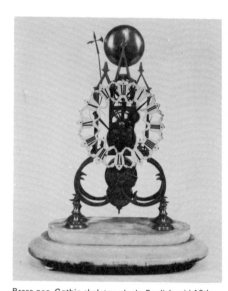

Brass neo-Gothic skeleton clock, English mid 19th century. Height 14 in (35·6 cm). Belgravia 6 February £140 ($336)

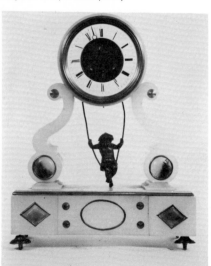

Onyx mantel clock signed on the backplate *Japy Fils*, French mid 19th century. Height 13½ in (34·3 cm). Belgravia 6 February £80 ($192)

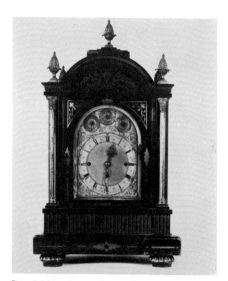

Brass inlaid mahogany bracket clock, English mid 19th century. Height 25 in (63·5 cm). Belgravia 6 February £330 ($792)

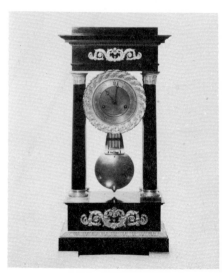

Ormolu-mounted ebony mantel clock, French mid 19th century. Height 25 in (63·5 cm). Belgravia 17 April £140 ($336)

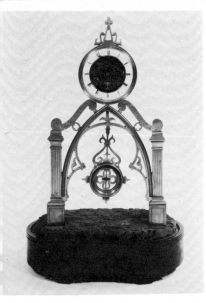

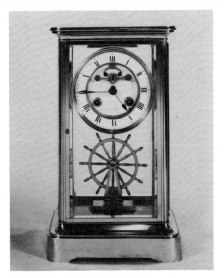

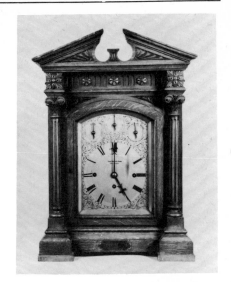

Gilt-bronze mantel clock, the dial inscribed *Potonié éon, à Paris*, the backplate stamped P. Bally, rench late 19th century. Height 14 in (35·6 cm). Belgravia 12 June £110 ($264)

Brass mantel clock, French late 19th century. Height 13 in (33 cm). Belgravia 12 June £180 ($432)

Oak bracket clock on stand, the dial inscribed *Thos. Smith & Sons, Edinburgh*, English late 19th century. Height 38 in (96·5 cm). Belgravia 15 May £230 ($552)

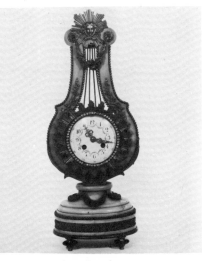

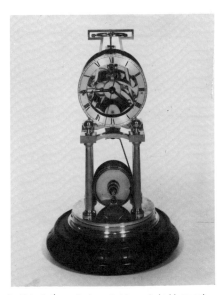

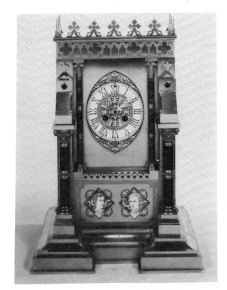

Gilt-bronze mounted marble lyre clock, the movement tamped *Marti Frères*, French third quarter of the 9th century. Height 19 in (48·3 cm). Belgravia 15 May £500 ($1,200)

English skeleton clock, probably made in Liverpool *circa* 1840. Height 12½ in (31·8 cm). Belgravia 24 July £500 ($1,200)

Pottery and hardstone mounted copper and brass mantel clock, the two-train movement stamped *BR*, English *circa* 1870-80. Height 18¾ in (47·6 cm). Belgravia 31 July £325 ($780)

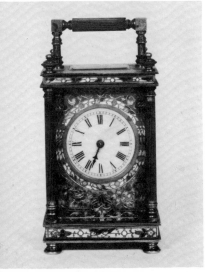

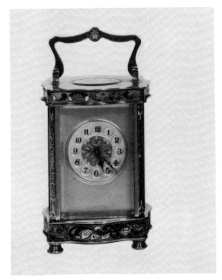

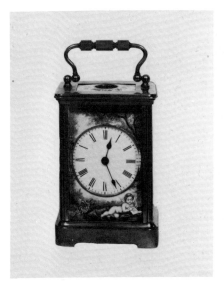

Champlevé enamel carriage clock, French late 19th century. Height 5¼ in (13·4 cm). Belgravia 24 July £215 ($516)

Champlevé enamel brass carriage clock, French *circa* 1900. Height 6½ in (16·5 cm). Belgravia 24 July £180 ($432)

Enamelled and brass carriage clock, French late 19th century. Height 5¾ in (14·6 cm). Belgravia 24 July £210 ($504)

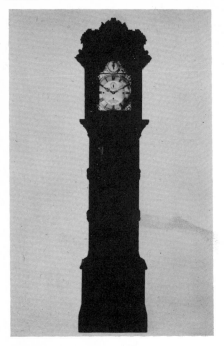

Carved oak long-case clock by *Tos Evans*, *London*, English mid 19th century. Height 96 in (244 cm). Belgravia 9 January £460 ($1,104)

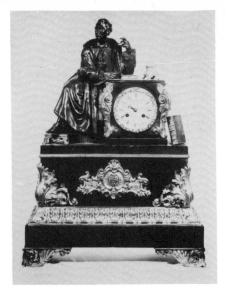

Gilt-bronze mounted sculptural mantel clock. French mid 19th century. Height 24 in (61 cm). Belgravia 24 July £90 ($216)

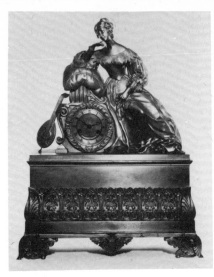

Gilt-metal sculptural clock, inscribed on the back-plate *Lèpin a Paris*, French mid 19th century. Height 21 in (53 cm). Belgravia 9 January £95 ($228)

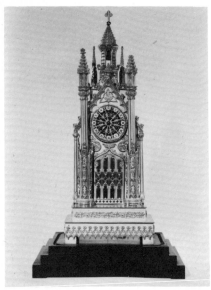

Brass cathedral clock, French mid 19th century. Height 24½ in (61·6 cm). Belgravia 27 November £250 ($600)

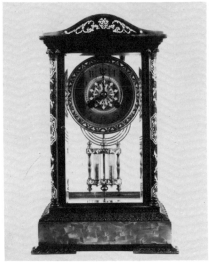

Champlevé enamel and onyx mantel clock, French mid 19th century. Height 13 in (33 cm). Belgravia 9 January £270 ($648)

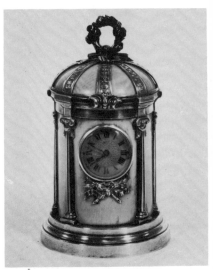

Silver-mounted circular ivory desk clock stamped *Bointaburet à Paris*, French *circa* 1885. Height 4½ in (11·5 cm). Belgravia 24 January £300 ($720)

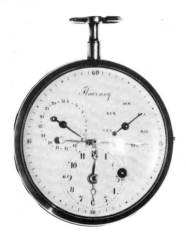

Silver cased verge watch by Flournoy, 1st quarter of the 19th century. Diameter 2⅐ in (5·5 cm). New Bond Street 2 December £130 ($312)

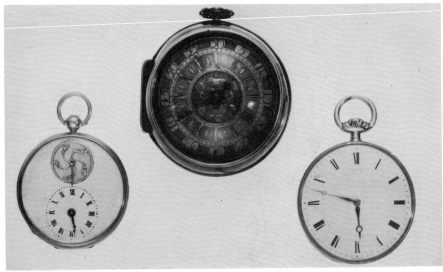

Left: Gold cylinder watch signed Breguet No 6091. Diameter 1¾ in (4·4 cm). New Bond Street 4 February £320 ($768)
Centre: Silver pair cased verge watch No 204 by Jasper Taylor of Grays Inn *circa* 1700. Diameter 2⅐ in (5·6 cm). New Bond Street 4 February £480 ($1,152)
Right: Breguet No 371(0) quarter-repeating keyless cylinder watch, one of a series made by Edward Brown upon his succession to the proprietorship of the Breguet business in the mid 19th century. Diameter 1¾ in (4·5 cm). New Bond Street 4 February £720 ($1,728)

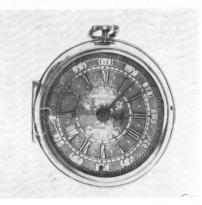

English gold pair cased verge watch No 845 by Henry Massy, hallmarked 1699. Diameter 2 1/16 in (5·1 cm). New Bond Street 18 March £900 ($2,160)

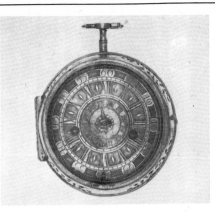

English gilt-metal pair cased alarum verge watch by Nicholas Bovovet *circa* 1710. Diameter 2 3/16 in (5·6 cm). New Bond Street 18 March £560 ($1,342)

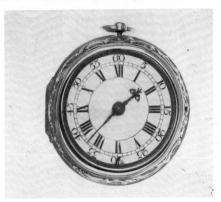

English repoussé gold pair cased verge watch No 3415 by Thomas Tompion and Edward Banger of London, the inner case hallmarked 1703 and the outer 1730. Diameter 2 1/16 in (5·3 cm). New Bond Street 18 March £650 ($1,560)

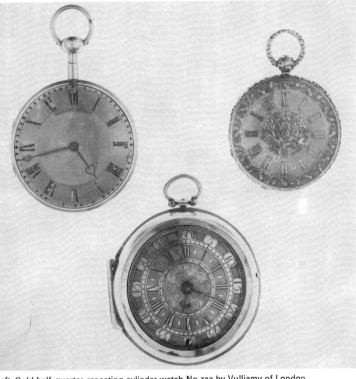

Left: Gold half-quarter-repeating cylinder watch No zaa by Vulliamy of London, hallmarked 1815. Diameter 2 in (5 cm). New Bond Street 20 May £440 ($1,058)
Centre: Silver pair cased verge watch by Thomas Windmills of London *circa* 1700. Diameter 2 5/16 in (5·9 cm). New Bond Street 20 May £780 ($1,872)
Right: Gold lever watch No 21009 by Henry W Harrison of Liverpool, first half of the 19th century. Diameter 1 3/4 in (4·4 cm). New Bond Street 20 May £190 ($456)

English gold pair cased cylinder watch No 3019 by Eardley Norton, London, hallmarked 1772. Diameter 1 7/8 in (4·8 cm). New Bond Street 18 March £420 ($1,008)

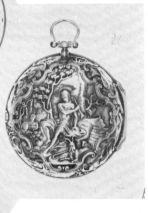

English gold repoussé cased cylinder watch No 5373 by George Graham, London *circa* 1730. Diameter 1 7/8 in (4·8 cm). New Bond Street 18 March £1,000 ($2,400)

English gold pair cased quarter-repeating verge watch No 8380 by C Cabrier, London *circa* 1740. Diameter 1 7/8 in (4·8 cm). New Bond Street 18 March £850 ($2.040)

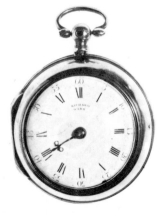

Silver pair cased verge watch by *Decky & Marsh of London*, the dial signed *Richard Warr*, English, case hallmarked 1780; sold with a gilt-metal pair cased verge watch by *William Thornton of London*, 18th century. New Bond Street 2 December £110 ($264)

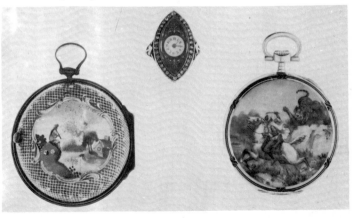

Left: Bilston enamel toy watch, 18th century. Diameter 1 11/16 in (4·9 cm). New Bond Street 20 May £240 ($576)
Centre: Gold, enamel and jewelled ring watch, 19th century. Length 1 1/8 in (2·8 cm). New Bond Street 20 May £540 ($1,296)
Right: Gold and enamel keyless dress watch, 19th century. Diameter 1 3/4 in (4·4 cm). New Bond Street 20 May £420 ($1,008)

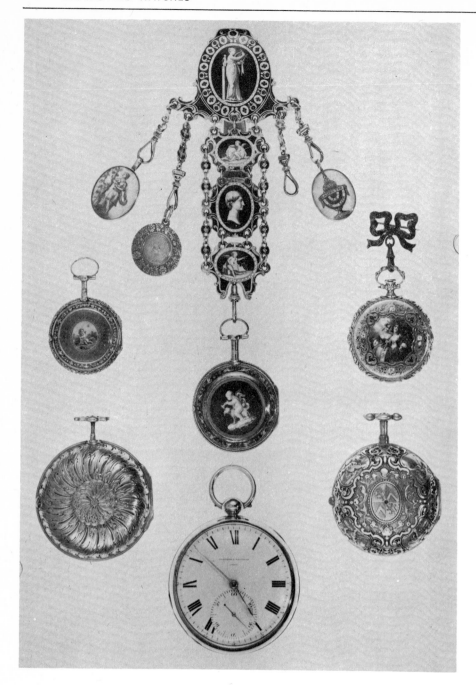

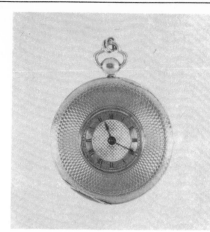

Gold very slim miniature fob watch, mid 19th century. Diameter 1⅜ in (3·5 cm). New Bond Street 18 March £260 ($624)

Centre: Gold and enamel watch and chatelaine inscribed *Sant Gendre en Madrid*, 18th century. Length overall 6⅞ in (17·5 cm). New Bond Street 4 February £780 ($1,872)

Left: Gold and enamel verge watch No 29034 by Bordier of Geneva *circa* 1790. Diameter 1¼ in (3·2 cm). New Bond Street 4 February £320 ($768)

Right: Gold and enamel cylinder watch, 19th century. Diameter 1½ in (3·8 cm). New Bond Street 4 February £180 ($432)

Left: Gold pair cased cylinder watch No 5738 by Ellicott of London, hallmarked 1766. Diameter 1¹³⁄₁₆ in (4·9 cm). New Bond street 4 February £1,000 ($2,400)

Right: Silver-gilt quarter-repeating verge watch No 405 by J Hubert of London *circa* 1730. Diameter 1¹³⁄₁₆ in (4·5 cm). New Bond Street 4 February £320 ($768)

Centre: Gold pocket chronometer No 1292 by Parkinson and Frodsham, hallmarked 1820. Diameter 2¹⁄₁₆ in (5·6 cm). New Bond Street 4 February £520 ($1,248)

19th-century silver and pearl set centre second lever watch made for the Chinese market. Diameter 2⁷⁄₁₆ in (5·6 cm). New Bond Street 18 March £600 ($1,440)

Pair cased verge watch No 329 by *John Baker of King Street, Covent Garden*, English *circa* 1780. Diameter 1¹³⁄₁₆ in (4·9 cm). New Bond Street 2 December £140 ($336)

Gold and enamel slim keyless dress watch by Cartier, 20th century. Diameter 1⅞ in (4·7 cm). New Bond Street 2 December £400 ($960)

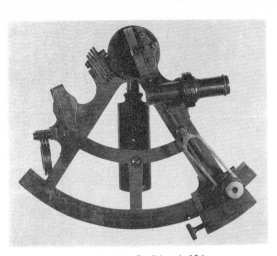

Brass sextant by Cary of London, English early 19th century. Radius 8½ in (22 cm). Belgravia 4 December £85 ($204)

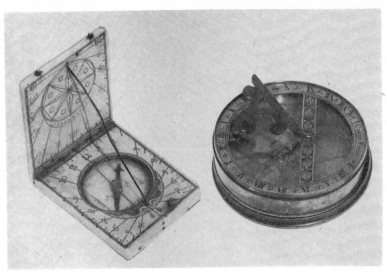

Ivory diptych dial by Conrad Karner early 17th century. Length 2¾ in (7 cm). New Bond Street 4 February £600 ($1,440)

Circular brass pocket sundial by John Coggs mid 18th century. Diameter 3⅛ in (8 cm). New Bond Street 4 February £260 ($624)

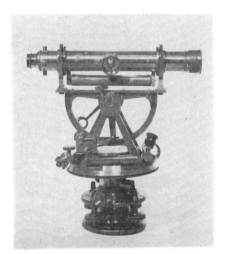

Brass Ramsden type altizimuth theodolite by R F Andrews, English mid 19th century. Length of tube 10 in (26 cm). Belgravia 4 December £130 ($312)

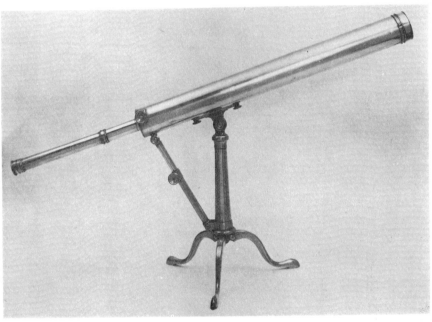

Brass refracting table telescope by Cary of London *circa* 1800. Diameter of barrel 2 7/16 in (6·5 cm) New Bond Street 8 April £280 ($672)

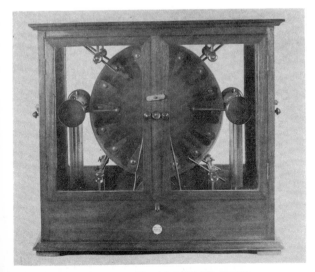

Wimshurst electric influence machine, label of *Griffin, Garrick Street, London*, English, *circa* 1900. Width 26 in (66 cm). Belgravia 4 December £200 ($480)

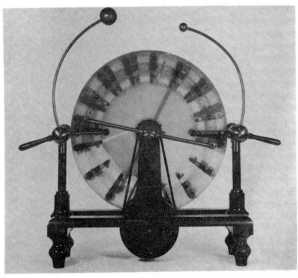

Electric influence machine, early 20th century. Width 26 in (66 cm). Belgravia 4 December £130 ($312)

Musical instruments

Specialist sales of musical instruments, pioneered by Sotheby's in New Bond Street, have now been taking place for nearly four years. This is a very specialised field and many of the instruments, especially those at the lower end of the price scale, are purchased by practising musicians. To form a collection of musical instruments would require considerable study and advice but this is a new field full of opportunity.

Naturally the finest violins by the leading Italian 17th- and 18th-century makers are now beyond the upper price limit of this book but, as can be seen in the following pages, it is still possible to buy good 18th-century instruments; that by Crescenzio Ugar of Rome, made, according to the label, in the year 1776, is particularly noteworthy, having fetched £720 ($1,728) at New Bond Street on 14 February. For less money, an attractive violin by the English maker George Craske (1797-1888) was sold for £320 ($768) at New Bond Street in June.

In general, fine woodwind instruments fall into a lower price-bracket than stringed instruments and we are able to illustrate some outstanding examples. A very good ivory seven-keyed flute with silver mounts dating from about 1800 and made by Goulding and Company of London, fetched £400 ($960) at Bond Street on 25 April and, at a more modest level, a good quality early 19th-century boxwood double flageolet by John Simpson of London was sold for £220 ($528) at the same location in June and a five-keyed boxwood clarinet with ivory mounts, brass keys and an ebony mouthpiece by Robert Wolff and Co. of London fetched only £100 ($240) in the same sale.

Musical instruments are essentially functional objects and a great deal of the pleasure to be derived from owning a fine piece is in the playing of it. Nevertheless, some magnificent collections have been formed by private individuals who are unable to play themselves but who are great admirers of music and have been willing to lend the instruments to musicians who have neither the money nor the opportunity to purchase examples themselves. As the prices in this section show, it is still possible to buy good instruments for fairly modest sums which, at the same time as giving pleasure to the owner, may serve to benefit others.

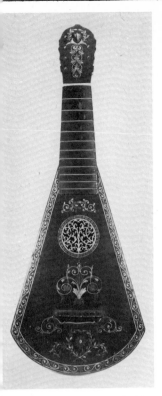

Harp guitar in maple, decorated with gilt floral scrollwork. Total length 33 in (83 cm). New Bond Street 25 April £220 ($528)

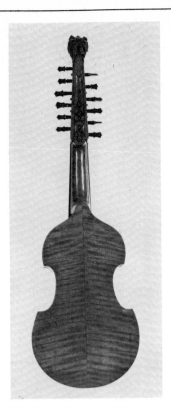

Viola d'amore by Joannes Guidantus, Bologna 1730, bearing its original manuscript label. Length of back 16 in (40·7 cm). New Bond Street 6 June £900 ($2,160)

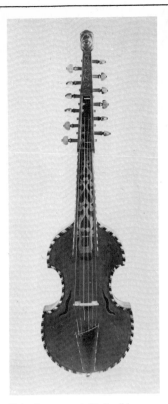

Viola d'amore, probably English. Length of back 14½ in (38·6 cm). New Bond Street 25 April £620 ($1,488)

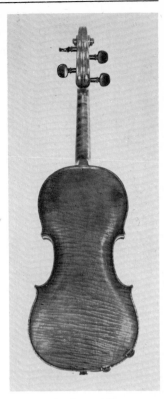

A violin by Jacobus and Marcus Stainer Absam, unlabelled. Length of back 13¾ in (35 cm). New Bond Street 6 June £950 ($2,280)

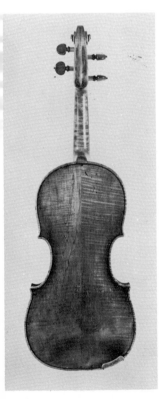

Violin by Johannes Florenus Guidantus, Bologna 1730. Length of back 14⅟₁₆ in (35·6 cm). New Bond Street 25 April £850 ($2,040)

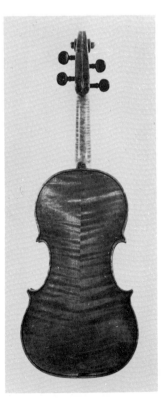

English violin by George Wulme Hudson, labelled *Antonio Gragnani fecit Liburni Anno 1752*. Length of back 14 in (35·5 cm). New Bond Street 14 February £750 ($1,800)

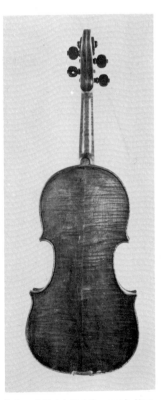

Italian violin labelled *Crescenzio Ugar fecit Romae anno 1776*. Length of back 14¼ in (36·2 cm). New Bond Street 14 February £720 ($1,728)

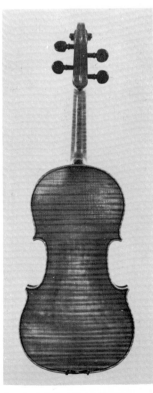

French violin by Honore Derazey, bearing its original label, mid 19th century. Length of back 14⅛ in (35·8 cm). New Bond Street 6 June £650 ($1,560)

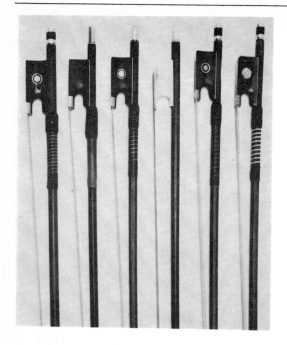

A　B　C　D　E　F

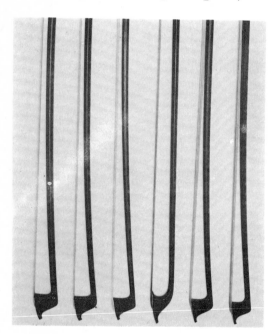

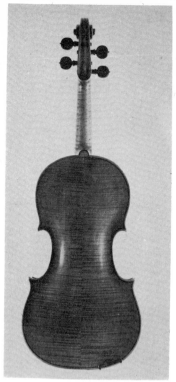

Italian violin labelled *David Tecchler Liutaro fecit Romae Anno 1709*. Length of back 14$\frac{1}{16}$ in (35·7 cm). Sold with a violin bow by Johs O Paulues. New Bond Street 14 February £600 ($1,440)

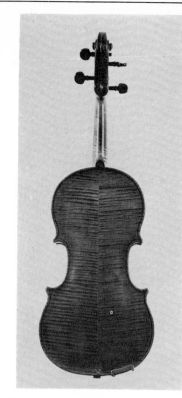

English violin by George Craske (1797-1888). Length of back 14$\frac{1}{8}$ in (35·8 cm). New Bond Street 6 June £320 ($768)

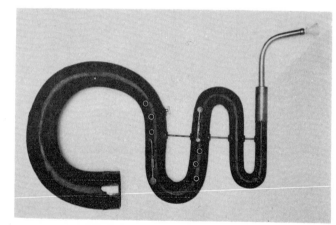

An English serpent of leather-bound wood with brass mounts, *circa* 1830. Total length of tube 94$\frac{1}{4}$ in (215 cm). New Bond Street 6 June £380 ($912)

A　Chased gold and tortoiseshell-mounted violin bow by A R Bultitude. New Bond Street 6 June £420 ($1,008)

B　Chased gold and ebony-mounted violin bow by W E Hill & Sons. New Bond Street 6 June £380 ($912)

C　Violin bow by Forster. New Bond Street 6 June £340 ($792)

D　Gold-mounted violin bow by W E Hill and Sons. New Bond Street 6 June £420 ($1,008)

E　Silver-mounted violin bow by James Tubbs, stamped *Jas Tubbs* on the shaft. New Bond Street 6 June £520 ($1,248)

F　Gold and tortoiseshell-mounted viola bow by W E Hill and Sons. New Bond Street 6 June £420 ($1,008)

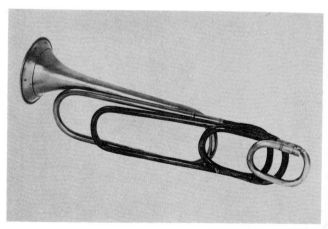

A brass natural trumpet by Joseph Wolf, Prague, engraved on the garland *Wolf in Prag*, late 18th/early 19th century. New Bond Street 6 June £550 ($1,320)

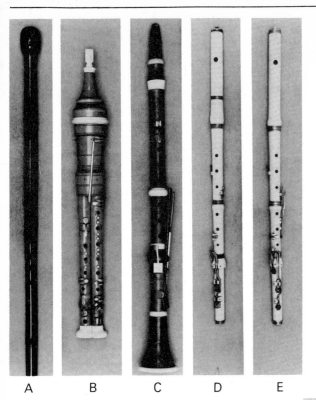

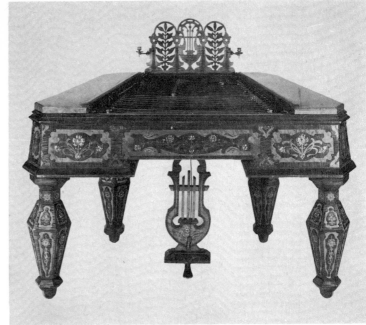

Cimbalom by Antal Habits, Budapest late 19th century. Maximum width 59 in (149·9 cm). New Bond Street 25 April £1,000 ($2,400).

A B C D E

A A walking stick flute of rosewood, engraved with the initials C.G. Length 34¾ in (88·2 cm). New Bond Street 6 June £140 ($336)

B Boxwood double flageolet by John Simpson, London, stamped *Simpson, London*, ivory mounts and silver keys, *circa* 1825. Length 19¼ in (48·9 cm). New Bond Street 6 June £220 ($528)

C A five-key boxwood clarinet by Robert Wolff and Co, stamped *Robert Wolff & Co, 20 St Martins-le-Grand, London*, ivory mounts, brass keys and ebony mouthpiece, *circa* 1845. Length 23⁵⁄₁₆ in (59·2 cm). New Bond Street 6 June £100 ($240)

D Six-keyed ivory flute with turned silver mounts and silver keys, *circa* 1815. Sounding length 23⁵⁄₁₆ in (59·2 cm). New Bond Street 25 April £160 ($384)

E Ivory seven-keyed flute by Goulding and Company, London, silver mounts and keys, including a long F with pewter plugs, *circa* 1800. Sounding length 23⁷⁄₁₆ in (New Bond Street 25 April £400 ($960)

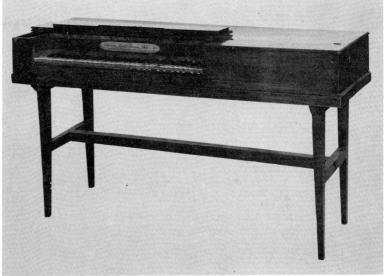

Square piano by Christopher Ganer, London 1781. Length 59½ in (151·1 cm). New Bond Street 25 April £320 ($768)

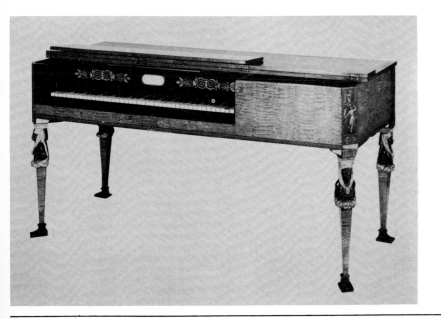

Viennese square piano by Johann Fritz. Length 65½ in (166·4 cm). New Bond Street 25 April £420 ($1,008)

Furniture

Much antique furniture is as serviceable as its modern counterpart. It is often less expensive even if it has an obvious superiority in quality of workmanship and materials over the contents of a modern furnishing store. In financial terms, buying old furniture of good quality has the added advantage that it will at least hold its value.

There are certainly collectors who aim to assemble large groups of furniture illustrating a style or period; far more numerous however, are those who attend a saleroom to buy a table, writing desk, bookcase, games table or a set of chairs in preference to furnishing their homes with modern pieces. Thus in this field, more than in any other, the epithet 'collector' is largely extraneous.

The furniture illustrated here ranges from 16th- and 17th-century examples in oak and walnut to pieces from the Arts and Crafts movement made at the end of the 19th century. Art Nouveau, Art Deco and modernist furniture will be found in the appropriate section. Surprisingly it is possible to include a number of good examples of French 18th-century furniture, some of it by named makers. French seat furniture is often more decorative than functional but a pair of fine Louis XVI side chairs will make a worthy addition to most rooms.

English 18th-century furniture is more practical and is generally more sober. Several good examples are illustrated. However, it is no longer possible to purchase fine George II, George III or Regency furniture cheaply. Most of the pieces shown in the following pages tend towards the upper limit of this book. Nevertheless the fine Irish George II card table or the George IV rosewood library table at £1,000 ($2,400) and £780 ($2,040) respectively represent very good value. Substantial pieces of 18th-century furniture which fetch much below these prices should be treated with caution. Intending purchasers should always ascertain the degree of restoration that has been undertaken, as this has a considerable bearing on the value.

If 18th-century furniture has now become fairly expensive, that of the 19th century of good quality still often sells for very modest sums. Prices of between £100 ($240) and £200 ($480) are paid regularly for pieces of real artistic merit, and some of the Arts and Crafts furniture will fetch much less. In the following pages we illustrate a set of five dining chairs in walnut by the noted early 20th-century English maker Arthur W. Simpson, which fetched £45 ($107), a set of six beechwood dining chairs which was sold for £58 ($139) and a set of six oak side chairs, of simple but pleasing proportions, which realised £68 ($163), in every case a price much lower than the cost of a new set of modern wood chairs.

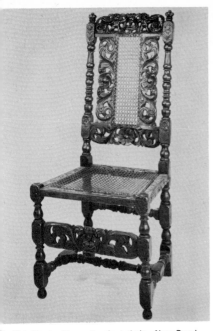

English Charles II caned walnut chair. New Bond Street 29 March £80 ($192)

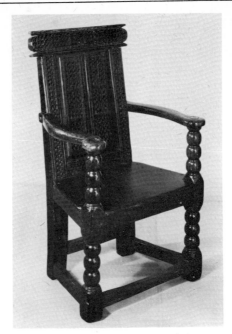

James I (and VI) oak and pinewood armchair, probably Scottish. New Bond Street 24 May £420 ($1,008)

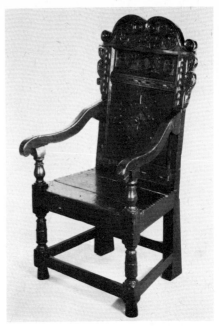

English late Elizabethan armchair. New Bond Street 24 May £720 ($1,728)

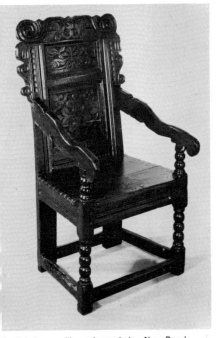

English Cromwellian oak armchair. New Bond Street 24 May £520 ($1,248)

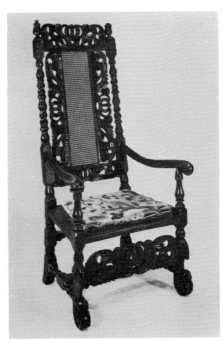

English James II caned walnut armchair. New Bond Street 29 March £400 ($960)

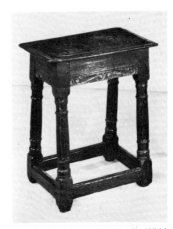

English late Elizabethan oak joint stool. Width 18½ in (47 cm). New Bond Street 24 May £620 ($1,488)

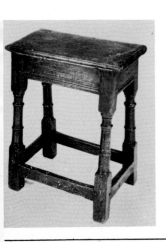

Left: English Charles I oak joint stool. Height 21½ in. (54·6 cm) width 16½ in (41·9 cm). New Bond Street 31 May £200 ($480)

Right: One of a pair of late 17th-century Flemish beechwood chairs covered in 17th-century verdure tapestry fragments. New Bond Street 29 March £620 ($1,488)

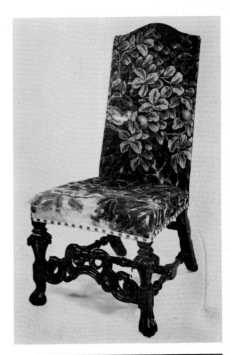

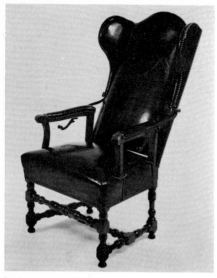

Louis XIV adjustable winged armchair, French second half of the 17th century. Los Angeles 21 April $2,500 (£1,041)

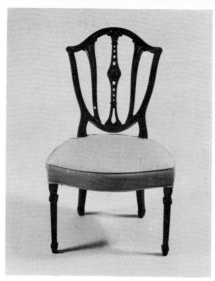

One of a set of six Federal mahogany dining chairs, American last quarter of the 18th century. Los Angeles 21 April $2,400 (£1,000)

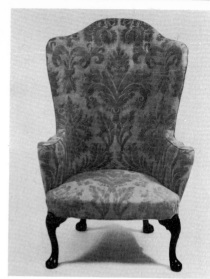

George I winged armchair, first quarter of the 18th century. Los Angeles 21 April $1,900 (£792)

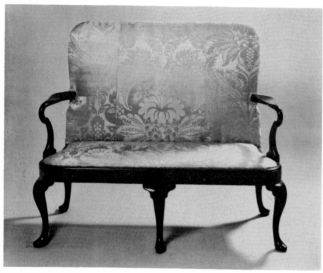

Queen Anne settee. Los Angeles 21 April $2,400 (£1,000)

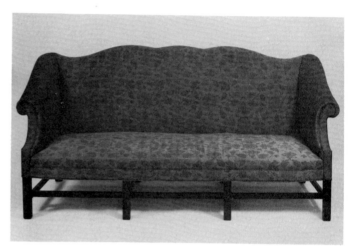

George II mahogany sofa, English mid 18th century. Length 84 in (213 cm) Los Angeles 21 April $1,200 (£500)

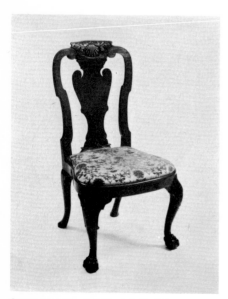

George I padoukwood side chair, English second quarter of the 18th century. Los Angeles 21 April $1,600 (£667)

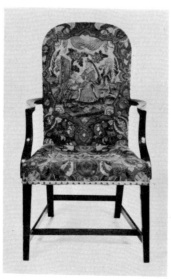

Early George II mahogany armchair, upholstered in contemporary *gros* and *petit point* needlework, English second quarter of the 18th century. New York 2 February $900 (£375)

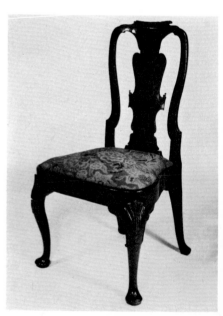

George I chair covered in 18th century red floral needlework. New Bond Street 25 January £350 ($840)

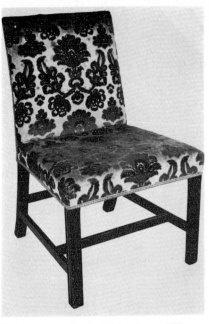

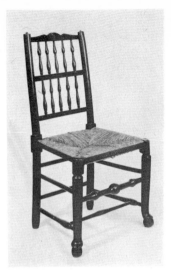

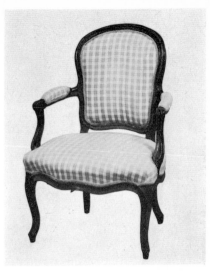

One of a set of twelve English late George II library chairs. New Bond Street 19 April £300 ($720)

One of a set of eight George II elmwood side chairs, English mid 18th century. New York 2 February $1,600 (£667)

One of a pair of Louis XV beechwood armchairs, French third quarter of the 18th century. Los Angeles 17 June $1,500 (£625)

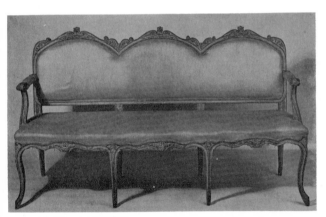

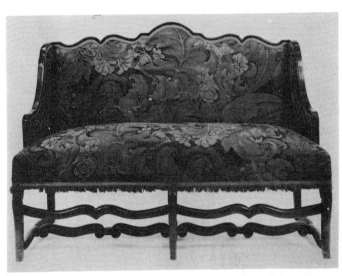

Italian painted settee, pale green painted decoration with gilded highlights, mid 18th century. Length 73 in (193 cm). New York 18 May $900 (£375)

Flemish fruitwood settee, third quarter of the 18th century. Length 62 in (157 cm). Los Angeles 21 January $1,000 (£417)

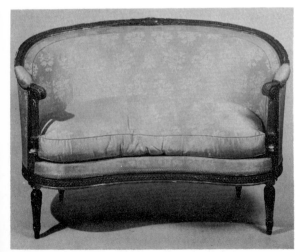

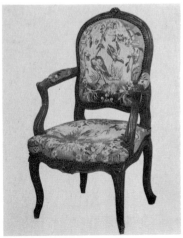

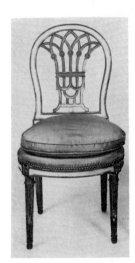

Louis XVI carved giltwood *canapé*, French late 18th century. Signed by Louis-Charles Carpentier, JME. One of the rails is stamped with a *fleur de lys*, possibly a mark of a royal palace or château. Length 48 in (122 cm). New York 18 May $1,500 (£625).

One of a pair of Louis XV carved walnut armchairs upholstered in Aubusson tapestry, French third quarter of the 18th century. Los Angeles 17 June $1,900 (£792)

One of a pair of Louis XVI carved and painted *chaises à la Reine*. French late 18th century. New York, 18 May $650 (£271)

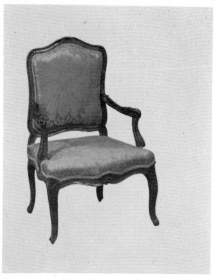

One of a pair of 18th-century German walnut armchairs. Los Angeles 17 June $1,600 (£667)

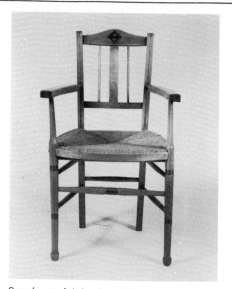

One of a set of six beechwood dining chairs, English *circa* 1900. Belgravia 3 April £58 ($139)

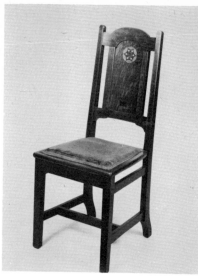

One of a set of six Arts and Crafts oak side chairs, English *circa* 1900. Belgravia 3 April £68 ($163)

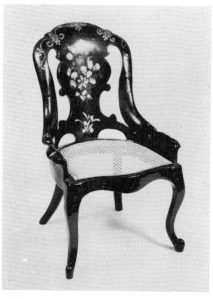

Papier mâché chair, English mid 19th century. Belgravia 6 February £30 ($72)

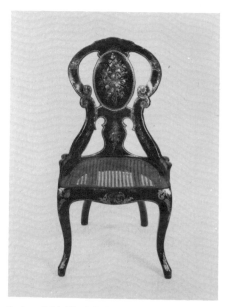

Papier mâché side chair, English mid 19th century. Belgravia 26 June £125 ($300)

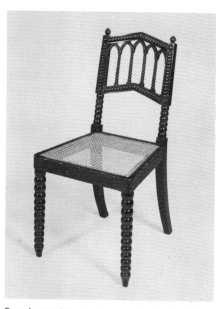

One of a set of six ebonised neo-Gothic side chairs, English *circa* 1830-40. Belgravia 24 July £90 ($216)

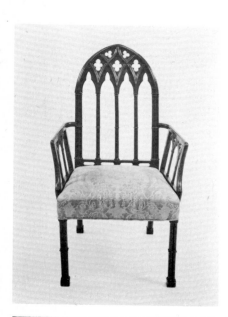

Left: George III mahogany 'Gothic' armchair, English first quarter of the 19th century. Los Angeles 21 April $1,300 (£512)

Right: One of a set of eight oak dining chairs by Heal and Sons, English *circa* 1910. Belgravia 31 July £200 ($480)

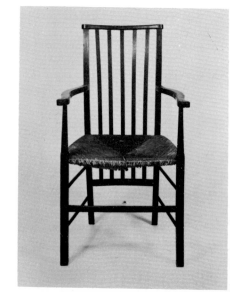

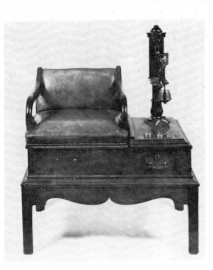

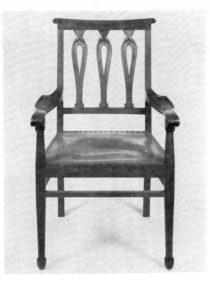

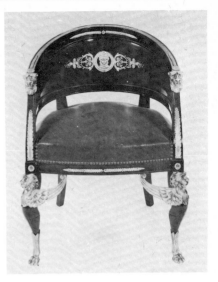

Mahogany weighing chair, the iron measuring scales inscribed *W. & T. Avery, Birmingham*. English mid 19th century. 44 by 34 in (107 by 86 cm). Belgravia 9 January £340 ($816)

Set of five walnut dining chairs by Arthur W Simpson of Kendal, English *circa* 1906. Belgravia 31 July £45 ($108)

Gilt-bronze mounted armchair in Empire style, French late 19th century. Belgravia 26 June £320 ($768)

Charles II walnut gateleg table, English third quarter of the 17th century. Height 29 in (73·7 cm). Los Angeles 21 April $1,100 (£458)

William and Mary walnut games table, English last quarter of the 17th century. Height 30 in (76·2 cm). Los Angeles 21 April $2,300 (£959)

William and Mary oak dressing table, English late 17th century. Height 28 in width 33 in (71·1 by 83·8 cm). New York 27 April $950 (£378)

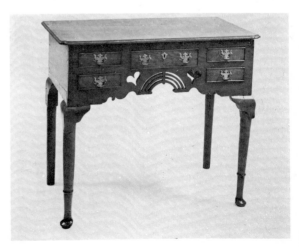

Charles II oak double gateleg table, English third quarter of the 17th century. Width 47½ in (121 cm). Los Angeles 21 April $1,400 (£584)

English oak side table early 18th century. Height 29 in (73·7 cm). Los Angeles 21 April $1,200 (£500)

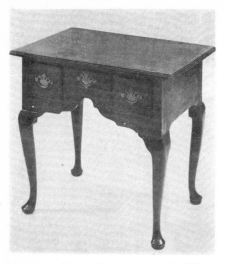

English oak table, early 18th century. Height 27 in (68·6 cm). Los Angeles 21 April $1,300 (£542)

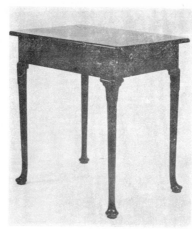

George II mahogany occasional table, English second quarter of the 18th century. Height 28½ in (72·2 cm). Los Angeles 21 April $1,000 (£417)

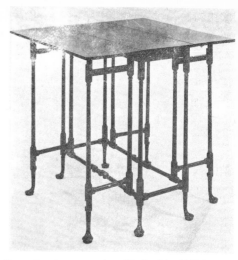

George II mahogany gateleg table, English mid 18th century. Height 28 in (71·1 cm). Los Angeles 21 April $1,800 (£750)

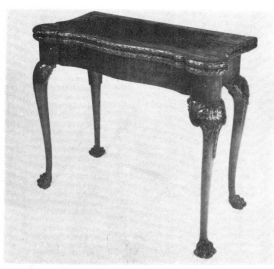

Irish George II mahogany card table, Width 3 ft (91·4 cm). New Bond Street 7 June £1,000 ($2,400)

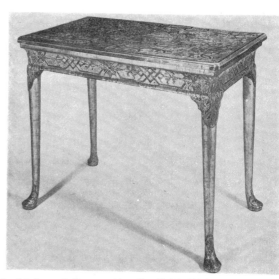

English George I gilt-gesso side table. Height 30½ in, width 38 in, depth 21½ in (77·5 by 96·5 by 54·6 cm). New Bond Street 19 April £660 ($1,584)

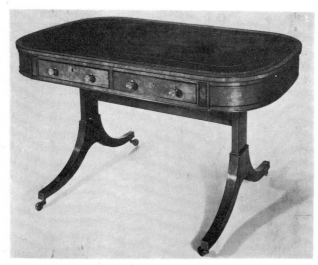

English late George III satinwood library centre table. Height 30 in (76·2 cm), width 53 in (134·6 cm), depth 22½ in (57·2 cm). New Bond Street 7 June £500 ($1,200)

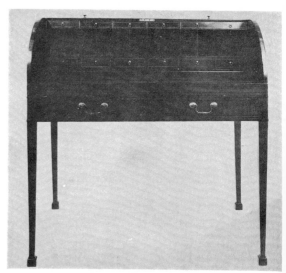

George III mahogany tambour writing table, English late 18th century. Height 38¾ in, width 40 in (98·5 by 102 cm). New York 2 February $900 (£375)

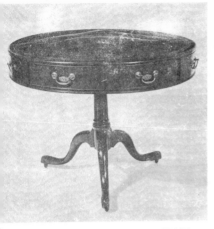

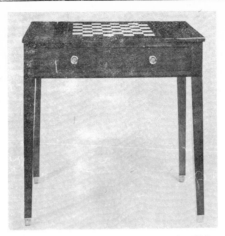

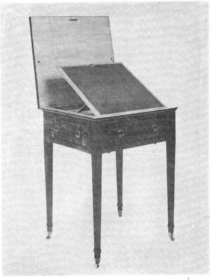

George II mahogany rent table, English mid 18th century. Height 31 in, diameter 42 in (79 and 107 cm). New York 27 April $1,600 (£667)

George III mahogany games table, English late 18th century. Height 30 in, width 30½ in (76 by 77·5 cm). New York 2 February $1,400 (£583)

George III mahogany work table, English late 18th century. Height 32 in, width 25 in (81 by 63·5 cm). New York 27 April $600 (£250)

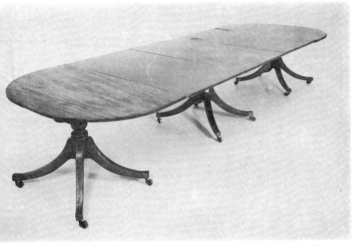

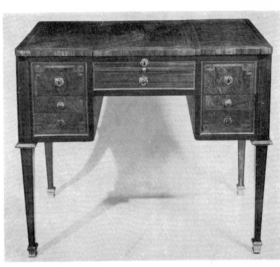

George III three-pillar mahogany dining table, last quarter of the 18th century. Maximum length 12 ft 6 in (381 cm). Los Angeles 21 January $2,400 (£1,000)

Louis XVI ormolu-mounted dressing table, veneered with panels of quartered tulipwood with beaded ormolu borders and purplewood, French late 18th century. Signed by Pierre-Harry Mewesen, JME. New York 18 May $2,300 (£959)

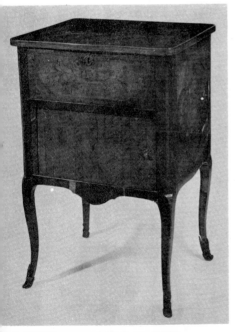

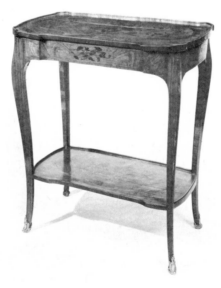

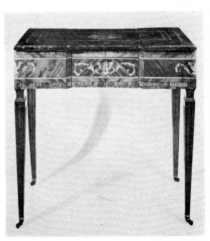

Louis XV/XVI marquetry *table de chevet*, third quarter of the 18th century, signed by François Gaspard Teune, JME. 31 by 19¾ in (79 by 50 cm). New York 18 May $2,000 (£833)

Louis XV marquetry writing table, French third quarter of the 18th century, signed by Etienne Levasseur, JME. 28¾ by 24½ in (73 by 62 cm). New York 18 May $1,600 (£667)

Italian parquetry dressing table, late 18th century. 31 by 32½ in (79 by 84·5 cm). New York 18 May $1,400 (£583)

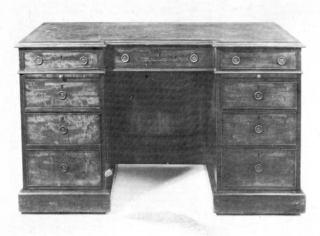

Regency mahogany pedestal writing table, English early 19th century, stamped Gillow. 32 by 54½ in (81·3 by 138 cm). New York 27 April $1,400 (£583)

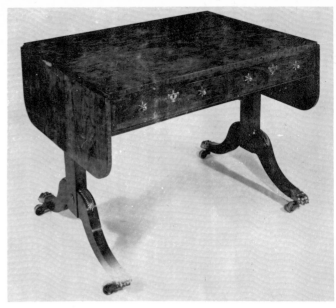

Regency Brazilian rosewood sofa table. Width 38 in, depth 29 in (97 cm by 74 cm). New Bond Street 25 January £850 ($2,040)

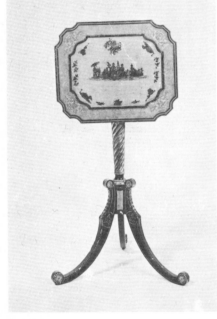

One of a pair of Regency painted and giltwood tripod tables, each top inset with a painted leather panel decorated with chinoiserie scenes in black and gold on cream ground. English early 19th century. Height 26¾ in, width 17 in (67 by 43 cm). New York 2 February $1,600 (£667).

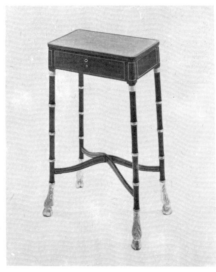

Regency giltwood and satinwood occasional table, English 18th/19th century. Height 29½ in (75 cm). Los Angeles 21 April $1,600 (£667)

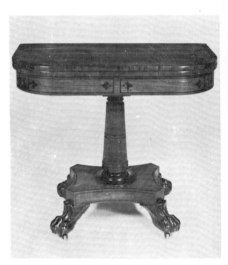

Mahogany card table, English mid 19th century. Width 36 in (91·5 cm). Belgravia 16 October £140 ($336)

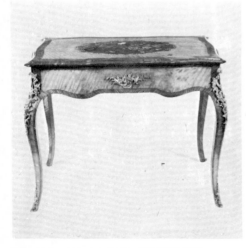

Satinwood and kingwood marquetry centre table, English mid 19th century. Width 40 in (102 cm). Belgravia 17 April £420 ($1,008)

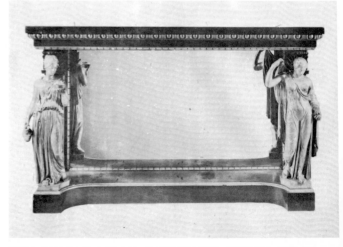

Giltwood and ebonised side table, English circa 1830. Width 66 in (168 cm). Belgravia 1 May £190 ($456)

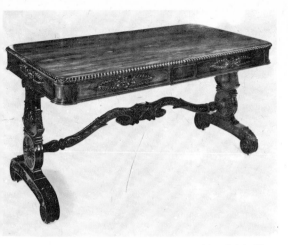

English George IV Anglo-Indian rosewood library table. Height 29 in (73·7 cm), width 57 in (144·8 cm), depth 30 in (76·2 cm). New Bond Street 7 June £780 ($1,872)

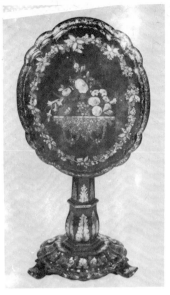

Mother-of-pearl inlaid papier mâché occasional table, English, *circa* 1850. Height 27½ in (70 cm). Belgravia 16 October £85 ($204)

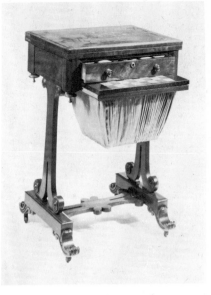

English rosewood combined games and work table, mid 19th century. Height 21 in (53·5 cm). Belgravia 20 February £90 ($216)

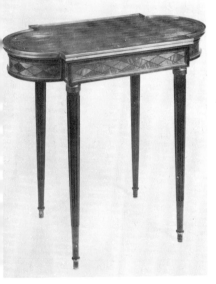

Mahogany marquetry centre table, French late 19th century. Width 31 in (78 cm). Belgravia 6 February £240 ($672)

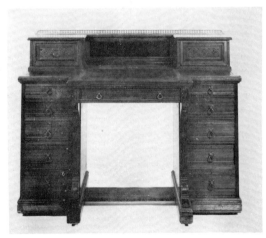

Mahogany writing desk by Gillow & Co, English *circa* 1870. Width 48 in (122 cm). Belgravia 3 April £190 ($456)

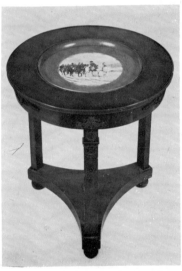

Mahogany centre table inset with a Sèvres porcelain plaque, the latter signed Guillon, French mid 19th century. Diameter 29 in (74 cm). Belgravia 15 May £400 ($960)

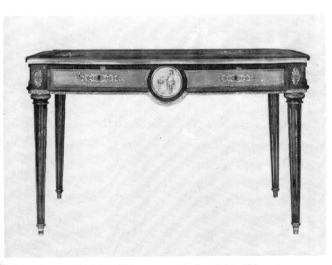

Satinwood centre table with gilt-bronze mounts, French late 19th century. Width 51¾ in (131 cm). Belgravia 26 June £650 ($1,560)

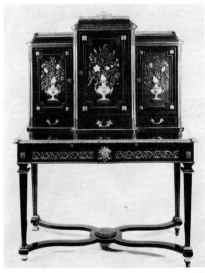

Pietra dura mounted ebony *bonheur-du-jour*, French mid 19th century. Width 46 in (117 cm). Belgravia 17 April £560 ($1,344)

George II black lacquer tripod table with Pontypool tinware top, third quarter of the 18th century. Height 27½ in (69 cm). Los Angeles 21 April $2,250 (£937)

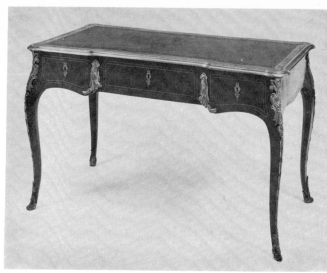

Ormolu-mounted kingwood *bureau plat*, French third quarter of the 19th century. Length 48 in (122 cm). Los Angeles 6 May $1,100 (£458)

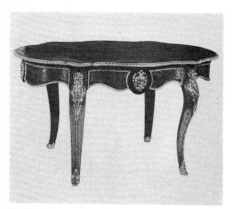

Boulle centre table, French second half of the 19th century. Width 60 in (152·5 cm). Belgravia 9 January £480 ($1,152)

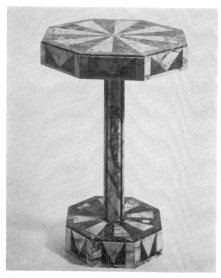

Marble occasional table, 20th century. Width 19½ in (49·5 cm). Belgravia 31 July £75 ($180)

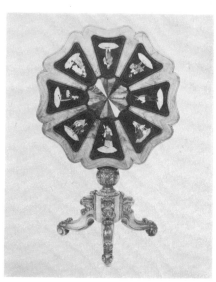

Walnut marquetry centre table, Italian mid 19th century. Width 32 in (81 cm). Belgravia 20 March £340 ($816)

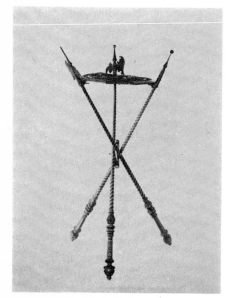

Cast-iron occasional table, German second half of the 19th century. Height 37 in (94 cm). Belgravia 12 June £50 ($120)

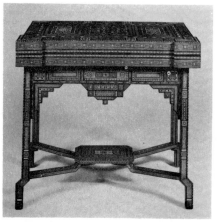

Inlaid Damascus games table, early 20th century. Width 35 in (89 cm). Belgravia 12 June £130 ($312)

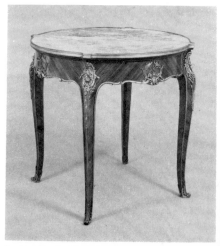

French kingwood centre table in Louis XV style, signed F. Linke, mid 19th century. Height 31 in (78·7 cm). Los Angeles 17 June $1,900 (£792)

Charles II oak and fruitwood chest of drawers, English third quarter of the 17th century. Height 40 in (101·6 cm) Los Angeles 21 April $1,100 (£458)

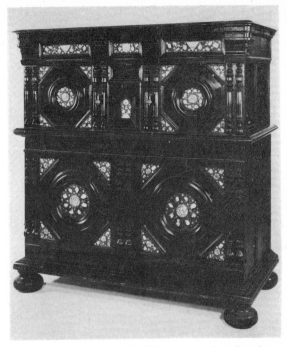

English Charles II oak chest inlaid with bone and mother-of-pearl, dated 1662. Width 47 in, depth 24 in (119·4 cm by 61 cm). New Bond Street 29 March £1,000 ($2,400)

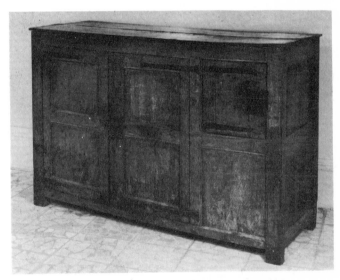

English Elizabethan oak hutch. Height 40 in, width 60 in, depth 23½ in (102 by 152 by 59 cm). New Bond Street 24 May £800 ($1,920)

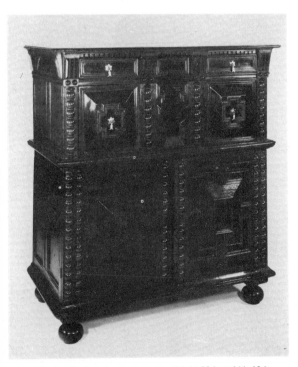

English Charles II oak and walnut chest. Height 50 in, width 46 in (127 cm by 116·8 cm). New Bond Street 29 March £950 ($2,280)

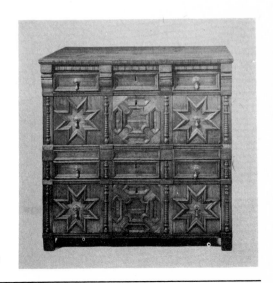

Right: Charles II oak chest on chest, English, late 17th century. Height 37½ in, width 39 in (95·2 by 99 cm). New York 27 April $1,300 (£542)

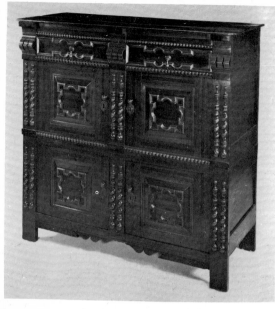

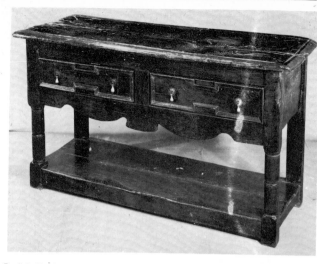

English Charles I small oak dresser. Height 30 in, width 53 in, depth 20 in (76 by 135 by 51 cm). New Bond Street 24 May £1,000 ($2,400)

English Charles II oak chest banded in palissanderwood. Width 49 in, depth 22½ in (124·5 cm by 57·2 cm). New Bond Street 29 March £850 ($2,040)

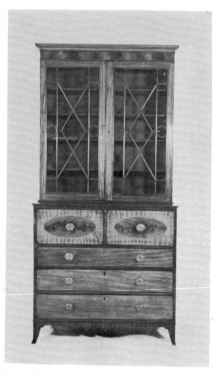

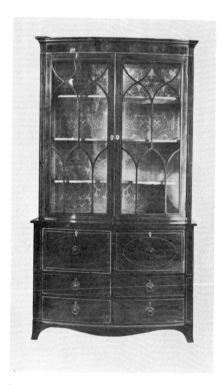

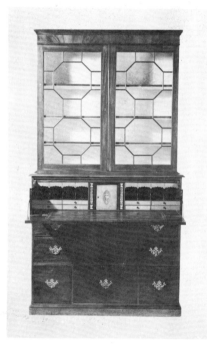

George III mahogany secretaire bookcase, English late 18th century. Height 7 ft 9 in, width 4 ft 3 in (236 by 130 cm). New York 27 April $1,900 (£790)

George III mahogany bureau bookcase, third quarter of the 18th century. Height 84 in (213 cm). Los Angeles 21 January $1,100 (£458)

George III mahogany bookcase chest of drawers, English last quarter of the 18th century. Height 82½ in, width 52¼ in (240 by 133 cm). New York 9 February $1,500 (£625)

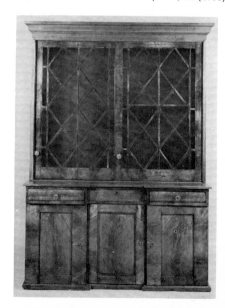

William IV mahogany breakfront bookcase, English first quarter of the 19th century. Height 89 in (226 cm). Los Angeles 17 June $1,000 (£417)

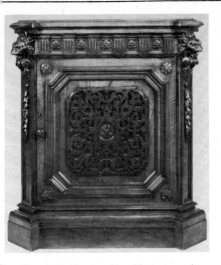

One of a pair of mahogany side cabinets stamped *Gillow & Co*, English, second half of the 19th century. Width 38 in (97 cm). Belgravia 1 May £130 ($312)

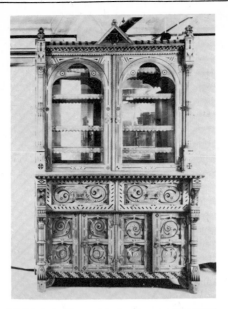

Inlaid oak double secretaire bookcase monogrammed BT. English dated 1875. 106 by 64 in (270 by 163 cm). Belgravia 21 July £580 ($1,392)

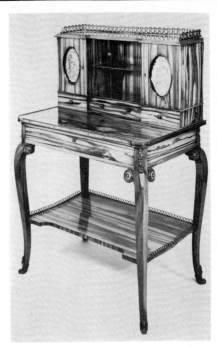

English Regency calamanderwood *bonheur-du-jour*, inset with *verre églomisé* panels. Width 28 in (71·2 cm). New Bond Street 7 June £1,000 ($2,400)

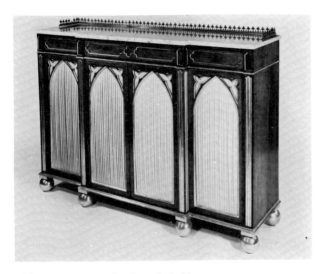

English Regency rosewood and parcel-gilt side cabinet. Height 37½ in (94·7 cm), width 55 in (139·7 cm). depth 16½ in (41·9 cm). New Bond Street 7 June £850 ($2,040)

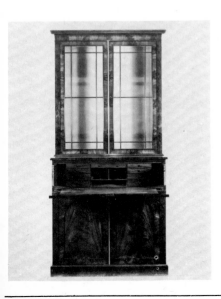

Left: Mahogany secretaire bookcase, English second quarter of the 19th century. 89 by 44 in (236 by 112 cm). Belgravia 9 January £340 ($816)

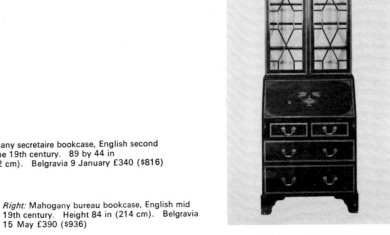

Right: Mahogany bureau bookcase, English mid 19th century. Height 84 in (214 cm). Belgravia 15 May £390 ($936)

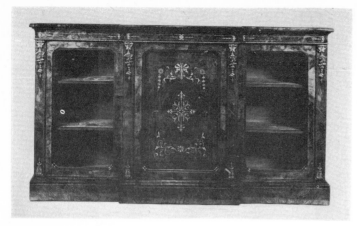

Inlaid burr-walnut side cabinet, English *circa* 1860. Width 70 in (178 cm).
Belgravia 9 January £460 ($1,104)

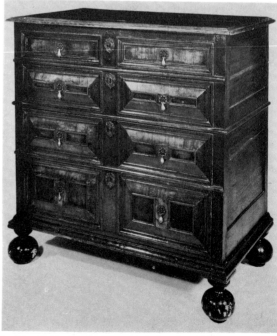

Flemish oak chest veneered in yew and walnut, late 17th century.
Width 40½ in, depth 23 in (102·9 cm by 58·4 cm). New Bond Street
29 March £650 ($1,560)

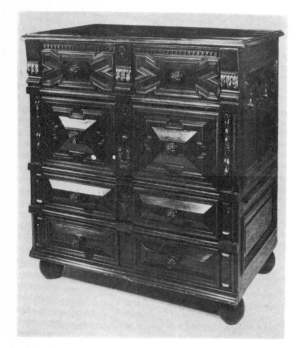

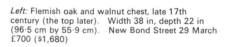

Left: Flemish oak and walnut chest, late 17th
century (the top later). Width 38 in, depth 22 in
(96·5 cm by 55·9 cm). New Bond Street 29 March
£700 ($1,680)

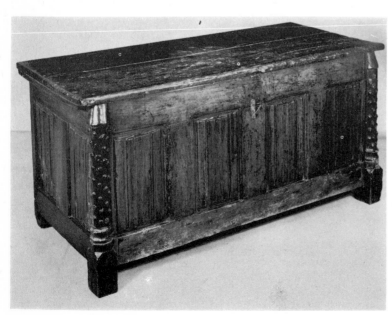

Late Gothic linenfold panelled chest. Height 28 in, width 58 in, depth 24½ in
(71 by 147 by 61·5 cm). New Bond Street 24 May £580 ($1,392)

Flemish oak chest, partly veneered in walnut, late 17th century.
Height 40 in, width 38 in (101·6 cm by 96·5 cm). New Bond Street
29 March £500 ($1,200)

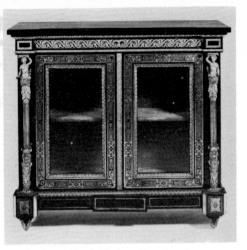

Black lacquer and boulle display cabinet, French third quarter of the 19th century. Height 45¾ in (116 cm). Los Angeles 6 May $1,000 (£417)

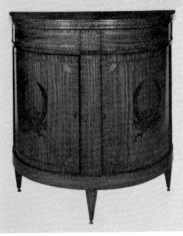

Painted satinwood side cabinet, English second half of the 19th century. Width 36 in (19·5 cm). Belgravia 6 February £170 ($408)

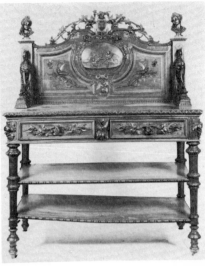

Relief-carved walnut buffet, French mid 19th century. 61 by 49½ in (155 by 126 cm). Belgravia 9 January £130 ($312)

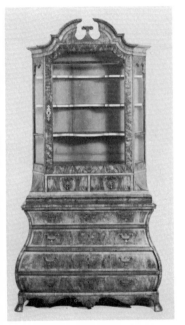

Dutch walnut bookcase-chest of drawers, mid 18th century. Height 89 in (226 cm). Los Angeles 21 January $2,000 (£833)

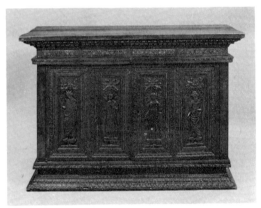

Italian Renaissance walnut side cabinet. Length 66½ in (164 cm). Los Angeles 17 June $1,800 (£750)

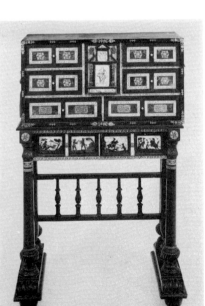

Venetian blue lacquer bureau bookcase, 19th-20th century. 8 ft 7½ in by 3 ft 11½ in (263 by 120 cm). New York 18 May $950 (£378)

George III mahogany library steps, English, late 18th century. Height 33½ in, width 24 in (85 by 61 cm). New York 27 April $900 (£375)

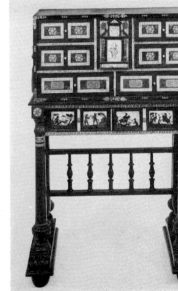

Spanish ivory and enamel inset cabinet on stand, 18th century (stand rebuilt). Height 48 in (122 cm). Los Angeles 6 May $1,600 (£667)

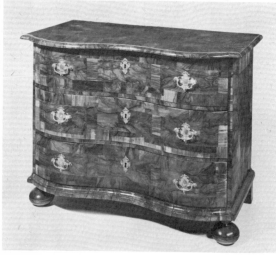

South German parquetry commode, the whole veneered in walnut, mid 18th century. Height 32¼ in, width 50 in (82 by 112 cm). New York 9 March $2,300 (£959)

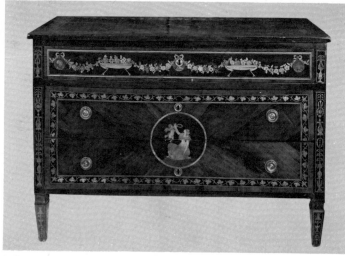

Italian Neo-classical marquetry commode, late 18th century. 33 by 49 in (84 by 125 cm). New York 18 May $2,500 (£1,042)

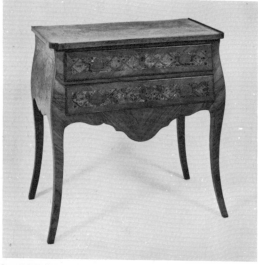

Swedish fruitwood commode, third quarter of the 18th century. Height 29 in (73·6 cm). Los Angeles 21 January $1,000 (£417)

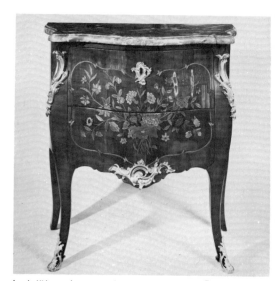

Louis XV ormolu-mounted marquetry commode, French mid 18th century. Height 35½ in, width 34½ in (90 cm by 87·5 cm). New York 18 May $2,500 (£1,042)

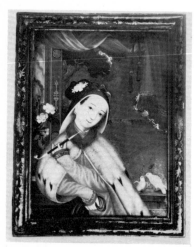

18th-century Chinese mirror painting. 9½ by 7 in (24·1 by 17·8 cm). New Bond Street 7 June £560 ($1,344)

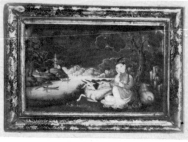

18th-century Chinese mirror painting. 4½ by 7¼ in (11·4 cm by 18 cm). New Bond Street 7 June £480 ($1,152)

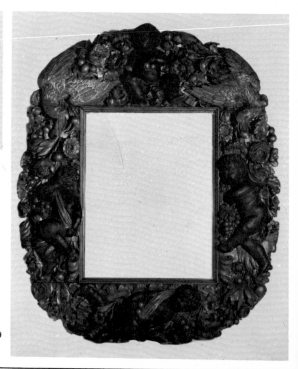

Right: English Charles II carved wood frame in the manner of Grinling Gibbons. 46 by 39 in (111·8 by 96·5 cm). New Bond Street 7 June £600 ($1,440)

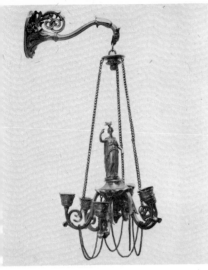

One of a pair of gilt-bronze wall candelabra, English
circa 1860. Width 11 in (28 cm). Belgravia
17 April £160 ($384)

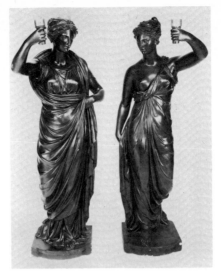

Pair of Regency black-painted plaster torchères
by Humphrey Hopper, dated 1808, Height 48 in
(122 cm). New Bond Street 25 January £480
($1,152)

One of a pair of late 16th-century Italian wood
chancel candlesticks. Height 55 in (140 cm).
New Bond Street 24 May £900 ($2,160)

Mahogany combined tantalus and games box,
English mid 19th century. Width 13 in (33 cm).
Belgravia 15 May £400 ($960)

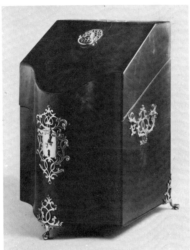

George III silver-mounted mahogany knife box,
English, third quarter of the 18th century, the silver
stamped T.W., London, *circa* 1765. Height 14¼ in,
width 9½ in (36·2 by 24·2 cm). New York
2 February $950 (£378)

One of a pair of George III mahogany bedside
cupboards, English last quarter of the 18th century.
Height 29½ in (75 cm). Los Angeles 21 April
$1,500 (£625)

Papier mâché sewing cabinet, English *circa* 1840.
Width 16 in (41 cm). Belgravia 16 October
£100 ($240)

Papier mâché tray inscribed *Peachey, 69 Regent
Street, London*, English *circa* 1830. Belgravia
16 October £70 ($168)

Right: Papier mâché tea caddy inscribed *Clay,
King St.. Covt. Garden*, English second quarter of
the 19th century. Width 7½ in (19 cm). Belgravia
16 October £65 ($156)

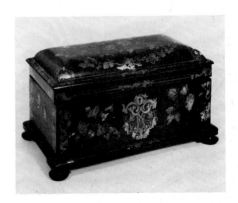

Carpets, tapestries and textiles

There are five basic groups of oriental carpets—Persian; Turkish; Caucasian, from what are now the Soviet states west of the Caspian sea; Turkoman, from the Soviet states of Turkmen, Uzbek, and Kazakh east of the Caspian sea; and Chinese.

Carpets are generally woven with wool, although goat's hair, camel's hair, cotton and silk are also used with some frequency. There are two main types of knots, the Sehna or Persian knot, in which the wool is knotted round one warp thread and looped under the other in an 'S' pattern, and the Ghiordes or Turkish knot which is knotted round two warp threads. Each knot is tied by hand and the finest Persian carpets can have anything between 500 and 1,000 knots per square inch. The Ardebil Mosque carpet in the Victoria and Albert Museum in London has a silk warp and weft and a wool pile, measures 34 by $17\frac{1}{2}$ feet and has 350 knots per square inch, making a total of 32 million knots. According to the inscription, it was woven by 'the slave of the Threshold Maqsud, the slave of the Holy Place of Kashan in the year 946' (1540 AD).

Since the Russian Revolution, few carpets have been woven in the Soviet states, thus effectively bringing to an end the production of genuine Caucasian and Turkoman carpets and rugs, although pieces of the same patterns are woven in what is today Pakistan. This latter area, previously called Beluchistan, also produced carpets of a distinctive type. Carpet weaving is still carried on actively in Iran and Turkey.

To distinguish old examples of Middle Eastern weaving from modern pieces requires considerable expertise, although any carpet more than about 80 years old falls into the category of 'antique' and can make a high price at auction. Illustrated in the following pages are some good examples of rugs most of which have been made since 1900 but all of which are of reasonable quality. As can be seen, the price range for these is between approximately £500 and £1,000 and, whilst worthwhile rugs can be purchased for less than this lower figure, the less a piece costs, the more the suspicion with which it should be treated.

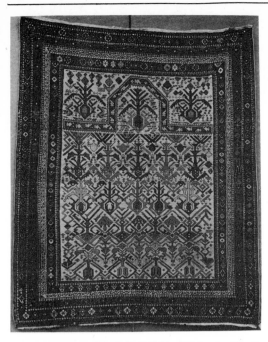

Shirvan prayer rug. 57 by 49 in (144·8 by 124·4 cm). New Bond
Street 1 March £650 ($1,560)

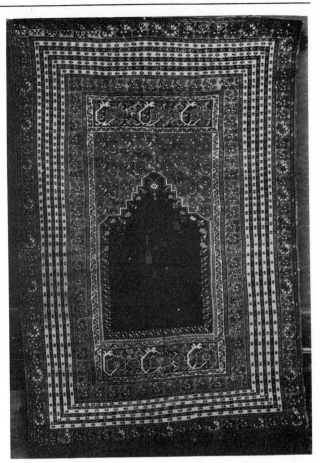

Ghiordes prayer rug, 18th century. 76 by 51 in (193 by 129·5 cm).
New Bond Street 1 March £420 ($1,008)

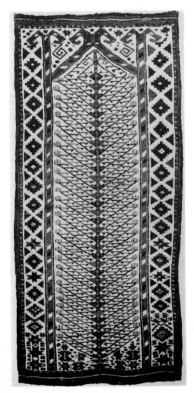

Beshir rug. 73 by 43 in (185 by 109 cm).
New York 1 March $1,900 (£791)

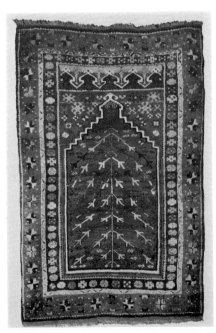

Turkish prayer rug, 18th century. 60 by 40 in
(152 by 102 cm). New York 1 March $2,300
(£958)

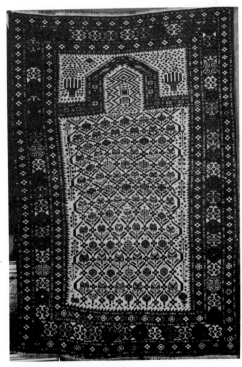

Daghestan prayer rug. 69 by 48 in (175 by
122 cm). New Bond Street 25 January
£600 ($1,440)

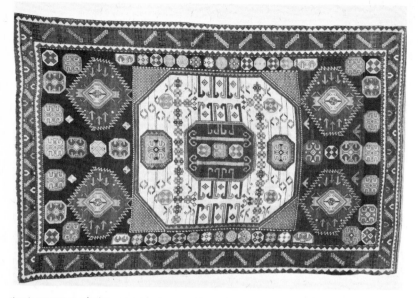

Kazak rug with a central ivory rectangle centred by a wine red octagon, 72 by 110 in (183 cm by 279 cm). New York 1 February $1,800 (£750)

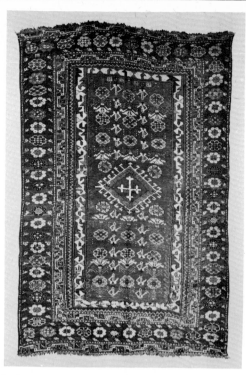

Bergama rug, 19th century. 75 by 56 in (191 by 142 cm). New York 1 March $1,800 (£750)

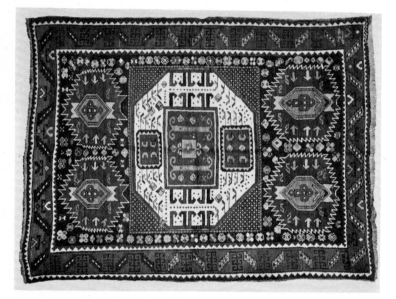

Kazak rug. 82 by 61 in (208 by 165 cm). New York 1 March $2,500 (£1,042)

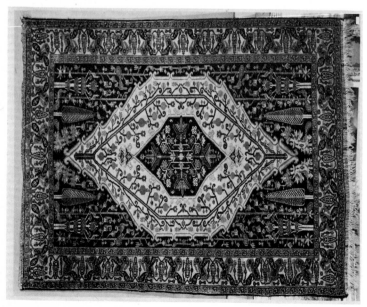

Bijar rug dated 1304 (about 1887 AD). 66 by 56 in (168 cm by 137 cm).
New Bond Street 25 January £920 ($2,208)

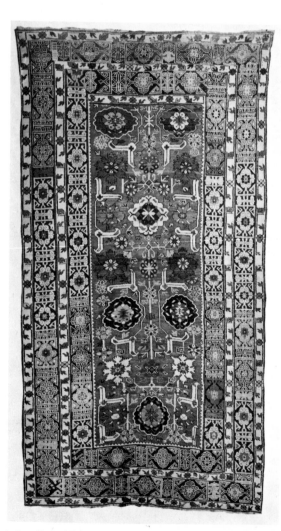

Antique Kouba long rug, central red rectangle woven with leaves and flowerheads in shades of green, blue, brown and ivory. 129 by 82 in (328 by 208 cm). New York 1 February $2,500 (£1,042)

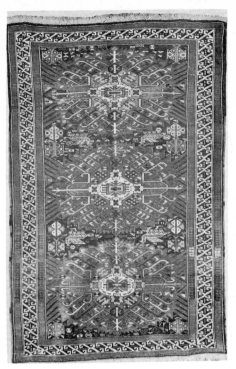

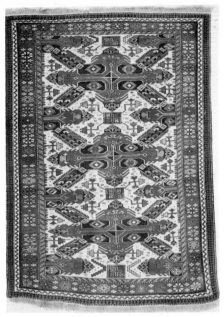

Shirvan rug, the ivory field with three cruciform medallions in shades of rust, black, blue and gold. 41 by 56 in (104 by 142 cm). New York 1 February $1,900 (£790)

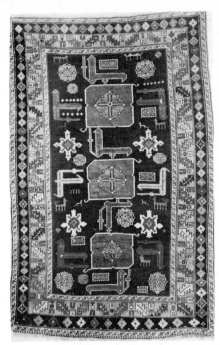

Antique Kouba rug, the midnight-blue field woven with three red polygons with gold and brown borders. 40 by 64 in (102 by 163 cm). New York 1 February $2,100 (£875)

Seichur rug. 79 by 52 in (200 cm by 132 cm). New York 1 March $2,300 (£958)

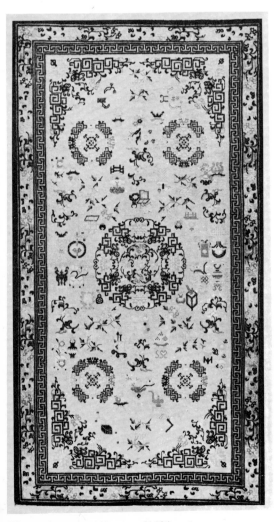

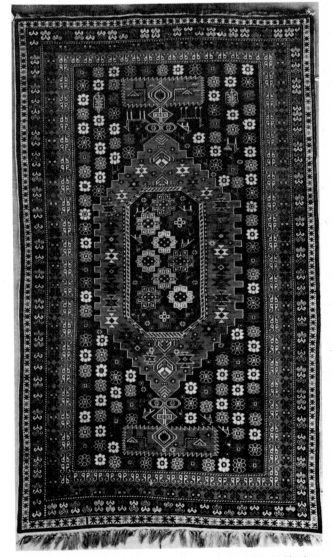

Chinese pale green and blue rug, mid 19th century. 135¾ by 72 in (345 by 183 cm). Los Angeles 1 July $1,700 (£708)

Shirvan rug. 90 by 56 in (228·6 by 142·2 cm). New Bond Street 1 March £780 ($1,872)

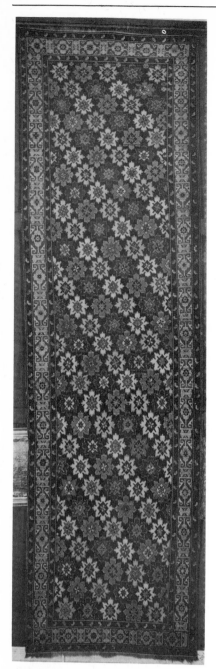

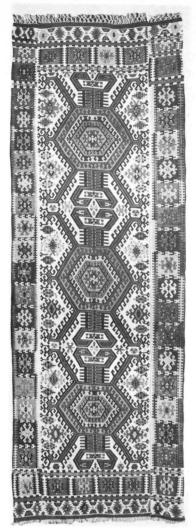

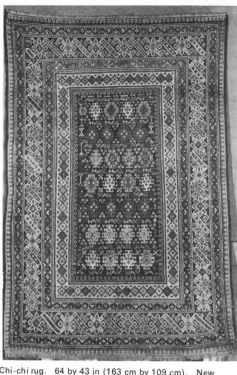

Chi-chi rug. 64 by 43 in (163 cm by 109 cm). New Bond Street 25 January £600 ($1,440)

Karabagh *kelim* runner with an ivory field and a border of red, green and ivory. 48 by 144 in (122 by 366 cm). New York 1 February $1,200 (£500)

Shirvan runner. 14 by 4 ft (427 by 122 cm). New Bond Street 25 January £700 ($1,680)

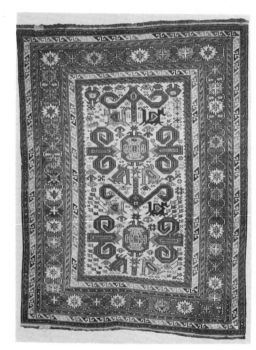

Perepedil rug. 62 by 48 in (157 by 122 cm). New York 1 March $1,400 (£583)

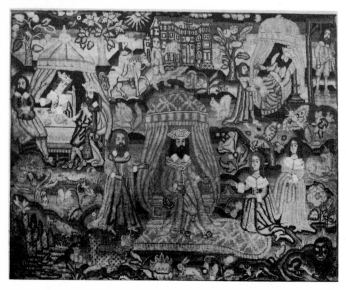

English Charles I embroidered picture depicting a scene from the story of Esther and King Ahasuerus. 17 by 21½ in (43·2 by 54·6 cm). New Bond Street 1 March £800 ($1,920)

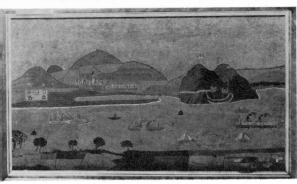

Embroidered wool picture depicting Dunbarton, English mid 19th century. Width 30 in (76 cm). Belgravia 15 May £38 ($91)

One of two embroidered wool pictures, English mid 19th century. Width 30 in (76 cm). Belgravia 15 May £28 ($67)

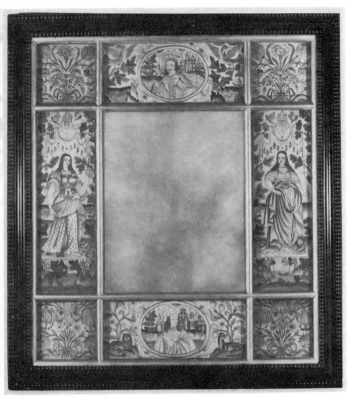

English Charles I silkwork mirror. 37 by 34 in (94 by 86·4 cm). New Bond Street 7 June £650 ($1,560)

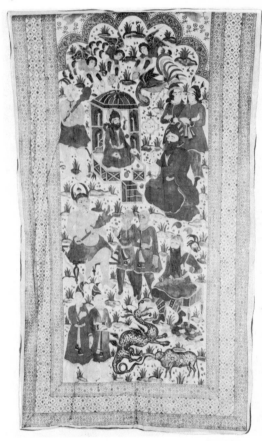

Indian cotton wall hanging printed from blocks and hand-painted with a named figure of Saloman, dated AH 1227 (AD 1912). 115 by 59 in (292 by 150 cm). Belgravia 6 February £25 ($60)

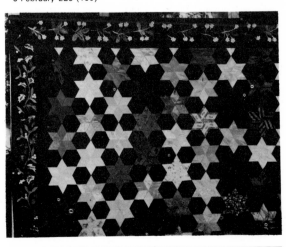

Left: Silk and wool wall hanging (detail), English dated 1881. 106½ by 93 in (270 by 239·5 cm). Belgravia 16 October £170 ($408)

Right: Patchwork bedspread (detail), English dated 1879. 106½ by 90 in (240 by 229 cm). Belgravia 16 October £70 ($168)

Chinese works of art and ceramics

As anyone with even a superficial knowledge of the art market will be aware, the value of oriental ceramics has increased at a rate during the last five years which may be described as phenomenal. Had we been compiling this volume ten years ago, we could have included pieces which today are worth several thousand pounds. To give one example, a 16th-century Ming green and yellow dragon sold at New Bond Street in 1967 for £550 fetched £88,000 in the same saleroom in November 1973.

From the following pages, however, it emerges that there still remains a large quantity of fine Chinese ceramic art at prices well below £1,000 ($2,400) while some of the provincial blue and white porcelain of the Ming dynasty, not of great importance certainly, but nonetheless extremely attractive, is illustrated, often at prices below £200 ($280), although in most cases such pieces have sustained some amount of damage. 18th-century Ch'ing dynasty wares from the reigns of the Emperor K'ang Hsi and Ch'ien Lung are also available and of special interest are the high temperature transmutation glazed pieces from this period, which had a profound influence upon many European potters of the late 19th and early 20th centuries and which still remain a comparatively unexploited field of Chinese ceramic art.

In the dynasties before that of the Ming emperors, notably in the Han, T'ang and Sung periods, the Chinese brought the art of pottery to perfection and began producing a primitive porcelain which was to flower during the 14th and 15th centuries. Among early pieces illustrated a Yüeh-yao jar of the Western Chin dynasty (265-317 AD) fetched £220 ($525) in New York in February and from an earlier period, that of the Warring States (481-205 BC), comes a grey bowl which realised $600 (£250) in the same sale.

Among pieces from the classic period of Chinese pottery, we illustrate a fine T'ang jar with typical splashed green, yellow and cream glaze which realised $2,000 (£833), a most interesting proto-porcelain jar of the 3rd century AD which fetched $1,800 (£750) and several examples of Sung celadons. Despite the enormous prices paid for the greatest examples of Chinese pottery and porcelain, therefore, this still remains an area of opportunity for the diligent collector.

We should mention also the metalwork and jade illustrated here, as well as some fine examples of 19th-century Chinese furniture, the latter often of superb workmanship but still, surprisingly, little regarded in the West. Among the archaic bronze work, mention should be made of the attractive pair of Han dynasty finials of the 3rd/2nd century BC which realised a mere $150 (£63) in New York in February or the Sung dynasty bronze tiger inlaid with gold and silver which fetched $700 (£295) in the same sale. Particularly attractive are the round bronze mirrors of which we illustrate a number of examples.

Jade ritual disc (*pi*), late Eastern Chou dynasty 1122-249 BC). Diameter 5¾ in (14·6 cm). New York 7 February $750 (£313)

Chinese grey pottery bowl, Warring States period (481-205 BC). Diameter 3½ in (8·9 cm). New York 7 February $600 (£250)

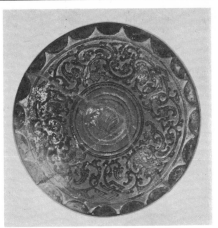

Chinese bronze mirror of Shou-Hsien type, second century BC. Diameter 5⅝ in (14·3 cm). New York 7 February $210 (£88)

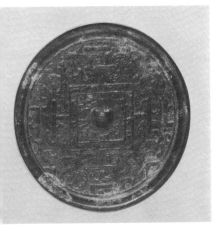

Shou-Hsien 'TLV' bronze mirror, 2nd century BC. Diameter 4⅛ in (10·5 cm). New York 7 February $375 (£156)

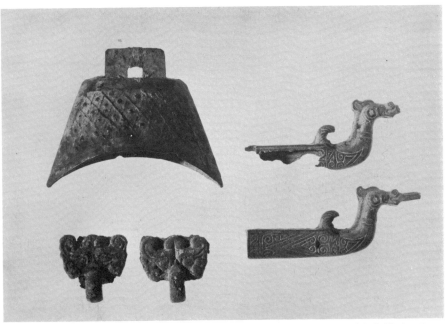

Upper: small bronze bell, late Huai /early Western Han (*circa* 200 BC). Length 2⅝ ın (6·7 cm). New York 7 February $120 (£50)

Lower: Pair of miniature bronze monster masks, Han dynasty (206 BC-220 AD). Length 1 in (2·6 cm). New York, 7 February $60 (£25)

Pair of small Chinese bronze finials, 3rd/2nd century BC. Length 2¾ in (7 cm). New York 7 February $150 (£63)

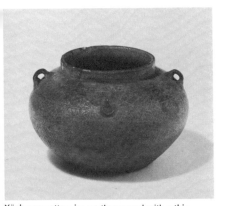

Yüeh-yao pottery jar, partly covered with a thin grey-green glaze, Western Chin dynasty (265-317 AD). Diameter 4½ in (11·4 cm). New York 7 February $525 (£220)

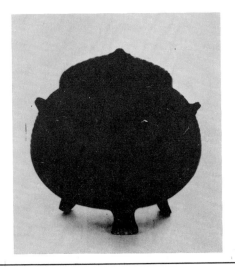

Right: Stoneware jar and cover, Han dynasty (206 BC-220 AD). Height 5¾ in (14·6 cm). New Bond Street 1 April £350 ($840)

One of a pair of Ordos bronze belt buckles, Han dynasty (206 BC-220 AD). Length 3¾ in (9·5 cm). New Bond Street 1 April £850 ($1,040)

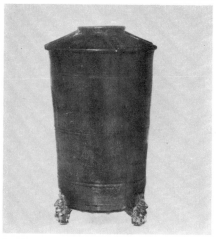

Green-glazed pottery granary jar, Han dynasty (206 BC-220 AD). Height 13 in (33 cm). New Bond Street 1 April £700 ($1,680)

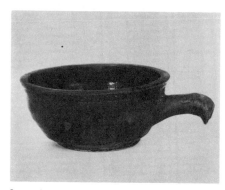

Green-glazed pottery scoop, Han dynasty (206 BC-220 AD). Length 8¾ in (22·2 cm). New Bond Street 1 April £180 ($432)

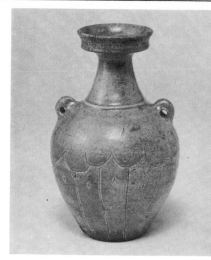

Yüeh-yao pottery two-handled vase coated with an olive-brown glaze, Six dynasties (220-589). Height 7⅛ in (18·1 cm). New York 7 February $1,600 (£667)

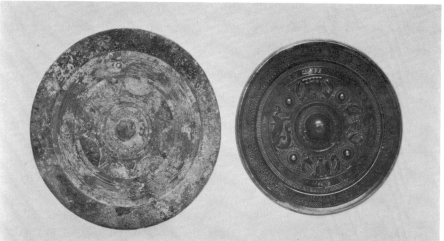

Left: Large astronomical bronze mirror, Chinese 1st century AD. Diameter 9 in (22·8 cm). New York 7 February $700 (£295)

Right: Large mirror of *Shao-Hsing* type, 2nd/3rd century AD. Diameter 8 in (20·3 cm). New York 7 February $1,100 (£459)

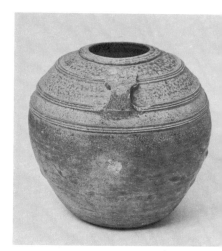

Chinese proto-porcelain jar with moulded mask handles, the upper part covered with a greenish-yellow kiln gloss, *circa* 3rd century AD. Height 12 in (30·5 cm). New York 7 February $1,800 (£750)

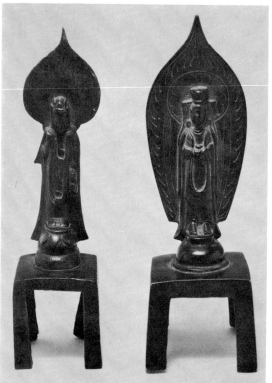

Far left: Chinese bronze figure of Avalokitesvara, Sui dynasty (581-618). Height 7¼ in (18·4 cm). New York 7 February $325 (£135)

Left: Chinese bronze figure of a Bodhisattva, inscribed date corresponding to the year 567 AD. Height 7¾ in (19·7 cm). New York 7 February $700 (£295)

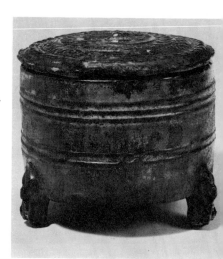

Iridescent green-glazed pottery toilet box with cover (*Lien*), Han dynasty. Diameter 7½ in (19 cm). New York 7 February $2,000 (£833)

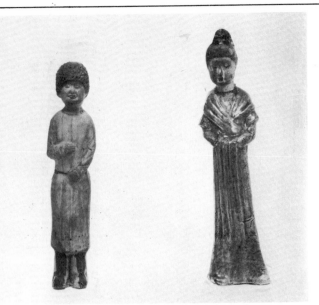

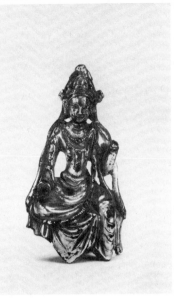

Unglazed pottery figure of a standing groom with curly hair, T'ang dynasty (618-906). Height 9 in (22·9 cm). New Bond Street 1 April £400 ($960)

One of a pair of ochre-glazed pottery figures of ladies, T'ang dynasty (618-906). Height 10¼ in (26 cm). New Bond Street 1 April £950 ($2,280)

Gilt-bronze figure of Kuan Yin, T'ang dynasty (618-906). Height 4⅝ in (11·7 cm). New Bond Street 1 April £240 ($576)

Gilt-bronze seated figure of Kuan Yin, T'ang dynasty (618-906). Height 4 in (10·2 cm). New Bond Street 1 April £320 ($768)

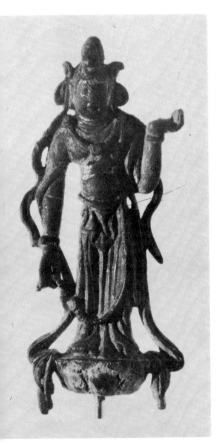

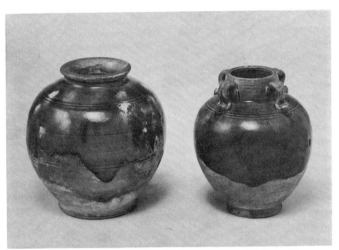

Left: Splash-glazed pottery jar coated with nasturtium-yellow splashed with green and cream, T'ang dynasty (618-906). Height 4½ in (11·4 cm). New York 7 February $2,000 (£833)

Right: Green-glazed pottery jar, T'ang dynasty (618-906). Height 4½ in (11·4 cm). New York 7 February $1,600 (£667)

Chinese gilt-bronze figure of a Bodhisattva, T'ang dynasty (618-906). Height 4 in (10·2 cm). New York 7 February $850 (£355)

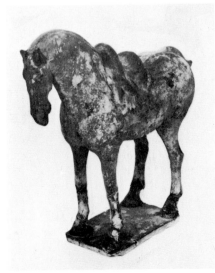

Unglazed pottery figure of a horse, T'ang dynasty (618-906). Height 13½ in (34·3 cm). New Bond Street 1 April £900 ($2,160)

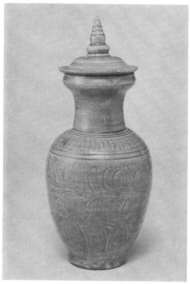

Celadon covered vase with incised decoration, covered with a greyish-green crackled glaze, early Sung dynasty (960-1279). Height 11¾ in (29·8 cm). New York 7 February $2,300 (£959)

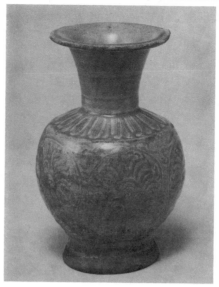

Yüeh-yao vase with floral decoration, coated with a greyish-green glaze, early Sung dynasty (960-1279). Height 6½ in (16·5 cm). New York 7 February $800 (£333)

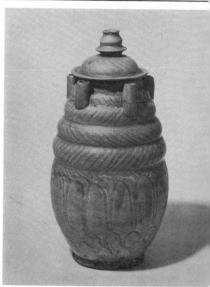

Celadon funerary vase and cover of the *Li Shui* type. Covered with a crackled yellowish-green glaze. Sung dynasty (960-1279). Height 10¼ in (26 cm). New York 7 February $1,100 (£459)

Ch'ing pai granary model, Sung dynasty (960-1279). Height 4¼ in (10·8 cm). New York 7 February $550 (£230)

Green-glazed pottery pillow, Sung dynasty (960-1279). Length 10¼ in (26·1 cm). New York 7 February $1,300 (£542)

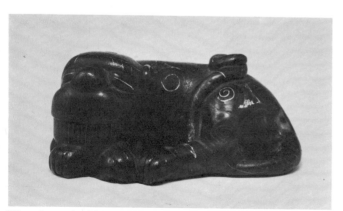

Chinese bronze tiger inlaid with gold and silver, Sung dynasty (960-1279). Length 4⅞ in (12·4 cm). New York 7 February $700 (£295)

Left: Southern temmoku glazed pottery teabowl. Sung dynasty (960-1279). Diameter 4¾ in (12 cm). New York 7 February $225 (£95)

Right: Honan shallow bowl, with a glassy black glaze running to a rich brown colour. Sung dynasty (960-1279). Diameter 4½ in (10·8 cm). New York 7 February $200 (£84)

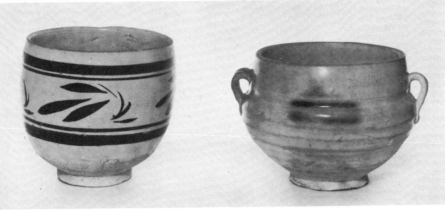

Tz'u Chou pottery jar, Sung dynasty (960-1279). Height 4½ in (11·4 cm). New Bond Street 2 April £700 ($1,680)

Tz'u Chou pottery jar, Sung dynasty (960-1279 AD). Height 4 in (10·2 cm). New Bond Street 2 April £180 ($432)

Ch'ing pai bowl with incised decoration and covered in a pale blue glaze. Sung dynasty (960-1279). Diameter 6⅞ in (17·4 cm). New York 7 February $1,300 (£542)

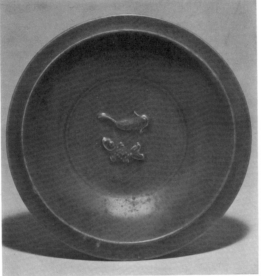

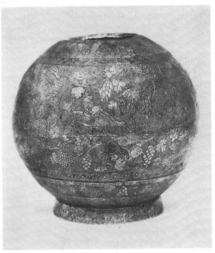

Ch'ing pai lobed conical bowl covered with a pale blue glaze. Sung dynasty (960-1279). Diameter 7¼ in (18·4 cm). New York 7 February $500 (£209)

Chinese Lung Ch'üan celadon pottery twin fish dish, the exterior carved with radiating lotus petals, Sung/Yüan dynasty. Diameter 8 in (20·3 cm). New York 10 April $425 (£178)

Engraved silver jar, 10th century AD. Height 5 in (12·7 cm). New Bond Street 1 April £500 ($1,200)

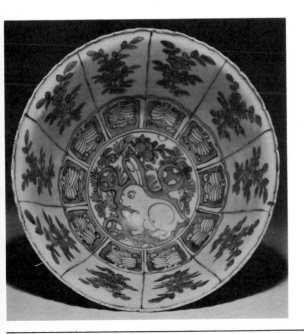

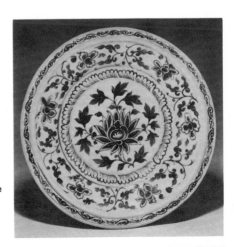

Left: Chinese blue and white 'Kraak porselein' bowl, late 16th century. Diameter 9 in (22·9 cm). New York 10 April $800 (£333)

Right: Annamese blue and white porcelain dish painted in an underglaze blue of a dark inky tone, the interior of the foot with a chocolate-brown wash, 15th century, Diameter 14 ½ in (36·9 cm). New York 10 April $2,100 (£875)

Svargaloka celadon bowl, the translucent glaze of a crackled pale green, 14th/15th century. Diameter 11 in (27·9 cm). New York 7 February $350 (£147)

Svargaloka pottery water dropper in the form of a blowfish, the features and scales incised under a splotchy iron-brown glaze, 14th/15th century. Length 3 in (7·6 cm). New York 10 April $160 (£67)

Painted Svargaloka pottery water dropper in the form of a human figure the head, face and robes painted in dark iron-brown under a matt grey glaze, 14th/15th century. Height 2¾ in (6·9 cm). New York 10 April $160 (£67)

Large Svargaloka pottery covered box painted in iron-brown on a white background, the knopped lid covered with a chocolate-brown wash, 14th/15th century. Diameter 6¼ in (15·9 cm). New York 10 April $130 (£54)

Painted Sukhotai pottery bowl of *cakra* design decorated in dark iron-brown applied on a white slip beneath a translucent ivory-tinted glaze, 14th century. Diameter 7⅞ in (18·7 cm). New York 10 April $170 (£71)

Painted Svargaloka pottery bottle, painted in iron-brown under a translucent glaze, the neck with incised decoration, 14th/15th century. Diameter 4¼ in (10·8 cm). New York 10 April $200 (£84)

Painted Svargaloka pottery covered box painted in rust-brown shading to olive under a milky-grey glaze, 14/15th century. Diameter 3⅞ in (9·8 cm). New York 10 April $180 (£75)

Painted Svargaloka pottery covered box, painted in iron-brown shading to black under a milky-bluish glaze, 14th/15th century. Diameter 3¾ in (9·6 cm). New York 10 April $180 (£75)

Painted Svargaloka pottery jar and cover painted in iron-brown under a bluish-grey glaze, 14th/15th century. Height 4 in (10·2 cm). New York 10 April $190 (£79)

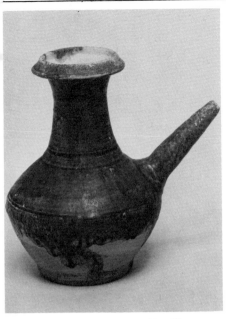

Chinese ochre-glazed pottery ewer of *kendi* form, Ming dynasty or earlier. Height 6¼ in (15·9 cm). New York 10 April $425 (£178)

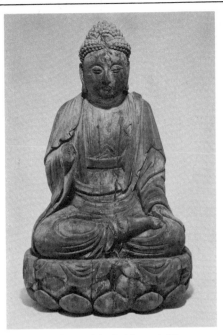

Carved wood figure of the Buddha, early Ming dynasty (14th/15th century). Height 17 in (43·2 cm). New York 7 February $1,300 (£542)

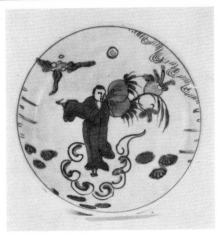

Polychrome porcelain dish, Ming dynasty, four-character mark of T'ien Ch'i (1621-27). Diameter 6¼ in (15·9 cm). New Bond Street 2 April £800 ($1,920)

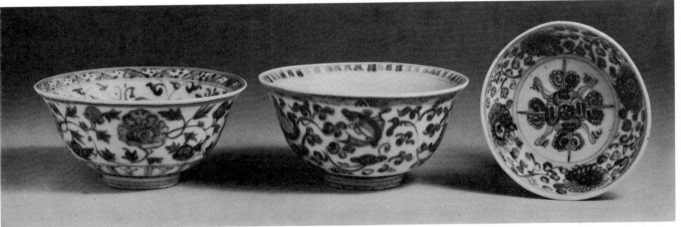

Chinese blue and white porcelain bowl, Ming dynasty 15th/early 16th century. Diameter 6 in (15·2 cm). New York 10 April $300 (£175)

Chinese blue and white porcelain bowl, Ming dynasty late 15th/early 16th century. Diameter 5⅞ in (14·9 cm). New York 10 April $250 (£104)

Chinese blue and white porcelain dish, Ming dynasty late 15th/early 16th century. Diameter 4⅝ in (11·8 cm). New York 10 April $225 (£95)

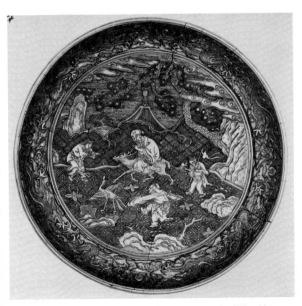

Lacquer dish, Ming dynasty, incised six character mark of Wan Li (1573-1619). Diameter 10⅛ in (25·7 cm). New Bond Street 1 April £280 ($672)

Chinese celadon dish covered with a blue-green glaze of *kinuta* type, Ming dynasty. Diameter 13 in (33 cm). New York 10 April $1,200 (£500)

Chinese turquoise and blue parcel-glazed biscuit figure of an official, hollow cast, Ming dynasty. Height 13½ in (34·3 cm). New York 10 April $1,450 (£605)

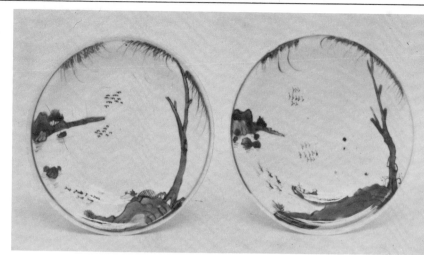

Pair of Chinese blue and white porcelain dishes, late Ming dynasty, T'ien Ch'i period (1621-27). Diameter 6 in (15·2 cm). New York 10 April $325 (£135)

Cloisonné enamel bowl, Ming dynasty 16th century. Width 9 in (22·9 cm). New Bond Street 1 April £240 ($576)

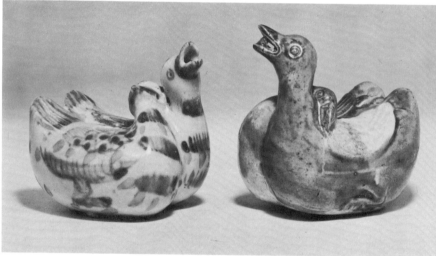

Chinese porcelain double duck water dropper, the plumage and other features drawn in underglaze blue and highlighted in pale green, late Ming dynasty 16th century. Length 3 in (7·6 cm). New York 10 April $475 (£199)

Chinese lead-glazed pottery double duck water dropper, enamelled on the biscuit in tones of aubergine, cream, ochre and bright green, Ming dynasty. Length 3¼ in (8·2 cm). New York 10 April $550 (£230)

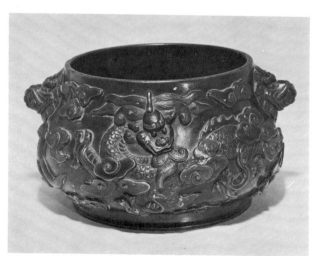

Chinese gold-splashed bronze censer, Ming dynasty, six-character mark of Hsüan Tê (1426-35). Diameter 7½ in (19·1 cm). New York 10 April $600 (£250)

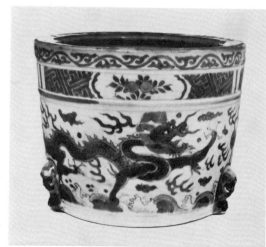

Blue and white porcelain censer, Ming dynasty, reign of Ch'ung Chên, dated 1637. Height 7¼ in (18·4 cm). New Bond Street 2 April £650 ($1,560)

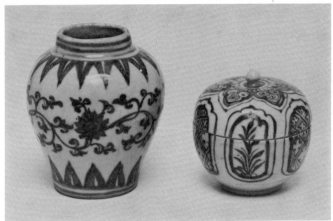

Chinese blue and white porcelain tray and water vessel, Ming dynasty 16th century. Length 9¾ in (23·8 cm). New York 10 April $325 (£135)

Chinese blue and white porcelain jar, Ming dynasty 16th century. Height 3¾ in (9·6 cm). New York 10 April $250 (£104)

Chinese blue and white porcelain box and cover, Ming dynasty 16th century Diameter 3 in (7·6 cm). New York 10 April $200 (£84)

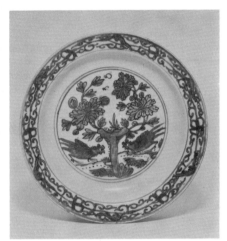

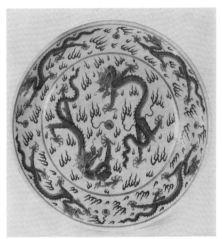

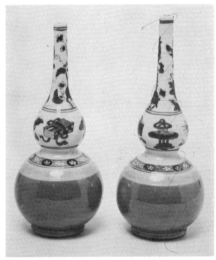

Late Ming dynasty blue and white porcelain dish, 16th century. Diameter 12 in (30·7 cm). New York 7 February $450 (£188)

'Rouge-de-fer' decorated porcelain dragon dish, K'ang Hsi (1677-1722). Diameter 13¼ in (33·6 cm). New Bond Street 2 April £950 ($2,280)

Two Chinese blue and white café-au-lait gourd bottles painted in underglaze blue with Buddhist symbols, the lower body with wide café-au-lait banding, K'ang Hsi period (1662-1722). Height 8 in (20·3 cm). New York 10 April $600 (£250)

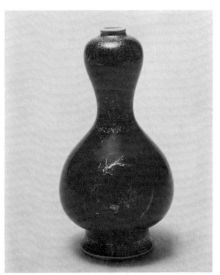

Chinese white porcelain saucer dish with incised dragon decoration, K'ang Hsi period, with the six-character mark of the reign within a double ring (1662-1722). Diameter 6¾ in (17·2 cm). New York 10 April $750 (£313)

Chinese gold-decorated mirror-black porcelain vase, K'ang Hsi period (1677-1722). Height 8 in (20·3 cm). New York 10 April $375 (£156)

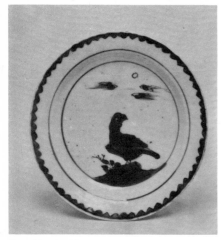

One of a pair of Chinese blue and white porcelain dishes, late Ming dynasty, T'ien Ch'i period (1621-27). Diameter 6 in (15·2 cm). New York 10 April $300 (£125)

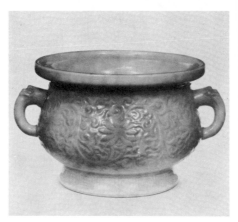

Carved white porcelain censer, Ch'ing dynasty, six-character mark of Yung Chêng (1723-35). Width 5⅜ in (13·6 cm). New Bond Street 2 April £520 ($1,248)

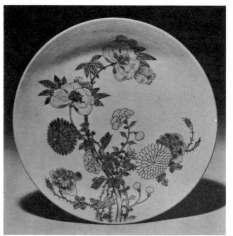

Chinese porcelain 'famille-rose' saucer dish, the interior enamelled in pastel colours with a trailing cluster of pink and yellow peony blossoms and chrysanthemums with pale green foliage, the lip rim with pale coffee brown glaze, Yung Chêng period (1723-35) and bearing the inventory mark of the Royal Saxon Porcelain Collection formed in the so-called Japanese Palace by Augustus the Strong, Elector of Saxony (1670-1733). Diameter 8¾ in (22·2 cm). New York 10 April $1,100 (£459)

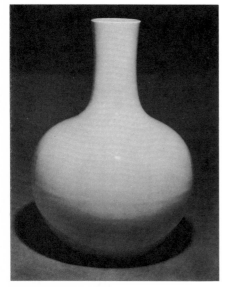

Mammoth Chinese porcelain blue-glazed moon-bottle, pale greyish-blue glaze thinning to white around the rim. Ch'ien Lung period with seal mark of the reign (1736-95). Height 20½ in (52·1 cm). New York 10 April $900 (£375)

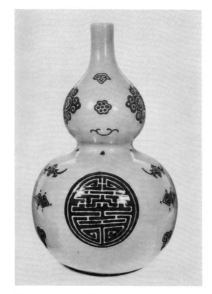

Celadon-ground double-gourd porcelain vase, Ch'ien Lung (1736-95). Height 13¾ in (34·9 cm). New Bond Street 2 April £320 ($768)

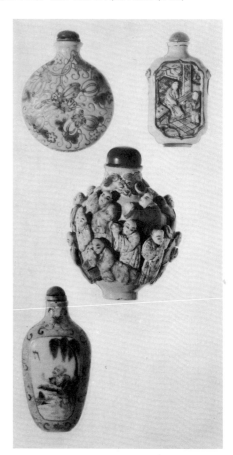

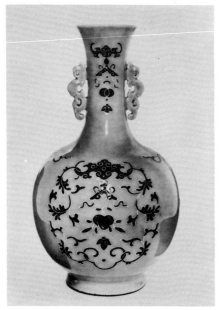

Pale blue-ground porcelain vase, Ch'ien Lung (1736-95). Height 14⅝ in (37·1 cm). New Bond Street 2 April £520 ($1,248)

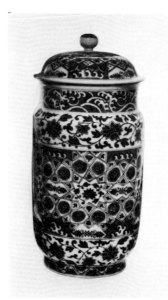

Ming style blue and white porcelain jar and cover, Ch'ien Lung (1736-95). Height 11 in (27·9 cm). New Bond Street 2 April £550 ($1,320)

Top left: Famille-rose porcelain snuff bottle, seal mark of Ch'ien Lung. New York 8 March $90 (£37)

Top right: Famille-rose moulded porcelain snuff bottle, seal mark of Ch'ien Lung. New York 8 March $150 (£63)

Centre: Famille-rose moulded porcelain snuff bottle, seal mark of Ch'ien Lung. New York 8 March $175 (£73)

Bottom: Famille-rose porcelain snuff bottle, seal mark of Ch'ien Lung. New York 8 March $80 (£33)

Chinese porcelain reticulated perfume ball decorated with 'famille-rose' enamels, Ch'ien Lung period (1736-95). Diameter 4 in (10·2 cm). New York 10 April $1,000 (£417)

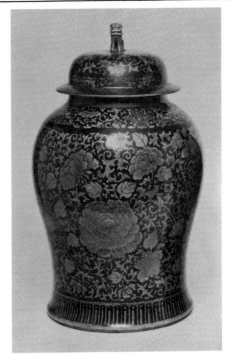

One of a pair of Chinese porcelain green-enamelled covered temple jars with black grounds. Height 26 in (66 cm). New York 10 April $1,600 (£667)

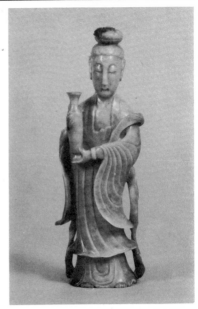

Pale green jade figure of Kuan Yin. Height 13¾ in (33·7 cm). Los Angeles 1 July $2,000 (£833)

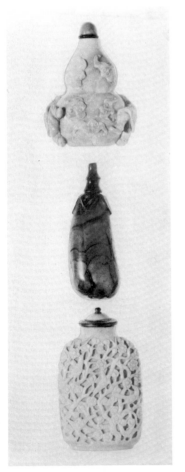

Top: Opal double-gourd snuff bottle. New York 8 March $275 (£115)

Centre: Malachite fruit-form snuff bottle. New York 8 March $80 (£33)

Bottom: Coral snuff bottle. New York 8 March $900 (£375)

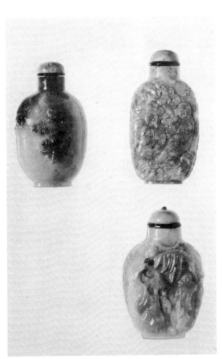

Top Left: Lavender and fei-ts'ui jade snuff bottle. New York 8 March $850 (£354)

Top right: Fei-ts'ui jade snuff bottle. New York 8 March $650 (£271)

Bottom: Fei-ts'ui jade snuff bottle. New York 8 March $275 (£115)

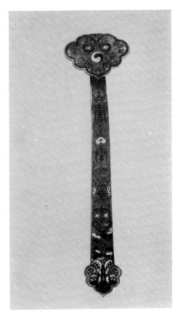

Cloisonné enamel ju-i sceptre, 17th century. Length 16 in (40·6 cm). New Bond Street 1 April £650 ($1,560)

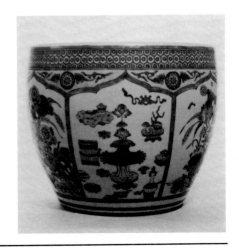

Right: Famille-verte porcelain jardinière, late 19th century. Height 12½ in (31·8 cm). Belgravia 30 January £160 ($384)

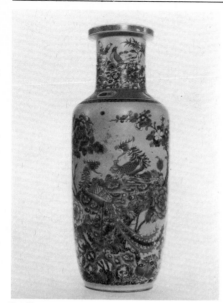

Famille-rose porcelain *rouleau* vase, seal mark of Ch'ien Lung but mid 19th century. Height 17¾ in (45·1 cm). Belgravia 30 January £180 ($432)

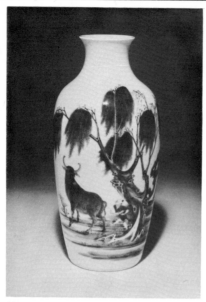

Chinese blue and white 'soft-paste' porcelain vase, 18th century. Height 10½ in (26·7 cm). New York 10 April $1,000 (£417)

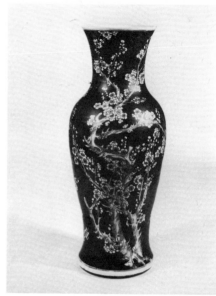

One of a pair of blue and white porcelain vases, late 19th century. Height 36 in (91·4 cm). Belgravia 30 January £400 ($960)

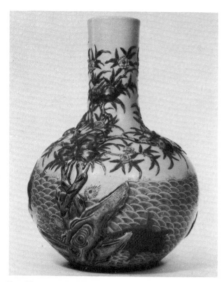

Famille-rose porcelain vase, Ch'ien Lung seal mark but first half of the 19th century. Height 20¾ in (52·7 cm). Belgravia 4 July £450 ($1,080)

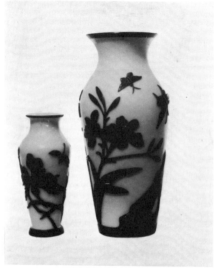

Left: One of a pair of Pekin overlay glass vases, 19th century. Height 6 in (15·2 cm). Belgravia 18 July £75 ($180)

Right: Pekin overlay glass vase, 19th century. Height 10¼ in (26 cm). Belgravia 18 July £85 ($204)

Canton porcelain vase, *circa* 1880. Height 13¼ in (33·7 cm). Belgravia 30 January £280 ($672)

Left: Celadon-ground Canton porcelain vase and cover second half of the 19th century. Height 17½ in (44·5 cm). Belgravia 30 January £160 ($384)

Right: One of a pair of yellow-ground famille-rose porcelain vases and covers, second half of the 19th century. Height 18¼ in (46·3 cm). Belgravia 30 January £440 ($1,056)

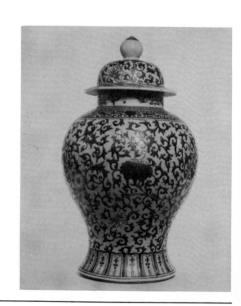

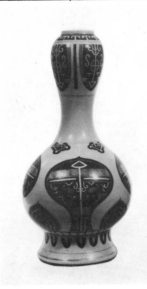

One of a pair of blue and white porcelain vases, mid 19th century. Height 16½ in (42 cm). Belgravia 19 September £260 ($624)

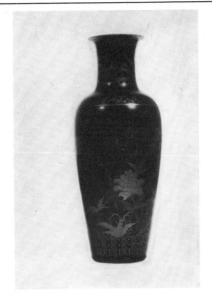

Mirror-black porcelain vase, six-character mark of K'ang Hsi but mid 19th century. Height 17¼ in (43·8 cm). Belgravia 4 July £80 ($196)

Mutton-fat jade bird vase, 18th century. Height 6¼ in (15·9 cm). New York 8 March $2,500 (£1,042)

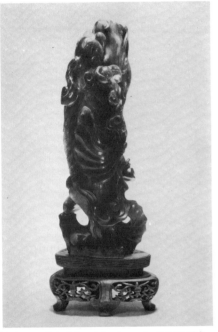

Dark green jade fish and dragon vase. Height 6¾ in (17·1 cm). New York 8 March $700 (£292)

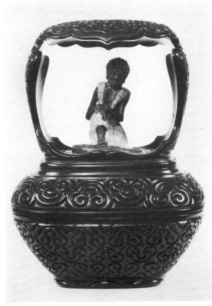

Chinese guri lacquer box and shrine figure, 19th century. Height 15 in (38·1 cm). Belgravia 23 May £260 ($624)

Red lacquer box, six-character mark of Yung Chêng but mid 19th century. Length 16 in (40·6 cm). Belgravia 28 February £115 ($276)

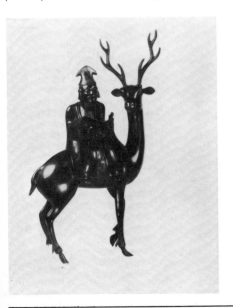

Left: One of a pair of bronze incense burners in the form of Shou Lao seated on a stag, mid 19th century. Height 16½ in (42 cm). Belgravia 30 January £480 ($1,152)

Right: Famille-rose porcelain Chinese-taste plate, Wan-Li seal mark but first half of the 19th century. Diameter 22½ in (57·2 cm). Belgravia 4 July £290 ($696)

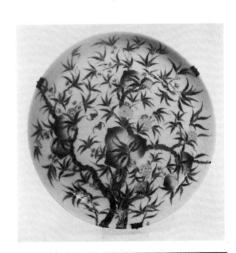

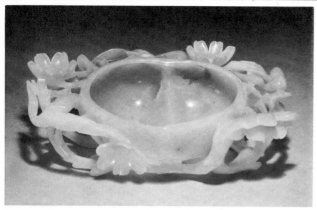

White jade peach-form cup. Length 6¼ in (15·9 cm). New York 8 March $1,000 (£417)

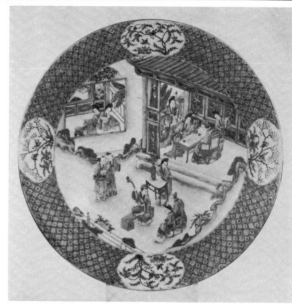

Canton porcelain plate, late 19th century. Diameter 16⅛ in (41 cm). Belgravia 4 July £65 ($156)

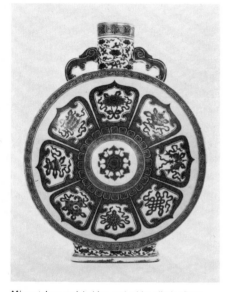

Ming style porcelain blue and white pilgrim flask. Ch'ien Lung seal mark but 19th century. Height 19 in (48·3 cm). Belgravia 4 July £480 ($1,152)

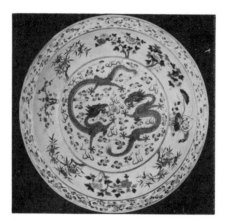

Chinese famille-rose dish, impressed mark and period of Kuang Hsü (1874-1909). Diameter 27 in (68·6 cm). Sotheby Parke Bernet (Hong Kong) 4 November £500 ($1,200)

Onion-green jade leaf-shaped dish. New York 8 March $1,800 (£750)

One of a pair of ivory figures of Kuan Yin, late 19th century. Heights 15½ and 16 in (39·4 and 40·6 cm). Belgravia 23 May £370 ($888)

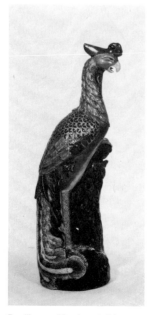

Famille-rose biscuit porcelain phoenix, last quarter of the 19th century. Height 23½ in (59·7 cm). Belgravia 4 July £150 ($360)

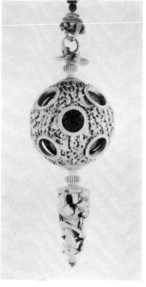

Pierced ivory ball, mid 19th century. Height 11 in (27·9 cm). Belgravia 23 May £210 ($504)

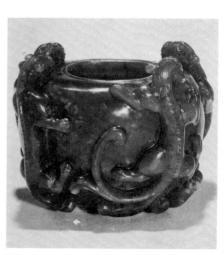

Spinach-green jade small dragon bowl. New York 8 March $2,500 (£1,042)

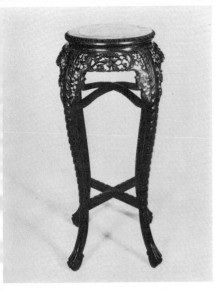

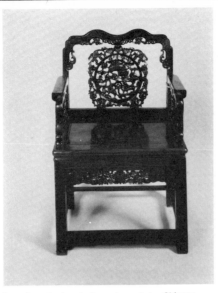

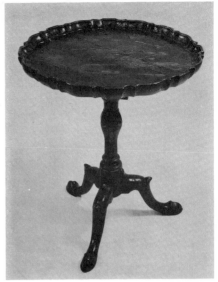

One of a pair of hardwood urn stands, Chinese, second half of the 19th century. Height 36 in (91·5 cm). Belgravia 4 July £180 ($432)

One of a pair of padoukwood armchairs, Chinese, mid 19th century. Belgravia 4 July £190 ($456)

Chinese late 18th-century black lacquer table in the English George III taste. Height $27\frac{1}{2}$ in (69·9 cm). Los Angeles 21 April $2,250 (£938)

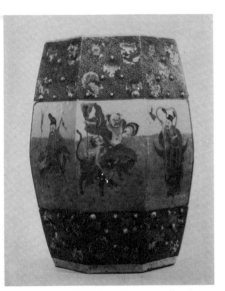

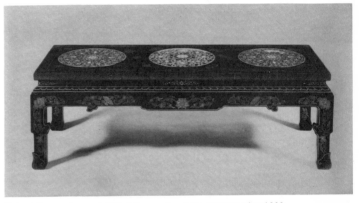

Cloisonné enamel mounted black lacquer low table, Chinese, *circa* 1900. Length 50 in (127 cm). Belgravia 4 July £170 ($408)

Famille-rose porcelain garden seat, first half of the 19th century. Height $18\frac{1}{2}$ in (47 cm). Belgravia 30 January £270 ($648)

Rosewood side cabinet, Chinese, late 19th century. Length $56\frac{1}{2}$ in (144 cm). Belgravia 4 July £300 ($720)

Right: Pair of Chinese porcelain mounted hanging screens, mid 19th century. 70 by 26 in (178 by 66 cm). Hong Kong 4 November £850 ($2,040)

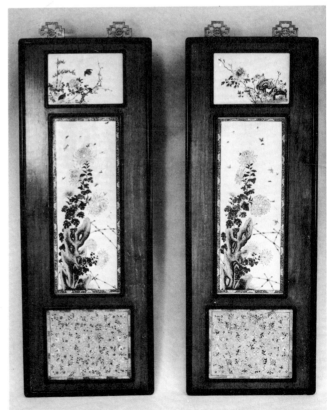

Japanese works of art and ceramics

Surprisingly, Japanese art itself has remained most admired by artists and designers themselves. Although there have always been a small number of dedicated collectors, some of whom began assembling Japanese prints as soon as they started appearing in Europe, few people have shown much interest. Admittedly prices have risen considerably in the last five years but even the finest ceramics and metalwork are not expensive by comparison with similar European or Chinese works of art. It must be said, however, that Japanese collectors, whose presence in the salerooms of Europe and America in recent years has been crucial to the increased interest in this market, have long been used to paying prices far above those prevailing in the West, and often for rare and exceptional pieces which seldom appear at auction either in Europe or the United States. Only in certain specific fields, particularly prints and drawings and netsuke, has the economic gap been narrowed.

For collectors and scholars in both East and West, the sword is one of the supreme achievements of Japanese art. The blade itself is divided into four main categories based upon size. These are the *tachi* and *katana* blades, which are each over two *shaku* (23.86 inches) long, the *wakizashi* which is between one and two *shaku* and the *tanto* which is less than one *shaku*. The Samurai would carry a pair of swords called *Daisho* which are often sold at auction although none, for reasons of price, is illustrated here. In Japan, prices of up to £100,000 have been rumoured for magnificent old blades but good examples can still be purchased for less than £500. It should be added that a fine example of a modern swordsmith's work is often more valuable than an old blade in poor condition.

Equal care was lavished on sword furniture. Excluding the blade, the fully furnished sword can be divided into nine pieces—the scabbard; the hilt; two small decorative pieces, often of gold, bound on each side of the hilt to facilitate grip, called *menuki*; two small metal pieces for the hilt called *fuchi-kashira;* the guard called *tsuba;* and a small knife and split weapon which could be used either as chopsticks or hair ornaments called respectively *kozuka* and *kogai*.

Japanese porcelain is still undervalued. Few pieces make more than about £6,000 ($14,400) although it must be admitted that some categories, for instance good Nabeshima or Kutani porcelain of the 18th century are now generally beyond the upper limit of this book. Japanese pottery is less expensive. A beautiful 18th-century earthenware dish by Ogata Kenzan is worthy of special interest; Bernard Leach learnt ceramics from the 16th Kenzan and is himself the 17th hereditary Kenzan master. Another potter associated with Leach, Shoji Hamada, is represented here; for £250 ($600) one could have purchased a good example of the work of the man who is recognised throughout the world as the greatest potter of the 20th century.

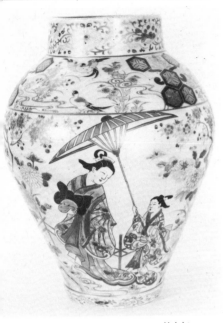

Imari porcelain vase, early 18th century. Height 16 in (40·5 cm). New Bond Street 20 February £950 ($2,280)

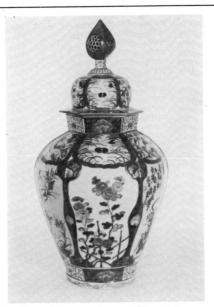

Imari porcelain vase and cover, 18th century. Height 20 in (50·7 cm). New Bond Street 20 February £580 ($1,392)

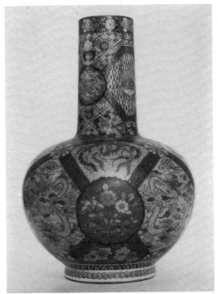

Kutani porcelain vase, last quarter of the 19th century. Height 16¾ in (42·5 cm). Belgravia 30 January £190 ($456)

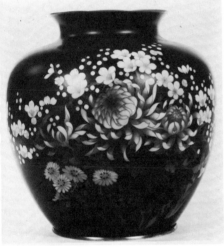

Ruby-ground translucent enamel vase, late 19th century. Height 9½ in (24·1 cm). Belgravia 30 January £220 ($528)

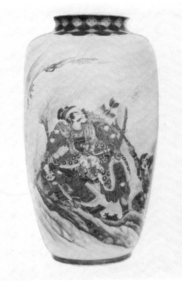

One of a pair of Shinsen porcelain vases, last quarter of the 19th century. Height 14¾ in (37·5 cm). Belgravia 30 January £95 ($228)

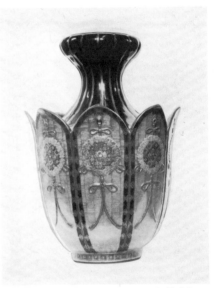

One of a pair of earthenware vases, first half of the 19th century. Height 16½ in (42 cm). Belgravia 25 April £380 ($912)

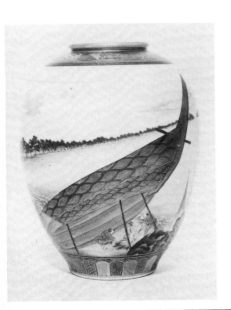

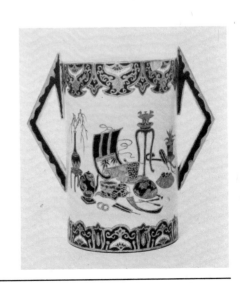

Left: Ryuzan Satsuma earthenware vase, *circa* 1900. Height 8¼ in (21 cm). Belgravia 25 April £85 ($204)

Right: Satsuma earthenware vase, first half of the 19th century. Height 6½ in (16·5 cm). Belgravia 25 April £78 ($187)

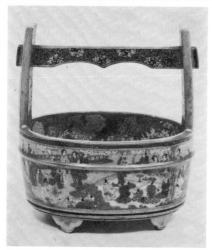

Seikozan earthenware vase in the form of a water bucket, *circa* 1900. Height 8½ in (21·6 cm). Belgravia 28 February £190 ($456)

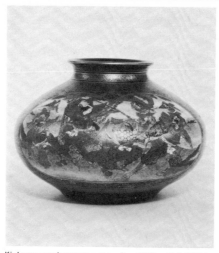

Kinkozan earthenware vase, *circa* 1900. Height 5 in (12·7 cm). Belgravia 30 January £60 ($144)

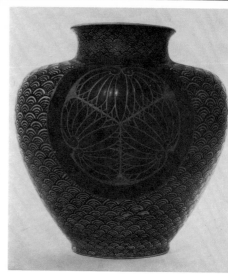

Kosai Satsuma earthenware vase, early 19th century. Height 14¼ in (36·2 cm). Belgravia 30 January £500 ($1,200)

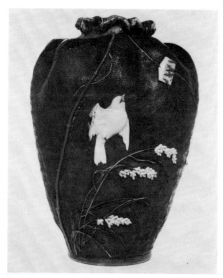

Stoneware vase, second half of the 19th century. Height 17¾ in (45·1 cm). Belgravia 19 September £200 ($480)

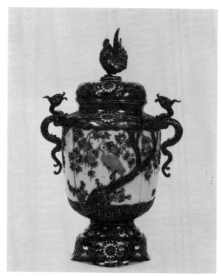

Silver-mounted Shibayama vase and cover, second half of the 19th century. Height 8½ in (21·6 cm). Belgravia 30 January £310 ($744)

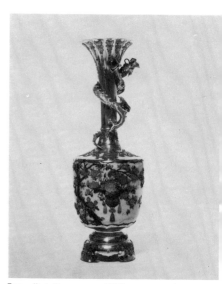

Enamelled silver mounted Shibayama and ivory vase, signed *Tomo-haru*, *circa* 1900. Belgravia 23 May £360 ($864)

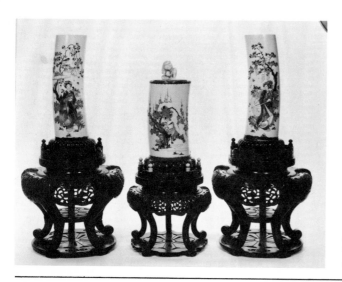

Pair of Japanese ivory Shibayama vases signed Masayuki, *circa* 1900, on revolving pierced wood stands. Height (overall 27 in (68·5 cm). Belgravia 24 October £820 ($1,968)

Centre: Japanese ivory Shibayama vase and cover, *circa* 1900, on a revolving carved wood stand. Height (overall) 24 in (61 cm). Belgravia 24 October £420 ($1,008)

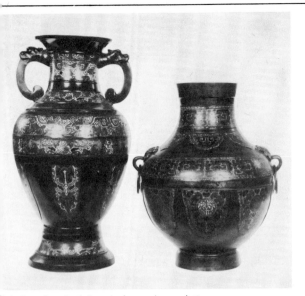

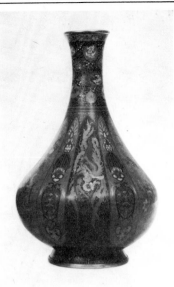

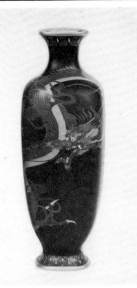

Left: One of a pair of champlevé enamel vases, last quarter of the 19th century. Height 23¼ in (59 cm). Belgravia 23 May £380 ($912)

Right: Champlevé enamel vase, last quarter of the 19th century. Height 18½ in (47 cm). Belgravia 23 May £175 ($420)

One of a pair of aventurine-ground cloisonné enamel vases, *circa* 1900. Height 12 in (30·5 cm). Belgravia 18 July £100 ($240)

One of a pair of cloisonné enamel dragon vases, incised *Myo-ko ya, Rin saku,* late 19th century. Height 6 in (15·2 cm). Belgravia 28 February £145 ($348)

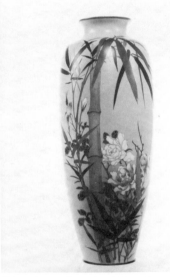

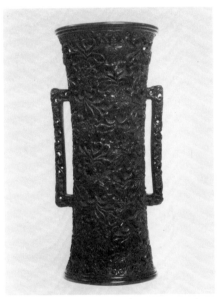

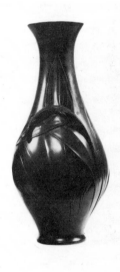

Cloisonné enamel vase, late 19th century. Height 14⅝ in (37·8 cm). Belgravia 30 January £75 ($180)

Kyoto pierced bronze flower-holder vase, second half of the 19th century. Height 12 in (30·5 cm). Belgravia 30 January £80 ($192)

One of a pair of bronze vases. Height 14½ in (37 cm). Belgravia 23 May £110 ($264)

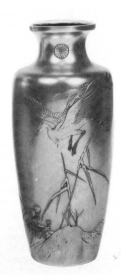

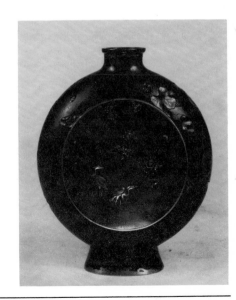

Left: One of a pair of miyamoto silver vases signed *Hiroyuki,* inscribed *Presented to R Gordon-Smith by His Imperial Majesty Yoshihito. The Emperor of Japan. December 6th 1912. Circa* 1912. 96 oz 14 dwt. Height 12 in (30·5 cm). Belgravia 18 July £390 ($936)

Right: Bronze moon-flask inlaid with gold, silver and other metals, late 19th century. Height 6⅛ in (15·5 cm). Belgravia 30 January £85 ($204)

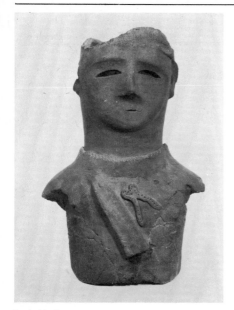

Kanto Haniwa earthenware bust, grave mound period, *circa* 300 AD. Height 14 in (35·5 cm). New Bond Street 20 February £360 ($864)

Kutani porcelain group of two mandarin ducks, mid 19th century. Height 7¼ in (18·4 cm). Belgravia 30 January £130 ($312)

One of a pair of porcelain shi shi, second half of the 19th century. Heights 8½ in and 9 in (21·6 and 22·9 cm). Belgravia 30 January £200 ($480)

Bizen stoneware figure of a tiger, 19th century. Height 12½ in (31·8 cm). Belgravia 30 January £170 ($408)

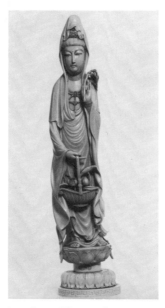

Ivory figure of Kwannon by Masakika, last quarter of the 19th century. Height 9¾ in (24·8 cm). Belgravia 30 January £440 ($1,056)

Stained ivory apple, *circa* 1900. Height 2⅛ in (5·4 cm). Belgravia 30 January £65 ($156)

Stained ivory banana, *circa* 1900. Length 6½ in (16·5 cm). Belgravia 30 January £65 ($156)

Stained ivory pear, *circa* 1900. Height 3 in (7·6 cm). Belgravia 30 January £52 ($125)

Stained ivory satsuma, *circa* 1900. Height 2¼ in (5·7 cm). Belgravia 30 January £68 ($163)

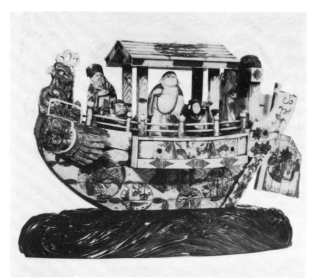

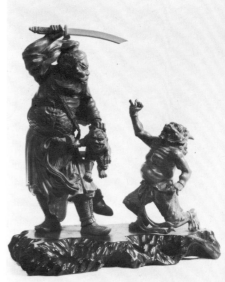

Left: Sectional ivory model of the Takarabune, late 19th century. Height 16¼ in (41·3 cm). Belgravia 30 January £340 ($816)

Right: Boxwood group of Shoki and a pleading *oni*, last quarter of the 19th century. Height 9½ in (24·1 cm). Belgravia 30 January £190 ($456)

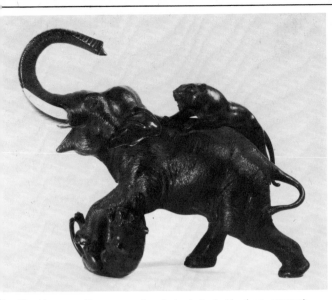

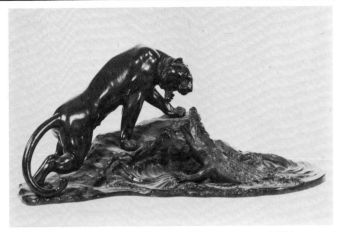

Bronze group of a tiger on a rocky ledge, late 19th century. Length 25 in (63·5 cm). Belgravia 18 July £200 ($480)

[I]mashitani bronze and ivory group of an elephant attacked by tigers, cast mark [I]mashi-tani saku, late 19th century. Length 9½ in (24·1 cm). Belgravia [3]0 January £75 ($180)

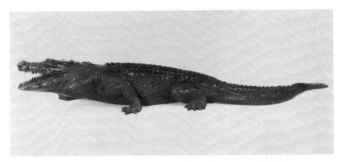

Bronze alligator, late 19th century. Length 18½ in (47 cm). Belgravia 23 May £220 ($528)

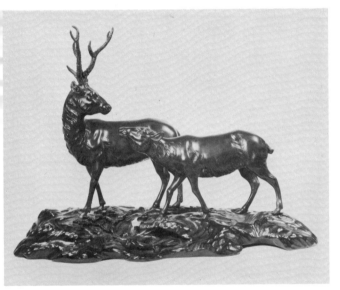

Bronze deer group, last quarter of the 19th century. Height 17¼ in (43·8 cm). Belgravia 23 May £160 ($384)

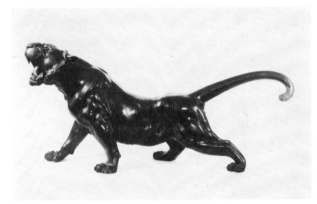

Takemitsu bronze tiger, last quarter of the 19th century. Length 38 in (96·5 cm). Belgravia 18 July £360 ($864)

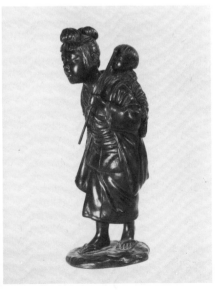

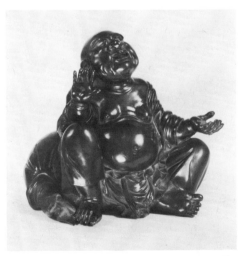

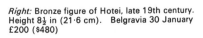

Left: Bronze group of a mother and child by Seiya, last quarter of the 19th century. Height 11 in (27·9 cm). Belgravia 23 May £130 ($312)

Right: Bronze figure of Hotei, late 19th century. Height 8½ in (21·6 cm). Belgravia 30 January £200 ($480)

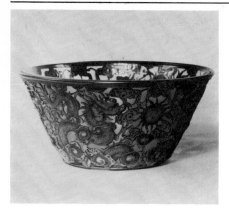

One of a set of six silver bowls, *circa* 1895.
Height 4¾ in (12 cm). Belgravia 30 January
£90 ($216)

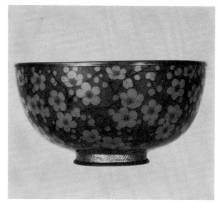

Plique-à-jour enamel bowl, last quarter of the 19th
century. Height 4¼ in (10·8 cm). Belgravia
30 January £120 ($288)

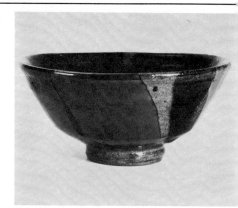

Pottery bowl with grey-glazed body and green and
brown splashes by Shoji Hamada, sold with
inscribed and signed wood box, post-1950.
Diameter 7¼ in (18·3 cm). New Bond Street
10 July £250 ($600)

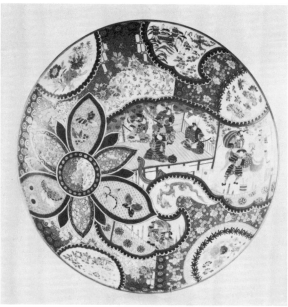

Yuda Guka imari porcelain dish, second half of the 19th
century. Diameter 24½ in (62·2 cm). Belgravia 30 January
£250 ($600)

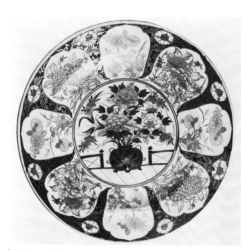

Imari porcelain dish, 18th century. Diameter 21⅜ in
(54·3 cm). New Bond Street 20 February
£450 ($1,080)

Pottery dish by Ogata Kenzan, 18th century.
6⅜ in (16·3 cm) square. New Bond Street
20 February £440 ($1,056)

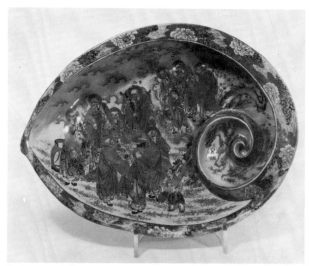

Earthenware shell dish, *circa* 1880. Length 16½ in (42 cm). Belgravia
25 April £180 ($432)

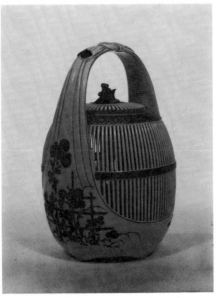

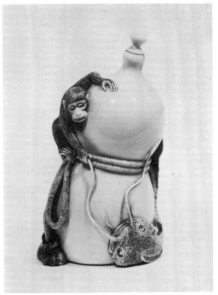

Mekizan Satsuma earthenware jar with wood cover, circa 1840. Height 13¾ in (35 cm). Belgravia 0 January £200 ($480)

Earthenware jar and cover, first half of the 19th century. Height 7¾ in (19·7 cm). Belgravia 4 July £200 ($480)

Ivory double-gourd box and cover, second half of the 19th century. Height 4¾ in (12 cm). Belgravia 18 July £300 ($720)

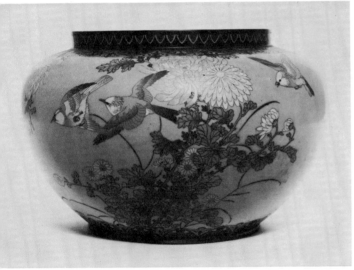

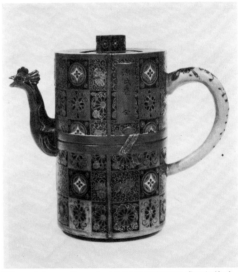

One of a pair of cloisonné enamel jardinières, late 19th century. Height 11½ in (29·2 cm). Belgravia 30 January £150 ($360)

Minamotoken earthenware sake pot and cover, first half of the 19th century. Height 7¼ in (18·4 cm). Belgravia 19 September £110 ($264)

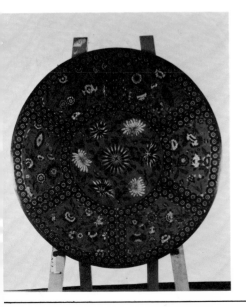

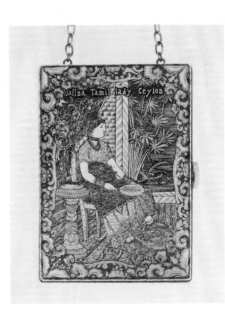

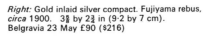

Left: Cloisonné and champlevé enamel table top, late 19th century. Diameter 28½ in (72·5 cm). Belgravia 23 May £310 ($744)

Right: Gold inlaid silver compact. Fujiyama rebus, *circa* 1900. 3⅝ by 2¾ in (9·2 by 7 cm). Belgravia 23 May £90 ($216)

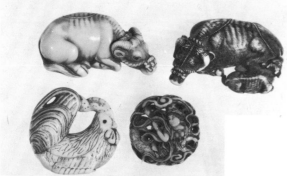

Top left: Ivory netsuke of a reclining ox, style of Tomotada.
New Bond Street 18 November £320 ($768)
Top right: Ivory netsuke of an ox and calf, Kyoto school.
New Bond Street 18 November £400 ($960)
Lower left: Ivory netsuke of a cockerel, 18th century.
New Bond Street 18 November £320 ($768)
Lower right: Walrus ivory manju, Asakusa school.
New Bond Street 18 November £240 ($576)

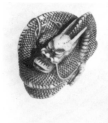

Ivory netsuke of a dragon, early 19th century.
New Bond Street 18 November £580 ($1,392)

Ivory netsuke of three turtles by Gyokkosai.
New Bond Street 18 November £320 ($768)

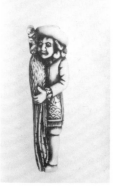

Ivory netsuke in the form of a figure of a Dutchman
18th century. New Bond Street
18 November £320 ($768)

Stag's-horn netsuke depicting a *chidori* flying past a
jakago, by Rensai of Asakusa. New Bond Street
18 November £520 ($1,248)

Ivory netsuke in the form of a fisherman seated on
the back of a turtle, 18th century. New Bond
Street 18 November £320 ($768)

Ivory netsuke of a grazing horse, 18th century.
New Bond Street 18 November £440 ($1,056)

Left: Ivory netsuke in the form of a figure of Chohi,
18th century. New Bond Street 18 November
£220 ($528)

Top: Ivory netsuke of a reclining horse, 18th century.
New Bond Street 18 November £480 ($1,152)

Centre: Ivory netsuke of a dog, school of Tomotada.
New Bond Street 18 November £320 ($768)

Lower: Ivory netsuke of a tiger by Okatori.
New Bond Street 18 November £650 ($1,560)

Wood netsuke of a smooth dragon, 18th century.
New Bond Street 20 February £520 ($1,248)

Left: Wood netsuke of a rat by Tomokazu. New
Bond Street 20 February £240 ($576)

Right: Wood netsuke of a toad by Matsuda
Sukenaga. New Bond Street 20 February
£900 ($2,160)

Ivory netsuke of a human skull with a snake, by
Masatoshi. New Bond Street 20 February
£320 ($768)

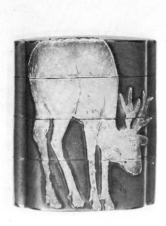

Three-case lacquer inro by Ogata Korin (1658-1716). New Bond Street 18 November £50 ($120)

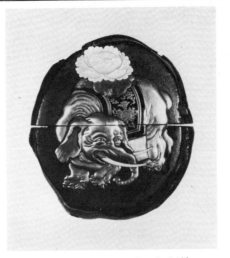

Single-case inro formed of a section of *reishi* fungus, decorated in gold and black *takamakie*, ivory and mother-of-pearl. New Bond Street 18 March £60 ($144)

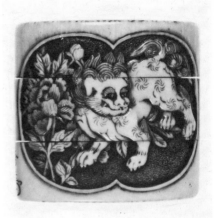

Small two-case ivory inro, by Hidemasa of Osaka, *circa* 1800. New Bond Street 18 March £340 ($816)

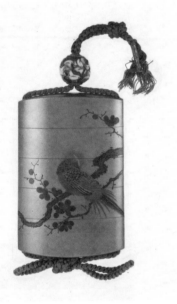

Four-case lacquer inro signed *Toshisaku*. New Bond Street 18 November £380 ($912)

Four-case lacquer inro, Shunsho family, 19th century. New Bond Street 18 November £110 ($264)

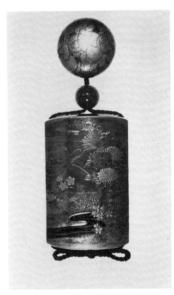

Four-case gold lacquer inro, Kajikawa school, 18th/19th century. New Bond Street 18 November £480 ($1,152)

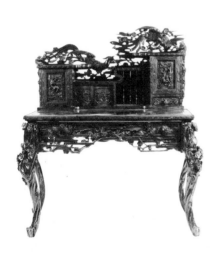

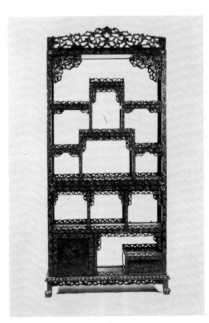

Left: Export carved writing table, late 19th century. Width 48 in (122 cm). Belgravia 4 July £190 ($456)

Right: Blackwood open display cabinet, second half of the 19th century. Height 84 in (214 cm). Belgravia 4 July £180 ($432)

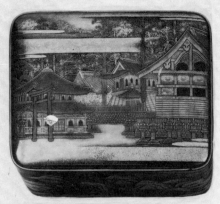

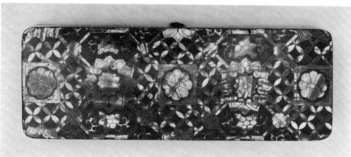

Small lacquer fubako, late Momoyama/early Edo period. 9$\frac{5}{16}$ by 3$\frac{1}{4}$ by 1$\frac{5}{8}$ in (23·6 by 8·2 by 4 cm). New Bond Street 18 November £400 ($960)

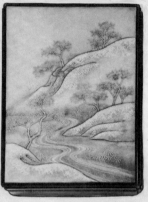

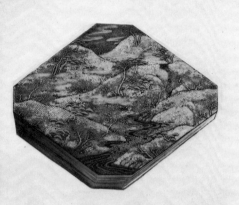

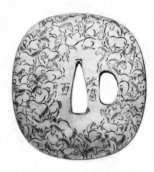

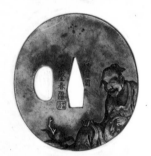

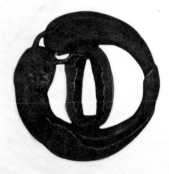

Top: Gold lacquer kashibako with interior tray, unsigned, late Edo period. 5$\frac{7}{8}$ by 4$\frac{1}{4}$ by 2$\frac{7}{16}$ in (13·8 by 10·7 by 6·5 cm). New Bond Street 18 November £360 ($864)

Left: Gold lacquer kobako with interior tray and four small boxes, unsigned, late Edo period. 4$\frac{7}{8}$ by 3$\frac{3}{4}$ by 1$\frac{7}{8}$ in (12·2 by 9·5 by 4·7 cm). New Bond Street 18 November £380 ($912)

Right: Gold lacquer two-tiered lozenge shaped jukobako, unsigned, late Edo period. 5$\frac{1}{4}$ by 3$\frac{3}{4}$ by 3$\frac{7}{16}$ in (13·2 by 9·4 by 8·7 cm). New Bond Street 18 November £280 ($672)

Top: Silver tsuba, Masayuki style. 3 in (7·5 cm). New Bond Street 18 December £350 ($840)

Centre: Brass tsuba by Hamano Haruyuki. 2$\frac{3}{4}$ in (7·1 cm). New Bond Street 18 December £60 ($144)

Bottom: Brass tsuba by Naoharu. 3$\frac{1}{4}$ in (8·2 cm). New Bond Street 18 December £175 ($420)

A Ivory kozuka. New Bond Street 18 December £32 ($77)

B Shakudo kozuka by Nagatsune. New Bond Street 18 December £240 ($576)

C Shakudo kozuka by Goto Jujo (1695-1742). New Bond Street 18 December £65 ($156)

D Shakudo nanako kozuka from the Goto school. New Bond Street 18 December £50 ($120)

E Shakudo kozuka of the Goto school. New Bond Street 18 December £40 ($96)

F Shakudo kogai attributed to Goto Kenjo. New Bond Street 18 December £110 ($264)

G Shakudo kogai attributed to Goto Kojo. New Bond Street 18 December £70 ($168)

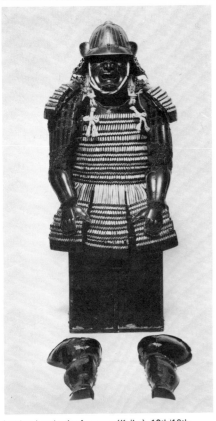

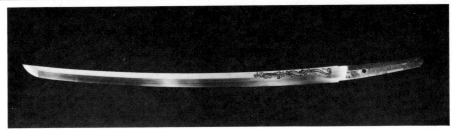

Wakizashi blade by Morimichi, mid 17th century. Length 21¾ in (55·2 cm). New Bond Street 9 October £550 ($1,320)

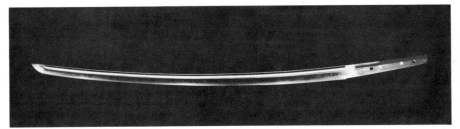

Daito blade, 18th century. Length 26⅜ in (67 cm). New Bond Street 9 October £950 ($2,280)

Leather-laced suit of armour (Keiko), 18th/19th century. New York 2-3 April $2,200 (£983)

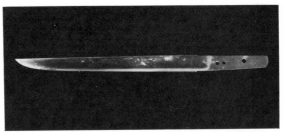

Tanto blade by Uda Kuninaga, 17th century, sold with full sword furniture. Length of blade 10¼ in (26·1 cm). New Bond Street 9 October £560 ($1,344)

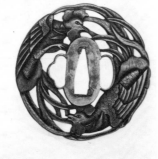

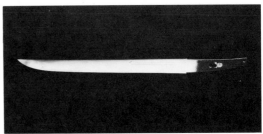

Copper and shakudo tsuba by Katsuaki. 3½ in (8·9 cm). New Bond Street 18 December £260 ($624)

Copper tsuba of the Shoami school. 3⅛ in (8·1 cm). New Bond Street 18 December £170 ($408)

Koto Bizen tanto blade by Osafune Kagemitsu. Length 11 in (28 cm). New York 2-3 April $350 (£146)

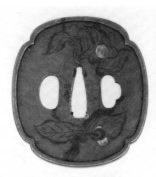

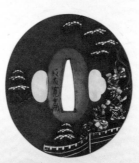

Copper tsuba by Umetada Mioju. 3⅛ in (8 cm). New Bond Street 9 October £140 ($336)

Rectangular tsuba after Hirata Harunari. 3¼ in (8·3 cm). New Bond Street 9 October £400 ($960)

Pair of tsuba for a daisho, by Goto Kanjo (1612-1653). 3 and 2⅞ in (7·5 and 7·2 cm). New Bond Street 9 October £780 ($1,872)

European ceramics

In general, Continental ceramics are now more expensive than English and although the range of pieces available at below £1,000 ($2,400) is still a wide one, the collector with limited financial resources will have to search more diligently for good examples. In this section pieces illustrated range from Italian and North European pottery of the 16th and 17th centuries to some of the ornate mid-to-late 19th-century products of the French and German factories. Examples of fine quality have been selected and those from some of the great factories which have fetched low prices by reason only of the damage they have sustained have been ignored. Nevertheless, it will be noticed that there are few areas of Continental ceramic production not available at reasonable prices. Some good examples of Italian maiolica are illustrated, including attractive Deruta dishes at prices between £380 ($912) and £750 ($1,800). Also from this early period, we should mention the exceptionally rare Hafnerware green pottery model of a stove, probably made in Nuremberg and dating from the second half of the 16th century, which fetched £780 ($1,872) in New Bond Street on 23 April. A piece of this importance is worthy to be exhibited in any national collection of ceramics.

From some of the great 18th-century porcelain factories, the collector will find a wealth of material at surprisingly modest prices. For example, a splendid Sèvres porcelain ewer with silver mounts bearing the date letter for 1770 and the painter's mark for Noel was sold for $1,800 (£750), and a beautiful yellow-ground *écuelle* with 'named-bird' decoration fetched $600 (£250), both sold in New York on 22 February. Among other important factories, examples will be found of Doccia, Capodimonte, Paris, Fürstenburg, Frankenthal, Nymphenburg and, of course, Meissen. Fine pieces from this last factory, arguably the greatest of all those 18th-century porcelain factories which changed the whole concept of European ceramics, can still be bought at prices below £500 ($1,200) and good examples by the two outstanding modellers, J. J. Kaendler and P. Reinicke, will be found illustrated here.

19th-century Continental porcelain is still, to many people, decadent and overblown and some of the worst excesses committed by the factories of France, Germany and Austria are certainly to be regretted. However, the revival of interest in the art of the last century in general has led to a re-appraisal of the ceramics of this period and the careful collector will find this a rewarding field for study. If he avoids the vast and often expensive products of the mid century, he should be able to find interesting things of great beauty. The richly decorated and charming Bohemian porcelain cup and saucer sold in New Bond Street on 10 December for only £55 ($132) may serve as an example.

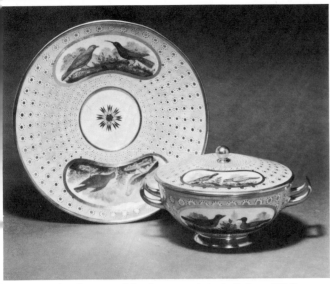

Sèvres porcelain yellow-ground *écuelle*, cover and stand with 'named bird' decoration, date letter CC for 1780. Diameter of stand 8⅜ in (21·3 cm). New York 23 February $600 (£250)

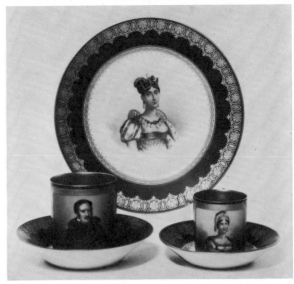

Sèvres porcelain coffee service of sixty-four pieces painted with portraits of French royalty by Perier, date code for 1804 but late 19th century. Belgravia 20 June £750 ($1,800)

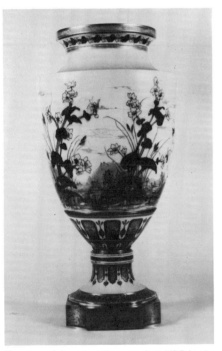

Early Sèvres porcelain square *déjeuner* tray, French, *circa* 1755. Width 4⅜ in (11·1 cm). New York 23 February $425 (£179)

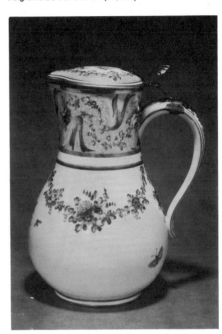

Sèvres porcelain presentation vase signed 'E.D.' and dated 1887. Height 28½ in (72·4 cm). Belgravia 17 January £520 ($1,248)

Silver-mounted Sèvres porcelain covered ewer, bears the date letter R for 1770, the painter's mark for Noel and the silver mounts bearing the Paris discharge mark for 1768-74. Height 7⅝ in (19·4 cm). New York 23 February $1,800 (£750)

French soft paste porcelain ram-form *bonbonnière* with silver and agate mounts, possibly Bourg-la-Reine 18th century. Length 2¾ in (7 cm). New York 23 February $1,050 (£438)

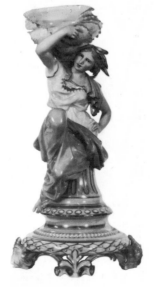

One of a pair of Gillet and Brianchon lustre-sheen porcelain vases, *circa* 1860. Height 17 in (43 cm). Belgravia 17 January £185 ($444)

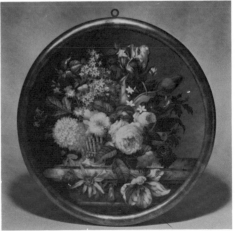

Paris porcelain plaque painted in the Derby style, late 19th century. Diameter 17¾ in (45·2 cm). New York 23 February $1,200 (£500)

One of a pair of Samson porcelain Mansion House dwarfs, after Derby originals, early 20th century. Height 6½ in (16·5 cm). Belgravia 20 June £70 ($168)

Pair of porcelain leopards by Samson, French last quarter of the 19th century. Length 5¾ in (14·6 cm). Belgravia 3 October £220 ($528)

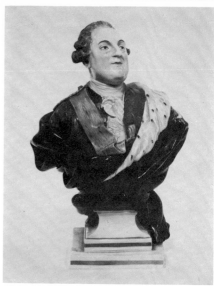

Samson porcelain 'Derby' bust of Louis XVI, last quarter of the 19th century. Height 11¼ in (28·6 cm). Belgravia 20 June £82 ($197)

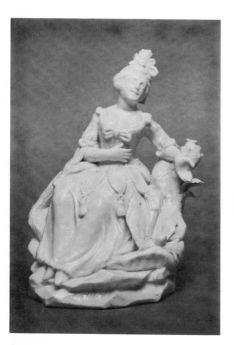

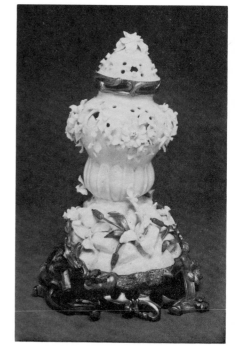

Left: St Cloud porcelain white glazed figure of a woman, French *circa* 1750. Height 6¾ in (17·2 cm) New York 23 February $450 (£188)

Right: St Cloud porcelain white pastille burner and cover with ormolu mounts and base, French *circa* 1750. Height 9¾ in (24·8 cm). New York 23 February $2,000 (£833)

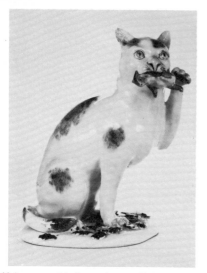

Meissen porcelain figure of a cat. Height 6¾ in (17 cm). New Bond Street 4 June £650 ($1,560)

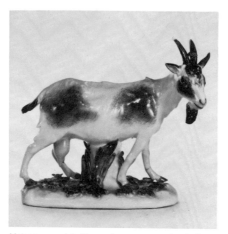

Meissen porcelain figure of a nanny goat by J. J. Kaendler. Height 5½ in (14 cm). New Bond Street 4 June £200 ($480)

Meissen porcelain figure of a sheep. Height 4 in (10 cm). New Bond Street 4 June £200 ($480)

Meissen porcelain group called *The Lottery*. Height 6⅜ in (16·2 cm). New Bond Street 4 June £400 ($960)

Meissen porcelain group called *Kinder Spielen Verlobung*. Height 6⅛ in (15·5 cm). New Bond Street 4 June £460 ($1,104)

Meissen porcelain figure of a Turk by Johann Joachim Kaendler (right hand replaced, slight restoration). Height 14 in (35·6 cm). New Bond Street 10 November £390 ($936)

Left: One of a pair of Meissen porcelain table obelisks. Height 6⅛ in (15·6 cm). New Bond Street 4 June £150 ($360)
Right: Meissen porcelain figure of a child as Columbine from a series of *Komödienkinder*. Height 5⅛ in (13 cm). New Bond Street 4 June £300 ($720)

Meissen porcelain figure of Scaramouche by Kaendler and Reinicke. Height 5⅜ in (13·7 cm). New Bond Street 4 June £450 ($1,080)

Meissen porcelain figure of a fusilier. Height 4⅝ in (11·7 cm). New Bond Street 4 June £280 ($672)

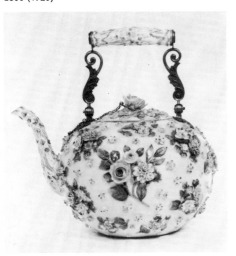

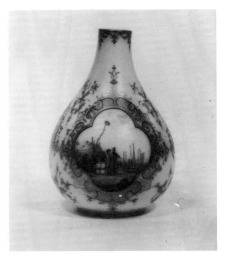

Meissen porcelain encrusted punch pot and cover, third quarter of the 19th century. Height to top of handle 10¼ in (26 cm). Belgravia 17 January £120 ($288)

Meissen porcelain mug. Height 3⅝ in (9·2 cm). New Bond Street 4 June £520 ($1,248)

Marcolini Meissen porcelain vase in mid 18th century style, early 19th century. Height 5½ in (14 cm). Belgravia 3 October £100 ($240)

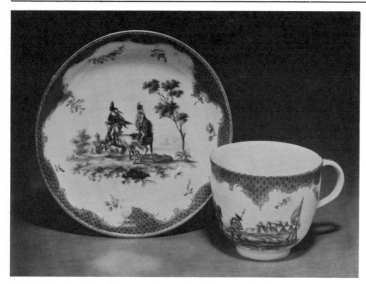

Fürstenburg porcelain coffee cup and saucer, 1770-80. New York
22 February $450 (£188)

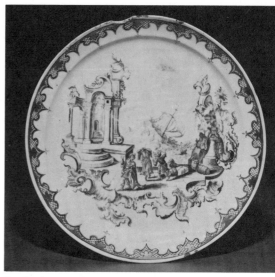

Nymphenburg porcelain plate, probably painted by a German
Hausmaler 1755-60. Diameter 8¾ in (22·2 cm). New York
23 February $450 (£188)

Dresden porcelain plaque painted with a portrait of
Dr Samuel Johnson, last quarter of the 19th
century. Length 5½ in (14 cm). Belgravia
17 January £85 ($204)

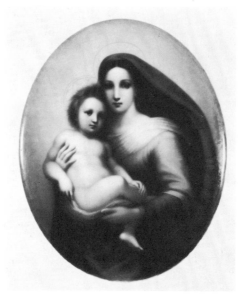

Berlin porcelain plaque painted with the *Madonna
and Child* after Raphael, second half of the 19th
century. Height 10¼ in (26 cm). Belgravia
17 January £250 ($600)

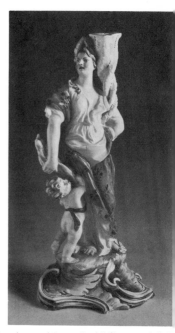

Doccia porcelain candlestick figure modelled
by B Permoser, Italian *circa* 1770. Height 8¾
in (22·2 cm). New York 23 February
$1,100 (£459)

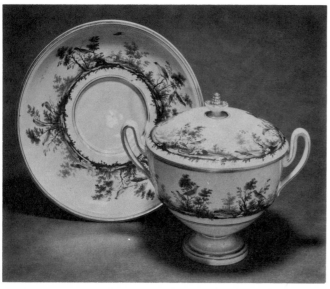

Left: Doccia *écuelle*, cover and stand,
Italian 1790-1800. Diameter of
stand 7½ in (19 cm). New York
22 February $450 (£188)

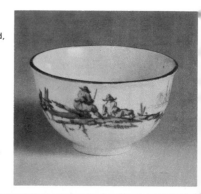

Right: Very rare Hewelcke Venice
porcelain teabowl, Italian 1761-
63. New York 23 February
$250 (£104)

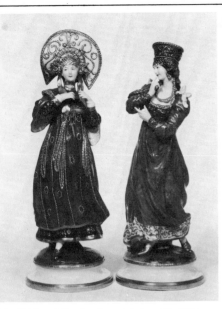

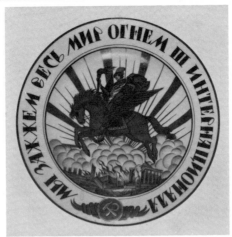

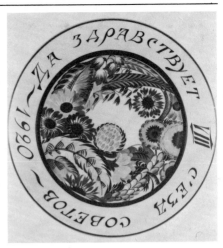

Third International Commemorative Russian porcelain plate dated 1922. Diameter 9¼ in (23·5 cm). Belgravia 3 October £85 ($204)

'Union of the Soviets' Russian porcelain plate, inscribed *Long live the meeting of the 8th Soviets 1920*, dated 1921. Diameter 9¾ in (25 cm). Belgravia 3 October £35 ($84)

Pair of Volkstedt Russian dancers, last quarter of the 19th century. Height 13 in (33 cm). Belgravia 20 June £250 ($600)

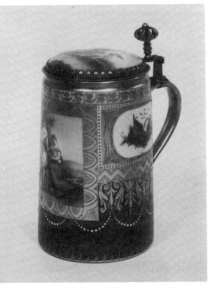

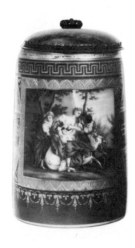

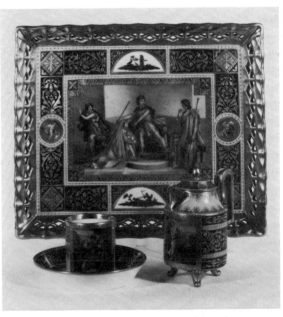

Vienna porcelain tankard and cover painted with *The Rape of Europa*, last quarter of the 19th century. Height 6¼ in (15·9 cm). Belgravia 17 January £240 ($576)

Vienna porcelain *tête-à-tête*, second half of the 19th century. Width of tray 13¼ in (33·7 cm). Belgravia 17 January £490 ($1,176)

Vienna porcelain tankard with gilt-metal mounts, the body painted with *The Three Graces*, last quarter of the 19th century. Height 6⅝ in (16·8 cm). Belgravia 3 October £220 ($528)

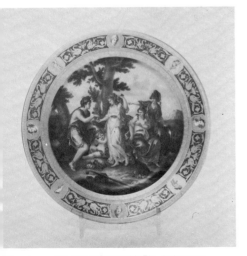

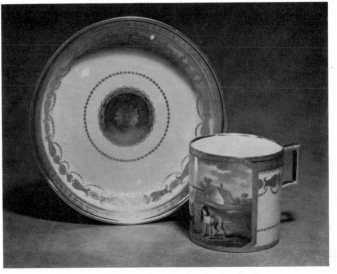

Vienna porcelain dish painted with *The Judgement of Paris*, last quarter of the 19th century. Diameter 12¾ in (32·5 cm). Belgravia 20 June £250 ($600)

Vienna porcelain 'Sorgenthal' cup and saucer, Austrian, bearing the gilder's numeral 96 for Anton Kothgasser and dated 1801. New York 23 February $1,050 (£438)

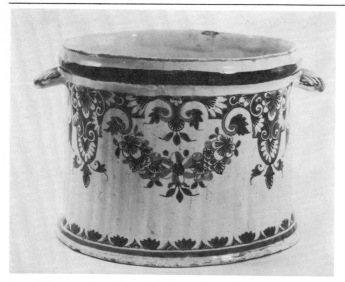

Rouen pottery *seau-à-bouteille*. Height 6½ in (16·5 cm).
New Bond Street 23 April £100 ($240)

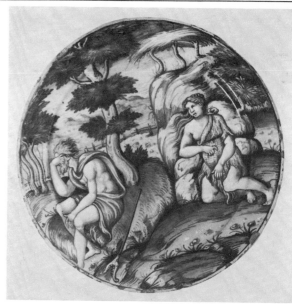

Lyons pottery painted plate with a scene from *Genesis III*. Diameter
9½ in (24·2 cm). New Bond Street 23 April £340 ($816)

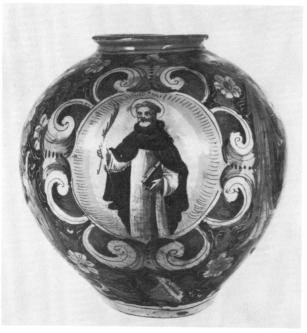

Venice pottery drug jar. Height 12½ in (31·8 cm). New Bond Street
23 May £520 ($1,248)

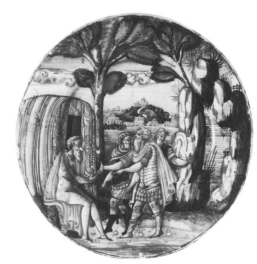

'Istoratio' pottery dish, probably Rimini. Diameter 9¼ in (23·5 cm).
New Bond Street 23 April £750 ($1,800)

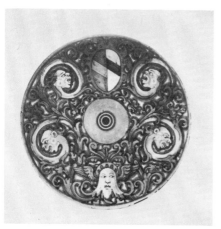

Deruta pottery dish. Diameter 9 in (22·9 cm).
New Bond Street 23 April £380 ($912).

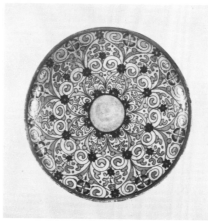

Deruta lustre pottery dish. Diameter 8½ in (22·6 cm)
New Bond Street 23 April £380 ($912)

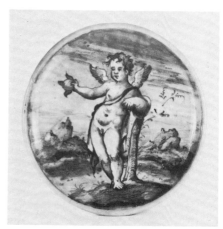

Venice pottery dish on foot. Diameter 6½ in
(16·5 cm). New Bond Street 23 April £150 ($360)

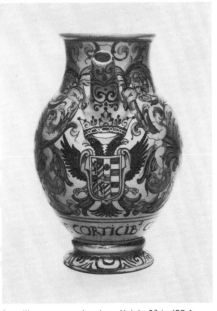

Castelli pottery wet drug jar. Height 9⅞ in (25·1 cm). New Bond Street 23 May £500 ($1,200)

Caltagirone pottery albarello, one of two, Height 9 in (22·9 cm). New Bond Street 23 May £220 ($528)

Italian lustred pottery plaque of Saint Jerome in the wilderness. Deruta or Gubbio Height 8¾ in (22·2 cm). New Bond Street 23 April £340 ($816)

Early Tuscan pottery jug. Height 5¼ in (13·4 cm). New Bond Street 23 April £300 ($720)

Sienna painted pottery albarello. Height 11½ in (29·2 cm). New Bond Street 23 April £900 ($2,160)

Urbino pottery plaque of Christ wearing the Crown of Thorns. Height 7½ in (19 cm). New Bond Street 23 April £320 ($768)

Left: Delft earthenware plaque painted by *Omaar Th Schwartze,* second half of the 19th century. 17¼ in by 11 in (43·8 by 27·9 cm). Belgravia 17 January £170 ($408)

Right: One of a pair of Dutch Delft pottery figures of cows, 1780-1820. Height 7¾ in (19·7 cm). New York 22 February $1,700 (£709)

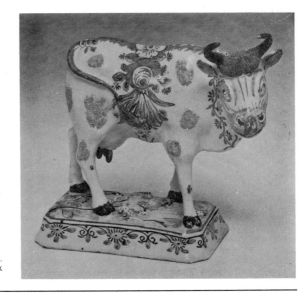

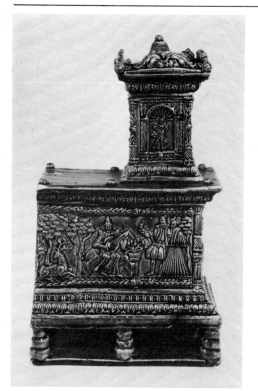

Hafnerware pottery green-glazed model of a stove, probably Nuremberg, second half of the 16th century. Height 10½ in (26·6 cm). New Bond Street, 23 April £780 ($1,872)

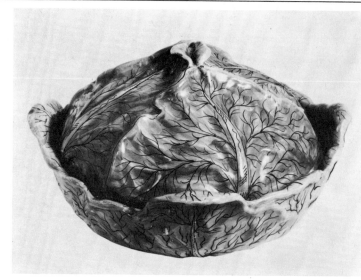

Schrezheim pottery 'cabbage' tureen and cover (some repairs). Length 11½ in (29·2 cm). New Bond Street 23 April £440 ($1,056)

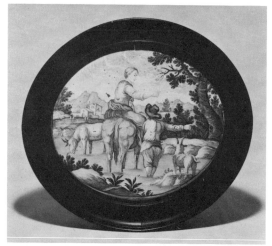

Castelli oval maiolica plaque, Italian early 18th century. Length 9⅜ in (23·8 cm). New York 22 February $550 (£230)

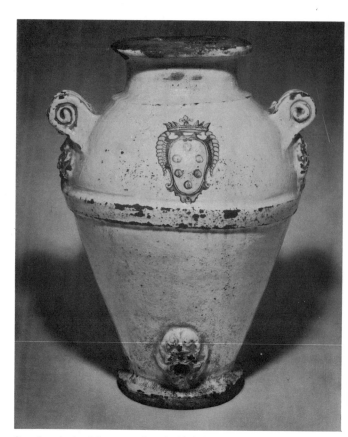

One of a pair of maiolica storage jars, the Medici arms painted on the shoulders, Italian, early 17th century. Height 20 in (50·8 cm). New York 2 March $2,200 (£916)

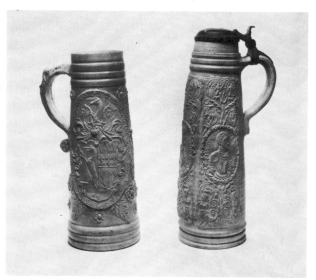

Far left: Siegburg stoneware tankard. Height 9¼ in (23·5 cm). New Bond Street 23 April £340 ($816)

Left: Siegburg stoneware tankard, with pewter top. Height 10½ in (26·6 cm). New Bond Street 23 April £550 ($1,320)

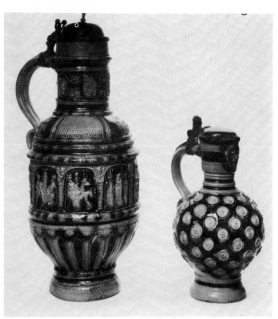

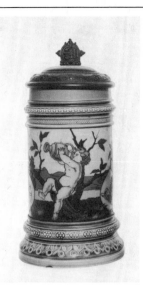

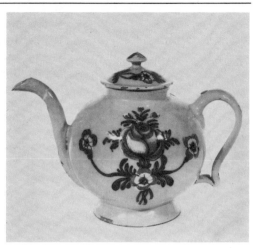

Montpellier faience yellow-ground teapot and cover. Height 6 in (15·2 cm). New Bond Street 23 April £100 ($240)

Mettlach stoneware stein by C Warth, date code for 1885. Height 8½ in (21·6 cm). Belgravia 17 January £70 ($168)

Left: Westerwald stoneware jug with pewter lid. Height 13¾ in (35 cm). New Bond Street 23 April £520 ($1,248)

Right: Westerwald stoneware jug with pewter lid. Height 8¾ in (22·2 cm). New Bond Street 23 April £140 ($336)

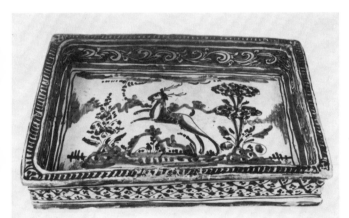

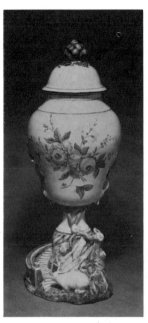

Spanish (Talavera) faience dish. Length 17¼ in (43·8 cm). New Bond Street 23 April £230 ($552)

Marieburg faience terrace vase and cover, Swedish dated 1778, mark of the Sten period. Height 13¾ in (34·9 cm). New York 22 February $275 (£114)

German faience jug with unicorn decoration, 18th century. Height 7⅞ in (20 cm). New York 22 February $925 (£385)

One of a pair of Glienitz faience melon tureens with covers and stands. Height 8¼ in (20·5 cm). New Bond Street 23 April £800 ($1,920)

Left: One of a pair of Strasbourg faience jardinières, *circa* 1765. Height 4½ in (11·4 cm). New York 22 February $100 (£42)

Right: Niderviller faience cruet stand, *circa* 1760. Length 10¼ in (26 cm). New York 22 February $100 (£42)

English ceramics

The collecting of English ceramics has lagged behind the traditional interest in the great factories of Germany and France. It is difficult to establish the reason for this, but it may be a feeling that even the finest English 18th-century porcelains, Chelsea, Worcester and Bow, are less bold and adventurous than those of, for instance, Meissen, Vincennes or Sèvres. It must be admitted that English pieces rarely equal the best Continental ceramics in quality.

Nevertheless, the low esteem in which 18th-century porcelain was held during the 1950s and early 1960s was an over-reaction which in the last half decade or so has given way to a more reasoned appraisal of the ceramic art of this period. Since 1970 prices have risen considerably and opportunities for the modestly financed collector to purchase the finest examples of Worcester and Chelsea are now past.

However, there are still splendid things to be bought in this field for a modest outlay, as can be seen in this section where are any number of pieces available for below £250 ($600), and it is not unusual to find good and interesting examples of the 18th-century porcelain realising prices below £100 ($240); we can cite the Longton Hall half mulberry-leaf dish sold in New York on 22 February for $200 (£83), the very rare Fulham factory white porcelain group of a putto riding a dolphin which fetched £55 ($132) in New Bond Street on 25 March, or the Grainger, Lee and Company figure of a dog which fetched a mere £35 ($84) in the same sale.

In the field of pottery, there are even more opportunities. In statistical terms, it could be argued that the rise in value of 17th- and 18th-century English pottery in the last few years is even greater than that of porcelain but it must be remembered that, whereas for porcelain we are thinking in terms of things which five years ago might have been worth £100 and are now costing £600, for pottery the equation is more in the order of £10 to £100.

The earliest pieces represented here are some fine 18th-century Staffordshire slipware dishes which were included in a magnificent collection of early English pottery sold in New Bond Street on 23 May. Some beautiful examples with combed decoration, the type which had a profound influence upon such modern potters as Bernard Leach and Michael Cardew, fetched as little as £170 ($408), much less than 20th-century examples by Cardew, one of which made nearly £400 ($960) at Christie's in 1974.

Chronologically, the section dealing with English ceramics continues well into the 20th century with animals modelled by Doris Lindner for the Royal Worcester Porcelain Company since the second World War. Worcester's contribution to 19th-century ceramic design was outstanding and good examples will be found here of the work of two leading 19th-century modellers, James Hadley and George Owen.

One of a pair of Liverpool delft wall-pockets. Height 8¼ in (21 cm).
New Bond Street 17 April £260 ($624)

Liverpool delft puzzle jug. Height 7½ in (19·1 cm). New Bond Street
17 April £190 ($456)

English delftware pottery 'blue-dash' charger. Diameter 13¾ in (34·9 cm).
New Bond Street 23 May £360 ($864)

English delftware pottery 'Adam and Eve' charger (slight repair). Diameter
13½ in (34·3 cm). New Bond Street 23 May £200 ($480)

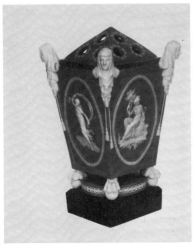

Turner and Co covered pottery vase of pale blue
Jasperware, mid 1780s. Height 7⅞ in (20 cm).
New Bond Street 17 April £420 ($1,008)

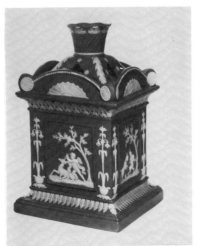

Neale pottery greyish-blue Jasperware pot-pourri
jar and cover. Height 7⅞ in (20 cm).
New Bond Street 17 April £270 ($648)

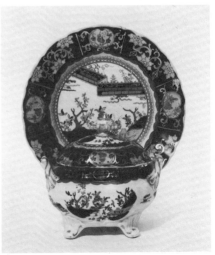

Mason's Ironstone dinner service of fifty-two pieces,
circa 1840. Belgravia 5 September £310 ($744)

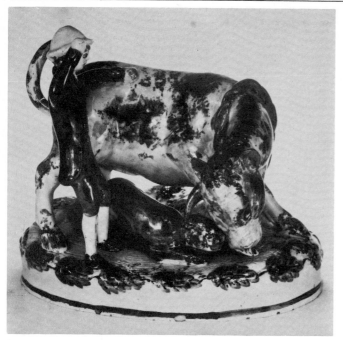

Scottish pottery bullbaiting group, probably Portobello. Height 6 in (15·2 cm). New Bond Street 25 March £420 ($1,008)

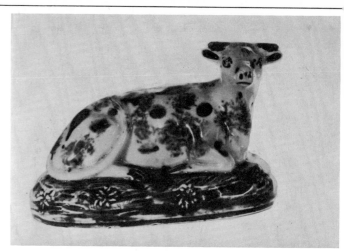

One of a pair of Portobello pottery figures of cows. Height 4 in (10·2 cm). New Bond Street 25 March £230 ($512)

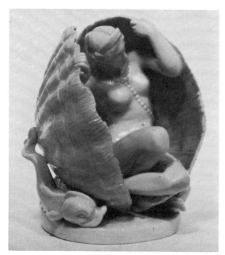

Goss Parian figure depicting *The Birth of Venus* after the marble by Pradier, *circa* 1870. Height 7¼ in (18·4 cm). Belgravia 9 May £80 ($192)

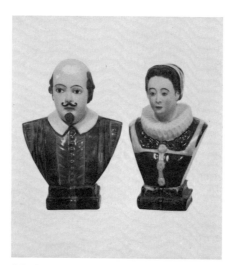

Pair of coloured Goss busts of William Shakespeare and Ann Hathaway, *circa* 1900. Height 4 in (10·2 cm). Belgravia 9 May £60 ($144)

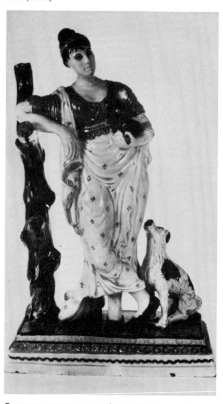

Prattware pottery group of a shepherdess and her dog. Height 9½ in (24·1 cm). New Bond Street 25 March £360 ($864)

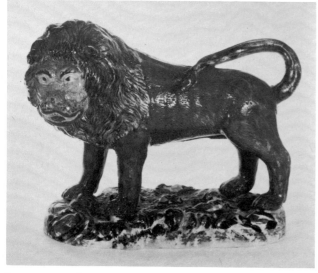

Prattware pottery figure of a lion decorated in dark splashed glazes. Height 7¼ in (18·4 cm). New Bond Street 25 March £180 ($432)

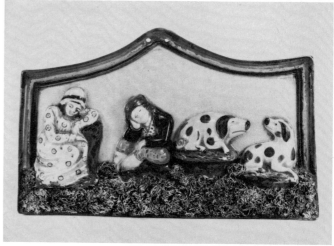

Prattware pottery polychrome painted plaque. Length 8½ in (21·6 cm). New Bond Street 17 April £160 ($384)

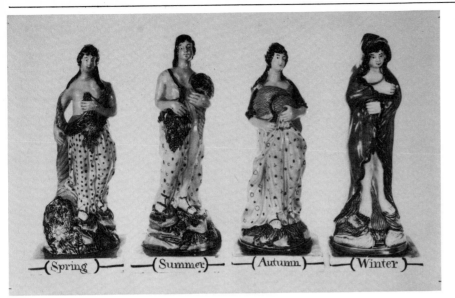

Set of Pratt pottery polychrome painted figures of the Seasons. New Bond Street 17 April £520 ($1,248)

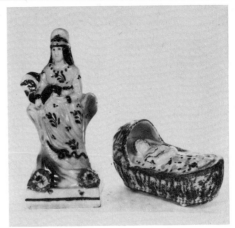

Left: Prattware pottery figure of a woman. Height 5 in (12·7 cm). New Bond Street 25 March £70 ($168)

Right: Prattware pottery model of a baby in a cradle. Length 3¾ in (9·5 cm). New Bond Street 25 March £55 ($132)

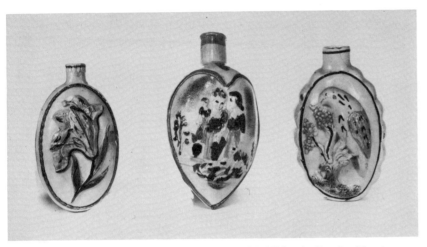

Left: Prattware pottery flask decorated with a tulip. Height 5¼ in (13·3 cm). New Bond Street 25 March £70 ($168)
Centre: Prattware pottery flask decorated with *Mischievous Sport* and *Sportive Innocence*. Height 6¾ in (17·1 cm). New Bond Street 25 March £70 ($168)
Right: Prattware pottery flask decorated with a parrot. Height 5¾ in (14·6 cm). New Bond Street 25 March £85 ($204)

Left: Pottery figure of a woman seated in a rocking chair. Height 3¼ in (8·3 cm). New Bond Street 25 March £32 ($77)

Right: Prattware pottery figure of a standing woman. Height 4⅞ in (12·4 cm). New Bond Street 25 March £40 ($96)

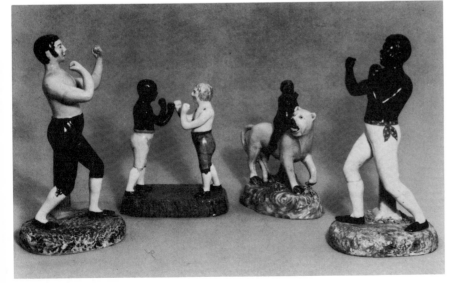

Outer figures: Pair of Staffordshire pottery figures of the boxers Molineaux and Cribb. Height 9 in (22·9 cm). New Bond Street 25 March £760 ($1,824)
Inner left: Staffordshire pottery group of Molineaux and Cribb. Height 6¼ in (15·9 cm). New Bond Street 25 March £520 ($1,248)
Inner right: Staffordshire pottery group of a putto riding a lioness. Height 6¼ in (15·9 cm). New Bond Street 25 March £260 ($624)

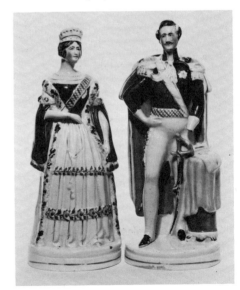

Pair of Staffordshire pottery figures of Queen Victoria and Prince Albert, *circa* 1845. Heights 11 and 11¼ in (27·9 and 28·6 cm). Belgravia 9 May £70 ($168)

Staffordshire pottery pot-lid:
Belle Vue, Pegwell Bay. Belgravia
9 May £18 ($43)

Staffordshire pottery pot-lid.
Pegwell Bay—Est. 1760. Belgravia
9 May £20 ($48)

Staffordshire pottery pot-lid:
I See You My Boy. Belgravia
9 May £30 ($72)

Staffordshire pottery pot-lid:
Shakespeare's House. Belgravia
9 May £22 ($53)

Staffordshire pottery pot-lid:
Albert Memorial. Belgravia 9 May
£15 ($36)

Staffordshire pottery pot-lid:
A Race or Derby Day. Belgravia
9 May £28 ($67)

Staffordshire pottery pot-lid:
Alexandra Palace. Belgravia 9 May
£30 ($72)

Staffordshire pottery pot-lid:
French Street Scene. Belgravia
9 May £18 ($43)

Staffordshire pottery pot-lid:
Preparing for the Ride. Belgravia
9 May £28 ($67)

Staffordshire pottery pot-lid:
The Grand International Building of
1851. Belgravia 9 May £38 ($91)

Staffordshire pottery pot-lid:
The First Appeal. Belgravia 9 May
£22 ($53)

Staffordshire pottery pot-lid:
The Second Appeal. Belgravia
9 May £22 ($53)

Staffordshire pottery pot-lid:
Skewbald Horses. Belgravia 9 May
£20 ($48)

Staffordshire pottery pot-lid:
On Guard. Belgravia 9 May £12
($29)

Staffordshire pottery pot-lid:
The Enthusiast. Belgravia 9 May
£18 ($43)

Staffordshire pottery pot-lid:
Uncle Toby. Belgravia 9 May
£15 ($36)

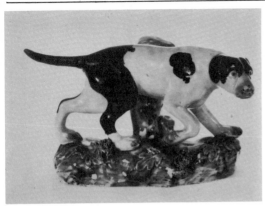

Staffordshire pottery figure of a pointer. Height 6¼ in (15·9 cm).
New Bond Street 25 March £70 ($168)

Staffordshire slipware pottery baking dish. Diameter 15¼ in (38·7 cm).
New Bond Street 23 May £170 ($408)

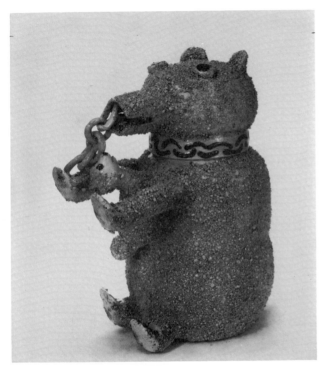

Staffordshire saltglaze bear jug and cover. Height 9 in (22·9 cm).
New Bond Street 17 April £230 ($552)

Staffordshire slipware pottery baking dish. Diameter 13 in (33 cm).
New Bond Street 23 May £340 ($816)

Staffordshire slipware pottery baking dish. Diameter 14¼ in (36·2 cm).
New Bond Street 23 May £380 ($912)

English slipware pottery baking dish. Diameter 15¼ in (38·7 cm).
New Bond Street 23 May £260 ($674)

Staffordshire slipware pottery dish by John Simpson. Diameter 13¾ in (34·9 cm). New Bond Street 23 May £720 ($1,728)

Staffordshire slipware press-moulded pottery dish by John Simpson (1685-1774). Width 13 in (33 cm). New Bond Street 23 May £750 ($1,800)

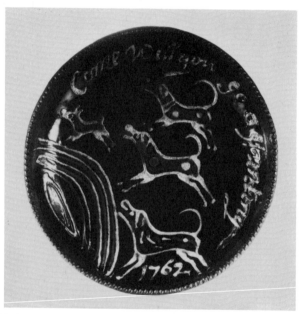

English slipware pottery dish inscribed *Come will you go a-hunting* and the date 1726, probably Ticknall. Diameter 13½ in (34·3 cm). New Bond Street 23 May £620 ($1,488)

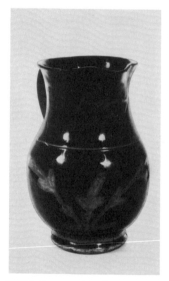

English slipware pottery jug, Bolsover or Ticknall, dated 1727. Height 6 in (15·2 cm). New Bond Street 23 May £500 ($1,200)

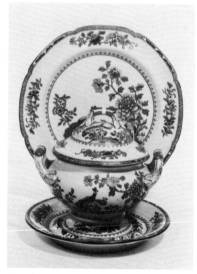

Spode 'New Stone' earthenware dinner service of sixty-eight pieces, 1805-15. Belgravia 6 June £280 ($672)

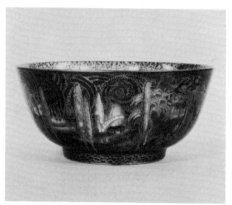

Wedgwood pottery Fairyland lustre bowl, 1920s. Diameter 9¼ in (23·5 cm). Belgravia 14 February £370 ($888)

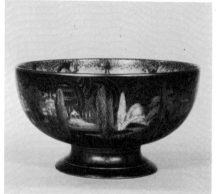

Wedgwood pottery Fairyland lustre punch bowl, 1920s. Width 9¼ in (23·5 cm). Belgravia 6 June £310 ($744)

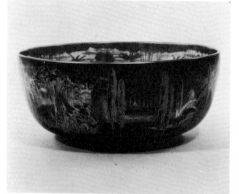

Wedgwood pottery Fairyland lustre bowl, 1920s. Width 10¼ in (26 cm). Belgravia 6 June £230 ($552)

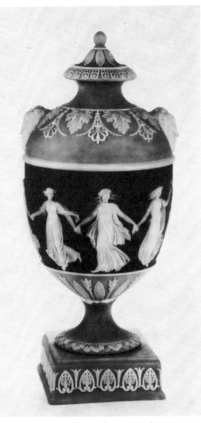

Wedgwood pottery three-colour urn and cover, decorated with a band showing *The Dancing Hours.* Height 7½ in (19·1 cm). New Bond Street 17 April £400 ($960)

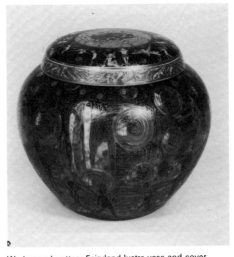

Wedgwood pottery Fairyland lustre vase and cover, 1920s. Height 7¼ in (18·4 cm). Belgravia 5 September £500 ($1,200)

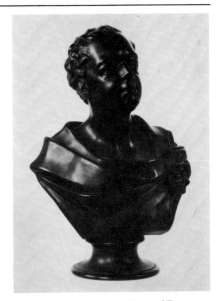

Wedgwood pottery black basalt bust of Thomas Moore, mid 19th century. Height 13¼ in (33·7 cm). Belgravia 14 February £200 ($480)

Wedgwood pottery Fairyland lustre vase and cover. dated *7.V.24.* Height 7¼ in (18·4 cm). Belgravia 5 September £450 ($1,080)

One of a set of twelve Wedgwood earthenware plates decorated with a cartoon after a Punch engraving, date code for 1868. Belgravia 6 June £230 ($552)

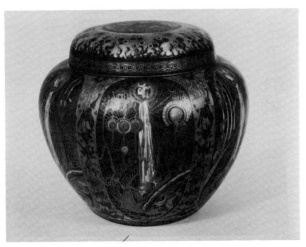

Wedgwood pottery Fairyland lustre bowl, 1920s. Width 8 in (20·3 cm). Belgravia 14 February £360 ($864)

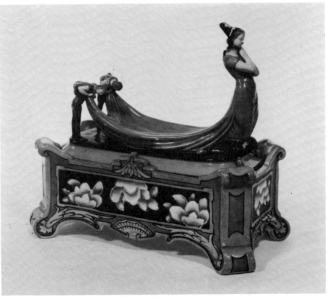

Wedgwood pottery 'Candlemas' Fairyland lustre vase and cover, 1920s. Height 10 in (25·4 cm). Belgravia 5 September £1,000 ($2,400)

Wedgwood earthenware inkstand, date code for 1872. Height 9½ in (24·1 cm). Belgravia 14 November £160 ($384)

Whieldon pottery figure of a hound. Height 3¼ in (8·3 cm). New Bond Street 25 March £240 ($576)

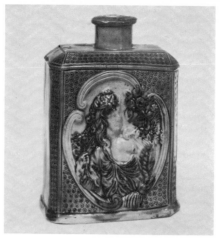

Whieldon pottery tea caddy and cover. Height 6¾ in (17·1 cm). New Bond Street 25 March £280 ($674)

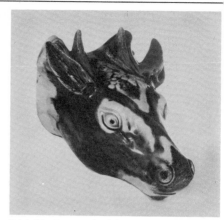

Ralph Wood pottery deer's head stirrup-cup. Length 4¾ in (12·1 cm). New Bond Street 25 March £360 ($864)

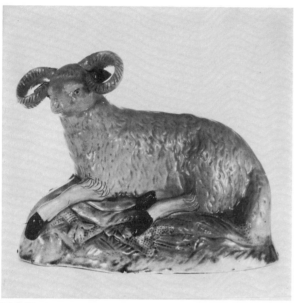

Ralph Wood pottery figure of a ram. Height 6½ in (16·5 cm). New Bond Street 25 March £180 ($432)

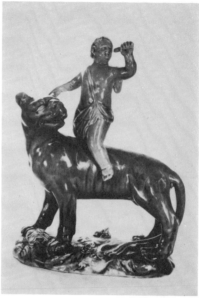

Ralph Wood pottery group of Cupid riding a lioness. Height 7½ in (19·1 cm). New Bond Street 25 March £450 ($1,080)

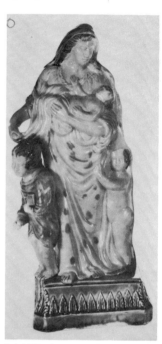

Ralph Wood pottery group of Charity. Height 9¾ in (24·8 cm). New Bond Street 25 March £560 ($1,344)

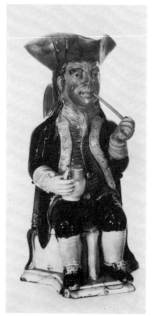

Ralph Wood pottery 'Squire' Toby jug. Height 11¼ in (28·6 cm). New Bond Street 17 April £240 ($576)

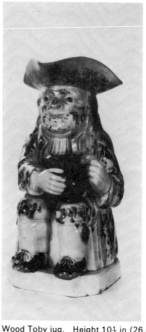

Ralph Wood Toby jug. Height 10¼ in (26 cm). New Bond Street 17 April £180 ($432)

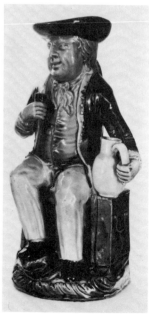

Ralph Wood pottery jug modelled as The Planter. Height 11¾ in (29·8 cm). New Bond Street 17 April £200 ($480)

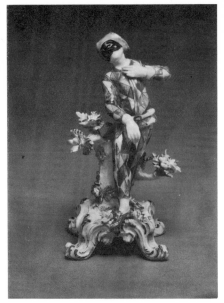

Bow porcelain figure of Harlequin, *circa* 1760. Height 7 in (17·8 cm). New York 22 February $1,050 (£438)

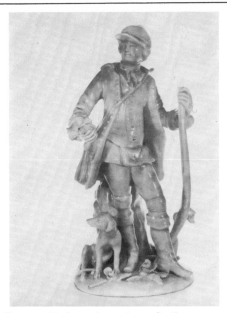

Bow porcelain figure of a sportsman after the Meissen original modelled by J. J. Kaendler. Height 6¾ in (17·1 cm). New Bond Street 25 March £230 ($552)

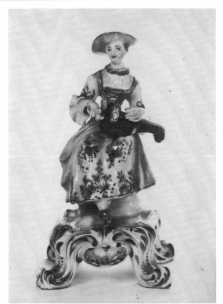

One of a pair of Bow porcelain figures of musicians after the Meissen originals, 18th century. Height 5¾ in (14·6 cm). New Bond Street 14 May £320 ($768)

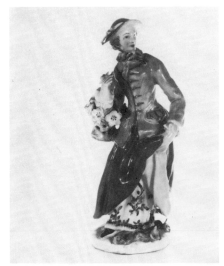

Bow porcelain figure of a girl, emblematic of Spring, third quarter of the 18th century. Height 5¾ in (14·6 cm). New Bond Street 14 May £400 ($960)

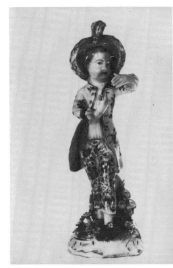

Bow porcelain figure of a 'New Dancer'. Height 7 in (17·8 cm). New Bond Street 12 March £170 ($408)

Very rare miniature Bow porcelain figure of a monkey with young. Height 4¾ in (12·1 cm). New Bond Street 25 March £360 ($864)

One of a pair of early Bow porcelain lions. Height 3½ in (8·9 cm). New Bond Street 25 March £560 ($1,344)

Bow porcelain figure of a goldfinch, 18th century. Height 3½ in (8·9 cm). New Bond Street 14 May £320 ($768)

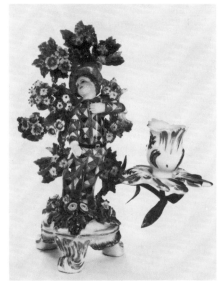

One of a pair of Bow porcelain candlesticks modelled as Harlequin and his companion, anchor and dagger mark (about 1760-76). Height 7 in (17·8 cm). New Bond Street 14 May £400 ($960)

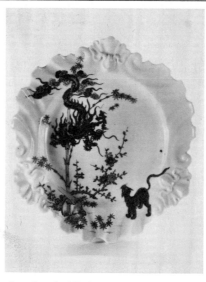

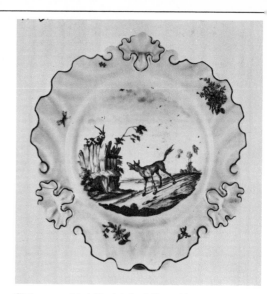

Chelsea porcelain cane handle in the form of a girl's head, triangle period (1745-50). Height 2 in (5·1 cm). New Bond Street 14 May £290 ($456)

One of a pair of Chelsea porcelain silver-shaped dishes painted in Kakiemon style, raised anchor period *circa* 1752. Diameter 8½ in (21·6 cm). New Bond Street 14 May £950 ($2,280)

Chelsea porcelain fable plate by Jeffreyes Hammett O'Neale, raised anchor period *circa* 1752. Diameter 9 in (22·9 cm). New Bond Street 14 May £600 ($1,440)

Chelsea porcelain cauliflower tureen and cover, red anchor period (1752-6). Length 4⅝ in (11·7 cm). New York 22 February $800 (£333)

One of a pair of Chelsea porcelain vine-leaf dishes (some repairs), red anchor period (1752-6). Length 8 in (20·3 cm). New Bond Street 14 May £210 ($504)

One of a pair of Chelsea porcelain peony dishes, red anchor period (1752-6). Length 9¼ in (23·5 cm). New York 22 February $1,200 (£500)

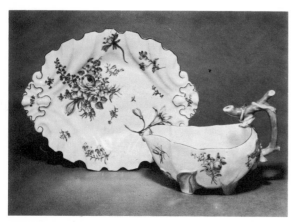

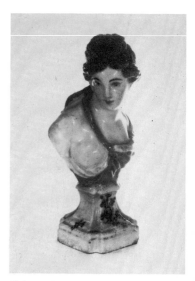

Left: One of a pair of Chelsea porcelain silver-shaped dishes, red anchor period (1752-6). Length 10 in (25·4 cm). New York 22 February $900 (£375)

Right: One of a pair of Chelsea porcelain sauce boats, red anchor period (1752-6). Length 7¼ in (18·4 cm). New York 22 February $600 (£250)

Chelsea porcelain monkey double scent bottle, red anchor period (1752-6). Height 2⅜ in (6 cm). New Bond Street 12 March £360 ($864)

Chelsea porcelain bust of a Goddess, perhaps representing one of the Seasons, red anchor period (1752-6). Height 4¼ in (10·8 cm). New Bond Street 14 May £210 ($504)

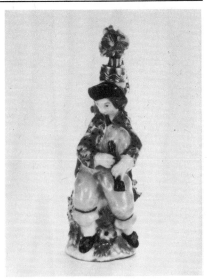

One of a pair of Chelsea porcelain fable plates from the so-called Warren Hastings service, painted by Jeffreyes Hammett O'Neale, red anchor period (1752-6). Diameter 11¼ in (28·6 cm). New Bond Street 14 May £480 ($1,152)

Chelsea porcelain figure of a cow, red anchor period (1752-6). Length 5½ in (14 cm). New Bond Street 14 May £150 ($360)

Chelsea porcelain scent bottle 'Boy with Bagpipes', gold anchor period (1756-69). Height 2¾ in (7 cm). New Bond Street 14 May £350 ($840)

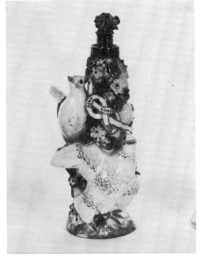

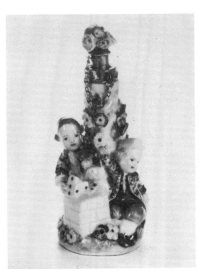

Chelsea porcelain scent bottle, gold anchor period (1756-69). Height 3½ in (8·9 cm). New Bond Street 14 May £320 ($768)

Chelsea porcelain scent bottle 'Playing card houses', gold anchor period (1756-69). Height 2⅝ in (6·7 cm). New Bond Street 14 May £600 ($1,440)

Chelsea porcelain scent bottle in the form of a boy tugging the horns of a goat, gold anchor period (1756-69). Height 3 in (7·6 cm). New Bond Street 12 March £210 ($504)

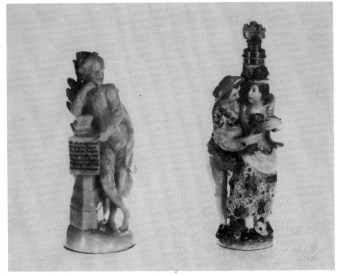

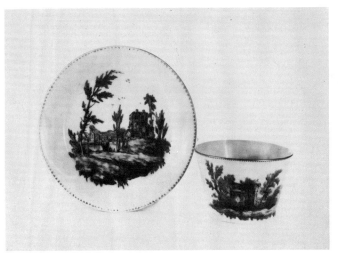

Chelsea porcelain scent bottle modelled as the figure of William Shakespeare after the statue by Peter Scheemakers in Westminster Abbey. Height 3⅜ in (8·6 cm). New Bond Street 14 May £120 ($288)

Chelsea porcelain scent bottle of lovers, gold anchor period (1756-69). Height 3⅞ in (9·8 cm). New Bond Street 14 May £280 ($672)

Chelsea porcelain teabowl and saucer decorated in the *atelier* of James Giles, gold anchor period (1756-69). New Bond Street 14 May £220 ($528)

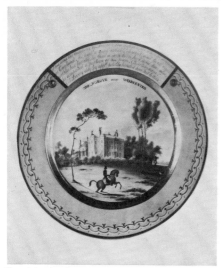

Porcelain plate from a 'landscape' part dessert service of twenty pieces, probably Coalport. New Bond Street 12 March £380 ($912)

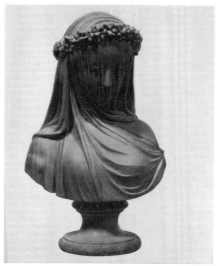

Copeland Parian bust of *The Veiled Bride* after Rafaelle Monti and executed for the Crystal Palace Art Union, 1861. Height 14 in (35·6 cm). Belgravia 14 November £105 ($252).

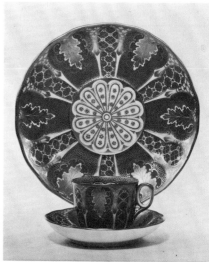

Davenport porcelain tea service of thirty-nine pieces, Design Registry mark for 31 January 1849. Belgravia 6 June £320 ($768)

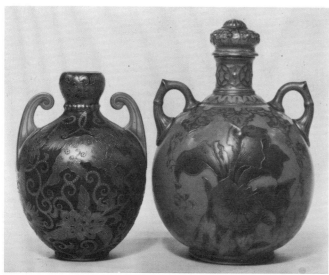

Crown Derby porcelain vase, date code for 1887. Height 5¼ in (13·3 cm). Belgravia 14 February £40 ($96)
Crown Derby porcelain pink-ground vase and cover, date code for 1886. Height 6½ in (16·5 cm). Belgravia 14 February £38 ($91)

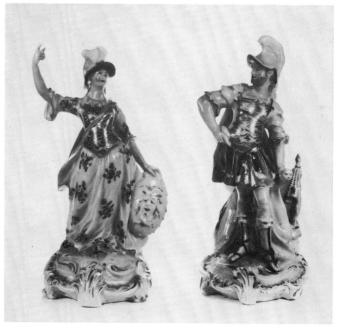

Pair of Derby porcelain figures of Minerva and Mars. Height 7½ in (19·1 cm). New Bond Street 14 May £160 ($384)

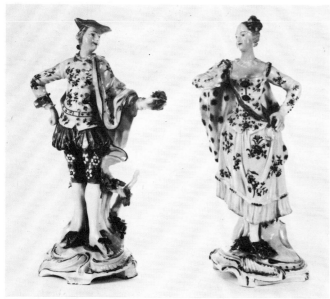

Pair of Derby porcelain 'Ranelagh' figures of a gallant and his companion, 18th century. Height 9¾ in (24·8 cm). New Bond Street 15 May £550 ($1,320).

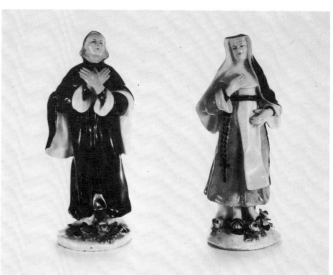

Pair of Derby porcelain figures of a monk and a nun, 18th century. Height 5½ in (14 cm). New Bond Street 14 May £480 ($1,152)

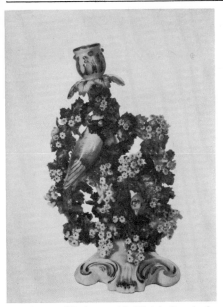

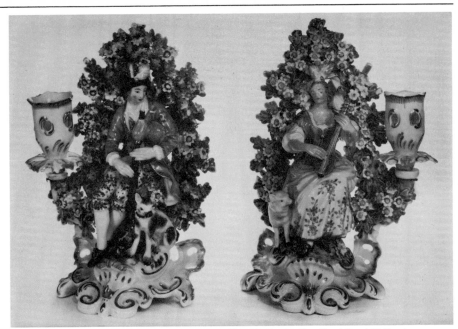

One of a pair of Derby porcelain 'Birds in Branches' candlestick groups, patch marks 18th century. Height 8¾ in (22·2 cm). New Bond Street 14 May £190 ($456)

Pair of Derby porcelain musician candlesticks. Height 7¾ in (19·7 cm). New Bond Street 25 March £270 ($648)

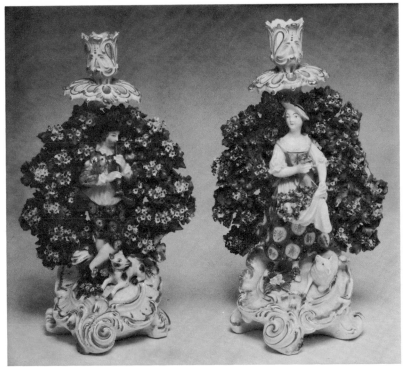

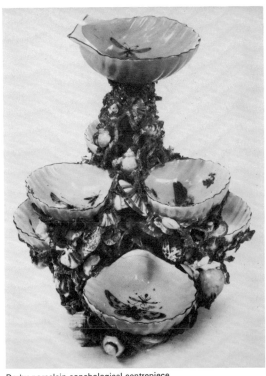

Pair of Derby porcelain *bocage* candlestick figures, *circa* 1770. Height 12 in (30·5 cm). New York 22 February $850 (£355)

Derby porcelain conchological centrepiece decorated by the Moth Painter, patch marks 18th century. Height 11½ in (29·2 cm). New Bond Street 14 May £210 ($504)

Left: Very rare Fulham white porcelain group of a putto and a dolphin. Height 3½ in (8·9 cm). New Bond Street 25 March £55 ($132)

Right: Grainger, Lee and Co. porcelain figure of a dog. Height 4¾ in (12·1 cm). New Bond Street 25 March £35 ($84)

Longton Hall porcelain cabbage-form box, *circa* 1755. Height 4¾ in (12 cm). New York 22 February $950 (£378)

Longton Hall porcelain leaf cream jug, mid 18th century. Height 3½ in (8·9 cm). New Bond Street 14 May £920 ($2,208)

Longton Hall porcelain figure of a boy, mid 18th century. Height 5¼ in (13·3 cm). New Bond Street 14 May £420 ($1,008)

18th-century Longton Hall porcelain figure of a Harlequin. Height 4¾ in (12·1 cm). New Bond Street 14 May £800 ($1,920)

Longton Hall porcelain figure of Ceres. Height 6¾ in (17·1 cm). New Bond Street 25 March £290 ($696)

Longton Hall porcelain 'Snowman' figure of Harlequin. Height 4¾ in (12·1 cm). New Bond Street 25 March £330 ($792)

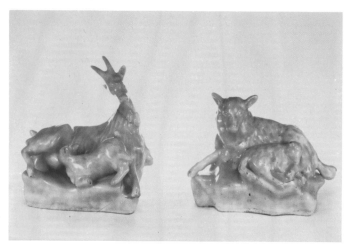

Pair of Longton Hall porcelain 'Snowman' animal groups. Heights 4¾ and 4 in (12·1 and 10·2 cm). New Bond Street 25 March £540 ($1,296)

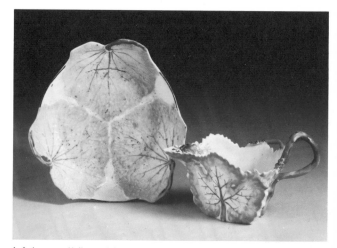

Left: Longton Hall porcelain half mulberry-leaf dish, 1755-60. Diameter 5⅝ in (14·3 cm). New York 22 February $200 (£83)

Right: One of a pair of Longton Hall porcelain half-leaf moulded cream boats, 1755-60. Length 5⅝ in (14·3 cm). New York 22 February $950 (£378)

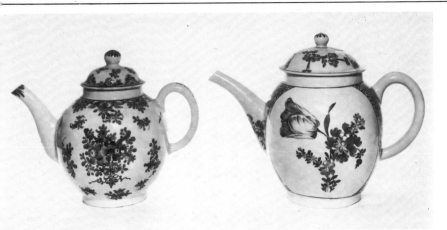

Left: Lowestoft teapot and cover painted by Thomas Curtis. Height 6 in (15·2 cm). New Bond Street 12 March £170 ($408)

Right: Lowestoft porcelain teapot and cover painted by the Tulip Painter. Height 6½ in (16·5 cm). New Bond Street 12 March £660 ($1,584)

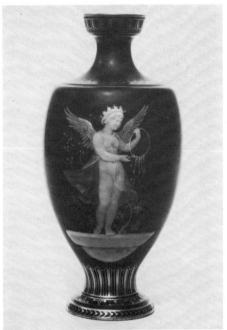

Minton porcelain *pâte-sur-pâte* vase by Marc Louis Solon, date code for 1894. Height 9 in (22·9 cm). Belgravia 6 June £880 ($2,112)

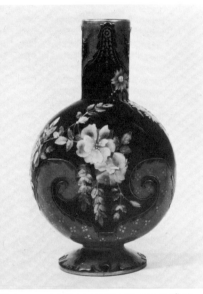

Minton porcelain three-colour *pâte-sur-pâte* flask, date code for ?1877. Height 7½ in (19·1 cm). Belgravia 6 June £240 ($576)

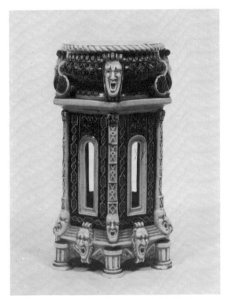

Minton 'Henri Deux' earthenware salt by Charles Toft, signed and dated 1877. Height 5¼ in (13·3 cm). Belgravia 5 September £150 ($360)

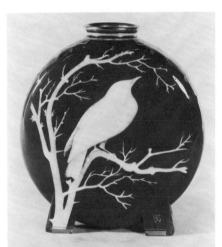

One of a pair of Minton's porcelain moon-flasks with four-colour *pâte-sur-pâte* decoration by T. Mellor, *circa* 1873-1891. Height 6 in (15·2 cm). Belgravia 14 November £210 ($504)

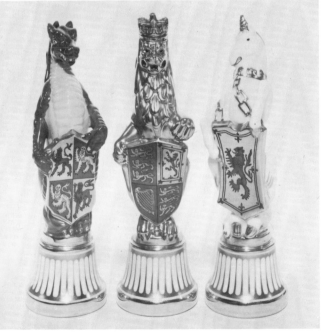

Three from the set of ten Minton pottery Queen's Beasts after models by James Woodford, one of 150 sets issued in 1955. Height 6 in (15·2 cm). Belgravia 3 June £680 ($1,632)

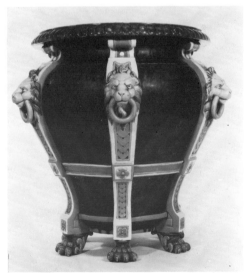

Earthenware 'majolica' jardinière probably by Minton's, third quarter of the 19th century. Height 17¾ in (45·1 cm). Belgravia 14 November £72 ($173)

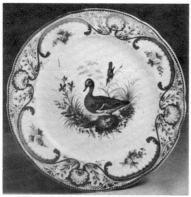

Nantgarw porcelain plate from the Mackintosh service, 1817-20. Diameter 9¼ in (23·5 cm).
New York 22 February $1,200 (£500)

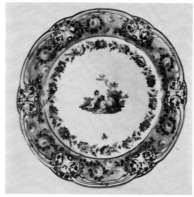

London-decorated Nantgarw porcelain plate painted by James Plant, early 19th century. Diameter 9¾ in (24·8 cm). New Bond Street 14 May £680 ($1,632)

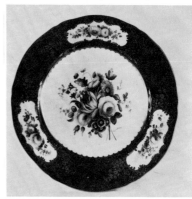

'Shagreen'-backed Nantgarw porcelain plate, early 19th century. Diameter 8¾ in (24·8 cm).
New Bond Street 14 May £320 ($768)

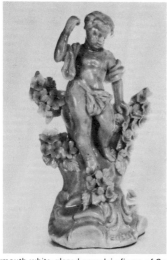

Plymouth white-glazed porcelain figure of Spring.
Height 5¾ in (14·6 cm). New Bond Street
25 March £130 ($312)

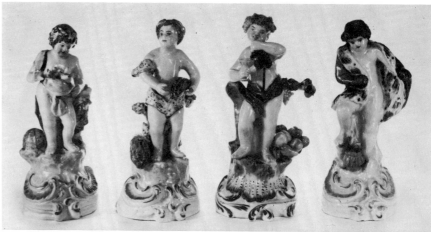

Set of Plymouth porcelain figures of the Seasons, 1768-70. Height 5¾ in (14·6 cm). New Bond Street 14 May £620 ($1,488)

Plymouth porcelain triple-shell sweetmeat stand.
Width 7 in (17·8 cm). New Bond Street 12 March
£440 ($1,056)

Rockingham porcelain spill-holder in the form of an elephant supporting a howdah. Height 3½ in
(8·9 cm). New Bond Street 25 March £140 ($336)

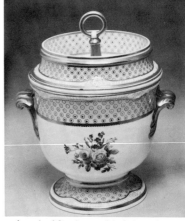

One of a pair of Spode porcelain fruit-coolers, covers and liners, *circa* 1821. Height 11½ in (29·2 cm).
New York 22 February $700 (£292)

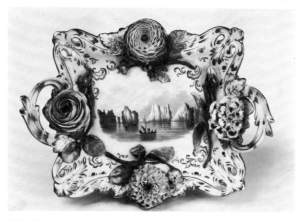

'Named View' porcelain dish with a view of The Needles, Isle of Wight, probably Rockingham.
Length 10 in (25·4 cm). New Bond Street
12 March £120 ($288)

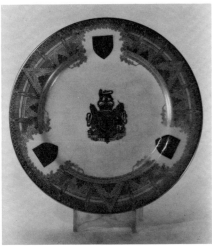

Spode bone china St Edward plate made in celebration of the nine-hundredth anniversary of the foundation of Westminster Abbey, number 540 of an edition of 900, 1965. Diameter 10½ in (26·7 cm). Belgravia 14 November £180 ($432)

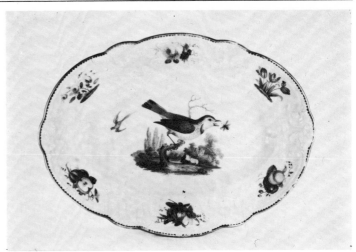

Swansea porcelain dish decorated in London with a blue-throat Redstart, script mark *J. Bradley & Co.: no. 47 Pall-Mall, London.* Length 10½ in (26·7 cm). New Bond Street 12 March £480 ($1,152)

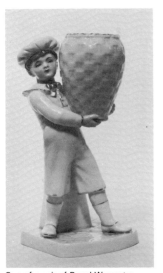

One of a pair of Royal Worcester porcelain figures of boys, Design Registry mark for 22 December 1866, date code for 1882. Height 7¼ in (18·4 cm). Belgravia 6 June £95 ($228)

Worcester porcelain plaque painted by R. Perling, *circa* 1870. 15¾ by 12¾ in (40 by 32·4 cm). Belgravia 14 November £280 ($672)

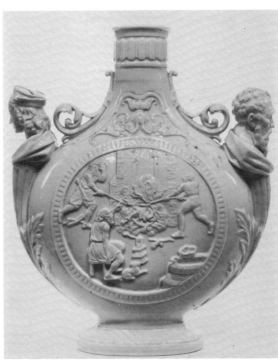

Royal Worcester porcelain cream-glazed moon-flask probably by James Hadley *circa* 1870. Height 11⅜ in (28·9 cm). Belgravia 14 February £50 ($120)

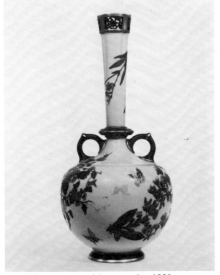

Royal Worcester porcelain vase, *circa* 1880. Height 15¾ in (14 cm). Belgravia 14 February £70 ($168)

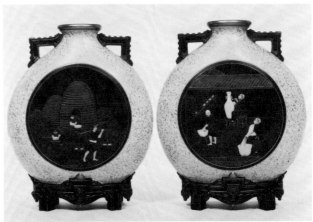

A pair of Royal Worcester porcelain moon-flasks modelled by James Hadley and coloured by James Callowhill, date code for 1872. Height 10¼ in (26 cm). Belgravia 5 September £210 ($504)

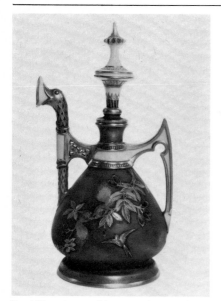

Royal Worcester porcelain ewer and stopper in Middle Eastern taste, date code for 1881. Height 9¼ in (23·5 cm). Belgravia 14 February £125 ($300)

Royal Worcester porcelain teapot and cover by George Owen, date code for 1881. Height 5 in (12·7 cm). Belgravia 5 September £550 ($1,320)

Royal Worcester porcelain dragon-handled vase, date code for 1889. Height 11¼ in (28·6 cm). Belgravia 14 February £120 ($288)

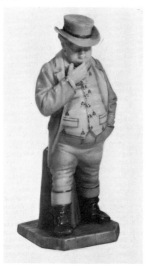

One of three Royal Worcester porcelain portrait figures modelled by James Hadley, the present example being of John Bull, the other two representing a Yankee and the Irishman, date code for 1893. Height 6¾ in (17·1 cm). Belgravia 14 November £240 ($576)

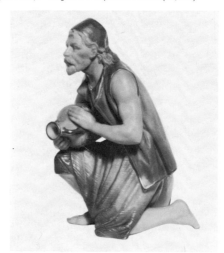

One of a pair of Royal Worcester porcelain figures of water-carriers, date code for 1904. Height of this piece 6½ in (16·5 cm). Belgravia 14 February £145 ($348)

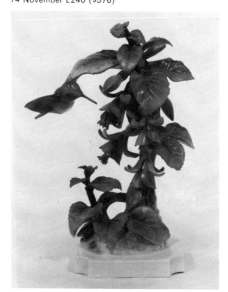

Royal Crown Derby porcelain Imari Geisha, date code for 1932. Height 6¼ in (15·9 cm). Belgravia 5 September £85 (204)

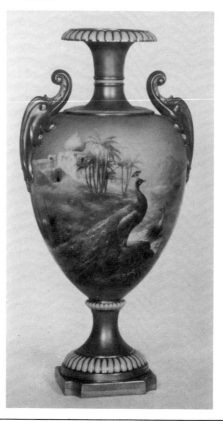

Royal Worcester porcelain humming-bird group by Dorothy Doughty, circa 1949. Height 9½ in (24·1 cm). Belgravia 5 September £300 ($720)

One of a pair of Royal Worcester porcelain vases painted by W. Powell, date code for 1911. Height 16 in (40·6 cm). Belgravia 5 September £1,000 ($2,400)

Royal Worcester porcelain vase painted by R Rushton, date code for 1914. Height 9 in (22·9 cm). Belgravia 14 February £95 ($228)

Royal Worcester porcelain figure of an officer of the Life Guards modelled by Doris Lindner, No 85 from an edition of 150, 1961. Height 8¼ in (21 cm). Belgravia 6 June £380 ($676)

Royal Worcester porcelain model of Arkle by Doris Lindner, number 251 of an edition of 500, signed and dated 1967. Height 9½ in (24·1 cm). Belgravia 14 February £600 ($1,440)

Royal Worcester porcelain group of *Charlotte and Jane* modelled by Ruth van Ruyckevelt, No 369 from an edition of 500, 1968. Height 6¼ in (15·9 cm). Belgravia 14 November £320 ($768)

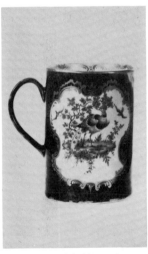

Worcester porcelain blue-scale mug, first period (1752-83). Height 4¾ in (12·1 cm). New Bond Street 12 March £240 ($576)

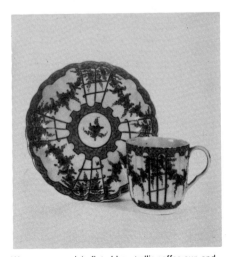

Worcester porcelain fluted hop-trellis coffee cup and saucer, first period (1752-83). New Bond Street 12 March £330 ($792)

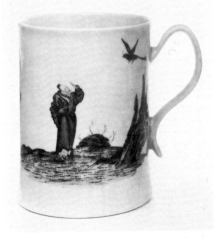

Early Worcester porcelain tankard, the body painted in strong coloured enamels, first period (1752-83). Height 4¾ in (12·1 cm). New Bond Street 12 March £350 ($840)

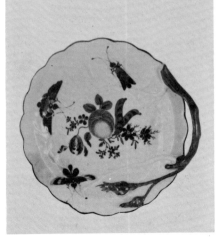

London decorated Worcester porcelain dish moulded with 'Blind Earl' pattern, decorated in the *atelier* of James Giles, first period (1752-83). Diameter 6 in (15·2 cm). New Bond Street 14 May £380 ($912)

European and American art ceramics

Although there have been a few collectors for the ceramics of this period for some years, interest, although far more widespread today, has still to move beyond a comparatively small number of specialists. Pottery and porcelain of the late 19th and early 20th centuries, made often by the individual studio potter, marks a renaissance of European ceramic art and, while it is unwise in principle to make prognostications about any particular area of the art market, one might suggest with some confidence that the best example of studio pottery will become extremely valuable within the fairly near future and that collectors in ten or twenty years time will look back upon today's prices with a strong feeling of nostalgia.

Under the general title 'art ceramics' we are describing three distinct types of pottery and porcelain; the pieces made by factories already established who employed the services of individual artists and designers, the products of factories founded at this time for the express purpose of producing what they described themselves as 'art pottery', and the pieces made by the studio potter, of whom the most famous in England is Bernard Leach.

Among the first category, we might instance the pieces by Doulton's of the late 19th century, and the 'tube-lined' earthenware vases in Art Nouveau taste made by Minton's in the early part of the 20th, several of which fetched below $100 (£42) in the sale in New York in January. For the second group, we illustrate fine examples of Rookwood and Tiffany pottery among the American factories and for the English factories, pieces by the Ruskin Pottery of William Howson Taylor, the de Morgan pottery and many others. Individual English potters are represented by the work of Charles Vyse, the Martin Brothers, pioneers of studio pottery in England and William Grueby, one of the most highly respected American studio potters.

Unfortunately, very few examples of fine French, German or Danish art ceramics appear at auction either in London or New York and it must be said that the best French examples will now fetch above our top limit. However, we can illustrate some fine vases by Emile Decoeur, considered one of the three greatest French potters of the last fifty years, some good early pieces by Théodore Deck, one of the most influential of the 19th-century French ceramic artists and some exceptional stoneware and porcelain figures designed by Knud Kyhn for the Royal Copenhagen factory in the 1930s.

White glazed porcelain vase by Emile Decoeur, French second quarter of the 20th century. Height 7 in (17·8 cm). Belgravia 20 November £580 ($1,392)

Peach-glazed porcelain vase by Emile Decoeur, French second quarter of the 20th century. Height 4¼ in (1·8 cm). Belgravia 20 November £540 ($1,296)

Speckled brown-glazed porcelain vase by Emile Decoeur, French second quarter of the 20th century. Height 5¼ in (13·3 cm). Belgravia 20 November £500 ($1,200)

Mottled brown-glazed stoneware vase by Emile Decoeur, French second quarter of the 20th century. Height 3¾ in (9·5 cm). Belgravia 20 November £500 ($1,200)

Yellow-glazed stoneware vase by Emile Decoeur, French second quarter of the 20th century. Height 6½ in (16·5 cm). Belgravia 20 November £340 ($816)

Mottled beige-glazed stoneware vase by Emile Decoeur, French second quarter of the 20th century. Height 10¼ in (26 cm). Belgravia 20 November £520 ($1,248)

French earthenware dish by Théodore Deck, painted by Raphael Corrin, circa 1880. Diameter 19½ in (49·5 cm). Belgravia 31 July £400 ($960)

French glazed earthenware cockerel egg basket by Théodore Deck, circa 1880. Height 15½ in (39·4 cm). Belgravia 31 July £52 ($125)

Faience cat by Emile Gallé, circa 1890. Height 12¾ in (32·5 cm). Belgravia 5 July £260 ($624)

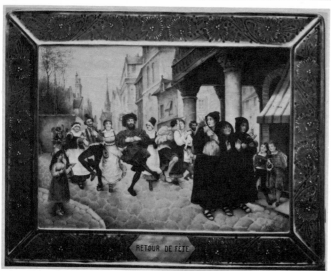

A French porcelain plaque painted with the *Retour de Fête* by Armand, by Charles Field Haviland, Limoges *circa* 1878-91. 11½ by 15 in (29·2 by 38·1 cm). New York 11 January $1,250 (£522)

Sèvres porcelain vase probably by Adolphe Belet with *pâte-sur-pâte* panel by Taxile Doat, ormolu foot, dated 1880. Height 8¾ in (22·2 cm). Belgravia 20 June £550 ($1,320)

One of a pair of jardinières in the Isnik style by Clément Massier, signed, *circa* 1880. Height 53½ in (136 cm). Belgravia 17 January £510 ($1,224)

Enamelled pottery cigarette holder and ashtray by A. Dubois, French 1920s. Length 10⅜ in (26·4 cm). Belgravia 5 July £120 ($288)

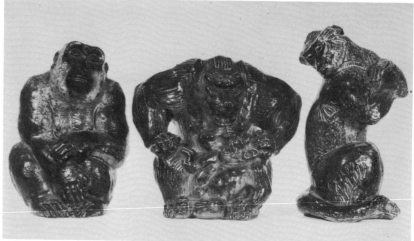

Left: Royal Copenhagen stoneware figure of a gorilla modelled by Knud Kyhn *circa* 1930. Height 10 in (25·4 cm). Belgravia 31 July £240 ($576)

Centre: Royal Copenhagen stoneware group of a mother ape and baby modelled by Knud Kyhn, dated 25.6-30. Height 9½ in (24·1 cm). Belgravia 31 July £360 ($864)

Right: Royal Copenhagen stoneware figure of a Howler Monkey modelled by Knud Kyhn, dated 3-1-27. Height 11⅝ in (29 cm). Belgravia 31 July £280 ($672)

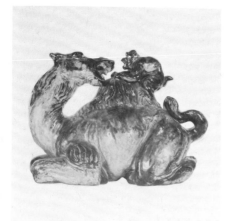

Royal Copenhagen porcelain group of a camel and a monkey modelled by Knud Kyhn *circa* 1930. Length 12½ in (32 cm). Belgravia 31 July £240 ($576)

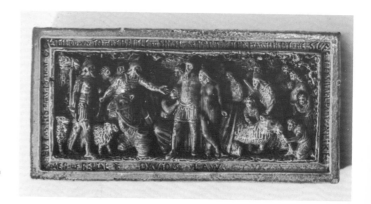

Right: Doulton stoneware panel by George Tinworth of *David's Law,* circa 1875-81. 8½ by 4 in (21·6 by 10·2 cm). Belgravia 4 April £90 ($216)

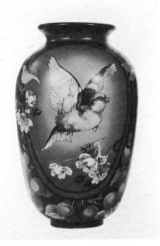

One of a pair of Doulton faience vases decorated by Isabel Lewis dated 1883. Height 10¾ in (27·3 cm). Belgravia 4 April £210 ($504)

Royal Doulton earthenware jardinière decorated by Hannah Barlow, late 19th century. Height 10¾ in (27·5 cm). Belgravia 4 April £110 ($264)

One of a pair of Royal Doulton pottery 'Chang' vases by Charles Noke and Harry Nixon, circa 1930. Height 16½ in (42 cm). Belgravia 31 July £800 ($1,920)

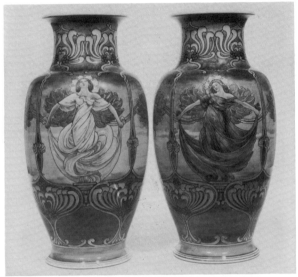

Pair of Doulton pottery faience vases decorated in Art Nouveau style, circa 1900. Height 15¾ in (40 cm). Belgravia 31 July £370 ($888)

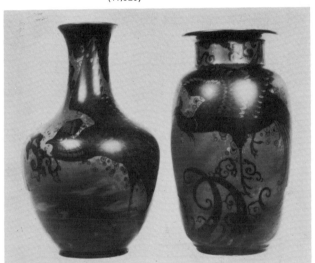

Left: Royal Doulton pottery 'Sung' vase by Charles Noke, painted by A Eaton, circa 1930. Height 16¼ in (41 cm). Belgravia 31 July £350 ($840)

Right: Royal Doulton pottery 'Sung' vase by Charles Noke, painted and signed by A Eaton, circa 1920. Height 15¼ in (38·7 cm). Belgravia 31 July £380 ($912)

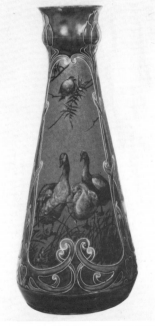

One of a pair of Doulton stoneware vases slip-decorated by Florence E Barlow circa 1900. Height 20½ in (52 cm). Belgravia 31 July £220 ($528)

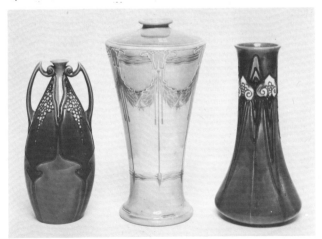

Left: Minton earthenware vase in Art Nouveau taste, with red, white and green glazes, English circa 1900-1908. Height 9 in (22·9 cm). New York 11 January $100 (£42)

Centre: Minton earthenware vase in Art Nouveau taste, with green, turquoise and yellow glazes. Height 11½ in (29·2 cm). New York 11 January $75 (£31)

Right: Minton earthenware vase in Art Nouveau taste with red, cream and green glazes. Height 9¾ in (24·8 cm). New York 11 January $100 (£42)

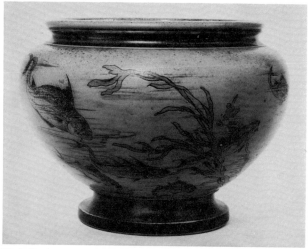

Martin Brothers stoneware jardinière with incised decoration signed and dated 10-1886. Height 9 in (22·9 cm). Belgravia 4 April £115 ($276)

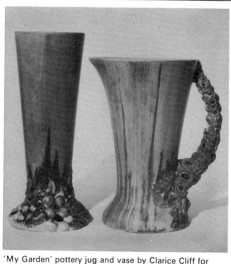

'My Garden' pottery jug and vase by Clarice Cliff for Wilkinson's, English 1930s. Height of jug 9¼ in (23·5 cm) height of vase 10½ in (26·7 cm). Belgravia 20 November £45 ($108)

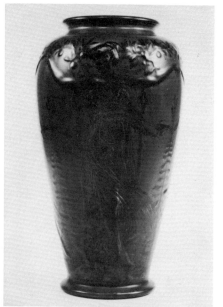

Pilkington's Royal Lancastrian earthenware lustre vase decorated by Richard Joyce after a design by Walter Crane, signed, *circa* 1910. Height 12¼ in (31·1 cm), Belgravia 4 April £210 ($504)

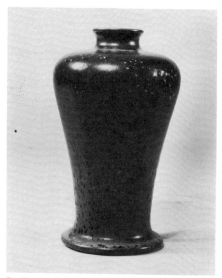

Ruskin stoneware vase with high-temperature glaze by William Howson Taylor impressed *Ruskin Pottery Smethwick* and dated 1906. Height 7 in (17·8 cm). Belgravia 4 April £170 ($408)

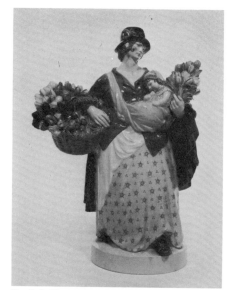

The Tulip Woman. an earthenware figure modelled by Charles Vyse, signed and dated Chelsea 1921. Height 10¼ in (26 cm). Belgravia 5 September £180 ($432)

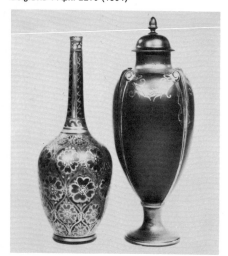

Left: Pilkington's Royal Lancastrian lustre pottery vase decorated by William S Mycock, dated 1916. Height 9¾ in (24·8 cm). Belgravia 31 July £80 ($192)

Right: Pilkington's Royal Lancastrian pottery lustre vase decorated by Gordon M Forsyth *circa* 1910. Height 10½ in (26·7 cm). Belgravia 31 July £40 ($120)

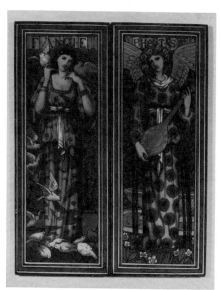

Pair of earthenware tiles by W B Simson and Sons. *circa* 1880. 15½ by 6 in (39·4 by 15·2 cm). Belgravia 31 July £170 ($408)

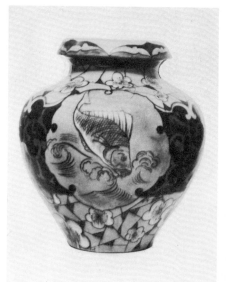

Burmantofts painted earthenware vase signed with the 'KL' monogram, *circa* 1885. Height 8½ in (21·6 cm). Belgravia 4 April £62 ($149)

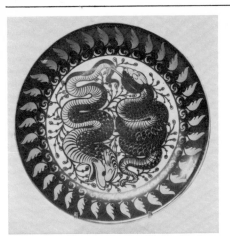

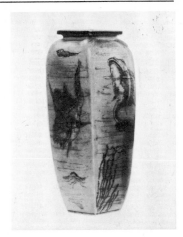

Left: William de Morgan red lustre earthenware dish, early Fulham period 1888-97. Diameter 14⅛ in (36 cm). Belgravia 4 April £210 ($504)

Right: Martin Brothers blue and brown glazed stoneware vase, signed and dated 4-1900. Height 10¼ in (26 cm). Belgravia 31 July £130 ($312)

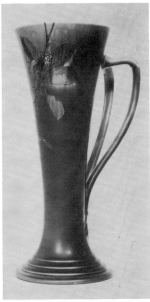

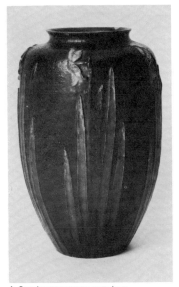

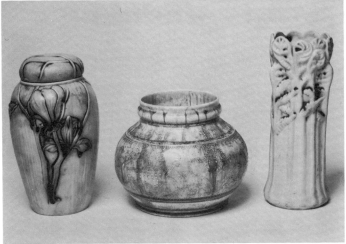

American earthenware vase by the Rookwood Pottery, painted by Albert Robert Valentien, signed and dated 1890. Height 13¾ in (35 cm). Belgravia 31 July £105 ($252)

A Grueby stoneware vase in a cucumber green glaze, the sides moulded with yellow daffodils, impressed 'Grueby Pottery, Boston U.S.A., 170', *circa* 1891-1901. Height 12¼ in (31 cm). New York 11 January $900 (£375)

Left: Tiffany pottery covered jar, the body covered with a green-buff glaze, by Louis Comfort Tiffany, New York *circa* 1904-10. Height 9 in (22·8 cm). New York 11 January $600 (£250)

Centre: Tiffany pottery vase, the body glazed ochre, by Louis Comfort Tiffany, New York *circa* 1904-10. Height 6½ in (16·5 cm). New York 11 January $650 (£271)

Right: Tiffany pottery vase covered in a buff glaze, by Louis Comfort Tiffany, New York *circa* 1904-10. Height 10 in (25·4 cm). New York 11 January $825 (£345)

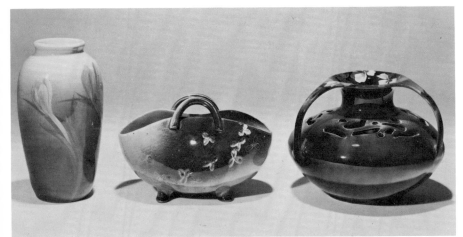

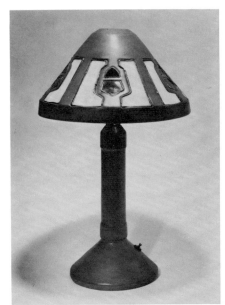

Left: Rookwood earthenware vase, painted in a palette of purple, yellow, green and blue, signed by the artist Rose Fechheimer and dated 1904. Height 7 in (17·8 cm). New York 11 January $80 (£33)

Centre: Rookwood earthenware bowl, the body with a 'Tiger Eye' (aventurine) glaze, painted with yellow clover, signed by the artist Anna Marie Bookprinter and dated 1886. New York 11 January $125 (£52)

Right: Rookwood earthenware vase, the brown body painted with flowers in yellow, brown and green, signed by the artist Harriet E. Wilcox and dated 1890. Height 6 in (15·2 cm). New York 11 January $150 (£63)

American pottery and stained glass lamp, the pottery decorated in matt brown and blue glazes, the glass stained blue, by the Fulper Pottery, *circa* 1915-25. Height 16½ in (42 cm). New York 11 January $325 (£135)

Nineteenth-century animalier bronzes

The production of naturalistically modelled figures of animals was a predominantly French phenomenon which developed throughout the second half of the 19th century and which spread in a limited way to the rest of Europe and the United States. The upsurge of this distinct type of bronze sculpture in the 19th century was due in part to the French Romantic movement in art and the reverence of nature which this entailed; 'nature red in tooth and claw' was a concept dear to the heart of the animalier sculptors. There is evidence also that the Japanese bronzes which began to find their way into Europe in the second half of the 19th century influenced many of the young sculptors working in France; certainly the similarities between Eastern and Western bronze animal sculpture is apparent.

The finest examples by the French animaliers have not been taken very seriously for long. This is a collecting field which has developed mainly in the last five years or so but the work of the most outstanding practitioners, P. J. Mêne, Fratin, Barye, and J. Moigniez for instance, are now fairly expensive, with pieces frequently fetching over £1,000. Nevertheless, bronzes of good quality by these artists are illustrated here as well as other examples by sculptors such as Rosa Bonheur, in her day considered one of the greatest animal painters of all time, a judgement which few art scholars would endorse now, and E. Delabrierre. The condition of a piece and the quality of its patina are of prime importance, and can make a considerable difference to the price. New collectors should be particularly careful to avoid re-patinated examples and modern re-casts, which have come on to the market in large quantities in the last two or three years.

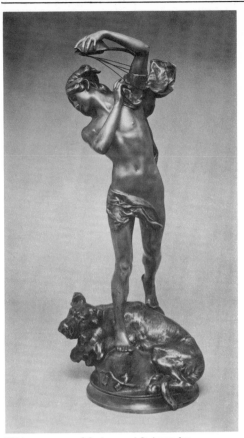

Gilt-bronze group of Orpheus and Cerberus, by Henri Peinte, late 19th century. Height 25¼ in (64·1 cm). New York 9 February $850 (£355).

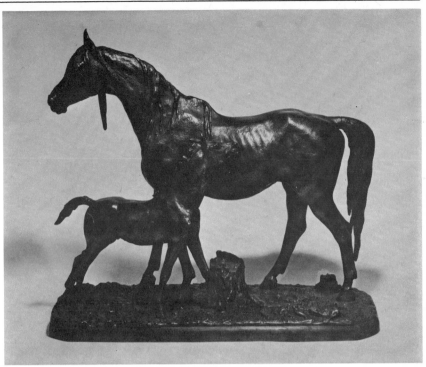

Bronze group of mare and foal, after Christophe Fratin, French late 19th century. Length 16¼ in (41·3 cm). New York 9 February $950 (£378)

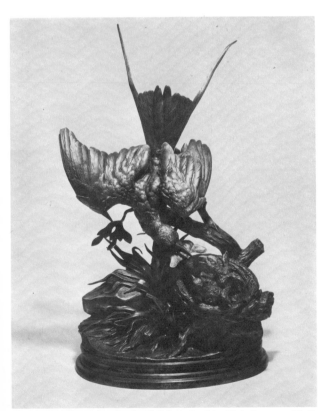

Bronze group of a bird feeding her fledglings, by Jules Moigniez, second half of the 19th century. Height 22⅛ in (56·2 cm). New York 9 February $750 (£313)

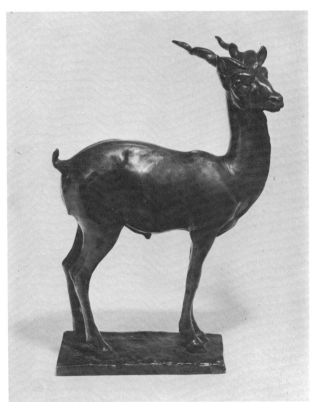

Bronze figure of an antelope by H Jackson, early 20th century. Height 12¼ in (31·1 cm). New York 9 February $500 (£209)

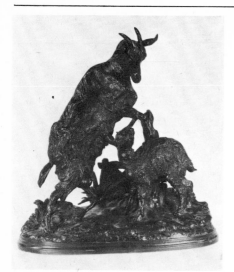

Bronze group of a nanny goat and kid after P J Mêne French mid 19th century. Height 9½ in (24·1 cm). Belgravia 20 March £320 ($768)

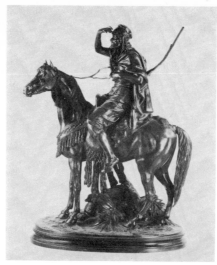

Bronze equestrian figure after Pautrot, French late 19th century. Height 29¼ in (74·3 cm). Belgravia 20 March £340 ($816)

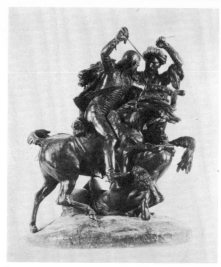

Bronze battle group after T Gechter, French mid 19th century. Height 25 in (63·5 cm). Belgravia 20 March £800 ($1,920)

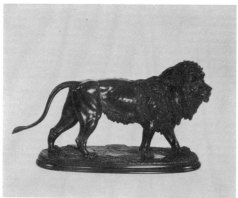

Bronze figure of a lion after J Moigniez, French third quarter of the 19th century. Height 7¾ in (19·7 cm). Belgravia 20 March £360 ($864)

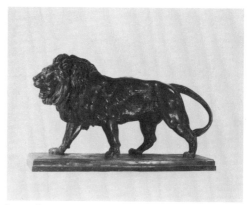

Bronze figure of a lion after Barye, French mid 19th century. Height 9½ in (24·1 cm). Belgravia 20 March £340 ($816)

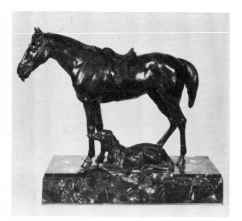

Bronze group of a stallion and Irish wolfhound inscribed *E Cana*, French late 19th century. Length 20 in (50·8 cm). Belgravia 27 November £450 ($1,080)

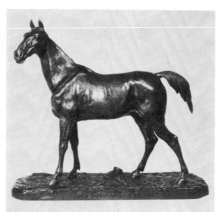

Bronze figure of mare P J Mêne, French second half of the 19th century. Length 14 in (35·6 cm). Belgravia 26 June £550 ($1,320)

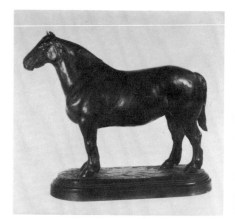

Bronze figure of a cart-horse after Isidore Bonheur, French third quarter of the 19th century. Height 10¼ in (26 cm). Belgravia 26 June £220 ($528)

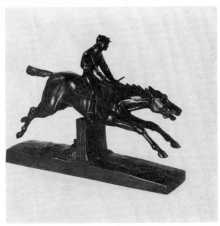

Bronze steeplechasing group after Chemin, French mid 19th century. Length 13 in (33 cm). Belgravia 26 June £210 ($504)

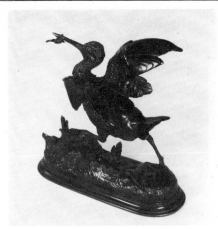

Bronze figure of a sand-curlew after E Delabrierre, French mid 19th century. Height 8¼ in (21 cm). Belgravia 26 June £180 ($432)

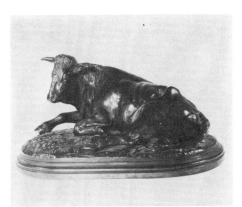

Bronze figure of a reclining bull after Rosa Bonheur, French mid 19th century. Height 6 in (15·2 cm). Belgravia 20 March £500 ($1,200)

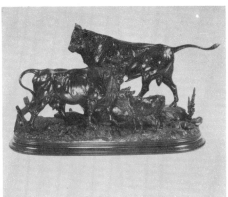

Bronze group of cattle after E Delabrierre, French mid 19th century. Height 13 in (33 cm). Belgravia 20 March £700 ($1,680)

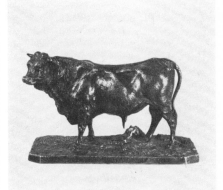

Bronze figure of a bull after P J Mêne, French third quarter of the 19th century. Height 5¾ in (14·6 cm). Belgravia 26 June £220 ($528)

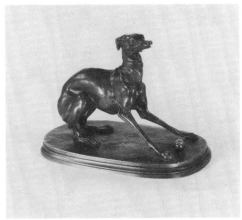

Bronze figure of a whippet with ball, after P J Mêne, French mid 19th century. Height 4½ in (11·4 cm). Belgravia 20 March £210 ($504)

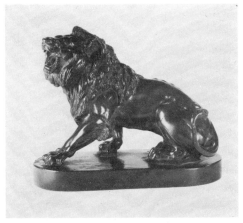

Bronze figure of a roaring lion after Ch Valton, French late 19th century. Height 7 in (17·8 cm). Belgravia 26 June £140 ($336)

Art Nouveau,
Art Deco and modern design

The market in the applied arts of the period between 1890 and 1930 takes its name from two sources, the shop *L'Art Nouveau* in Paris founded and owned by Samuel Bing which at the turn of the century sold works of art by leading contemporary craftsmen, as well as oriental pieces, and the exhibition of decorative arts in Paris in 1925 which, ironically, marked, not the beginning of a new style, but the high point of its achievements.

The clientèle for the finest examples of Art Nouveau and Art Deco were largely French, and Paris was itself the centre of manufacture. This has had a considerable effect upon the market in Great Britain since it is illegal to import works of art less than a hundred years old, with the exception of books, paintings, sculpture and prints, without paying duty, which is calculated as a percentage of their current value. Thus it is that the finest examples of Art Nouveau jewellery and metalwork or French Art Deco furniture rarely appear at auction in London.

Nevertheless, this is an extremely popular new market and enough fine pieces appear at auction each year to ensure a lively following. Of especial interest is the work of the glassmakers, Louis Comfort Tiffany in America and Gallé and the school of Nancy in France, who were active around the turn of the century, whilst in France in the 1920s makers such as Walter, Argy Rousseau, Décorchement, Lalique, Thuret and Marinot added a new dimension to this art. Very few examples of the last named artist's work appear at auction today and in any case they would be well above our top limit but we are able to illustrate fine examples by other makers.

One of the chief glories of British Art Nouveau was the work of the silversmiths. The firm of Liberty in Regent Street commissioned superb designs which were marketed under the trade names 'Cymric' for silver and 'Tudric' for pewter. So typical of Art Nouveau style are these pieces that in Italy the London firm has given its name to the whole movement. Whilst fine examples of 'Cymric' silver are now rare and fairly expensive, especially if they are enamelled pieces designed by Archibald Knox, 'Tudric' pewter of equally fine design and of a particularly high grade metal is still very modestly priced, as indeed is all Art Nouveau pewter, and it would be well worth forming a good collection.

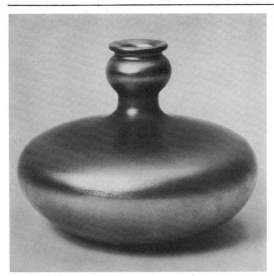

American iridescent glass vase in amber tones, by Victor Durand, Vineland, New Jersey, *circa* 1900-25. Height 8½ in (21·6 cm). New York 11 January $350 (£147)

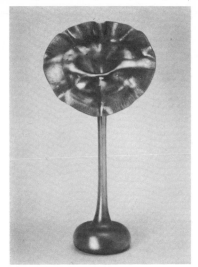

Tiffany Favrile glass 'jack-in-the-pulpit' vase, in amber iridescent glass, by Louis Comfort Tiffany, New York, *circa* 1906. Height 18½ in (47 cm). New York 11 January $2,000 (£833)

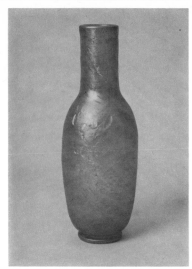

Tiffany Favrile glass 'Cypriote' vase, the pitted sides in amber iridescence, by Louis Comfort Tiffany, New York, *circa* 1898-1928. Height 11⅝ in (29·5 cm). New York 11 January $700 (£295)

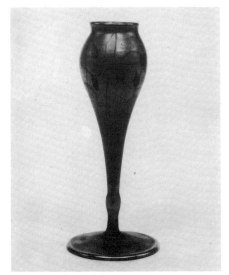

Tiffany flower form Favrile glass vase, *circa* 1900. Height 6⅜ in (16·2 cm). Belgravia 3 April £230 ($552)

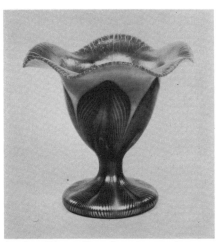

American iridescent flower form glass vase by Quezel, *circa* 1900. Height 4¼ in (10·8 cm). Belgravia 5 July £240 ($576)

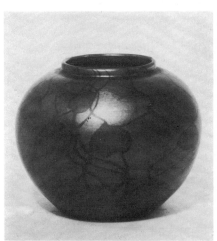

Tiffany peacock iridescent lily-pad Favrile glass vase, *circa* 1900. Height 2⅜ in (6·7 cm). Belgravia 3 April £220 ($528)

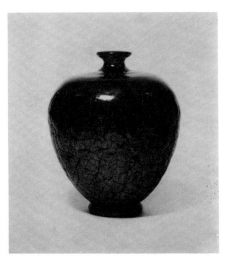

Austrian iridescent glass vase by Loetz, *circa* 1900. Height 6 in (15·2 cm). Belgravia 3 April £360 ($864)

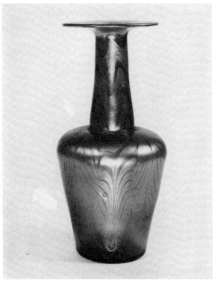

Austrian iridescent glass vase by Loetz, *circa* 1900. Height 9¼ in (23·5 cm). Belgravia 3 April £270 ($648)

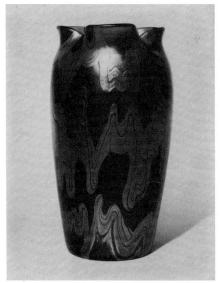

Austrian iridescent glass vase by Loetz, *circa* 1900. Height 9½ in (24·1 cm). Belgravia 20 November £320 ($768)

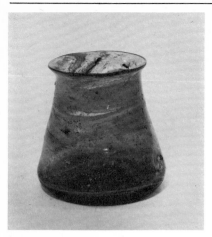

'Clutha' glass vase designed by Christopher Dresser for James Couper and Sons of Glasgow, mid 1890s. Height 3⅛ in (7·9 cm). Belgravia 3 April £120 ($288)

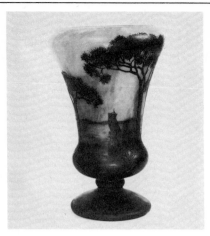

Overlaid and etched glass vase by Daum, *circa* 1910. Height 9½ in (24·1 cm). Belgravia 3 April £140 ($336)

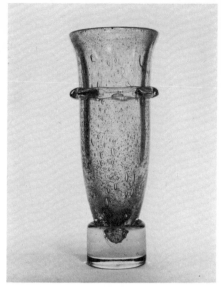

Art Deco glass vase by Schneider, 1930s. Height 13¼ in (33·7 cm). Belgravia 3 April £280 ($672)

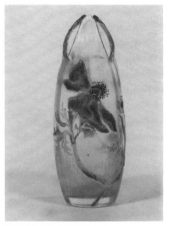

Enamelled glass vase by Emile Gallé, *circa* 1890. Height 9 in (22·9 cm). Belgravia 20 November £280 ($672)

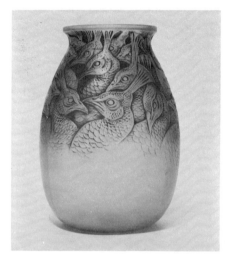

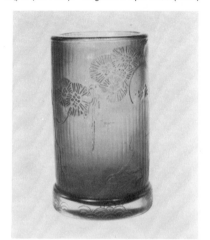

Glass peacock vase by René Lalique, 1920s. Height 9⅛ in (23·2 cm). Belgravia 3 April £220 ($528)

Carved amber glass in the Japanese taste by Emile Gallé, 1890s. Height 6½ in (16·5 cm). Belgravia 20 November £850 ($2,040)

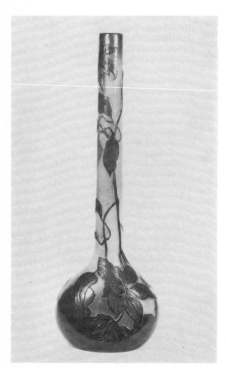

One of a pair of overlaid and etched glass vases by Emile Gallé, French *circa* 1900. Height 19¼ in (48·9 cm). Belgravia 5 July £500 ($1,200)

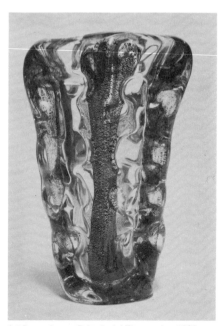

Art Deco glass vase by André Thuret, *circa* 1930. Height 11¼ in (28·6 cm). Belgravia 3 April £420 ($1,008)

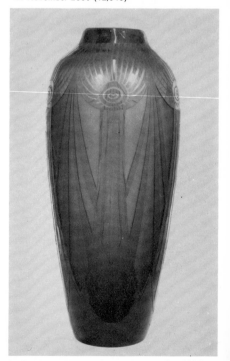

Art Deco glass vase by Legras, French *circa* 1925. Height 21 in (53·4 cm). Belgravia 5 July £160 ($384)

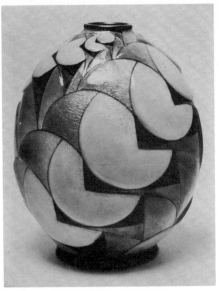

French enamel vase by C. Fauré, Limoges, *circa* 1925. Height 7 in (17·8 cm). New York 11 January $1,300 (£542)

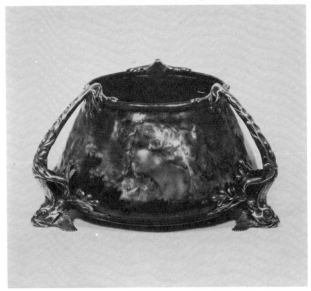

Enamel vase by L. Hirtz with gilt-metal mounts by F Boucheron, French *circa* 1900. Width at base 8 in (20·3 cm). Belgravia 5 July £820 ($1,968)

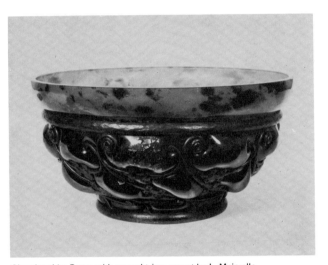

Glass bowl by Daum with wrought-iron mount by L. Majorelle, *circa* 1920. Diameter 11½ in (29·2 cm). Belgravia 5 July £70 ($168)

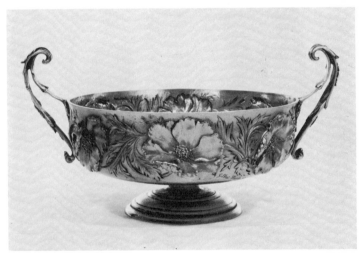

Silver-gilt rose bowl by Gilbert Marks, London 1897. 45 oz 9 dwt. Width over handles 12½ in (31·7 cm). Belgravia 10 October £380 ($912)

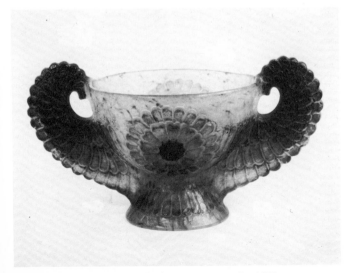

French *pâte-de-cristal* bowl by Gabriel Argy-Rousseau, *circa* 1925. Width 8¼ in (21 cm). Belgravia 3 April £400 ($960)

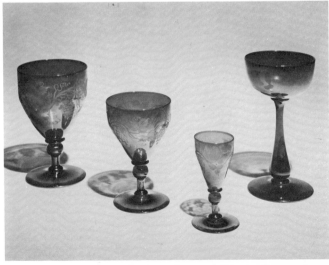

Four from a set of twenty-two American red engraved glass wine, liqueur and champagne glasses, by the Steuben Glass Works, *circa* 1920-30. New York 11 January $875 (£366)

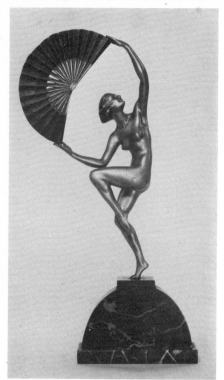

Bronze figure, *The Fan Dancer*, by Bouraine, *circa* 1930. Height 17⅞ in (37·8 cm). Belgravia 3 April £120 ($288)

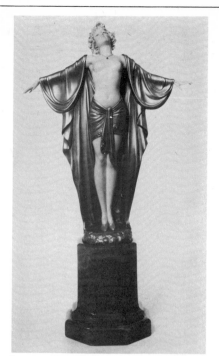

Bronze and ivory figure, *Invocation*, by F Preiss, 1930s. Height 14⅜ in (36·5 cm). Belgravia 3 April £950 ($2,280)

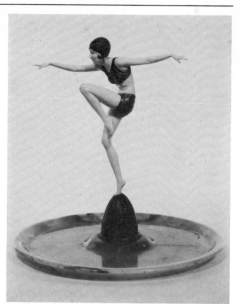

Ivory and bronze figure, *Con Brio*, on onyx base by F Preiss, *circa* 1930. Height 11½ in (29·2 cm). Belgravia 20 November £680 ($1,632)

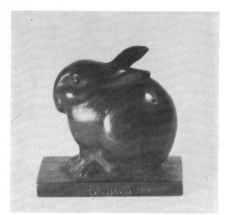

Bronze rabbit paperweight by Edouard Marcel Sandoz, 1920s. Height 2⅛ in (5·4 cm). Belgravia 3 April £120 ($288)

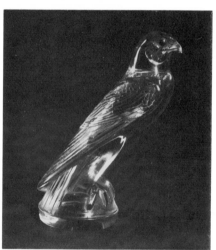

Glass sitting hawk car mascot by René Lalique, 1930s. Height 6½ in (16·5 cm). Belgravia 20 November £290 ($696)

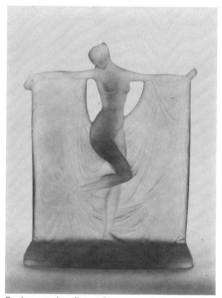

Opalescent glass figure, *Suzanne au Bain*, by René Lalique. Height 8¾ in (22·2 cm). Belgravia 3 April £290 ($696)

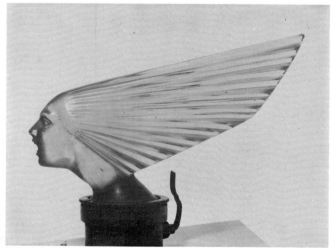

Glass car mascot, *The Spirit of the Wind*, by René Lalique, *circa* 1930. Height 10¼ in (26 cm). Belgravia 5 July £560 ($1,344)

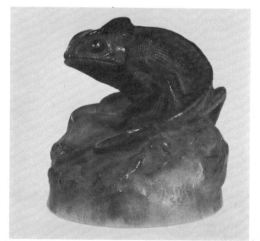

Pâte-de-verre chameleon paperweight modelled by Henri Berge for A Walter, French *circa* 1910. Height 3⅜ in (8·6 cm). Belgravia 5 July £580 ($1,392)

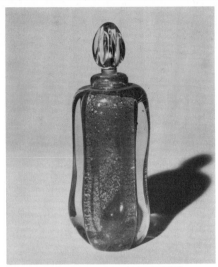

Orange flecked glass scent bottle by André Thuret, French *circa* 1930. Height 6½ in (16·5 cm). Belgravia 20 November £740 ($1,776)

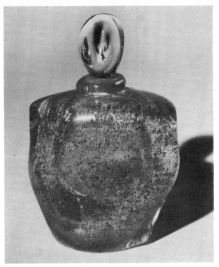

Blue-green flecked glass scent bottle by André Thuret, French *circa* 1930. Height 6½ in (16·5 cm). Belgravia 20 November £420 ($1,008)

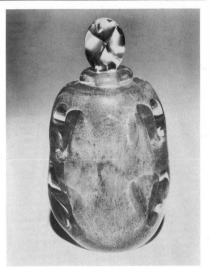

Red flecked glass scent bottle by André Thuret, French *circa* 1930. Height 7½ in (19 cm). Belgravia 20 November £850 ($2,040)

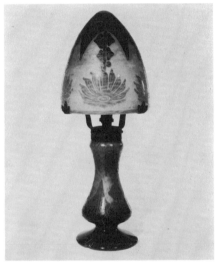

Cameo glass lamp by *Le Verre Français, circa* 1900. Height 20 in (50·8 cm). Belgravia 20 November £340 ($816)

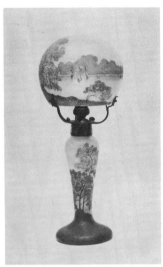

French riverscape glass lamp, the glass pink-grey overlaid in shades of green, brown and lilac, by Legras, *circa* 1900. Height 15 in (38 cm). New York 11 January $600 (£250)

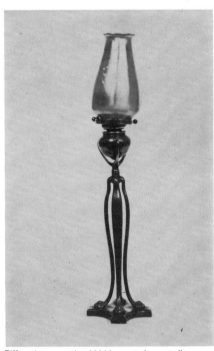

Tiffany bronze and gold iridescent glass candle holder, *circa* 1900. Height 17 in (43·2 cm). Belgravia 5 July £200 ($480)

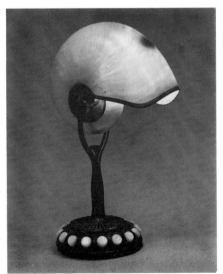

Tiffany bronze and nautilus shell table lamp. Height 14 in (35·6 cm). Los Angeles 18 November $1,700 (£708)

Silvered metal teapot in 'Cubist' style by Gerard Sandoz, late 1920s. Height 3¼ in (8·3 cm). Belgravia 3 April £180 ($432)

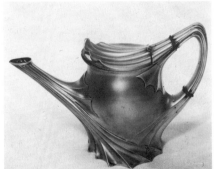

French silvered teapot by Paul Follot, *circa* 1900. Height 7¾ in (19·7 cm). Belgravia 3 April £260 ($552)

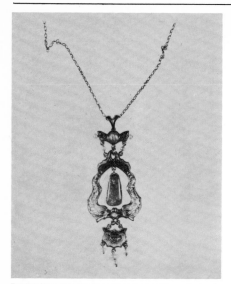

English Arts and Crafts gold and enamel pendant set with opals, turquoise and pearls. Belgravia 3 April £300 ($720)

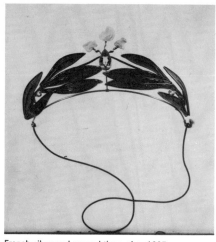

French silver and enamel tiara, *circa* 1905. Belgravia 30 May £100 ($240)

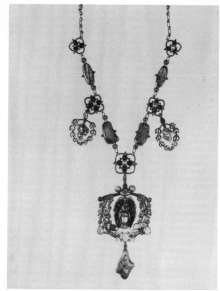

Gold enamelled necklace decorated with opals, pearls and cabochon emeralds by Henry Wilson, mid 1890s. Belgravia 3 April £400 ($960)

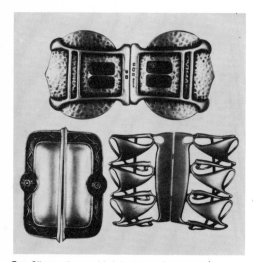

Top: Silver and enamel belt buckle by *Ce & Fd Ltd,* Birmingham 1910. Width 4 in (10·2 cm). Belgravia 3 April £58 ($139)

Left: Liberty and Co silver and enamel belt buckle, Birmingham 1907. Length 2⅛ in (5·4 cm). Belgravia 3 April £50 ($120)

Right: Liberty and Co 'Cymric' silver belt buckle, Birmingham 1901. Width 3 in (7·6 cm). Belgravia 3 April £130 ($312)

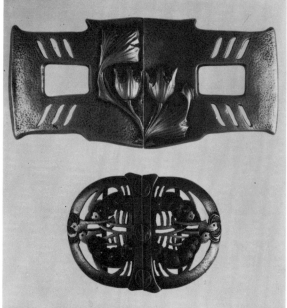

Upper: 'Cymric' silver belt buckle by Liberty and Co, Birmingham 1902. Width 5 in (12·7 cm). Belgravia 20 November £60 ($144)

Lower: Silver and enamel belt buckle by Liberty and Co, Birmingham 1906. Width 2⅞ in (7·3 cm). Belgravia 20 November £130 ($312)

One of a set of six 'Cymric' silver and enamel spoons by Liberty and and Co, sold with a pair of matching menu holders, Birmingham 1903 (spoons) and 1904 (menu holders) Belgravia 20 November £250 ($600)

Silver presentation mantel clock in the form of clock tower of Shell-Mex House as seen from the South Bank of the river Thames, London ; the clock by Smith's English Clocks Ltd, the case by Mappin & Webb, London 1932. Width 11½ in (29·2 cm). Belgravia 25 July £460 ($1,104)

Shagreen cigarette box with silver mounts, by Omar Ramsden, London 1924. Width 6¾ in (17·5 cm). New Bond Street 23 May £480 ($1,152)

Silver-gilt standing salt set with gem-stones (six missing) by Omar Ramsden, London 1930. 25 oz 11 dwt (all in). Height 5½ in (14 cm). Belgravia 10 October £100 ($240)

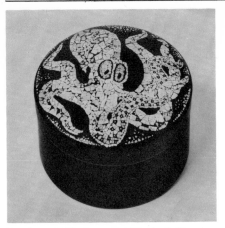

French eggshell lacquer covered box by A. Marcat, *circa* 1930. Diameter 5½ in (14 cm). New York 11 January $100 (£42)

'Tudric' pewter and enamel tobacco box and cover by Liberty and Co, after 1904. Height 4¾ in

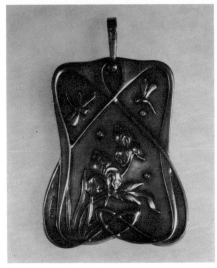

Art Nouveau gold and ivory memorandum case, *circa* 1900. Length 2¼ in (5·7 cm). Belgravia 20 November £140 ($336)

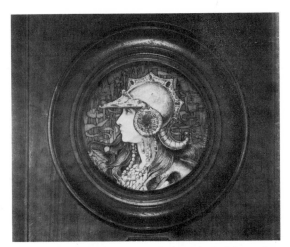

Limoges enamel plaque of the head of Minerva by Paul Bonnaud, dated 1901. Diameter 3 in (7·5 cm). Belgravia 25 July £150 ($360)

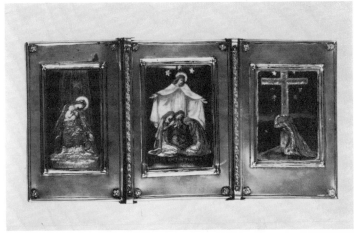

Silver and enamel triptych attributed to Alexander Fisher, English 1890s. Width overall 12 in (30·5 cm). Belgravia 25 July £210 ($504)

Art Deco carpet by Mrs Pindar Davis, English 1930s. 142 by 104 in (361 by 264 cm). Belgravia 20 November £240 ($576)

Art Deco rug by Marian Dorn, *circa* 1930. 72 by 56 in (183 by 142 cm). Belgravia 5 July £400 ($960)

Art Deco carpet by Marion Dorn, English 1930s. 149 by 98 in (378 by 249 cm). Belgravia 20 November £360 ($864)

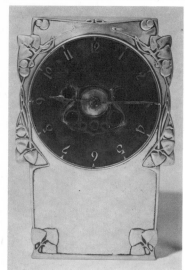

Liberty and Co. 'Tudric' pewter and enamel clock, English *circa* 1900-10, the design first registered in 1905. Height 8 in (20·2 cm). New York 11 January $750 (£313)

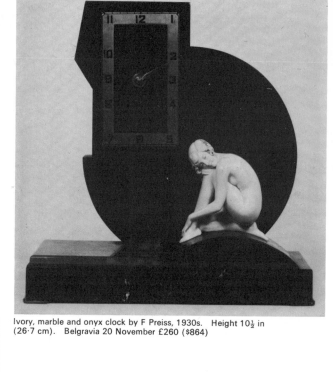

Ivory, marble and onyx clock by F Preiss, 1930s. Height 10½ in (26·7 cm). Belgravia 20 November £260 ($864)

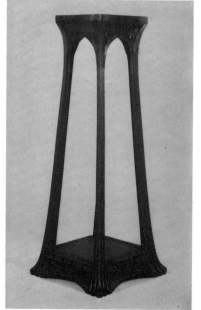

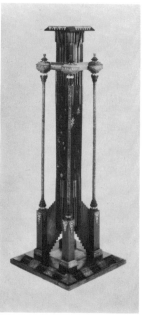

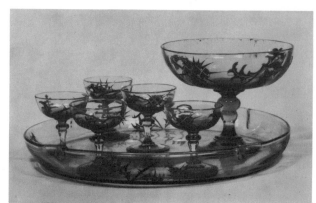

Enamelled glass cocktail set by Emile Gallé, *circa* 1890. Diameter of tray 12¾ in (32·4 cm). Belgravia 20 November £170 ($408)

Carved sellette attributed to Louis Majorelle, French *circa* 1900. Height 49½ in (126 cm). Belgravia 5 July £220 ($528)

Sellette by Carlo Bugatti, Italian *circa* 1900. Height 51½ in (131 cm). Belgravia 20 November £620 ($1,488)

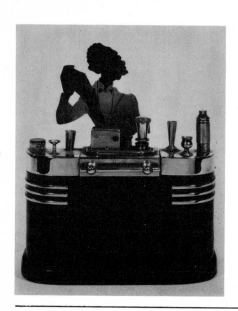

Left: Art Deco table lighter and cigarette holder, marks of *Ronson* and the *Art Metal Works Inc*, *Newark N.J. U.S.A.*, *circa* 1930. Height 6⅞ in (17·5 cm). Belgravia 5 July £150 ($360)

Right: Art Deco cocktail cabinet, *circa* 1930. 55 by 36 in (140 by 91·5 cm). Belgravia 20 November £100 ($240)

Wardrobe by *Charles Rennie Mackintosh,* 1890s. 73 by 58 in (186 by 147 cm). Belgravia 5 July £920 ($2,208)

Art Nouveau mahogany secretaire, probably English *circa* 1900. Height 52 in (132 cm). Belgravia 31 July £320 ($768)

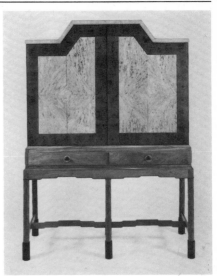

Walnut and burr-elm cabinet on stand, inscribed *The Russell Workshops. Broadway. Worcs. This piece of furniture. Design No 693, was made throughout in the Russell Workshops. Broadway, Worcs. Designer: Gordon Russell. Foreman: Edgar Turner. Cabinetmaker: I. Shilton. Metal Worker: A. L. Fry. Timber used, burr-elm. yew-wood and ebony. Date 20/7/28.* 57 by 40½ in (145 by 103 cm). Belgravia 31 July £520 ($1,248)

Fruitwood marquetry three-tiered *étagère* by *Louis Majorelle, circa* 1900. Height 49 in (125 cm). Belgravia 3 April £420 ($1,008)

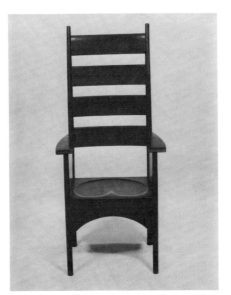

Armchair by *Charles Rennie Mackintosh* designed in 1897 for the Smoking Room of the Argyle Street Tearooms, Glasgow. Height 54 in (137 cm). Belgravia 20 November £480 ($1,152)

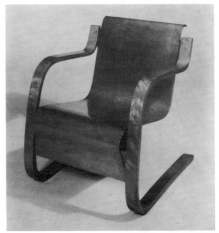

Laminated wood armchair by *Alvar Aalto,* stamped *Finmar Ltd . London. Design Registered, circa* 1935. Belgravia 20 November £220 ($528)

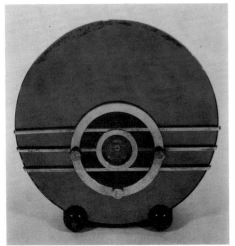

American Art Deco wireless, the face inscribed *'Spartan', Police, Amateur, Aircraft, Jackson, Michigan, Made in USA, circa* 1930. Height 14¼ in (36·2 cm). Belgravia 20 November £110 ($264)

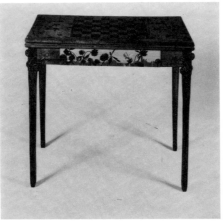

Fruitwood marquetry games table by *L Majorelle,* French, *circa* 1900. Width 36 in (91·4 cm). Belgravia 5 July £450 ($1,080)

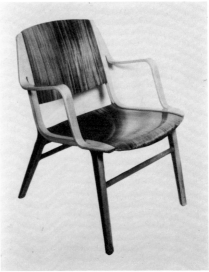

Laminated wood armchair by *Fritz Hansen,* Danish *circa* 1935. Belgravia 31 July £20 ($48)

American folk art

Not surprisingly this is still a domestic market, although recent exhibitions of patchwork quilts and allied American folk fabrics in London and other European capitals have widened the audience for a rich part of North America's cultural heritage.

One of the most important sales to have taken place in 1974 was that of the Jacqueline D. Hodgson collection of American ceramics in New York on 22 January, primarily a collection of folk pottery and the most significant of its kind sold since the war. Pieces of this calibre are rarely seen at auction today and many fetched sums well within our price bracket; of particular interest were some beautiful Connecticut slipware pottery dishes of the early 19th century, one of which, decorated in a loop pattern with four trails of yellow slip, realised a mere $190 (£79). The sale also contained some exceptional Bennington 'Rockingham glazed' animal figures of a type for which this important factory was famous, some of which are illustrated in the following pages.

Among other examples of folk art, we illustrate several fine Frakturs. This is an art form peculiar to the Pennsylvania German settlers (often called 'Pennsylvania Dutch' from a corruption of 'Deutsch'), the word being derived from *Frakturschrift*, a German typographical expression; it usually takes the form of a birth, baptismal or marriage certificate which is embellished with ornate calligraphy, this turning what would otherwise have been a mundane legal document into a decorative picture. Some were further embellished with watercolour drawings. We illustrate also some fine samplers, needlework pictures and theorem paintings. The last, usually still-lifes, were stencil patterns intended originally for furniture but stamped on to squares of velvet and hand-coloured, an early form of 'painting by numbers'.

The appeal of American folk art is two-fold. It is a continuation of the lively European folk tradition carried to the New World by immigrants whose individual cultures were merged with those of other nations, thus forming a unique and fascinating synthesis. In addition, it is a rich source of historical information about migration patterns and the social structure of early immigrant communities. Apart from these art historical and sociological aspects, however, there can be no denying that, at its best, American folk art is of great beauty, with a strong decorative sense.

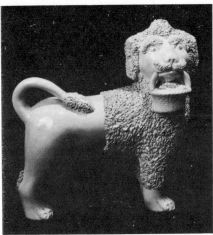

One of an extremely rare pair of Bennington glazed graniteware pottery poodles with blue eyes (both pieces restored), *circa* 1850-58. Height 8⅜ in (21·3 cm). Length 9 in (22·8 cm). New York 22 January $1,400 (£583)

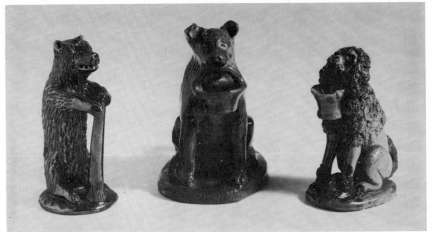

Left: A Pennsylvania glazed redware pottery bear rattle, 19th century. Height 5 in (12·7 cm). New York 22 January $425 (£178)

Centre: A Pennsylvania glazed redware pottery figure of a dog, possibly by Jacob Fretz. 19th century. Height 5¼ in (13·3 cm). New York 22 January $550 (£230)

Right: A Pennsylvania glazed redware pottery figure of a seated poodle, 19th century. Height 4½ in (11·5 cm). New York 22 January $375 (£156)

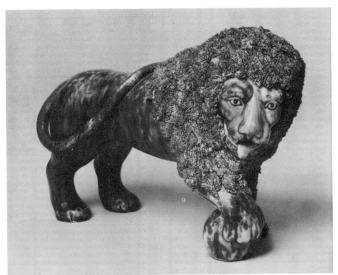

One of a pair of Bennington pottery free-standing lions with 'flint-enamel' glaze, *circa* 1849-58. Length 10 in (25·5 cm). New York 22 January $1,800 (£750)

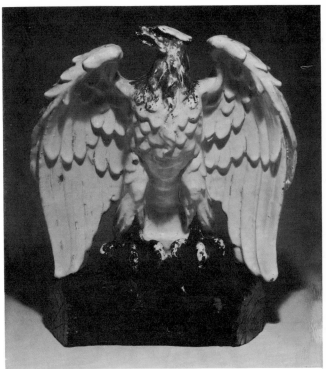

A Pennsylvania pottery eagle, the body glazed white, with traces of overglaze painting, the log realistically coloured, *circa* 1872-77. Height 17¾ in (45 cm). New York 22 January $775 (£324)

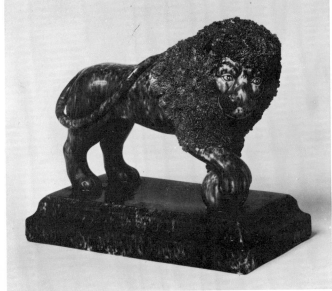

Bennington pottery 'flint-enamel' glazed figure of a lion (tail restored). Impressed 1849 mark, *circa* 1849-58. Length 11¼ in (28·6 cm). New York 22 January $1,000 (£417)

An American 'Rockingham' glazed inscribed pottery 'Railroad Pig' flask. The body covered with a splotchy brown glaze and incised with a local railroad map and the Mississippi River. Inscribed *from Sandford Wells & Co. N.214 N. Main St., St. Louis, Mo., with a little Fine Old Bourbon.* Midwestern, *circa* 1870-90. Length 7 in (17·8 cm). New York 22 January $900 (£375)

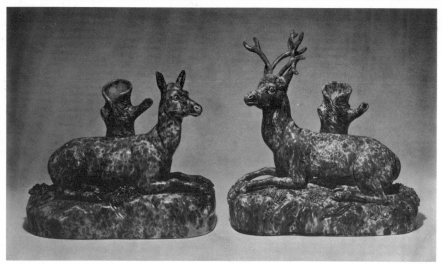

Pair of Bennington pottery 'flint-enamel' glazed figures of recumbent deer (the stag's detachable antlers replaced), *circa* 1849-58, impressed 1849 mark. Length 11 in (28 cm). New York 22 January $1,900 (£790)

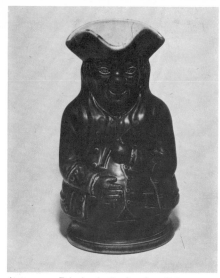

A stoneware Toby jug by the American Pottery Company of Jersey City, New Jersey, The exterior glazed a chocolate-brown colour. Strap handle restored. Impressed marks, *circa* 1833-45. Height 5⅞ in (15 cm). New York 22 January $325 (£135)

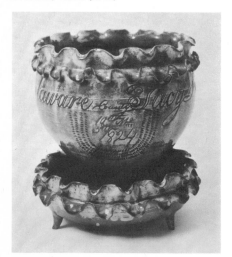

A Pennsylvania glazed redware pottery inscribed flower pot and (cracked) stand. Decorated with shaded white slip and inscribed *Tacy Lewis Newtown Township Delaware County, 10th Mo. 5th 1824.* 19th century. Height 10 in (25·4 cm). New York 22 January $2,400 (£1,000)

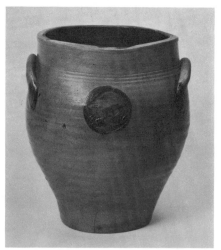

An American salt-glazed stoneware crock with incised cobalt-blue medallions, probably Old Bridge, New Jersey, *circa* 1830. Height 13¾ in (34 cm). New York 22 January $425 (£178)

A Connecticut slipware inscribed pottery dish, the interior inscribed in yellow slip *On Hand*, early 19th century. Diameter 12⅛ in (30·7 cm). New York 22 January $650 (£271)

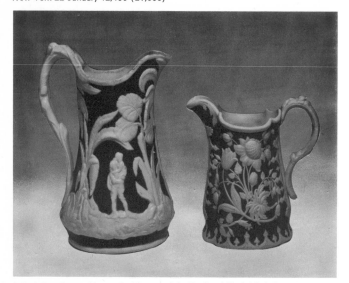

Left: A Bennington blue and white porcelain 'Paul and Virginia' pitcher, *circa* 1825-58. Bears the United States Pottery Company 'ribbon' mark and impressed No 10. Height 10¾ in (27·5 cm). New York 22 January $325 (£135)

Right: A very rare Bennington brown and white porcelain pitcher in the 'Tulip and Sunflower' pattern, *circa* 1852-58. Bears the extremely rare United States Pottery Company 'lozenge' mark in brown. Height 7⅝ in (19·4 cm). New York 22 January $750 (£313)

A Connecticut slipware pottery dish the centre decorated with a loop pattern in four trails of yellow slip, early 19th century. Diameter 13¾ in (35 cm). New York 22 January $190 (£79)

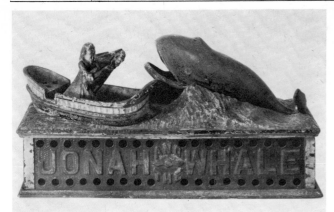

Cold-painted cast-iron *Jonah and the Whale* money-box, stamped *Pat, July 15th, 1890*. American late 19th century. Width 10 in (25 cm). Belgravia 6 March £140 ($336)

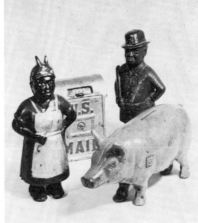

Three of a collection of thirteen cast-iron money boxes, mainly American late 19th century. Belgravia 10 July £95 ($228)

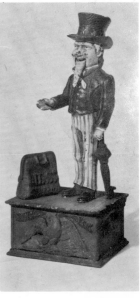

'Uncle Sam' cold painted cast-iron money box, American late 19th century. Height 11½ in (29 cm). Belgravia 4 December £55 ($132)

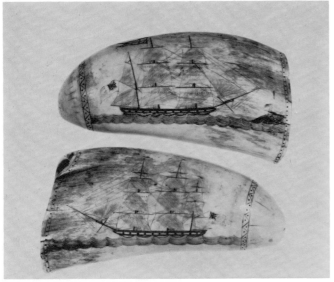

Pair of engraved scrimshaw teeth, American late 19th century. Length 7 in (18 cm). Belgravia 9 January £170 ($408)

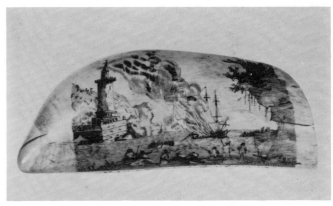

Colour-engraved scrimshaw tooth, American mid 19th century. Length 8 in (20 cm). Belgravia 9 January £210 ($504)

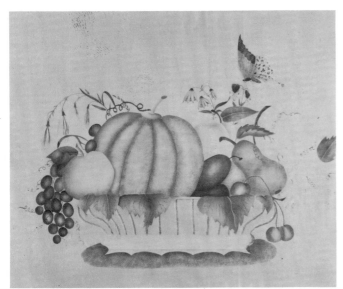

Theorem painting, *The Full Basket*, anonymous, 19th century. Painted on silk. 13½ by 16 in (31·2 by 40·6 cm). New York 23-24 January $500 (£209)

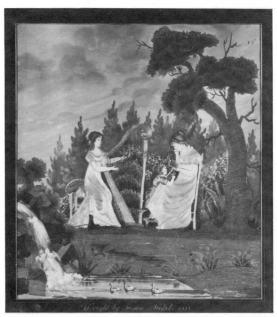

Embroidered picture, *The Concert*, by Susan Nichols, Massachusetts, dated 1818. Embroidery and paint on silk. 20 by 18½ in (50·8 by 47 cm). New York 23-24 January $900 (£375)

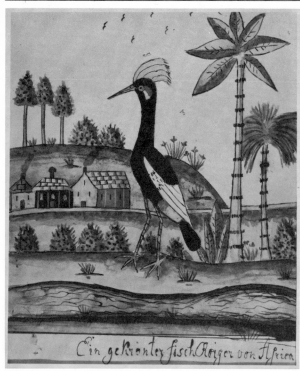

Watercolour Fraktur: A crane from Africa, anonymous, probably Pennsylvania, early 19th century. 8 by 6½ in (20·3 by 16·5 cm). New York 8-9 May $1,000 (£417)

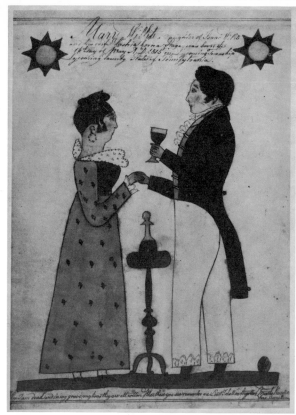

Fraktur: Birth certificate of Mary Willits, inscribed *Martha Kunkel, Lycoming County, Pennsylvania*, dated 1815. 11½ by 8 in (29·2 by 20·3 cm). New York 8-9 May $2,100 (£876)

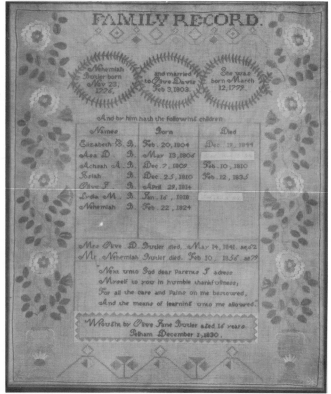

Embroidered sampler: Family record. Olive Jane Butler, Pelham, New York, dated 1830. 20½ by 17 in (52 by 43 cm). New York 23-24 January $400 (£167)

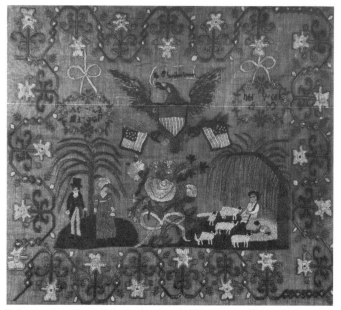

Embroidered sampler, indistinctly signed, early 19th century. 21½ by 25½ in (54·8 by 64·7 cm). New York 8-9 May $1,500 (£626)

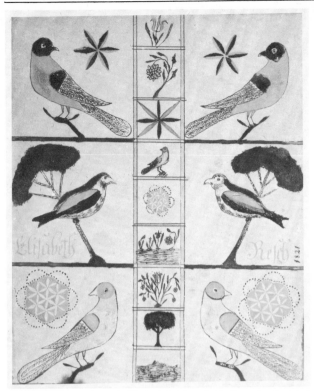

Fraktur: watercolour picture by Elizabeth Reich, probably Pennsylvania, dated 1821. 9¼ by 7¼ in (23·5 by 18·4 cm). New York 8-9 May $850 (£355).

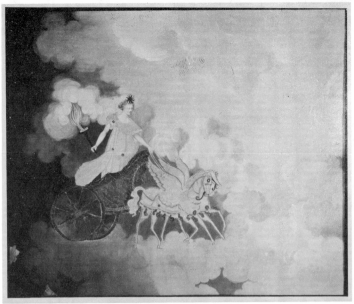

Embroidery picture, *Aurora*, by Abby Eddy, Providence, Rhode Island, early 19th century. Watercolour and embroidery on silk. 16 by 20½ in (40·6 by 52 cm). New York 23-24 January $500 (£209).

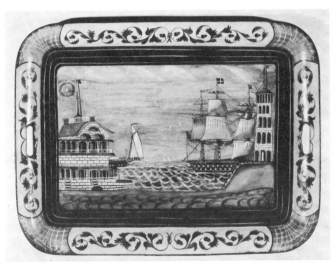

Painted tin tray with a view of the Nahant Hotel, Massachusetts, early 19th century. 19¼ by 26¾ in (48·8 by 67·9 cm). New York 8-9 May $600 (£250).

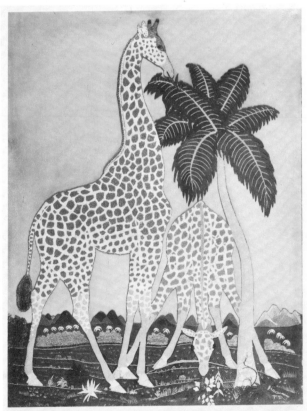

Needlework picture, *Giraffes*, anonymous, late 19th century. 30¼ by 23 in (76·7 by 58·4 cm). New York 8-9 May $700 (£295).

Cutwork picture of a farmyard scene, anonymous 19th century. 12½ by 13¾ in (31·8 by 34·3 cm). New York 23-24 January $450 (£188).

Dolls, automata
and miscellaneous collectors' items

This section covers a very wide range of objects, from fine 18th-century dolls to 20th-century postcards of scantily clad young ladies, which one Sotheby cataloguer at least found titillating. The collecting of early dolls, a comparatively new activity, is now taken very seriously. It is not unusual for fine examples, especially if dressed in original costume and in good condition, to realise considerably more than £1,000 at auction.

In the remaining part of this section all types and conditions of objects will be found. A close study of all of them will indicate that anything, if assembled with sufficient enthusiasm and dedication, can be of value and that absolutely nothing can be taken for granted. A few years ago, the Bodleian Library at Oxford accepted a collection of printed ephemera assembled by one man during his lifetime. Everything—sweet wrappings, tin cans, bus and train tickets, cinema and theatre programmes and posters, official forms, newspapers and magazines etc.— was represented and the result, formed over a period of some seventy years, was several tons of paper which, when fully catalogued, will give a valuable insight into the economic and social history of the 20th century.

This section also contains early gramophones, telephones and other items of domestic equipment which again illustrate the development of those standards of living which in the West are taken for granted but which are the results of years of experiment. On a different level, there is a wide selection of toys and games, including model train engines, lead soldiers, tin clockwork toys and some early examples of fluffy animals. Because of the hard use to which they are subjected, objects made to entertain children are among the most ephemeral of artifacts and examples preserved in good condition are now keenly collected.

Many of the things illustrated in the following pages will be laughed at by those who consider themselves serious collectors of art. Indeed, it would be specious to argue that they are all of great significance; nevertheless, there is an intellectual value in ignoring nothing and it would be a great pity if, because of a general indifference, so many of the things which have become humble but typical examples of life in the present century were to disappear. Those who collect them may be scorned now but they are performing a valuable service to the social historians of the future.

Queen Anne *papier mâché* doll dressed in the habit of a choir nun of one of the Benedictine Orders, English *circa* 1710-20. Height 17½ in (49·5 cm). New Bond Street 19 April £250 ($360)

Queen Anne *papier mâché* and wooden doll, English *circa* 1710-15. Height 17 in (48·2 cm). New Bond Street 19 April £1,000 ($2,400)

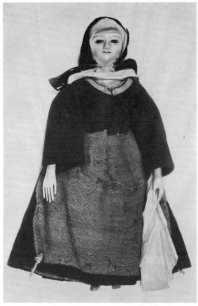

English wooden doll dressed in the habit of what is probably that of a lay sister of the order of the Dames of St Clare, 1740-60. Height 15 in (38·1 cm). New Bond Street 19 April £700 ($1,680)

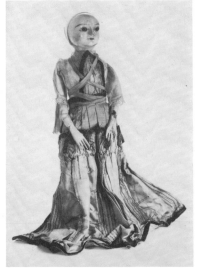

Wooden doll, English 1730-40. Height 8¾ in (22·2 cm). New Bond Street 19 April £650 ($1,560)

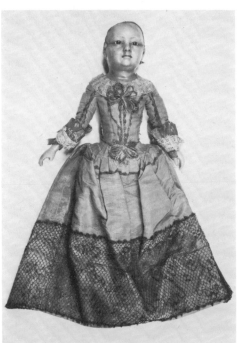

Wax doll (head damaged), Italian or Spanish late 17th century. Height 22½ in (57·2 cm). New Bond Street 19 April £150 ($360)

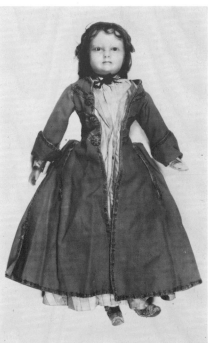

Wax doll (head and right hand damaged, left hand missing), probably Italian. Height 23 in (58·4 cm). New Bond Street 19 April £180 ($432)

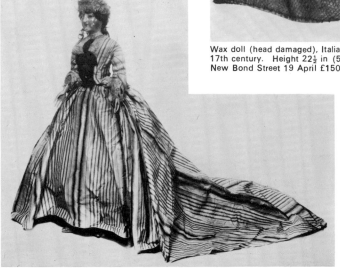

George II *papier mâché* and wooden doll, English 1735-40. Height 25 in (63·5 cm). New Bond Street 19 April £550 ($1,320)

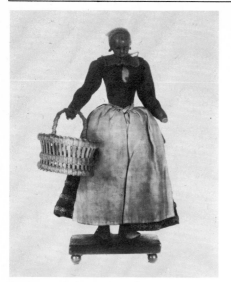

Dutch wax doll of a peasant woman (hands missing, feet replaced and a later basket), early 18th century. Height 8 in (20·3 cm). New Bond Street 19 April £60 ($144)

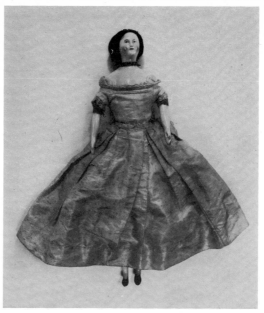

Mid 19th-century shoulder-china doll. Height 14½ in (36·8 cm). New Bond Street 19 April £380 ($912)

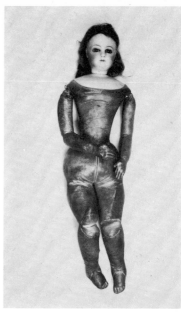

Bisque fashion doll, French *circa* 1870. Height 16½ in (41·9 cm). New Bond Street 19 April £200 ($480)

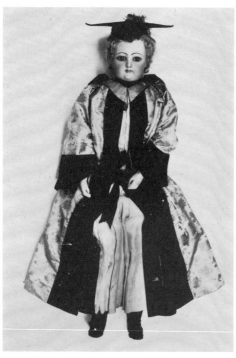

Jumeau bisque doll dressed as H.H. Princess Alexandra when receiving a Doctorate of music at the Royal University of Dublin, the doll *circa* 1881, the costume *circa* 1885. Height 26 in (66 cm). New Bond Street 19 April £550 ($1,320)

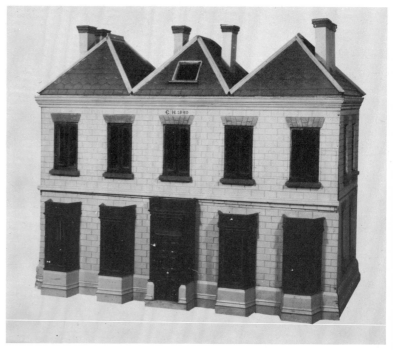

Victorian doll's house dated 1860, and including some contemporary furniture. 54 in high by 63 in long by 29 in deep (137 by 160 by 73·7 cm). New Bond Street 19 April £170 ($408)

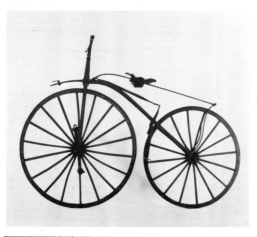

Cast-iron framed bicycle, English *circa* 1860. Front wheel diameter 38 in (96·7 cm), overall length 68 in (173 cm). Belgravia 6 March £170 ($408)

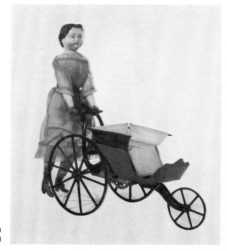

Clockwork pram and doll, inscribed *H,M,F, Goodwinn Patents Jan 22 1867 & Aug 25 1878*, English late 19th century. Height 11 in (28 cm). Belgravia 4 December £100 ($240)

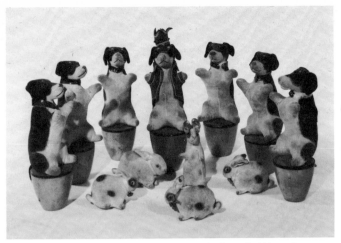

Set of seven felt animal skittles and five 'bowls' in the form of rabbits and a kangaroo, English *circa* 1900. Belgravia 4 December £75 ($180)

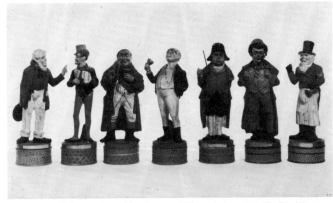

Part of a set of eleven composition figures of Dickens' characters, English late 19th century. Height 7 in (17·8 cm). Belgravia 4 December £45 ($108)

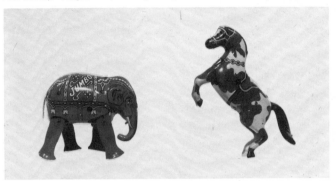

Left: Moko tin clockwork toy of *Jumbo the Walking Elephant*, English early 20th century, in original cardboard box. Width 4¼ in (10·8 cm). Belgravia 10 July £18 ($43)

Right: One of three tin clockwork circus horses, English 20th century. Height 6¼ in (15·9 cm). Belgravia 10 July £5 ($12)

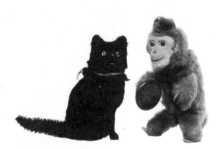

Left: Clockwork purring pussy, early 20th century. Height 6¼ in (15·9 cm). Belgravia 10 July £18 ($43)

Right: Clockwork monkey bandsman, 20th century. Height 8 in (20·3 cm). Belgravia 10 July £8 ($19)

One of a collection of approximately 43 song sheets, *circa* 1850-1910. Belgravia 10 July £75 ($180)

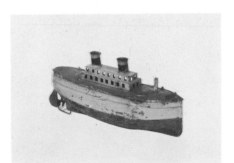

One of a collection of seven painted tin toys, English 20th century. Belgravia 4 December £34 ($82)

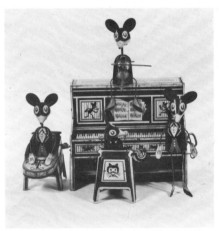

Marx *Merrymakers* clockwork mouse orchestra contained in glazed ebonised case, English early 20th century. Width 9 in (22·9 cm). Belgravia 10 July £70 ($168)

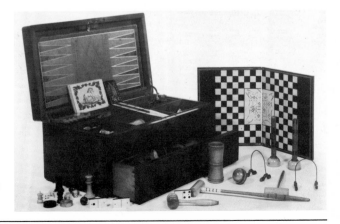

Mahogany games-box enclosing boards, chess and draughtsmen, dominoes, cribbage, bezique and marbles, with a drawer in the base containing table croquet, English late 19th century. Width 17½ in (44·5 cm). Belgravia 16 October £140 ($336)

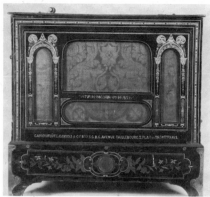

Marquetry table barrel organ inscribed *Gavioliflute, Gavioli & Cie Btes. S,G,D,G, Avenue Taillebourg 2. Place du Trone, Paris,* French *circa* 1870. Width 26 in (66 cm). Belgravia 4 December £620 ($1,488)

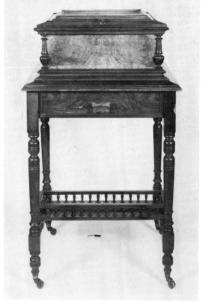

Walnut marquetry symphonion on matching stand, German *circa* 1880, sold with 47 discs. Height overall 34 in (86·5 cm). Belgravia 4 December £360 ($864)

Lambert typewriter manufactured by the *Gramophone and Typewriter Company,* in original wooden case with two interchangeable type faces and two ink bottles, English *circa* 1900. Length of carriage 11 in (27·9 cm). Belgravia 10 July £40 ($96)

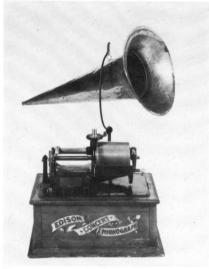

Edison concert phonograph, American *circa* 1899, diameter of horn 13½ in (34·3 cm). With twenty 5 in (12·7 cm) wax discs. Belgravia 6 March £90 ($216)

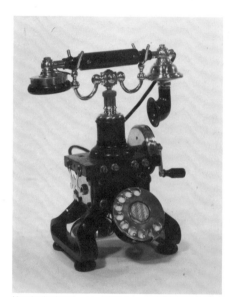

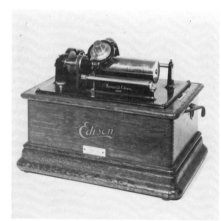

Edison standard phonograph, American *circa* 1909 (lacks horn). Belgravia 4 December £65 ($156)

Hand telephone, *circa* 1900 (converted for modern use). Height 12 in (30·5 cm). Belgravia 10 July £85 ($204)

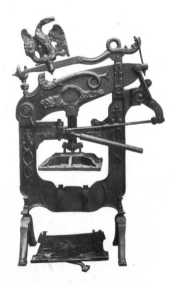

Columbian printing press by George Dixon, English late 19th century. Platen 23 in (58·4 cm) wide. Belgravia 4 December £500 ($1,200)

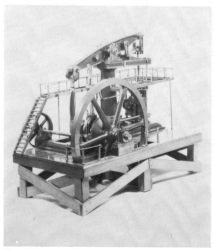

Model Watt vertical beam engine, English, *circa* 1900. Width 16½ in (42 cm). Belgravia 10 July £150 ($360)

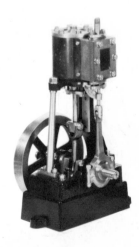

Model Stuart Turner 'No 1' vertical steam engine. Height 10¼ in (26 cm). Belgravia 10 July £35 ($84)

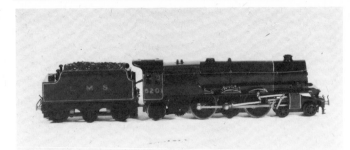

Model of the Royal Scot '00' gauge trix twin AC Stanier Pacific locomotive and tender No 6201 *Princess*, sold with a rake of four Royal Scot coaches in LMS livery. English *circa* 1940. Belgravia 10 July £45 ($108)

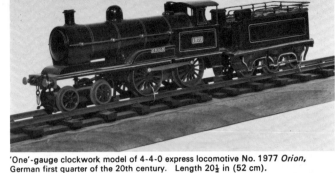

'One'-gauge clockwork model of 4-4-0 express locomotive No. 1977 *Orion*, German first quarter of the 20th century. Length 20½ in (52 cm).
Belgravia 4 December £120 ($288)

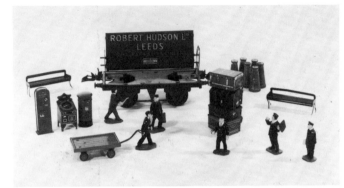

Part of a Hornby '0' gauge train set, English *circa* 1940. Belgravia 10 July £75 ($180)

Brass locomotive nameplate *Princess Victoria* in GWR livery, English early 20th century. Length 68 in (173 cm). Belgravia 6 March £190 ($456)

Ship automaton, English late 19th century. Width 30 in (76 cm). Belgravia 4 December £12 ($29)

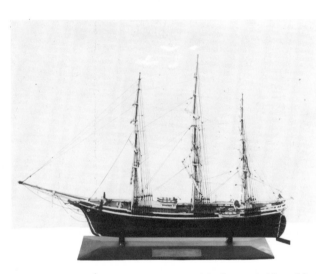

Model of the American clipper ship *Sovereign of the Seas*, scale ⅛ in to 1 foot, late 19th century. Length 40 in (102 cm). Belgravia 4 December £190 ($456)

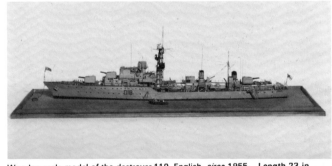

Wooden scale model of the destroyer 119, English, *circa* 1955. Length 23 in (58·5 cm). In glazed case. Belgravia 4 December £190 ($456)

Below: A collection of approximately eighty lead scale models of the world's fighting ships, English, *circa* 1950. Belgravia 4 December £40 ($96)

Photographs
and photographic equipment

This is one of the most recent markets represented in this book to have gained a widespread audience; it is indeed surprising to notice how quickly it has established itself as a serious field for collecting and, concomitantly, to see with what speed prices have risen. Museums, especially in the United States, have appreciated for many years the sociological and historical importance of photography, and this might be given as one of the few instances in recent years where they, rather than private individuals, have set the pace. The impetus for private collectors more often comes from aesthetic appreciation and it has taken some time—there are those who would say that it has not happened even yet—for the artistic qualities of photographic composition, the sheer beauty of the images, to establish themselves on an equal plane with painting and print-making.

This is not to say that private collectors, in England especially, have not been active for some time, but the early recognition by museums has stimulated the market. The following pages will make it clear that the finest images by the leading 19th-century English photographers—William Henry Fox Talbot, David Octavius Hill, Lewis Carroll, Julia Margaret Cameron for instance—now cost from about £300 ($720) to well over £1,000 ($2,400) for fine, clean examples. A perusal of sale catalogues over the past five years indicates that prices for such things have risen by a factor of about six in this period, while ten or fifteen years ago, when some of the major English private collections were being formed, good work by the photographers we have mentioned could have been purchased for less than £1. It would now be an extremely expensive business forming a collection of quality equal to that of the painter Graham Ovenden, who is also one of the leading experts on early photography, whose magnificent assemblage of some 30,000 to 40,000 Victorian and Edwardian images, put together over the last fifteen years, cost a minute fraction of its current value.

Nevertheless, this is still a new market and much remains to be discovered and properly documented. It is noticeable that a wide economic gap separates those who have been elevated to the ranks of 'masters' and the legion of minor Victorian photographers, both amateur and professional, whose work is of great charm, and who showed an often unerring instinct for composition which might be the envy of many modern photographers, for all their sophisticated equipment. Similarly, prints by some of the leading photographers of the 20th century are still comparatively inexpensive and particularly noteworthy is a group of images by Man Ray, the American Dadaist painter and photographer. Finally, a copy of the calendar nude posed by Marilyn Monroe, which has become one of the key images of 20th-century mythology, is illustrated; items associated with the cinema, although specialist sales have been devoted to them in the past by a number of different salerooms, have not proved very successful at auction (the calendar illustrated here being an exception). If it is accepted that this is one of the few great contributions to art made by the 20th century, the formation of a good collection of this sort might well prove to have been a wise move in future years.

A small group of photographic equipment is illustrated, as well as examples of early viewing machines. This is a highly specialised field where a scientific knowledge of the development of photography is essential for an understanding of the wide price differential which prevails. The early 'detective' camera should be of interest not only to those studying the early history of photography but also to students of current affairs.

Right: Heriots Hospital. Edinburgh.
Calotype by William Henry Fox Talbot,
1845. 7¼ by 9 in (18·4 by 22·8 cm).
Belgravia 8 March £250 ($600)

Left: A corner of Lacock Abbey.
Calotype by William Henry Fox Talbot,
circa 1840-45. 7½ by 9½ in (19·8
by 24 cm). Belgravia 8 March
£600 ($1,440)

Edinburgh Castle: group by a porthole. Calotype print by David
Octavius Hill and Robert Adamson, 1843-48. 5⅝ by 7¾ in
(14·2 by 19·6 cm). Belgravia 8 March £290 ($696)

Two Newhaven fishwives. Calotype print by David
Octavius Hill and Robert Adamson, 1843-48.
7¹¹⁄₁₆ by 5¾ in (19·5 by 14·6 cm). Belgravia
8 March £260 ($624)

Kakewaquonaby. Calotype print by David
Octavius Hill and Robert Adamson, 1843-
48. 7⅞ by 5¹³⁄₁₆ in (20·1 by 14·8 cm).
Belgravia 8 March £280 ($672)

The Sands of Time. A stereoscopic daguerreotype by T R Williams, *circa*
1852. 3⅜ by 7 in (8·6 by 17·5 cm). Belgravia 21 June £720 ($1,728)

Stereoscopic daguerreotype of the installation of the Great Exhibition of 1851
in the Great Nave of the Crystal Palace, 1851. 3¼ by 6⅞ in (8·4 by 17·4 cm).
Belgravia 8 March £440 ($1,056)

Left: Sixth-plate daguerreotype portrait of Esther
Reed Merriman, *circa* 1850. Belgravia 21 June
£25 ($60)

Right: The Strength of the Normans, Ely Cathedral:
North nave aisle to choir. Platinum print by
Frederick Evans from his original negative signed
in the mount, *circa* 1895. 7⅜ by 9¼ in (18·8 by
23·6 cm). Belgravia 8 March £260 ($624)

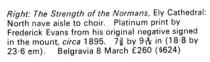

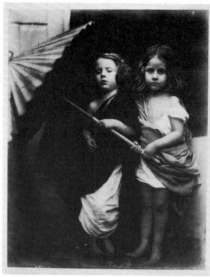

The Head of St John the Baptist in a charger by Oscar Gustav Rejlander, *circa* 1857-58. 5½ by 7 in (14 by 17·7 cm). Belgravia 21 June £480 ($1,152)

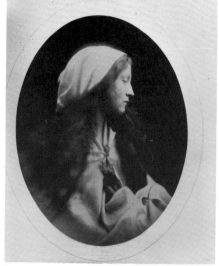

Paul and Virginia by Julia Margaret Cameron, *circa* 1865. 10½ by 8¼ in (26·6 by 21 cm). Belgravia 8 March £480 ($1,152)

The Dream by Julia Margaret Cameron, 1869. 13⅜ by 10⅜ in (34 by 26·2 cm). Belgravia 8 March £440 ($1,056)

Judith se redresse, fière d'avoir sauvé son peuple, a study of Madame Ferkel, the medium. Original print by Alphonse Mucha, *circa* 1900. 6⅝ by 4⅝ in (17·5 by 11·8 cm). Belgravia 8 March £260 ($624)

W Holman Hunt by Julia Margaret Cameron, *circa* 1870. 8¼ by 6¾ in (21 by 16·2 cm). Belgravia 21 June £320 ($768)

George Bernard Shaw. Photogravure plate hand-pulled by Alvin Langdon Coburn from his original negative, 1904. 8¼ by 6½ in (21 by 16·5 cm). Belgravia 21 June £190 ($432)

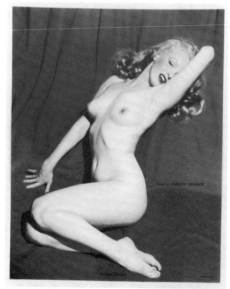

Kutenai type. Photogravure print made from the original negative of Edward S Curtis, studies for his series *The North American Indian*, published 1911. 7⅛ by 4¾ in (18 by 12·5 cm). Belgravia 21 June £22 ($53)

Roller Skater and Shadow by Man Ray. Photographic print made by Ray from his negative before 1940. 9⅝ by 7⅝ in (24·6 by 19·5 cm). Belgravia 8 March £360 ($864)

Golden Dreams, mechanically printed colour calendar photograph of Marilyn Monroe by Tom Kelly. Original photograph taken 27 May 1949 this with unused calendar for 1954. The print 9⅞ by 7⅞ in (25 by 20 cm). Belgravia 8 March £120 ($288)

The Landing of Colombus, black thermoplastic whole-plate union case, attributed to S. Peck & Co, *circa* 1858. 7¼ by 9¼ in (18·5 by 23·5 cm). Belgravia 8 March £160 ($384)

English half-plate wet collodion camera by Horne and Thornthwaite, *circa* 1860. Length 14 in (35·5 cm). Belgravia 21 June £450 ($1,080)

The Phenakistoscope or Magic Disc, published by *Forrester & Nichol of 10 George Street and John Dunn of 50 Hanover Street, Edinburgh.* Sold with 33 discs of various sizes. 1830s. Belgravia 8 March £220 ($528)

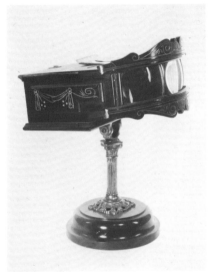

Triple viewer kinora, *circa* 1900. Length 17¾ in (45·1 cm). Sold with 22 reels. Belgravia 8 March £380 ($912)

Waistcoat detective camera by C P Stirn. *circa* 1900. Diameter 7½ in (19 cm). Belgravia 21 June 21 June £620 ($1,488)

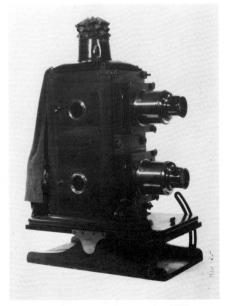

The Oakley Bi-unial magic lantern, *circa* 1890. Sold with wooden slide carriers, original wooden carrying case and projection screen. Height 30¼ in (77 cm). Belgravia 21 June £100 ($240)

The Wheel of Life, a zeotrope, 1860s. Diameter 11¾ in (29·8 cm). Sold with forty-five strip cartoons and eight circular cards. Belgravia 8 March £220 ($528)

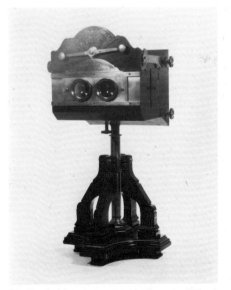

The Nautical Stereoscope, a table viewer by J Wood of Huddersfield. Early 1860s. Height 23½ in (59·7 cm). Belgravia 21 June £340 ($816)